Mart
Tel: (

To be re

D0323145

For Creative Geographies

This book provides the first sustained critical exploration, and celebration, of the relationship between Geography and the contemporary Visual Arts. With the growth of research in the Geohumanities and the Spatial Humanities, there is an imperative to extend and deepen considerations of the form and import of geography-art relations. Such reflections are increasingly important as geography-art intersections come to encompass not only relationships built through interpretation, but also those built through shared practices, wherein geographers work as and with artists, curators and other creative practitioners.

For Creative Geographies features seven diverse case studies of artists' works and exhibitions made towards the end of the twentieth and the beginning of the twentieth-first century. Organized into three analytic sections, the volume explores; the role of art in the making of geographical knowledge; the growth of geographical perspectives as art world analytics; and shared explorations of the territory of the body. In doing so, Hawkins proposes an analytic framework for exploring questions of the geographical "work" art does, the value of geographical analytics in exploring the production and consumption of art, and the possibilities of different forms of encounter that artworks develop, whether this be with their audiences, or their makers.

Harriet Hawkins is a Lecturer in Geography at Royal Holloway, University of London.

Routledge Advances in Geography

For Creative Geographies

Geography, Visual Arts and the
Making of Worlds

Harriet Hawkins

 Routledge
Taylor & Francis Group
NEW YORK LONDON

First published 2014
by Routledge
711 Third Avenue, New York, NY 10017

Simultaneously published in the UK
by Routledge
2 Park Square, Milton Park, Abingdon, Oxon OX14 4RN

*Routledge is an imprint of the Taylor & Francis Group,
an informa business*

Library of Congress Cataloging-in-Publication Data
Hawkins, Harriet, 1980–
 For creative geographies : geography, visual arts and the making of
worlds / by Harriet Hawkins.
 pages cm. — (Routledge advances in geography)
 Includes bibliographical references and index.
 1. Art and geography. 2. Geographical perception. 3. Art and
design. 4. Visual perception. I. Title.
 N72.G55H39 2013
 701'.04—dc23
 2013005925

ISBN13: 978-0-415-63625-4 (hbk)
ISBN13: 978-0-203-79628-3 (ebk)

Typeset in Sabon
by IBT Global.

For Anne, Louis and Joseph. Thank you.

Contents

Figures

Acknowledgments

This book is the product of over a decade of research and writing that has taken place around the world, and I am hugely grateful to the many people who have assisted me, and who have offered intellectual, moral and emotional support over the years.

Stephen Daniels and Nicholas Alfrey, my PhD supervisors at the University of Nottingham, were and remain an inspiration. I will always be grateful for their gentle guidance and perseverance as I worked out how to navigate interdisciplinary scholarship in a way that worked for me, supporting me in what I wanted to do but keeping some of my wilder impulses in check. I am also thankful for the time I spent working with Nicola Thomas and David Harvey, and other colleagues at Exeter who helped me learn what it means to be an academic and to be part of a scholarly community. The genesis and development of this book owes a debt to very dear friends and colleagues in Tuscon, Arizona, Wisconsin-Madison, Aberystwyth and Glasgow: Sallie Marston, J.P. Jones, Keith Woodward, Mrill Ingram, Deborah Dixon, and Elizabeth Straughan. I am especially grateful to Deborah for encouraging me to write the book in the first place, and to Sallie for providing me with the space, support, and friendship to make it happen. The wisdom, friendship, and dedication of this collective continually pushes me outside of my comfort zone, and reminds me to strive for good rather than Tuesday.

Thanks must also go to my new (ish) colleagues at Royal Holloway, University of London, including Phil Crang, Katie Boxall, Cara Gray, Danny McNally, Laura Price and the Landscape Surgery Group, as well as to colleagues elsewhere including Iain Biggs, Veronica Della Dora, Amanda Rogers and Brad Garrett for endlessly stimulating discussions. I am lucky to get to work with you all. I am also grateful to Joseph Hawkins for many hours of reading and for many years of discussions that keep me thinking.

Of course, this text could not have been written within the curiosity and generosity of spirit of the artists, curators, and organizations that I have worked with. This is a community, whether directly included in this text or not, who have been overwhelmingly generous with their often scarce time and resources over the years, special thanks go to, Agnes Poitevin-Navarre, Amy Houghton, Annie Lovejoy, Greg Humphries, Irene Hediger, Mac Dunlop,

Paul Goodwin, Susan Stockwell, and Teresa Cisneros, as well as Vandana Patel and staff at RGS-IBG, Iniva, Tate Britain, Swiss Artists in Labs and Arts Catalyst.

The research in this text was funded directly and indirectly by a range of organizations over the years, principally the Arts and Humanities Research Council; but also the US National Science Foundation; The British Academy, Royal Geographical Society, Social and Geography Research Group of the Royal Geographical Society, and by Research Strategy Funds from the University of Exeter and Royal Holloway, University of London.

I am hugely grateful to Jenny Kynaston, Department of Geography, RHUL, for patiently scanning images and spending time editing and preparing them. I also want to thank the following for granting permission to reproduce the images: The Royal Geographical Society (with the Institute of British Geographers), Amy Houghton, Michael Landy and the Lisson Gallery, Richard Wentworth, Thomas Dane Gallery and DCAS, Annie Lovejoy, Tomoko Takahashi and the Serpentine Gallery, and Galarie Lelong and the Foundation of Ana Mendieta. I would also like to thank David Gilbert and the Department of Geography at Royal Holloway for helping fund copyright licenses where they were needed. Thanks must also go to Eleanor Chan from IBT/Hamilton for her patience and editorial help.

Introduction
For Creative Geographies

This book is directed at questions of creative geographies, and specifically at points of over-lap and spaces of co-operation between geography and art. It is "for" these creative geographies by virtue of two reasons. Firstly, and simply, because it is a celebration of the growing richness and diversity of relations between geography and the visual arts. But secondly, and perhaps most importantly, because the text builds an argument around these shared concerns, exploring how, and with what import, creative geographies can and do proceed. At a time when there seems to be increasingly common conceptual ground and a growing set of shared practices between geographers and artists and art theorists, it seems important to temporarily press pause on the continued proliferation of these engagements in order to extend and deepen reflection on productive differences as well as shared areas of enquiry, and common themes and practices. As these exchanges accelerate, multiplying the artistic mediums and themes geographers engage, as well as developing exciting disciplinary moves towards creative practice-based research, it seems imperative to begin the work of considering how, and to what ends, these geography-art interrelations have been, are being, and could be negotiated and built.

If geography-art relations are the focus of this text, the idea of creative geographies more broadly encompasses a range of different approaches and forms of creativity. These range from the analysis of diverse creative practices and products (film, literature and so on) to the studies of the socio-spatial workings of the creative economy, the productive force of vernacular or everyday creativities, as well as creativity as a variegated political strategy—whether neoliberal, revolutionary, or as a politics of local possibility—and creativity considered as an inhuman force.[1] While taking geography-art relations as its focus, as this text progresses through its seven case study chapters a range of these other ideas of creativity emerge too; whether these be in terms of the the political possibilities of creative processes and products; the importance of attending to the geographies of creative production; or the coming together of artistic and earthly creative forces. Further, the central terms of the analytic framework for geography-art relations that the text builds are, I would contend, more broadly relevant across geographical

studies of creative practices. Proceeding through seven case study chapters, each focused on the geographical analysis of an art work, an exhibition, or a set of works from a particular artist, the volume builds an analytic framework for the geographies of art. This framework proposes the need to question art as a critical object in terms of; firstly, querying the work art does in the world, secondly, questioning the sorts of art encounters that are being developed and the analytic modes appropriate to them, and thirdly, asserting the need to reflect on the geographies of art's production and consumption.

In its reflections on geography-art relations, this text builds on a suite of rich, thematically driven geography-art explorations, but, what marks the difference between this volume and such studies—variously concerned with, for example, landscape, urban politics and space, and questions of globalization, borders, and territories—is a more concerted focus here on exploring the form and import of the relationship between geography and art.[2] Thus, in place of a thematic focus—wherein art is used by geographers as an empirical entry point onto a particular conceptual discussion—I want to flip this relationship and take the nature of geography-art relations themselves, and what could be identified as their core analytics, as the conceptual focus of this text.

GEOGRAPHY-ART RELATIONS

Arts practices—broadly understood—have been part of the nature and expression of geographical knowledge for centuries. The common ground but also the productive differences between geography and the arts, perhaps especially literature and the visual arts, have long been recognised by key commentators to offer forceful contributions to the making and mapping of knowledge and worlds.[3] Thus, we find arts practices proffering everything from an empirical naturalism in the service of eighteenth- and nineteenth-century geographical sciences, to the "soul" of twentieth-century disciplinary geography, wherein they provide a riposte to the "arid formalism" of a positivistic geographical science of the mid-twentieth century.[4] Whether enrolled in the service of geographical disciplinary interests, or as a critique of the same, arts practices take up a disciplinary place as a generative and transformatory force in the making and shaping of subjects, imaginaries, and disciplinary knowledge and worlds.

Geographers' engagements with artistic practices have, of late, become increasingly diverse, finding expression in a vibrant body of research that enrolls a wide variety of themes, approaches, and artistic mediums from across a series of time periods. Geographical studies have engaged, for example; painting; installation; sculpture; social sculpture; participatory art; new genre public art; photography; performance art; sound art; bio art; body art; Surrealist and Situationist inspired works; and other urban artistic walking practices.[5] This range of mediums is matched by a thematic

profusion, engaging such diverse themes as touch and the body; landscape; rubbish; nature; commodity politics and activism; mental health; identity and place; material culture; home; memory and urban politics; posthumanism; postcolonialism; and so on.[6]

Mirroring this there are, within the art world, a myriad of instances where geography provides a set of conceptual frameworks or practices. The relationship between artistic production and location, for example, has been an important art world analytic since Antiquity, and such geohistories of art can be traced to present day studies of the geobiographies of individual artists, art schools, and styles and their changing global geographies.[7] Furthermore, as this text will explore, geography has an important role to play in art theory's increasingly complex querying of art-site relations.[8] Along rather different lines, arts practitioners and theorists take up, and problematise, a range of practices and concepts that we might regard as inherently geographical—for example, questions of space and subject relations; theorisations of bodies and mobilities; the politics of critical urban spatialities; topographic studies of place and location; globalization and theorisations of place, community, and locality; landscape theorisations; critical cartographies and mappings.[9]

If the common ground between art and geography is now rather more occupied than it once used to be, one area that has tended to be overlooked is the question of shared practices.[10] The nature of the relationship between geography and the art world is changing, diversifying beyond the role of the geographer as just another interpreter of art, or geographical thought as proffering a useful analytic framework. Indeed, as a number of the case study chapters discussed here explore, geographers, art theorists, historians and practitioners are coming together in a range of practice-based ways. So geographers are becoming involved across the art-making process, from commissioning works to curating exhibitions, as well as being involved in artistic practices, sometimes pursuing their own practice, other times working in collaboration.[11] To be clear, from a geographical perspective, this is not just another way of talking about art as a "source material," wherein artistic practices are part of a broader suite of cultural products that proffer geographers empirical entry points into a diverse range of issues.[12] Rather, it is about making space for geographers to recognise the expanded role of artistic and creative practice-based research within geographical scholarship.[13]

Furthermore, if Hal Foster once identified the artist as ethnographer and archivist, then the time is perhaps ripe for also thinking through the artist as geographer.[14] Within the emergence of what have been termed "experimental geographies," we find a strain of practitioners exploring ways of knowing and critically occupying spaces and places.[15] This is perhaps evidenced most clearly, if rather obviously, in artists' cartographic enactments. If on the one hand, these are often bound up with radical political practices or modes of critical or subversive engagement with place, elsewhere we see

artistic reinterpretations of mapmaking offering the possibilities to reflect anew on cartography, extending its dimensions through explorations of materiality and embodied practices.[16] This is a reciprocal relationship, that also sees critical cartographers—theoretically inclined geographic information science practitioners and geovisualisers—turning to artistic and creative practices as a means to engage and develop new forms of mapping practices.[17] Elsewhere, rich intersections are developing around shared explorations of place. So artists draw together multiple forms of material and practice-based research to engage with specific places, while geographers are experimenting with artistic techniques and visual culture methods more broadly. These aid in their coming to terms with changing epistemological assumptions regarding places, and the associated methodological demands for multi-sensuous and affective explorations.[18]

The breadth of geography-art engagements, dispersed across diffuse thematic fields, guided by myriad thematic preoccupations, and engaging a disparate set of artistic media and approaches is at once both invigorating and challenging. Further, it is undoubtedly indicative of the currency of artistic practices within contemporary geographical debates and vice versa. The aim of this volume is neither to describe nor map these intersecting fields, nor is it simply to expand them by elaboration on yet another thematic approach. Rather, across the case study chapters, attention is drawn to *how* and with what *effect* geography-art engagements have proceeded, such that a productive analytic framework for these relations can emerge and their potential be realised.

Ahead of moving into the seven case study chapters, the remainder of this introductory discussion will address the contextual ground across which this discussion of creative geographies plays out. As befits the interdisciplinary approach adopted here this context has both geographical and art theoretical dimensions. Discussion will turn first to a history of geography-art relations. If Part I of this text addresses the centuries long history of geography art relations, then this is prefaced here with a focus on the recent past. It querys the problems posed and the lessons learnt from the last few decades of geography's interpretative engagement with landscape painting. Following this recent geographical history, discussion will move to the second contextual dimension: what art theorist Rosalind Krauss termed the "expanded field" of twentieth-century arts practices.[19] The lens offered by Krauss's work has three-fold value here, firstly, it enables a recognition of the shifts in the materialities, spatialities, and temporalities of art since the mid-twentieth century. Secondly, it allows for a taking account of the demands that these shifts placed on the traditional coordinates of art historical analysis. The result was an assertion of the need to overhaul understandings of what art is and does, and to develop a whole series of analytic coordinates akin to the new forms of art practice that developed. Included within this overhaul, is, it can be suggested, a substantive engagement with ideas and practices we

might recognize as geographical. This latter points towards a third value of Krauss's idea of "expanded fields," offering as it does a useful territorialisation of the disciplines, enabling an imaginary of disciplinary fields—in this case art and geography—expanding toward one another, thus directing our attention to their productive intersections.[20] To turn first though, to geography's studies of landscape painting.

LANDSCAPE PAINTING: AN INVITATION TO THOUGHT

The impetus for this book was a problem that, over time, became a very productive invitation to thought. Simply stated, the problem was this: the research largely responsible for shaping and making possible recent interrelations between geography and art took as its empirical entry point, at least initially, nineteenth-century landscape paintings, and its primary thematic focus was the conceptual understandings of landscape that such paintings developed.[21] Yet my empirical frame and conceptual interests were rather different: I was interested in the geographies of art made in the latter half of the twentieth century, and in particular the decades on either side of the millennium. These artworks present geographers with differently configured fields of enquiry, but ones that nonetheless are well served by the analytic model offered by earlier engagements.

To elaborate, if rather simplistically: during the 1980s and early 1990s, the predominate studies of art within geography took landscape paintings—principally the great canon of Constable, Turner, Wright of Derby, and so on—as their primary focus.[22] Epitomizing the interpretive turn in cultural geography, this scholarship repositioned geographical studies of art away from centuries of function as a form of empirical naturalism, building instead upon the emergence of a more humanistic framework, wherein art was valued for the access it offered to the "hearts and minds of men."[23] As such, landscape aesthetics, whether rendered in art or gardens, proffered the means to explore "the relation between the world outside and the pictures in our heads."[24] Moving away from a solely pictorial focus and centralising landscape experience, Lowenthal and Prince argued effectively for the value of "art and literature [as] providing invaluable routes into realms of environmental meaning," because "affective response to landscape and place is not simply a decorative façade to life but forms its core."[25]

Building on these foundations, the contentiously termed "new cultural geography" forged new directions and intersections for art history and geographical studies. It did so primarily via a methodological and theoretical yoking of art historical methods of iconography and iconology with a Marxist humanism drawn from cultural studies.[26] Such studies grew out of a large-scale, postmodern, and poststructural "crisis of meaning and method."[27] This saw geographers, alongside a whole suite of other scholars, break away from views of images and language as providing a

"transparent window on a 'real' world;" rather, images and languages were now regarded as opaque, distorted by relations of power and knowledge.[28]

Playing out within geographical studies of landscape painting, this was to find its most salient articulation in Daniels's study of the "Marxist Duplicity of the Landscape."[29] Comprehensions of painted scenes as mimetic representations were replaced by understandings of aesthetic productions shaped by the dominant power relations of the day. Furthermore, these were aesthetics that "veiled" the complex power relations that shaped both material landscapes and their representations, forming duplicitous images whose ideal forms—the English picturesque, the rural idyll—came to shape landscapes and lives around the world.[30] This research not only extended humanistic perspectives within geography, it also drove cultural geographical debates into territories beyond the discipline, cementing a relationship between geography and the humanities that continues to this day.[31]

Lessons Learnt

There is much to admire in this research, and while this text diverges from a thematic and empirical focus on landscape, the agenda for geography-art relations that this interpretative approach to landscape painting formulated offers direct inspiration to my thinking here. Firstly, this mode of scholarship was not afraid to commit to putting the art object—most often painting—at the heart of geography's conceptual development. Art was no longer merely a data point, playing second fiddle to scientific methods within geographical scholarship. Instead, shedding its functions as either mimetically illustrative of people and places, or as an instrumentalised force for enrolling followers into the geographical cause, art was understood to proffer a sophisticated empirical entry point in the development of central geographical concerns: namely, landscape, and later, questions of urban space and politics.

Secondly, geographical research on landscape painting displays a consummate inter-disciplinarity. It takes seriously the value of deploying the analytical methods and frameworks of art history alongside those of geography to offer an engaging and invigorating form of analysis that centralises the artworks and the practices and contexts of their production. As such, this was scholarship that did not shy away from demanding that geographers learn about another field of practice and theory. In doing so, it provided a vibrant and at times challenging terrain within which to situate geographical inquiry. Crucially, however, this relationship was reciprocal, and, as the uptake of these geographical texts within art history makes clear, it inaugurated a wider consideration of the form and value of taking a geographical approach to the study of art.[32]

Thirdly, what drives this research on landscape art, and is perhaps its largest contribution to interdisciplinary relations, has been its resolute commitment to exploring the "work" art does in the world—in other words, what

these artworks produce, sometimes directly, sometimes indirectly. To take an example, this research explored not only the duplicitous "visions" of English picturesque landscape painting, but also explored how these "visions" came to shape the material form of other rural landscapes, including re-making colonial landscapes in the form of these iconic landscapes of "home."[33] These same aesthetics also shaped subjects, whether the fleshy bodies of those working these landscapes, or the imagined national communities of young men transformed into soldiers, fighting for England's green and pleasant land.[34] Such perspectives move us beyond disciplinary assertions of the descriptive value of the arts, and beyond understandings of aesthetics as merely decorative flourishes beneath which lay the base of socio-economic relations.[35] Instead, these studies offer a foundation for the geographical exploration of art that requires us to consider the implication of artistic production within networks of power, and to reflect on art as enrolled, but also as potentially intervening within, political and socio-economic considerations.

The lessons of method, approach, and value learnt from these interpretative studies of landscape painting play forward into the seven case study chapters presented here, and shape elements of the analytic framework for creative geographies that the conclusion proposes. Alongside the geographical contribution to thinking through contemporary geography-art relations, the discussion in this text is shaped primarily in response to changes in the art world over the twentieth century: namely, as this discussion will now explore, the expanded field of twentieth-century art practices.

ENGAGING ARTS' EXPANDING FIELD

Humanistic geographer Yi-Fu Tuan, writing in the late 1970s, noted three modes of engagement in the relationship between geography and the arts (specifically literature), none of which he was entirely satisfied with.[36] He noted that literature offered geographers a source material for their studies, a perspective on how people experience the world, and he observed that geographical writing could itself have a literary quality. Tuan goes onto suggest that throughout the discussion there has been a tacit assumption that "we know the purpose of literature and the modes of expression appropriate to it."[37] To develop a more satisfying and substantial relationship between geography and literature, he suggests geographers need to reflect in a rather more concentred way on the nature and purpose of literature.

The same is true, I would suggest, of geographical engagements with art practices: an awareness of the central tenets of the artistic practice under study undoubtedly enables a more substantive engagement with the work in question. To begin to develop such an awareness, I want to explore the framework for understanding shifts in late twentieth-century art that is offered by Rosalind Krauss's discussion of arts' expanded field.[38]

Writing in 1979, Krauss, an influential art critic and professor of art history and theory, identified an expanded field of art practice. She was concerned, as were a number of art critics at the time, with the kneading, stretching, and twisting of the categories of sculpture and painting that had accompanied the critical operations of postwar art in the United States and Europe. These developments had moved the category of art beyond traditional forms to encompass a wide range of different ways of working, different materials, and sites far beyond the gallery and studio—for example, large landscape-based earth works or dematerialised performance pieces that saw feminist artists scrub gallery steps. This is a narrative often retold—with many different twists and turns—in the vast sweep of art histories of the era. But, binding all these different tellings together is an appreciation of the shifts in the practices, materialities, temporalities, and spatialities of artworks that posed new questions and demanded new analytic frameworks.[39]

The source of the enduring value of Krauss's critique lay in its admittance of the challenges posed by this expanded field to the normative frameworks of art historical analysis. Krauss's work was radical for the break it made with other studies, which in the face of these new forms of practices, were either restricted to describing these works, or reduced to attempts to develop historical frames of reference for them, often merely restating their difference from more traditional forms. Instead, and focusing on sculpture, Krauss demonstrated how these ways of artistic working enabled an ongoing meditation on what art is and does, making live a set of questions around the analytical coordinates demanded by the vast multiplication of arts' sites, practices, and operations that has occurred over the last hundred years.

Indeed, as a range of accounts make clear, during this period there was a significant calling into question of arts' traditional critical discourses and analytic coordinates, as well as the development of new frameworks and analytic modes that continues to this day.[40] Value had once been demonstrated through establishing (patriarchal) lineages based on a work's form and medium, or which located meaning solely in signification. Furthermore, the workings of these myriad new forms of art practices posed fundamental challenges to the illusions of stable subjects of "artist," "viewer," and "critic." Faced with an expanded field of art practices to study, and challenged by the growing influence of structuralist and poststructualist thinkers in Western art history, especially in the United States, grand historical and formalist narratives of art faltered. Enduring aesthetic categories no longer seemed able to account for, or make sense of, the proliferation of art mediums and practices. The response was a mode of art theory that embraced a whole suite of new frameworks—critical social theory, philosophy, radical politics, and even, in some cases, spatial-geographical discourse—as proffering the means with which to engage in the academic study of emerging art practices.[41] It is in the context of these new frameworks, and the place of questions and approaches that might be thought of as geographical within them, that this book operates.

Writing nearly three decades later, and following Krauss's formulation, art theorist and architect Jane Rendell observes an "explosion" rather than a mere expansion of the field of arts practices.[42] She develops an understanding of art as the product of processes of production and reception that operate within multiple expanded interdisciplinary fields. Here, the terms of creation are defined by many disciplines simultaneously, with artists "operating at sites within, at the edge of, between and across different disciplinary territory."[43] Space and spatial thinking are key to Rendell's argument in manifold ways, not only does she use a spatial metaphor as a means to understand interdisciplinarity, but further, she implicates spatial analytics and thematics—and thus geography—as one of those disciplinary fields with which art engages. Part II takes up the discussion of this "turn" to spatial analytics within arts' expanded field in more detail.

Hand in hand with the turn to other disciplines, including geography, as the means to explore arts' expanded field came a renewed concern to theorize our encounters with art. In order to understand the challenges and possibilities this expanded field of arts practices poses for geographers, we need to consider how it demanded from audiences and critics alike new modes of engagement and interpretation. Principally, these modes were required to recognize the productive force of art and its multiple dimensions: intellectual, affective, emotional, and sensory. These creative encounters are not, it should be emphasised, only applicable to certain mediums and forms of practice, but rather they proffer modes of engagement and interpretation that are valid across eras and mediums of art making.

Creative Encounters

Historically, institutionally, and ideologically art critique has long proceeded through Enlightenment-based logics of viewing, classifying, and heirarchising (visual) objects according to a scheme of relative values.[44] Art in these formulations was rendered intelligible in the context of the grand narratives of an art historical lineage of "comforting sameness."[45] Key analytic framings here were formed by accounts of the histories of forms, the development of particular mediums, or descriptions of the logics of influence and of stylistic development. As such, current art forms were read back through historical works, with the latter understood to contain the meaning of future forms, styles, and configurations in a "nascent" state.

Such a mode of engaging art rests on particular understandings of what it is, the demands of analyzing it, as well as how it is we understand the figures of the "artist," the "audience," and the "critic." To simplify, classically in art history, and in questions of the audiencing of art more generally, the key figures have been the intentional artist as the originary creator, and the critic/audience as a Kantian disinterested observer, whose informed

spectatorship was premised on a critical distance—a corporal and emotive spacing.[46] The result is a primacy of interpretative mode that foregrounds the cognitive abilities of these critics and historians to either situate the art work in a longer history, or to "decode" the artwork's "true" meaning. Alongside casting meaning as awaiting the deciphering skills of a trained interpreter, this approach "veiled" the critic/audience, subsuming the "vagaries of subjectivity" and the "vicissitudes of desire" under the imperative of a critical rigour.[47] Further, to foreground such transcendental and universal meaning in artworks, put there by the singular genius of their artist-author, is to deny any sense of distributed creativity, locating the latter solely with the artist, and thus occluding what has more recently been understood as the interpretative series of the "viewer" and "critic."[48]

To insist on the liveliness of art, as this book does, is to rework understandings of art, artist, and audience, and to demand two things. Firstly, that we need to move towards a sense of art as "productive of," attending to the doings of art, rather than focusing on questions that centralize the idea of art "produced by." The second thing to note is the revised ideas of audience/spectatorship, the role of the critic, and the dimensions of art experience and encounter that are needed to enable the recognition of art experiences as creative encounters with transformative potential. I want now to explore these ideas in a little more detail.

The "Work" of Art

At the heart of these shifts in understandings of art lies a demand to query what art can do (rather than what it means) and also what it can set in motion. This is to re-orientate understandings of art away from thinking of it as offering access to a presence—as standing for something—but rather to think about art *as* something, something that produces effects, produces difference, when coupled with other bodies (in this text, principally the bodies of the human subjects encountering it). These effects might be aesthetic, they might be acts of signification, they might be political and critical, or all these at once. Art is thus less to be understood as the output of a teleological, singular, linear chain of production, distribution, and consumption, with creativity lying solely at the beginning of that chain (as if that was ever really the case). But rather, art practices are to be described as in process, always producing: worlds in progress, knowledge in the making, subjectivities to come.[49]

Looking to existing geographical studies of art, including the interpretative relations just outlined, there is already a clear traffic between certain habits of art history, certain theories of criticism, and emerging practices of analysis based around querying bodies, materialities, and experiences. Indeed, engaging the role of art as a form of production, productive of subjectivities and worlds, is not a new stance for geographers. Whether considering the circulation of landscape paintings and their associated codifications of landscape aesthetics, or turning to that other popular

terrain across which geographers have cast their engagements with art—urban space—there is a sense that arts practices have long been understood as generative sites.

Suggesting that art is thus not simply about something, but *is* something, may be a familiar stance but it brings with it a need to theorize further what forms of "something" artworks are. In other words, to query how it is that art is a "dynamic, active . . . being," to question what is produced by this being, what it is working on and with.[50] A number of different answers have been proposed, many produced under the influence of some of the twentieth century's key philosophers and critical social theorists.

Art, following Foucault, for example, has been understood to offer the means to transform the field that conditions its appearance.[51] It thus harbors the possibilities—and indeed, the capacity to oppose consensus, question habits, and posit new values—to break with an existing realm and a regime of thinking and to develop new "being" for itself.[52] This same forcefulness of art practices for Deleuze and Guattari is understood in terms of a replacement of hermeneutic understandings with machinic ones.[53] In other words, art does not, or does not only, mean or represent; it produces, it circulates the world, independent of its makers, with singular powers and properties. One question that follows, therefore, is this: If art is a producing machine, what does it produce and what flows through this machine? The answer, for Deleuze and Guattari at least, is that art produces blocks of sensation, sensation that is not tied to a person, but that is liberated, out there in the world.[54] Abroad in the world, delinked from the sensory apparatus of a human individual, such blocks of sensation can propagate engagements with the world beyond those of human lived experience to make us think of the world, and our place within it, otherwise.[55]

At the heart of both these understandings of art, as well as a whole series of recent theories around what art is and does, is the need to appreciate art in terms of the encounter. O'Sullivan articulates it thus, "an object of encounter is fundamentally different from an object of recognition."[56] He continues, "an object of recognition is . . . a representation of something always already in place . . . our habitual way of being and acting in the world is reaffirmed and reinforced, and as a consequence no thought takes place. Indeed, we might say that representation precisely stymies thought."[57] By contrast, he argues that the encounters staged by art contain within them the possibilities to challenge our typical ways of being in the world; disrupting our systems of knowledge, we are in effect, forced to (new) thought and actions.[58]

What I want to take forward here is the general framing of art that emerges from these sets of ideas. For, to argue for a particular theoretical framework through which understanding the transformative potentials of art is not the intention or mechanism of this text, that is work for elsewhere. What is important here is that, whichever way these ideas are cut,

art encounters emerge as thoroughly creative encounters, obliging us to be aware of the possibilities they present for experiencing and thinking the world differently. Art in all these cases is a material being, less *about* meaning or sensation than *creative* of it. Whether understood as a "shock to thought" or more mutedly as a "difference machine," art holds within it the potential to enable "new" forms of experience.[59] As such, it provokes questions, offers moments of engagement, inspiration, and enthusiasm, and can challenge teleological and/or overlooked epistemological assumptions. In doing so art has the potential to transform the field on which it is working, creating the possibilities for different kinds of subjects, knowledge, and worlds. It is an exploration of this understanding of art, its import for geography, and implications for methods of analysis, and to some degree its responsibilities, that preoccupies this text.

Exploring the Nature of Art Encounters

Propagating from understandings of art as something with the potential to transform the artists that make it and the objects and people that encounter it, is a requirement to spend more time thinking through the nature of art encounters and the demands they place on our research methods and the modes through which we write about art. One of the principal elements in need of consideration is an appreciation that our art encounters are always excessive of our intellectual frameworks; they cannot be exhausted by art historical connoisseurship, or by the accrued scholarly frameworks of contextual understanding or theoretical development. For, alongside the expanded field's concern with conceptual art, has been a renewed querying of the role of aesthetics, of visceral and affective responses to artworks.[60]

From arts' expanded field has developed a series of art works that, as Parts II and III will explore in more detail, promote corporeal and material encounters between bodies, spaces, and objects, or in some cases, the development of encounters based on social (often understood principally as human) relations.[61] The result is a need for new methodologies and new modes of art writing that are able to come to terms with these dimensions of art encounters. The return of aesthetics and the embodied audience to art critique, for example, has resulted in calls for more subjective, evocative writing practices, and in the demand that art writing also concern itself with the conditions of the encounter. To take another example, the growth of social relations as constitutive of a form of aesthetics, has driven a turn to social science methods and practices as the means to take account of the form and kind of social relations that these artworks are understood to develop.

More generally, considerations of the productive force of creative encounters also demand, it has been argued, an overarching appreciation of an expanded sense of art practice, wherein, "making art, seeing art, or

writing about it is . . . no longer the static production, distribution and consumption of an object, but art practice as a process . . . always "in" production."[62] Art historian Griselda Pollock, for example, proffers an "ethics of interpretation" as a means to understand the creativity in each encounter, with ethics naming that live, co-constitutive relation between artworks and audiences—and worlds.[63] Such an ethics requires that we also engage with a politics of interpretation, and the creative differencing of art and of our thinking about art that is generated from such a politics.

Whether engaging an "ethics of interpretation" or embracing other means for thinking through artistic encounters—Rendell talks of the "principal of interactivity"—treating works of art as transformative performative events is to recognize that art "constantly transcends the boundaries of its initial historical moment of creation."[64] This stands in contrast to those understandings of art works as riddles or texts to be deciphered, or as codes that hold their own meaning within their terms of creation, contextualised by a singular interpretative frame.[65] Art's excessiveness ensures that it will escape being wholly captured, explained away, by any of the many contexts within which we might situate our analysis: author's intention, historical setting, audience reception, geographical framework, and so on. Thus, art experiences and interpretation understood in terms of primary making and belated reading is replaced by a sense of an event of poesis in all parties involved: artwork, artist, audience.[66] In other words, creativity does not lie solely with the artist in producing the work, but rather there is a distributed creativity in which the artwork is itself recognised as productive, transformative, and in which our products as critics must also be recognised as functioning within this expanded creative register.[67]

The creativity of the artist can therefore be conceptualised as but one creative instance in a distributed set of creative relations: the artist as first "interpreter," some would suggest rather than the singular author, as each and every encounter with artworks incites us to talk about it in terms of an ever-changing present.[68] This is not, as Pollock notes, to install a perpetual ahistorical present of transcendental, universal works of art, but rather, is to suggest that each moment of interpretation, each encounter with art, holds within it a potential for interpretation that may not have been co-present with the event of artistic "production."[69] "Meaning," and the "work" of art, its doings, are thus contingent on the conditions of the encounter in which works of art both articulate their own histories of making and anticipate practices of exploration that are not confined to this.

This of course places demands and responsibilities into the hands of curators, critics, and writers. For, such creative seriality layers productive encounter on top of productive encounter, and serves to complicate the geographies of art as it gives to exhibitions, to curators in actual space, and to the virtual exhibitions of catalogues and online collections, as well as to texts like this, a particular creative force and responsibility in their own

right. The demand is for the production of a dynamic within the text that re-centers ideas of interpretation in the relation between artwork, audience, and world. In place of foregrounding accumulated scholarship on a work's meaning, such exhibitions and texts can themselves be understood as productive of creative encounters, leading us back to the artwork. As such, then, we need to attend closely to the choices we make about how it is that artworks become re-presented within the spaces/pages of exhibitions and texts.

As a result of art's expanded field, we find therefore, the need to query what art is and does, to attend to questions posed by its expanded field of spatialities and temporalities, and to develop new methodological approaches and theoretical coordinates through which artistic practices could be studied. This discussion, thus far, has explored these in the broadest possible terms, and I want to go on now to pin down a little more firmly the impact of this expanded field of art on the analytic framework for creative geographies this text develops.

CREATIVE GEOGRAPHIES: AN ANALYTIC FRAMEWORK

The "creative geographies" in this text not only name the geography-art relations that are its focus, but also refer to the analytic framework the text promotes as a result of the expanded field of art and its intersection and impacts on geography-art relations and their histories. As such, then, running throughout the text is a backbone of three intersecting forms of inquiry.

The first of these three sets of queries around creative geographies directs our attention to the geographical "work" that artworks, events, and exhibitions do in the world. The seven case studies assembled here consider how art does various forms of work in the world, and how it is we can understand the value of that for geography. Part I explores the particular work that art has done with respect to the critique and transformation of the practices, sites, and methodologies of disciplinary knowledge making in the context of both the history of geography-art relations as well as their contemporary expression. Part II argues that to understand the work art does in the world—how it produces and transforms sites, spaces, subjects, and so on—we need to attend closely to the sites of its production and consumption and modes to circulation, in short, to its geographies. Part III collects together examples of how artworks can develop ways of sensing and experiencing the world that move us beyond our lived experience. This allows us to extend not only our experience and thinking on the relationship between our bodies and spaces, but also the very spatialities of our bodies, mapping the senses and exploring corporeal substance.

The second facet of the analytic framework for creative geographies proposed here is the importance of attending to the geographies of the artworks themselves. As Part II will address, arts' expanded field prompted

an art world attention to the geographies of art, although the disciplinary affiliations are perhaps not often recognized as such. This attention was principally a result of the changing relations between artwork, studio spaces, gallery spaces, and the wider world. As these relationships have been perceived to become more complex, geographical questions have gained attention within the art world as valuable analytics. Indeed, key across the art world, and interestingly in relation to range of different mediums, has been the demand for a vocabulary and methodology that enables the close parsing of art-site relations. Interestingly, the geographies of artistic production, consumption, and circulation have long formed an important focus of geographical attention across a whole range of mediums and periods of artistic making. Rose offers us a simple schema for thinking about this when she proposes a threefold analytic for visual culture more generally: the site of an image's production, the site of the image itself, and the site where it is seen by audiences. The chapters collected together in Part II begin to explore the complex and interrelated sets of queries around art and site. The impetus behind these queries is an appreciation for their importance in developing a geographical analysis of art, but also, in particular their importance in understanding how arts' agency is distributed and goes to work, and indeed is put to work, in the world.

The third element of creative geographical inquiry that emerges in the wake of arts' expanded field, is an attunement to the nature of art encounters. As outlined earlier, this has variously been understood as the "interactive principle," or as an "ethics of interpretation," but what it names more generally is a close attention to the productive relations between artwork, world, and the various audiences of the work.[70] For some art theorists, this marks a new mode of art research and writing that expands and deepens a focus on art historical frameworks or connoisseurship by way of exploring and experimenting with our cognitive, emotional, affective, and socio-political encounters with art.[71] As such, all the case study chapters experiment with research approaches, methods and writing practices—from ethnographic work to iconographic analysis, and collaborative practice-based research to modes of embodied writing—in order to reflect on the challenges of researching and writing different art encounters.

Intersecting with the redistributed sense of creativity that ideas of the art encounter develop, is the need to reflect on geography's embrace of artistic "doings" as a mode of research practice.[72] Across the seven case studies developed here are practices of both interpretation and collaboration. As these latter practices gain momentum within the discipline, an imperative emerges to consider the critical questions and judgments that they demand of us as scholars. It could be argued that these questions are, or should be, the same ones that we ask of the creative productions of others: What work do they do? How do we encounter them? What are their geographies, including the politics of their creation and interpretation? These are sets of questions that, it seems, are only just beginning to be opened up as

geography looks to move beyond a creative festishism to settle these creative and collaborative practices, once more, into disciplinary vocabularies and research methods.

Each of the seven case study chapters demonstrates the analytic value of combining these three forms of creative geographies. While analytic attention is not distributed across all three of these forms of enquiry evenly in each chapter, the impulse is to resist a disaggregation of these sets of creative geographies, a disaggregation that oftentimes happens at the expense of productive and careful analyses of the art under study.

ENCOUNTERING THIS TEXT

There are a number of different ways this book can be engaged. Read as a whole, the text will offer an argument that explores and celebrates the development of "creative geographies," and that looks to advance further a case for their value and import. A second way to engage the text is to explore its seven case study chapters individually, and they have been written in such a way as to enable that to happen. Guided by the lessons learnt from interpretive studies of landscape painting, each chapter can stand alone, foregrounding the analysis of particular artistic works, projects, or exhibitions. Further, each chapter draws together the three sets of creative geographies that are central here, querying the geographies of arts' production and consumption, considering the form of encounters that are developed, as well as exploring the "work" that art can do with respect to a series of different sub-disciplinary themes.

A third way to read the text is by exploring the three organisational headings the chapters are grouped into. Each of these parts addresses a key issue raised by the intersection of arts' expanded field and the history of geography-art relations. Part I is concerned with the critical value of art with respect to disciplinary knowledge production. Part II explores the growth of the geographies of art as an analytic within the expanded field, and Part III examines the common project of the body, wherein artists, audiences, and geographers share practice-based and theoretical concerns regarding explorations of the body in space and the spatialities of the body. The intention with these three parts, and the text overall, is not to de-limit the field, nor to provide an exhaustive survey of the possibilities and challenges of geography-art relations, but rather to indicate key points of analytic departure that, I argue, are important to understanding these intersections going forward. Unlike, however, thematic survey texts on, for example, art and landscape, or art and urban space, the goal is less to advance a particular or complete argument about the theme in question, but rather each part aims merely to indicate the potentiality of these points of analytic departure for our understandings and practice of geography-art relations.

Each of the three parts begins, therefore, with a substantial review that highlights key issues, in the case studies that follow these are elaborated, methods are explored, and points for future development are raised. The emphasis across the text is thus on formulating a generative study that looks to pose questions for the future, provide examples of how key ideas within arts' expanded field of practice enable geographers to explore important thematic and methodological questions, but also to think about how they might go about developing this research, what questions might be asked, and how these art encounters might be represented.

The Structure, in detail

The first part of the text explores the relationship between art and geographical knowledge production. If the number of geographers working with and as artists and creative practitioners has increased of late, often in the contemporary verve and vigor of these practices what can be forgotten is the role that varied intersections of art and geography have played in the production of geographical knowledge over the centuries. The aim of Part I is less to narrate a history of the changing form of these past relations; that would be a project far beyond the scope of this text. Rather, the discussion highlights a series of incidences where artistic practices have been a force for critical transformation within the development of the modern day discipline, its practices, and methods. This is to begin, therefore, from a point that unsettles any stable sense of how to understand "geography" or "art," but also a point that suggests that productive value of setting the two in play together.

The two case study chapters in Part I take up these questions of art as a force in the production of geographical knowledge, and epistemological critiques of the same. The chapters proceed via an examination of *Creative Compass* (2010), a site-specific commissioning and exhibition project at the Royal Geographical Society, and a study of the new media art and exhibition project *Connecting with Gertrude* (2010–2011). In both cases, my engagement with the projects was rather more than one based in the interpretative act carried out on a "finished" artistic product. Exploring the development of these two examples enables a study of the place of art as not only a critical tool for deconstructing particular ideologies of geographical knowledge, but also as a form of practice that offers possibilities for enacting the making of geographical knowledge otherwise.

Part II turns to questions of the geographies of art, and to what could tentatively be explored as a geographical turn in recent art world analytics. Perhaps unsurprisingly, geographer's research on art has long operated with a close eye on the geographies of artistic production, and the circulation and consumption of art works. With the shifts in the geographies of art, in the wake of arts expanded field, a shift often dubbed "from Studio to Situation,"[73] we find, it could be argued, a growing place for such

geographical querying beyond the discipline's own bounds. Thus, Part II begins by revisiting some of the geographies of artistic production and consumption, and from there outlines the beginnings of a programme for exploring geography as an art world analytic.

The three case study chapters that constitute Part II, explore the intersection between the geographies of art works' production and consumption, and the sites, spaces, subjects (and so on) that they produce and transform. Each case study explores how artworks create, manipulate, evoke, and critique a multitude of sites in the course of their production and consumption. The first of the three chapters examines the multiple sites of the work *Break Down* (2001) by Michael Landy. It foregrounds the need to attend to the manifold sites of the work's production and consumption (the installation and two artists books) and their intersections with those spaces it evokes (the shop, the rubbish tip, the factory) if we are to comprehend the transformative force of that particular work. The second of the chapters in Part II explores the urban imaginary of photographer and sculptor Richard Wentworth (1947–). Focusing on the spatialities, temporalities and materialities of the artist's practices of production, and of the consumption of the photographs, becomes key to understanding the politics of these works and their urban imaginary. The final chapter in Part II attends to the claims of site engagement and community transformation brought about by onging art project *Caravanserai* (2009–). Mimicking the unfolding of the research process at this site, the chapter proceeds through a combination of ethnographic research findings and reflections on the artist's book—*insites*—I produced collaboratively with *Caravanserai's* instigators in the process of researching the project.

Part III focuses on the project of the body that has been key to twentieth-century art, but also to the last few decades of thinking within geography, including acting as a driving force behind the geographical turn to creative methodologies. It considers how art encounters enable reflection on the relationship between bodies and spaces, but also the spatialities of the body, its boundaries, and reconfigured mappings of the senses. Bound up with this, the chapters performativly explore ideas about art writing and the writing of the body that are a crucial part of attending to the sensory experiences and affective relationships produced in art encounters.

Each of the two chapters in Part III takes up a different slant on art-body relations. The first develops an auto-ethnographic account of the experience of *Myplay-station*, an installation by artist Tomoko Takahashi (1966–). Experimenting with forms of critical creative writing, the chapter focuses on how these art experiences presence the senses, and in recuperating them from a backgrounded place, enable us to remap the body and in doing so to critique geography's "argument of the eye." Chapter Seven explores the relationships between bodies and landscapes that are developed within the work of body-earth artist Ana Mendieta (1948–1985). This chapter is an appropriate place to close a book

that began from questions raised by geographical engagements with landscape painting. What is foregrounded is a querying of the form of body-earth relations developed here, as well as ideas of landscape and environment that emerge from the body-earth encounters Mendieta's work develops.

The text concludes by reprising the threefold analytic framework for creative geographies by way of the lessons learnt from the case study chapters. It addresses, therefore, firstly, the geographical work that art does, secondly, the geographical analytics we apply to the study of the arts' production and consumption, and thirdly the different forms of art encounter that are emerging, from reformed ideas of what it means to interpret art works, to the expanded role of geographers as collaborators, curators, co-producers and so on. Attention is given to an examination of the interdisciplinary forms and lessons that this work offers for those who might want to practice and develop creative geographies, whether alongside the visual arts or other creative practices.

Central to the conclusion, as throughout this volume, is the development of a critical account of creative geographies that aims to retain productive differences between geography and art, whilst seeking to explore the benefits of these relationships. In the context of the excitement and energy that is proliferating around geography-art relations and creative practice based research within geography, it is important that we not simply fetishise creativity as inherently good. Rather, we need to take these relationships seriously, in order to develop the means to explore, understand and even harness the force of creative geographies, and the work they can do in transforming knowledge, subjects, and worlds.

Part I

Art and the Making/ Transforming of Geography

"The descriptive geographer is nothing other than a landscape painter and a map drawer in words" (Wimmer 1885).[1]

"We expect of him (sic) that he should have in him something of the poet and the painter" (Younghusband 1920).[2]

"We shall not have a humanistic geography worthy of the claim until we have some of our most talented and sensitive scholars deeply engaged in the creation of the literature of the humanities. Geography will deserve to be called an art only when a substantial number of geographers become artists" (Meinig 1984).[3]

INTRODUCTION: SOME VIGNETTES

In concluding his 1983 guest lecture to the Royal Geographical Society Annual General Meeting, held in Edinburgh, Scotland, Donald Meinig issued geographers a rallying call to creativity.[4] This is not, he summarised, "a call for geographers to become novelists . . . it is a call only for greater openness, a clearing away of the pedantic barriers, for a toleration of geographical creativity wherever it may lead."[5] While he steps back from the brink of asking geographers to become creative practitioners, Meinig desired that the relationship between geography and the humanities become one that was more complex than that he was witnessing. In place of what he, and others in this era, saw to be a supplemental relationship wherein humanities offered the "spice" or "flavouring" for a geographical science, Meinig desired a more wholesome relationship. He saw in a disciplinary alignment with the arts ways for geography to grow, shape, and extend itself, until it could stand as much as one of the arts as one of the sciences. But, he noted for this to be the case, it was crucial that the discipline move beyond the arts "as a resource, something we borrow from rather than contribute to, something we use rather than something we create as part of the vocation of geography."[6]

Opening this discussion of the place and possibilities of artistic practice in making and transforming geographical knowledge, will be a series of further short vignettes that between them start to explore the relationship between geography and the arts. Drawn from a number of presidential addresses and plenaries of the Association of American Geographers and the Royal Geographical Society (with Institute of British Geographers), these brief sketches serve to illustrate moments in what is a much longer, and often overlooked, history of relations between geography and the arts. To review this history in any depth is far beyond the scope of this text, but these selected moments serve to indicate some of the critical disciplinary work that these relations can be understood to do. Not least because, if nothing else, the place of the arts within these disciplinary addresses indicates the place and value that pondering geography-art relations has had at points of disciplinary self-reflection. As such, and whilst cognoscent of the dangers of reading too much into the place these addresses give to the arts, when set alongside contemporaneous examples of broader empirical work and thinking, they become a useful barometer of shifts within the discipline.[7]

In concluding his presidential address to the 43rd Annual Meeting of the Association of American Geographers (30 December 1946), John Kirtland Wright proposed a new subfield of geographical inquiry: geosophy.[8] Geosophy was "the study of geographical knowledge from any or all points of view," what "historiography is to history," its focus was an attention to "the nature and expression of geographical knowledge both past and present."[9] Two features of J.K. Wright's study stand out in the context of discussions of creative geographies. Firstly, in outlining who he counted as the producers of geographical knowledge Wright offers us an expanded field of geographers, moving beyond the "core" producers and concerns of "scientific geographical knowledge, or of geographical knowledge as it is otherwise systemized by geographers."[10] Indeed, Wright included artists amongst those who created geographical knowledge, arguing we should take into account "the whole peripheral realm," covering:

> Geographical ideas, both true and false, of all manner of people—not only geographers, but farmers and fishermen, businesses executives and poets, novelists and painters, Bedouins and Hottentots.[11]

Secondly, accompanying this broadening of the base of geographical praxis, Wright was also adamant that study should be made of what he termed "aesthetic geosophy," in other words, "the study of the expression of geographical conceptualizations in literature and in art."[12] For Wright, the place of literature and arts within geography was, he considered, and as Keighren demonstrates, not a repudiation of the logical positivism of a scientistic geography; rather, he sought to enroll artists and others on the "periphery" into the core of geography's scientific endeavor only if their

work was to the advancement of the latter.[13] Thus, Wright divides the arts three ways: into work he deems legitimate—work that is of no threat to scientific geography—work that he deems desirable, in other words art work that will contribute to the progression of scientific geography, and illegitimate work, which, by contrast, is seen to do damage, to undermine the coordinates of scientific knowledge and the discipline.

Moving forward forty odd years to Meinig and others of his era, we find a rather different set of relations cast between the arts and a scientistic geography. Meinig's rallying cry for the arts was far from a lone call, for, as the quantitative revolution was waning, a (re)turn to the arts by geographers, and a recognition of the need to query and develop geography's own artfulness was in the air. During his presidential address at the same 1983 RGS conference as that Meinig spoke at, John Wreford-Watson extolled the need to get in touch with the "soul" of geography.[14] Taking the fifty-year anniversary of the founding of the Institute of British Geographers as an occasion to look back, he asserted the value of the arts against the systematic studies that had come, over the course of his career, to replace geography's topographic tradition. His attention was a little different to Meinig's, noting his interest less in "geography as literature, but to the value of literature for geography."[15] This was a value that, as his writings demonstrate, he "found in virtually every field, physical, human and regional," and its source lay in how the arts "supplanted mere description" and, how in the face of an ever more rational discipline, "literature stresses those empirical traits geographers wanted most vehemently to escape . . . it was based in personal experience, whereas geography was marching forward to categorize abstractions."[16] Far from "mere" description for Wreford-Watson, the "images of America" created in literature, and "held in the American mind, were transforming the American Landscape," artists and writers were thus "fashioners" and "perpetrators" of a form of geographical knowledge that reached far beyond the academy.[17]

Less than a year earlier, and 5,000-odd miles away in Los Angeles, John Fraser Hart had, in his presidential address to the 77th Annual Meeting of the Association of American Geographers, also deployed the arts to hit back against the forces of positivist science.[18] He read the exclusionary scientism that the quantitative revolution had installed at the heart of the discipline as a damaging expression of disciplinary insecurities. Providing us with that well-known phrase "the highest form of the geographer's art is the production of good regional geography—evocative descriptions that facilitate an understanding and appreciation of places, areas and regions," Hart positioned the arts to enable an appreciation of regions as "subjective artistic devices," in whose study a solely "scientific" approach would fall short.[19] For Hart, at least, the arts as both a source, but also as representative of a particular epistemology, offered the "proper" means to assert a regional geography and to counter the ascension of disciplinary scientism.

Nearly thirty years later, Stephen Daniels, writing in a forum on the futures of cultural geography, tellingly detours the title of Peter Jackson's careful interpretations of ideologies in *Maps of Meaning*, to explore the growing interest in "Maps of Making."[20] Daniels' discussion, together with other contributions to the forum, point towards a (re)newed form of geography and arts engagement.[21] Together these discussions would suggest that studies and practices of creative making have come to sit alongside the interpretative registers that had, in the intervening three decades, come to dominate geographical studies of the arts. This focus on making takes many forms: ranging from studies of processes of inspiration, and the spaces and sites of creative practice, to a growing interest in conducting creative practice-based research.[22] For Daniels, the materiality of these making processes develops interesting parallels with older traditions of cultural geography concerned with the material making and shaping of landscapes and environments.[23] For others, this contemporary proximity between geography and creative practice is celebrated for its enmeshing of different critical practices, and the coalescence of these practices around, a series of conceptual themes (e.g. place) or around critiques of knowledge, or by providing "beyond academy" impact. All of these different valuations of the arts of geography, are, as this section will develop, eminently traceable from longer histories of these interdisciplinary relations.[24]

Beginning this discussion with some very brief vignettes of the much longer history of geography-art relations has a number of benefits, primary amongst these being to situate this text's study of creative geographies. For, despite the increasing popularity of geographers working with a range of forms of the arts, whether as interpreter and/or practitioner, very little attention has been paid to the historical underpinnings of these relationships. While the Introduction began the work of situating the creative geographies in this text in relation to the history of geography-art relations it did so through a relatively recent history. In the remainder of this introduction to Part 1 I want to offer, albeit in necessarily a curtailed manner, selected periods from a history of geography-arts engagements.

Offering even selected moments from the history of creative geographies aids in the exploration of the form and nature of contemporary geography-art intersections. While I am primarily interested here in geography-visual art relations, thinking historically also helps bring into view the more expansive field of the "geohumanities," folding visual arts together with the arts more generally.[25] Some commentators made a feature of parsing the singularities and differences between forms of arts practices (e.g., the value of written word versus the sketched/painted scene), while for others these differences are covered over and turned away from in more general "statementing" on the arts.[26] These issues are further complicated by the need to remain aware of the changing nature of both art and geography. In other words, to reflect on these forms of practice and bodies of knowledge, and their sorting and grouping into disciplinary categories, as an

ongoing, evolving process. Thus, as this discussion unfolds, it does so not only against the backdrop of the making of modern-day geography, but also the institutionalisation of a European academic arts scene and evolution of forms of artistic practice.

Clearly, it is beyond the scope of this text to develop a comprehensive aesthetic geosophy *pace* J.K. Wright, further, his particular formulation of geography-arts relations is arguably not necessarily the most helpful register with respect to their current configuration. For, I am less interested in taking preformed geographical conceptualisations—whatever these may be—and finding them within the arts, as Wright suggests, rather I am concerned here with incidences where arts practices, of various different forms, have influenced the making and shaping of modern geography itself. In short, I am interested in how the arts, and in particular visual or fine art, have been deployed, often strategically, within the progression of geography, and concepts normally defined as geographical, within and without the academy. The discussion will focus on three particular issues wherein the critical potential of the arts with respect to epistemological questions and issues ideas of research practice and methods can be most clearly seen. Firstly, the arts as a form of geographical "data," secondly, the arts as enabling ways to think about, but also to reconfigure the politics and relations of working with audiences and stakeholders beyond the academy. And, thirdly, the final section of this discussion will explore explicit instances where art has been deployed by geographers as the means to question disciplinary habits and posit new values in the face of normative methods and approaches. The two empirical chapters that follow this discussion take up these sets of ideas through their exploration of the politics and possibilities of exhibitions and installations with respect to the histories of geographical knowledge and our contemporary modes of knowledge production.

ART AS GEOGRAPHICAL DATA SOURCE

Reflecting, in the 1970s on the relationship between humanistic geography and the arts, Yi Fu Tuan decried geographers for their role as merely "intellectual middleman," taking "'nuggets' of experience as captured in art" and sorting them into "simpler themes that can be systemically ordered."[27] Once experience is "simplified and given an explicit structure, its components may yield to scientific experience."[28] In this rather scathing description Tuan directs us toward one of the key facets of twentieth century geography-art relations—namely, that art is understood to offer preexisting "data" points for a geographical science. Unpacking this history by way firstly, of an exploration of empirical naturalism and secondly through a Humboltian-influenced geoaesthetics enables us to query both the forms of this "data," as well as the power relations posited by such a formulation of art in the "service" of geographical science.

The possibilities of art forms, whether this be visual art or literature, to proffer "packets of information" about people and places tracks across centuries of understandings of the place of art within geographical knowledge making. In one of the more recent revivals of these arguments, Balm turned to understandings of paintings as information sources as a means to chart a passage through what he perceived as the "interdisciplinary gulf" between geography and art.[29] Turning away from "celebratory fine artists," which he felt had led geographers to promote "technique and aesthetic conventions over content," Balm asserted the need to attend more closely to art's "expeditionary optic."[30] By this he meant those artworks made by artists travelling between 1760 and 1860, whose work, produced in the line of empirical naturalism, has been widely understood as driven by a provision of information rather than primarily by aesthetic conventions.[31] In doing so, he echoes those art historians and historians of science for whom this era was a "winter of the imagination." This description captures the era's domination by mimetic practices, a trait that cast art in the service of Enlightenment sciences, as but one of the latter's armory of tools and technologies for the gathering, sorting, categorising, and so fixing of a whole host of objects and species.[32] The result was a range of artistic products—from quickly captured landscape sketches to carefully considered drawings and paintings and even large oils, made both in the field and onboard ship—whose choice of subject and treatment was developed under the sway of regimes of collection and in service of science and surveillance.[33]

Despite several decades of interpretative-based studies that challenge the presupposed "neutrality" of artistically produced images, Balm's argument about art as providing "packages of information" resonates down the centuries. So we see the British Admiralty urging Captain Cook to take artists with him when he set sail in 1760 so as to "make drawings and paintings as may be proper to give a more perfect idea . . . than can be formed by written descriptions alone."[34] This is not a trait confined to the history of the discipline, nor should such mimetic understandings be decried. Today, geomorphologists, climate scientists, and volcanologists amongst others, find artistic representations of landscape to be invaluable substitutes for absent scientific records of coastline change, glacier movement, or vegetation growth.[35] Even more complex studies situate artistic outputs as proxies, deploying, for example, the coloration of painted skies as an indicator of atmospheric ash loadings in the aftermath of eruption events.[36] Not without their challenges, these studies rest on some sense of artistic adherence to empirical naturalism across time, space, and mediums—a belief in mimesis over and against the vagaries of aesthetic conventions, pictorial perspectivalism, personal style, taste, and skill levels, as well as the effects of aging and restoration on canvas and pigment.

J.K. Wright would have deemed such enrolments of artistic practices thoroughly appropriate, with art being part of the advancement of geographical science. But yet, even during the reign of empirical naturalism,

we see the artists and scientists invovled in these projects denying such a subordination of art to science, and refusing the legacy of the arts as offering "objective, self effacing and precision engineered" data.[37] Indeed, turning, as discussion now will, to the work of Alexander von Humboldt and his followers, we can find a rather different, and indeed empowering, place for art within geographical history; one that works away at the boundaries that sit at the heart of those reductive settlings out of "arts" and "sciences."

Humboldtian Geopoetics

The influence of Humboldt's work on geographers' deployment of art and aesthetics, and in their understandings of landscape and environment, is hard to underestimate. Even cursorily, we can trace his influence in the eighteenth- and nineteenth-century formation of branches of geography as different as geomorphology and the geographical imagination, as well as in twentieth-century critiques of geography's scientism. Humboldt also reappears in twentieth-century humanism, and even more recently in physical geographers' turn to enchantment and the arts, and in human geography's renewed interest in the aesthetic.[38]

Humboldt's work is for many, especially in relation to physical geography tension laden, "by virtue of his insistence that poetry and etchings were to be valued alongside systematic observations of physical processes."[39] For Humboldt, writing several centuries before Wright, to "instrumentalise" art in the service of science was to misread the relationship between artistic practices, broader aesthetic sensibilities, and the scientific investigation of landscape and environment. For Humboldt finds in artistic sensibilities not just a desirable source of information, but a form of "human truth in its own right, in other words, an equal partner to science."[40] Indeed, for Humboldt, artistically inspired landscape appreciation can be developmental of scientific enquiry.[41]

Importantly though this was not to the detriment, or epistemological compromise of science. For, combining artistic intuition with astute, and often groundbreaking scientific observation, Humboldt argued, by demonstration, that "a certain degree of scientific completeness in the treatment of individual facts is not wholly incompatible with a picturesque animation of style."[42] For Humboldt, artists (and he considered himself only satisfactorily skilled in this area) were privileged in their ability to develop more than "truthful imitation."[43] Of great importance here were the artist's compositional abilities, abilities that enabled a synthesizing of imaginary elements of the landscape with the analysis of very large numbers of "various and direct impressions" afforded by the landscapes they moved through.[44] As Humboldt writes, "it is the artist's privilege, having studied these [vegetable] groups, to analyze them; and thus in his hands the grand and beautiful form of nature which he would portray resolves

itself . . . like the written works of men, into a few simple elements."[45] In short, this was a vision in which the sensuous and objective set firmly side-by-side, and as Bunkse notes of Humboldt's writings, were often bound up within a single sentence.[46]

Above and beyond the role of artworks, Humboldtian texts demonstrate how an aesthetic sensibility "undergirded fieldwork practices more broadly," this was "manifest in his philosophy which presumed that the ordering principles of nature were to be sought neither within its hidden depths, nor in its visible surface, but in landforms as sensible/insensible assemblages."[47] Following Burke, Kant, and others, Humboldt believed in a single catalyst behind the arts and the sciences: a subjective appreciation of a universal order in nature. This order drove human inquiry, inspired questioning, and resulted in aesthetic productions, which could in turn lead humans back to nature where they would be "inspired anew." Recent geographical revisitings of Humboldt's posing of this particular relationship between arts, aesthetic sensibilities and science have highlighted its value for a number of different purposes, not least of which is for making sense of key tenets of humanistic geography. As Anne Buttimer, a leading theorist in geography's humanistic tradition notes, the "aesthetic and experience based facets of [Humboldt's] overall vision . . . enable the work to transcend tension between objectivity and subjectivity, macro-scale survey and micro-scale theatre, scientific explanation and artistic representation."[48] Humboldt thus offers an interesting perspective from which to inquire as to the place of art in relation to a scientific geography, but further, his work serves a wider purpose in pointing towards the need to explore precisely what forms of art are being valued here, and to query what characteristics and traits were/are considered important.

Different Kinds of Data: The Hearts and Minds of Men [sic]

To engage, even in so cursory a manner, with the facets of Humboldtain geopoetics is to become attuned to the form and kind of data attributed to "art." These questions begin to coalesce most clearly in the shifting deployment of the arts within geography's descriptive tradition.[49] Joseph Wimmer observed (in 1885) that "the descriptive geographer is nothing other than a landscape painter and a map drawer in words," and by the early twentieth century, numerous geographers were turning to the work of landscape painters and writers as sources for a regional geography.[50] As such, art took up a place alongside other descriptive practices within geography's topographic tradition, including; "counting, measuring, comparing, classifying, mapping and illustration, and precisely written prose."[51]

Key to understanding the place of the arts within this tradition is to appreciate how its value changed. For, as geography developed throughout the twentieth century, we find art transitioning from being just another data point in a larger array, to proffering a very particular type of data. Novels, poems, and

paintings went from being one source amongst many, providing "facts," part of the formulation of a "complete" picture of a region, to offering a different form of data that was gradually, although far from universally, understood to "enhance" geography's descriptive tradition. [52] The arts become not just a source of data, but a means to engage with and assert "the value of feelings and insights." [53] Writing on geography and literature, Pocock notes, "literature is a production of perception, or more simply, it is perception, it therefore provides us not only with data, it opens up the topic in ways that may be ignored or underplayed in our usual geographical treatments." [54] The battle, for Lowenthal, was to ensure that people understood "the link between the pictures in our heads and the world outside" [55] and further, that aesthetics, and the appreciation and perception of landscape and places, were understood as not "simply a decorative façade to life," but rather there was an appreciation that "affective response forms its core." [56] As such, arts practices became a key empirical entry point in the midst of developing debates around humanistic geography; in particular where methodological challenges arose in the face of phenomenological work, arts practices became a valued part of the humanistic geographer's arsenal. [57]

Moving briefly to geographical work at the end of the twentieth century and beginning of the twenty-first century, we find arts practices and the practices of visual culture (photography and videography in particular), coming to have a key place in geographical explorations of people and places. Principally, though, such methods are often deployed as the means to engage with, evoke, and to take account of contingent, embodied, and subjective experiences of place, whether these be ruined and abandoned cityscapes, landscapes, or waterscapes. [58] Partaking in creative production processes, often as part of wider methodological assemblages, emerges through these texts as enabling access to—framing—embodied, affective encounters with places and experiences of human-environmental relationships. Common across these accounts is a sense of creativity as enabling understandings of the contingency of spaces and the grasping of a sense of place as process. [59] Furthermore, in addition to proffering research methods, such creative practices are also often understood to enable the presentation of these encounters in a way that is better able to convey/evoke them for readers/audiences.

Crang offers 'texturing' as one means to describe these disciplinary deployments of creative practices. [60] In place, however, of comprehending texture merely as detail, the embroidery on top of, or the folding of an already extant surface—with its echoes of earlier critiques of art as solely decorative, as surface gloss or aesthetic "veiling"—Crang's texturing is concerned with materially co-constitutive processes. As such, creative practices become part of the appreciation of place as in process rather than as fixed and static, questions that Part II will pick up on in more detail.

Despite its brevity, this survey of the changing role of art as offering geographic "data" is valuable less for its specificity than for its generalized

assertion of the historical place of arts within the discipline, and the indica-
tion of a legacy of arts practices as challenging the epistemological tenets
upon which modern geographical science based its claims to know peoples,
places, and regions. As such, this survey offers one part of the backdrop
against which to situate, firstly, those current creative geographies that find
value in arts practices as offering a means to engage with the particularities
of site and places, and secondly, the broader querying around the "work"
that art did and does do within the discipline.

ENCOUNTERING THE ARTS: ENCHANTMENT, COMMUNICATION, AND REFORMING RESEARCH RELATIONS

Several years prior to Meinig's lecture, David Stoddart, in an address to the
Royal Geographical Society, marking its 150th year, appeals to his assem-
bled audience, and later the readers of *The Geographical Journal*, not to
"allow an arid formalism to replace the true attraction of geography."[61] In
his appeal, Stoddart echoes a geographical understanding of the value of the
arts that echoes down the centuries, namely that the arts have great value as
a form of communication, able to engage and enchant audiences. We find a
similar sensibility in everything from Humboldt's recognition of the value of
aesthetic practices in scientific engagement, to contemporary articulations
of the value of the so-called "new orthodoxy" of the arts within geography.
This is a value that situates the arts less in the service of geographical science
than in the service of the contemporary "impact" agenda.[62]

Sir Francis Younghusband in his presidential address to the Royal Geo-
graphical Society in 1920, outlines the model geographer, concluding, "this
is nothing less than saying that we expect of him that he should have in him
something of the poet and the painter."[63] Geographers, he believes, should
cultivate a "seeing eye" not only to discern the natural beauty of a region,
but they should have "acquired the capacity for expressing either in words
or painting what the eye has seen, that than he can communicate better it
to us."[64] We should, he asserts, "no longer tolerate a geographer who will
learn everything about the utility of a region. . .but who will take no trouble
to see the beauty it contains."[65] He acknowledged that what he was saying
may seem "desperately revolutionary" to a scientifically inclined RGS that
had fought long and hard to have geography be recognized as a science,
but as he assures his audience at the outset, his conclusions are based in
extensive field work and travelling: modes still valued by the RGS.[66] For
Younghusband therefore, the artistically inclined geographer was not just a
better geographical scientist, but also a better communicator, and, impor-
tantly, better able to enroll followers within the geographical cause.

The value of arts in creating exciting geographical texts was not
restricted to the early twentieth-century evolution of travel writing. It was

also understood as an important antidote, as Stoddart argues, to the characteristics of quantitative formulations that came to dominate the discipline in the mid-twentieth century. Reflecting on writing regional geographies, Hart, for example, argues that good regional geography should

> be written with imagination, flair, style, verve, dash, panache, enthusiasm, vivacity, animation and perhaps even a bit of flamboyance. Above all, it should be fun to read. Writing imaginative, informative and readable descriptions of places is extremely difficult. . .and it demands a creative flair that is as much intuitive and emotional as intellectual.[67]

Once again, the arts are understood to proffer the ability to engage and enchant audiences, to move them and engage them in their subject matter.

In the late twentieth and early twenty-first centuries, arts practices are still a source of engagement and enchantment within and beyond the academy, but this takes a rather different form. Across research practices that engage a range of arts forms, from exhibition curation to playwriting and performance, video making, and painting, we find geographers, especially those interested in participatory research and public geographies, turning to the arts to both reach audiences beyond the academy, but also importantly to reformulate these research relations.[68]

The aesthetic, emotional, and visceral nature of arts encounters continues to be an important justification for geographers turning to the arts. As Pratt and Johnston write eloquently of *Nanay*, a testimonial play they co-wrote with research participants, this can be a way of "bringing academic research to a wider public in an immediate, engaging way."[69] In their account, the play enables them to develop an aesthetic mode of encounter that affords the ability not merely to engage an existing public, but rather allows them to *create* an interested public around an important social issue.[70] The intimacies of the geographies of production they created formed "emotional geographies of public significance" that operated through sensual exchanges that "inspires moments in which audiences feel themselves allied with each other, and with a broader, more capacious sense of a public, in which social discourse articulates the possible rather than the insurmountable obstacles of human potential."[71] Beyond better, more enchanting description practices, the power of the arts is here seen to lie in the potential of aesthetics to both enroll, and potentially to transform the subjectivities and actions of the "publics" engaged and created by the work.

Alongside existing research by geographers on, for example, participatory art and commodity chains or arts and health issues, the potential of art as a transformatory force is also being explored in the field of science communication,[72] not least in the field of climate change, where researchers, artists, scientists, and politicians alike are beginning to query the potential of art as a catalyst for behavioral change.[73] But, to conceive of art's potential for transforming subjects, and to enroll it in doing so in the name of

various geographical intents, is to run the risk of subjection. Thus, to begin to "use" art in this way requires an awareness of the power relations at stake here, relations that participatory geographers have both engaged and critiqued in a range of useful ways.

In the ongoing querying and reworking of the relations between researcher and research participant, geographers have turned to arts practices as enablers of these different forms of research politics. As Tolia-Kelly explains, visual culture techniques have become bound up with "geography's methodological aspirations towards policy change, local inclusion and participatory action research."[74] Whether with respect to video-making practices or painting workshops, we see the collaborative practicing of the arts by researcher and researched understood to enable a whole range of things. On the one hand arts are understood to offer a mode of access to issues not easily addressed or easily vocalized; as Parr notes of a collaborative film making project, these practices helped researchers come "to a better understanding of participants' lives."[75] Above and beyond better access however, the process of collaborative making, in this case not only filming, but also editing, was a process of reworking the researcher-researched relationship. In this case, the different skill-sets and bodies of knowledge which individuals brought to bear on these arts processes, disrupted the "traditional" figure of researcher-as-expert, and forged research relationships differently.[76] Importantly, just as we can appreciate how participatory scholars have turned to arts and visual culture practices, so, it could be argued that the critical focus on power relations and the ethics of participation that are the hallmark of these participatory geographies offers a productive starting point for much needed critical perspectives on the responsibilities of developing and mobilising arts' transformatory potentials.

DISCIPLINARY TRANSFORMATIONS

A third key theme in the study of geography-art relations, and one that ties together the discussions thus far, is the persistent place of arts practices providing geographers with tools for disciplinary critique and models for the transformation of modes of knowledge production. As O'Sullivan describes more generally, "by blurring discreet categories, producing new encounters and fostering monstrous couplings, new kinds of writing and new kinds of thought become possible."[77] Where we see this operating most consistently is in face of geography's legacies of disciplinary scientism, and in the context of understandings of representation. Across disciplinary history the arts are repeatedly evoked as offering the means to cut into dogmatic thought and destabilize teleological knowledge politics, challenging a scientism that for many still continues to channel geography's epistemological formulations and research practices.[78] Ahead of the two empirical chapters, this discussion will close by beginning to explore the

different roles that art has taken up in this regard. On the one hand, geographers are turning to the arts as offering both a source of different type of data, but also for alternative models of knowledge production they proffer. On the other hand, there are an increasing number of examples of artists making work that explicitly draws its critical force from a materially or performance-based thinking through of geographical spaces, practices, and epistemological concerns.

The Arts as an Alternative Model

As the earlier section on arts-as-data began to explore, one of the most enduring of geography's engagements with the arts has been in the context of regional description. Importantly though, over time the products of the arts evolved from providing just another data-point in the array, to providing an additional form of data. In their subjective and localised form these data were inherently critical of the "universal laws" of regional science and eventually became a means to undermine them. Leighly, an early proponent of the place of art as a component of a descriptive geography, wrote in 1937 that "a science for regions is a vain dream . . . literary art, not systematic description is the proper medium of regional synthesis."[79] The artist, he continues, is valued for their ability as a "synthesizer of phenomena, so far as we can see, the only one who can join intellectual incommensurables to form a comprehensible and satisfying conceptual whole."[80] The value of the arts lay here in their associations with subjective choice, which was at the root of their effective and lively integration of, "a multitude of seemingly disconnected facts about nature and man in the region he is describing."[81] Leighly concludes thus, "the highest synthesis of discrete facts concerning regions is artistic, since synthesis can only be made subjectivity not rationally."[82] Gilbert, writing some thirty years later, reprises these arguments to assert the "art" of describing regions. He is less concerned with the always-subjective act of synthesis, but rather with the challenge of accounting for the history and future of regional geography.[83] He notes, "regions like individuals have very different characters . . . that are constantly changing," as a result, he notes the description of a region is always a form of art, "for it is futile to regard it as an exact science with universal laws."[84] Thus, the arts, understood as sensitive to localisations, to histories, and future trajectories, were able to assert facets of regional description that universal laws were considered blind to, and in doing so began to shift and change the coordinates of geographical knowledge.

It was not just with respect to regions that the arts were an important alternative way of geographical knowing, but also, as J.B. Harley's classic study develops, with respect to cartography.[85] Harley evokes the arts as part of his deconstructive critique of cartography's scientism. He describes a world of Western map-making that is "untainted by the social," in which "art has been edged off the map" in favour of a scientific chauvinism.[86] He

imagines an alternative map-making army that lurks at the edge of civilised mapmaking society, an army whose "inaccurate," "subjective," "valuative," and "ideologically distorted" images offer a silent challenge to the "mimetic bondage" of Westernised, institutionalised mapping, a bondage "secured by standardization and measurement."[87] Art practices are part of the arsenal of this army, proffering, as critical cartographies explore, but also as Chapter One develops, the means to challenge the unquestioned scientism of cartography, and to develop a more ethical set of mapping practices.[88]

One might assume that in the wake of the science wars, scientism within geography has been laid to rest. Several decades later, however, Dewsbury calls for geographers to value an artistic orientation toward the world that would enable a critique of "the know-and-tell politics," and the "inevitable scientism within which our research is staged."[89] In contrast, he suggests the arts provide opportunities to explore "the need to consistently rethink the frames of thought by which we stage our research."[90] The evocation of artistry here is one that finds in arts practices a methodological model for more lively and responsive engagements with the world.

For Dewsbury, performance studies scholars offer one of the most useful touchstones for engaging with the methodological and representational challenges of studying the ephemeral performances and experiences of being in the world. Here he locates research questions and methods that address themselves directly to querying meaning making in its localised, momentary, and materially constituted existence. Using writings on live performance to talk about researching, interpreting, sensing, and presenting, he argues:

> the idea is to get embroiled in the site and allow ourselves to be infected by the effort, investment, and craze of the particular practice or experience being investigated. Some might call this participation, but it is a mode of participation that is more artistic and, as with most artistic practices, it comes with the side-effect of making us more vulnerable and self-reflexive.[91]

The arts more generally, and dance in particular, have become, it can be argued, almost mainstream within currents of geographical thinking that experiment with how, "spaces are made and remade through practices that engage the capacities of moving bodies in diverse ways."[92] Situated as part of "thinking" space, the arts are valued for their ability to move away from stasis, representation, and closure, toward considerations of intensities, capacities, and forces, "to explore rhythms, cycles, events, encounters, movements and flows, instincts, affects, atmospheres and auras, relations, knots and assemblages."[93] As Part III explores in more detail, in doing so, art becomes something geographers can engage with as a way of thinking about the embodied subject and its spatial and temporal situatedness in the world. Furthermore, this is a model of arts practices that not only effects the

discipline, and the knowledge produced, but also in the process changes the researcher, forcing them to consider their research and writing practices, and their orientations toward the worlds that they live in and are researching.

Critiquing Practices and Spaces

In addition to offering a model for how geographical knowledge production might proceed otherwise, artists can also be seen to stage, in the making and presentation of their work, direct queryings of the practices, spaces, and procedures of geographical knowledge production. Important here is an appreciation of how a whole series of creative practitioners, whether working collaboratively or alone, have taken the processes of disciplinary and institutional knowledge production as a focus of their attention. Within existing geographer-artist collaborations, as well as in turns to creatively inflected research practices, the spaces of geographical knowledge production become the sites of artistic intervention. Thus the conduct of creative practice-based research in the spaces of the archive, the field, and the institution, proffers the means to query the structures and spaces of disciplinary knowledge making, to question vocabularies and to challenge practices.[94]

Such studies provide a fruitful beginning, but we could also look to the intersection of art practices and science studies as a means for further development of these ideas. Here artistic making offers the means to reflect on elements of the scientific method, from experimentalism, to questions of truth and rigour, as well as the localised specificities of lab-based practices and ethical frameworks.[95] Such working and reworking of questions of the production of knowledge are important, as Haraway argued:

> knowledge making technologies including crafting subject positions and ways of inhabiting such positions, must be made relationally visible and open to critical intervention . . . to do so one must be in the action, be finite and dirty, not transcendent and clean.[96]

In such a context, geographical turns to artful practices have been evoked more generally as able to locate knowledge making within a messy, risky realm of creative and fallible encounters.[97] Here the value of the arts is seen to lie in their epistemological critique, and their enacting of appropriate forms of knowledge making in the face of questions of excess, contingency, and indeterminacy posed by poststructuralist theories. As Dwyer and Davies summarize, "artistic practices provide a way to enfold uncertainly into the account," to allow for, and indeed even assert partial and contingent practices of knowledge.[98]

But we should, perhaps, caution against any reductive reading off of arts practices as standing for the messy, for the subjective, for a lack of rigour. These are characteristics which, arts' very presence is understood to interject into the spaces and practices of knowledge production. For, as studies of art-science

collaborations have shown, as valuable and important as the differences between these two forms of practice are, it is also problematic to set them up too simplistically as oppositional; rather, the stories of their similarities and differences, and the transformative potentials therein, are more nuanced than accounts of "two cultures" might suggest.[99]

In the two chapters that follow, two collaborative projects develop situated, localised accounts of the relationship between art and geographical knowledge production. These studies try to resist any over-simplistic reductivism in understanding the role and value of artistic ways of knowing in the context of the production of geographical knowledge, and the making of the modern discipline. Chapter One explores *Creative Compass* an exhibition focused on mapping practices that was located at the Royal Geographical Society, a key site for the institutionalisation of geography. Chapter Two explores *Connecting with Gertrude*, a project that revolves around the challenges of telling the story of an overlooked female explorer in the early twentieth century. In both cases, specific stories about the disciplinary place of artistic practices are situated within larger epistemological and methodological critiques of knowledge production, and are discussed for the possibilities both offer for "doing" geography otherwise.

These collaborative creative projects make us mindful of questions around who and what counts in the histories of geographical knowledge. They also make us aware of the "complex locations" of disciplinary knowledge production.[100] As such, artistic practices take up a place within the broader rescaling of the cartographies of geographical knowledge, which, in the wake of reassessments of Enlightenment knowledge, objectivity, and language, makes space for "other" stories of "minor" figures and ways of knowing, such as artistic practices.[101] In such a context, art becomes a way for thinking through, but also performing, the limits that have been drawn around questions of geographical science, including questions of who is a "proper" geographer, of what "proper" geographical knowledge might look like, and what, often perhaps assumed, epistemologies underpin it.

1 Placing Art at the Royal Geographical Society

Creative Compass,
Exhibition Imaginaries, and
Cartographic Critiques

CREATIVE COMPASS

Hoisted in the window of the Royal Geographical Society's gallery in South Kensington, London, visible from the road outside, are the two sepia-toned sails of Susan Stockwell's *The Empire Builders* (2010). Printed onto the fabric sails, the faces of Scott, Livingstone, Smith, Raleigh, and Cabot gaze out across the gallery. Surveying the room from their canvas location, these disembodied explorers and industrialists celebrate a legacy of mapping and geographical knowledge making.

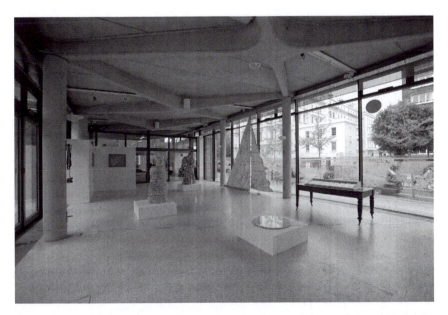

Figure 1.1 Exhibition Pavilion with *The Creative Compass* Installation, 2010 (The Creative Compass Catalogue, Royal Geographical Society (with IBG), London; supported by Arts Council England; photography: Sir Colin Hampden-White).

Overlooked by these empire builders are two other pieces by Stockwell, *Colonial Dress* (2009) and *Money Dress* (2010); both sculptures are headless, anonymous, female dress forms. *Colonial Dress* is constructed from maps of the British Empire dating from the 1920s, with occupied territories picked out in pink. Stitched and glued onto the metal frame of a tailor's dummy, the female form re-shapes these cartographies; Europe sits above the heart, while Africa fills out the front of the bodice, Brazil curves in from the left-hand side suturing the mid-Atlantic ridge. A sash constructed from a folded map is held in place on the right hip by a carefully stitched rosette of Africa, further rectangles of turquoise and pink fall to the floor as the frills on the skirt.

At the far end of the gallery is Poitevin-Navarre's *Proustian Map of London (Land of Achievements)* (2010), a "wall paper piece" 6-m high by 4-m long it almost fills the space (Figure 1.2). In its form, the piece recalls the decorative traditions of maps and their aesthetic role as wall-hangings, frescos, and floor mosaics. Here though, the decorative cartouches and symbolic elements of maps, especially those designed to be seen from a distance, are almost entirely missing. Instead, we have a simple outline of London bisected by the Thames. The overall effect is of a base map for the institutional gathering of geo-located data, but yet, the data plotted across it are part of a participatory census of sorts. Configuring the audience's physical encounter with the map, the artist has printed, unreadable until you get close, statements such as "working and raising enough money to come the United Kingdom" or "feeling at home in exile." Close up, picked out in baroque font, the capital is known through a series of personal achievements, territory is configured via a plotting of life-courses and personal milestones.

This exhibition, entitled *The Creative Compass,* was shown at the Royal Geographical Society's South Kensington base in the summer of 2010. The Society was not only a space of display, it was also the site of the making of a number of the artworks on show. The exhibition was the culmination of the Royal Geographical Society's (with the Institute of British Geographers) second artist-in-residence programme.[1] In this case the two artists—Agnès Poitevin-Navarre and Susan Stockwell—worked in collaboration with staff from the RGS, the Tate Gallery, the Institute for International Visual Arts (Iniva), and myself as a geographical consultant. In addition to a handful of carefully selected pre-existing works, the majority of those on display were made by the two artists in response to their residency at the Society, and in particular their exploration of its archives and map library. Drawing on, discussions with the artists during and since their residencies, ideas that emerged during the programming that surrounded the exhibition, as well as analysis of the works, their production, display and curation, this chapter will explore the cartographic imaginary that the exhibition develops.

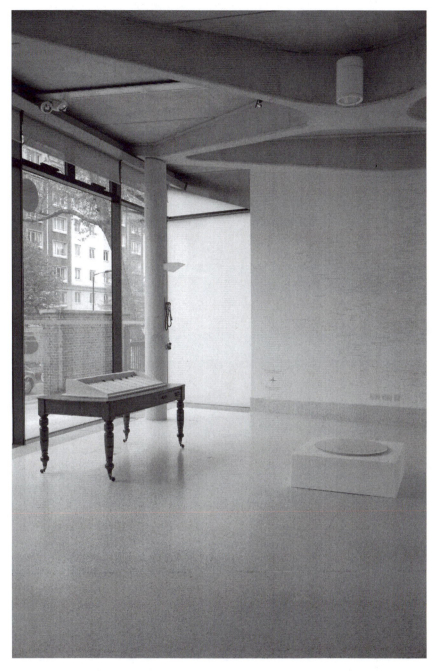

Figure 1.2 Exhibition Pavilion, view two, with *The Creative Compass* Installation, 2010 (The Creative Compass Catalogue, Royal Geographical Society (with IBG), London, supported by Arts Council England, photography: Sir Colin Hampden-White).

The exhibition's cartographic imaginary will be situated in a dual context. On the one hand, it will be situated in relation to the analysis of the practices and materialities of mapping that has been conducted by cultural historical geographers interested in disciplinary knowledge making, and on the other, in relation to recent perspectives on cartography that fall under the rubric of so-called critical cartography.[2] If the former are concerned to flesh out disciplinary history, recovering the visual and material cultures of geographical exploration, and the sites and spaces of disciplinary knowledge making.[3] Then, and resonating with this, the latter asserts the study of the cultures and power relations of production in order both to challenge existing power-knowledge structures, but also to catalyse the development of new mapping and geovisualisation practices.[4]

The diverse projects that fall under the "critical cartographies" heading have been drawn together via a "one-two punch" of the theoretical critiques and new mapping practices that they are understood to land on traditional practices of cartography.[5] The first of these blows, often understood as the working through of the disciplinary Science Wars of the 1990s, was struck by researchers who deploy critical social theory to challenge the positivistic bent and the power-knowledge nexus associated with cartographic practices.[6] The second blow is struck by the ongoing development of new mapping practices; a suite of techniques within which artistic practices, and creative practices more generally, take up a well-acknowledged place.[7] In the analysis which follows these two 'blows', between them defining critical cartography's project, form an important lens through which to assess the critical force of the cartographic imaginary developed through both the individual works included within *Creative Compass*, as well as by the exhibition as a whole.

Map Art

Maps and mapping practices have long offered "astonishingly fertile material for artistic expression and intervention," with the history of cartography marked by debates regarding maps as aesthetic and/or technical objects.[8] At the time of its display, *Creative Compass* was part of a rich terrain of international exhibitions that aptly illustrated the scope of these map-art relations. The British Library's *Magnificent Maps: Power, Propaganda and Art* (2010) for example, focused on display maps, largely but not solely wall maps, as well as tapestries, murals, and ceramic tiles produced between 1450–1850.[9] Less concerned with geographical accuracy, the display map was about the visual effects of political authority, an aesthetic enactment of worldly power, rather than the "verisimilitude of topographical exactitude."[10] *Whose Map Is It?* (2010), commissioned by and exhibited at the Institute for International Visual Arts (Iniva), was created in conjunction with *Creative Compass*, and, in keeping with Iniva's tendency to develop cultural critique and politicize cutting edge arts

practice, it showcased works by female artists who engage with mapping practices as intersections of power and identity.[11]

Whose Map Is It? resonated perhaps more strongly than *Creative Compass* with current artistic interest in critical cartographic ideas of counter-mappings, wherein artistic mappings proffer performative acts of resistance, and thus the means to engage with the politics of the other by challenging dominant narratives and seeking other ways of knowing people and places.[12] On display were film, installation, print, and audio works that engaged with the erasures and silences of mapping, making present elements left off maps, from pollution in the Niger Delta to issues of migration and displacement. The exhibition was also highly participatory, including for example, contemporary mapping technologies such as GPS used in the piece *Nomadic Milk* (2009) to track nomadic and modern dairy distributions across the desert, as well as other works that brought participation into the gallery space. Work such as *The New(er) Middle East* (2007) for example, invited viewers to experiment with territorial boundaries, to explore, via an interactive magnetic puzzle, how a "better Middle East could look."

Such expanded artistic mappings explore the multitude of ways of "organising, documenting and representing spatial knowledge in a graphic form," but are also, importantly, about intervening in existing understandings of mapping to create new mapping practices. [13] As kanarinka claims, "the project of art mapping is nothing less than the remaking of the world . . . Map artists do not reject maps. They reject the authority claimed by professional cartography uniquely to portray reality as it is." [14] What is at stake in map art she claims, is the "nature of the world we want to live in," drawing attention to the world-making power of professional mapmaking she considers how art maps, in place of "such professional values as accuracy and precision. . . assert values of imagination, social justice, dreams, and myths."[15]

What is most interesting, and unique, about *Creative Compass* within this broader body of mapping art, is the critical relationship and encounter that the exhibition and its constituent art works develop with the site of the Royal Geographical Society. This is a site that has a history as a location for the making, storage, and display of maps, and it is a site that played a key role in the institutionalisation of cartographic and geographic knowledge and practices. Made through the engagement with the practices, objects, and knowledge the artists encountered during their time at the RGS, their artworks and the exhibition as a whole take much of their critical force, in this analysis at least, from their relation to the site of their making and display. What is equally important here is that whilst much critical cartographic research situates map art in relation to the second of its two blows—the development of new mapping practices—*Creative Compass* by virtue of its situated institutional critique excels in relation to the first blow too; offering critical reflections on and interventions within the sites, practices, and materialities of cartographic production.

Institutional Critique

Cartographic practices, linked to travel, exploration, and of course, empire, have sat at the heart of the Royal Geographical Society's enterprise since its foundation in 1830. The map, and accompanying surveying practices, were powerful weapons in the geographical arsenal, and "potent devices of the European Imperial project . . . deploying scientific instruments and trained personnel in political acts of appropriation of those territories with clear strategic value."[16] The Royal Geographical Society was responsible for one of the largest private map collections in the world and for training and funding cartographers throughout the nineteenth and twentieth centuries, in the service of colonial projects, and as part of nineteenth and twentieth century military activities.[17]

The Royal Geographical Society was, and remains, a key site of the institutionalisation of geography as a discipline in the UK.[18] As such, the Society's site and staff together with its publications and practices, have formed a prism through which scholars have considered the whos, wheres, whys, and hows of geographical knowledge making in the UK and Europe in the nineteenth and twentieth centuries. As such, the site has become a locus for debates around the epistemological formation of geography, including discussions of the gendering of geographical knowledge making, reflections on geography's deployment as a tool of empire and war-craft, and analyses of the visual and material cultures of exploration.[19] One of the contributions that this chapter and the next make, is to explore the value of artistic and exhibitionary practices as offering the means to extend the dimensions of such queries.

The potential of art to engage in critical dialogue with the site at which it is made and displayed has a long legacy that is rooted in the role of art as a form of institutional critique. The latter emerged as an artistic practice in the 1960s by way of arts' critical self-reflection on its place within galleries and museums, as well as on the conditions of the "institutionalisation" of modern art as a form of practice.[20] The result was a set of conceptual questionings and performative critiques of power-knowledge that were directed by site-specific artworks to a range of locations, from galleries to hospitals, factories and schools.[21] The favoured mode of artistic engagement was the presencing of often overlooked, or deliberately hidden, ideological values that shaped the spaces and practices of these institutions.[22] More recently, these institutional critiques have come to include the development of new ways of working within their production of a critical space within the institution: in other words artists, for example, pose new forms of curation as a challenge to existing museological spaces and practices and to overthrow existing practices of institutionalism. *Creative Compass* can be understood, therefore, to offer a set of critical reflections on established mapping practices that operate by way of a situated, localised critique. And, like these other recent institutional critiques, *Creative Compass* develops a form that *both* challenges the normative practices and forms of knowledge making

that are associated with the institution, but *also* begins to take part in the creation of alternatives, in this case tentatively forming and performing "new" mapping practices.

To situate the site-based critique this exhibition develops, I want to briefly outline the history of the RGS as an exhibitionary and institutional site. The chapter then moves to an analysis of the cartographic imaginaries developed by the exhibition. The analysis proceeds by way of key ideas drawn from the critiques of mapping and disciplinary knowledge production outlined above. Thus it queries, in turn, maps as distanced objective productions versus the role of the embodied gaze of socially situated and fleshy, desiring cartographers; the overthrowing of the "incarcerated coordinates" created by black-boxed technologies, in favour of an attention to mapping practices and processes; and, the rise of counter-mappings, enabled by new spatial media, the geoweb, and amateurisation. All of these dimensions of the argument come together to contribute to the ongoing challenges mounted to those cartographic scientisms that continue to enforce sanctions over what is mapped, by whom, and how.[23]

THE ROYAL GEOGRAPHICAL SOCIETY AS CARTOGRAPHIC ESTABLISHMENT AND EXHIBITIONARY SPACE

J.B. Harley, in his well-known essay on power, knowledge, and cartography, asserted the image of a civilised cartographic society, wherein measurement and standardisation ruled.[24] Beyond this civilised land, there lurked, in his description, an imagined army of non-cartographers who favoured "inaccurate, heretical, subjective, valuative and ideologically distorted images."[25] The "other" of seventeenth-century European mapmakers, this unscientific rabble were cast out from the "citadel of the 'true map,'" wherein ruled the cohesion and discipline of "civilised," scientific mapping practices, a mimetic bondage that held fast in the belief in the progress of science towards ever more precise representations.[26] Whilst the disciplined society Harley explored was located in the workshops of seventeenth-century Europe, his description is partly applicable several centuries later to the Royal Geographical Society as one of the centres of calculation for exploration, colonialism, and cartography.

The Royal Geographical Society was founded in 1830 to promote the advancement of geographical science, it was concerned therefore to disseminate geographical information around the globe, but also to safeguard the image and content of geography, and shape its future role.[27] As such, the Society played an important role in producing and circulating both geographical imaginaries of particular places, as well as our imaginaries of geography as a discipline. By 1872, the RGS was a bastion of the geographical establishment and one of the largest scientific societies in London. Serving as an "information exchange for explorers, soldiers, administrations

and natural scientists," it attracted considerable attention inside and out-side the scientific community.[28] Providing a ready source of information for government departments, a role for which it eventually received a Royal Charter, the Society occupied an important place on the map of imperial science. Indeed, biographies of its founders have suggested that, "by the late 1850s the Royal Geographical Society more perfectly represented British expansionism in all its facets that any other institution in the nation."[29]

The RGS, like other scientific societies, proffered a mechanism for socially formalising the Enlightenment sorting of knowledge into disciplines. As a result a vibrant body of research has explored how, through rules and rewards, scientific tools, journals, and manuals, the "proper" practice of geographical science was formulated and inscribed by the Society.[30] Studies of the Society's 1854 *Hints to Travellers* argues that such guides represent attempts to impose authority over the emergent and far from coherent dis-ciplinary field, attempting to "guide method and the object of geography as a nascent science through the conjoint regulated use of instruments and inscription."[31] The RGS's exhibition programme, which really developed during the twentieth century, whilst not yet studied in this context could be considered, as other exhibitionary programmes have been, as a further tool of institutionalisation.

The RGS as an Exhibitionary Site and its Cultures of Display

While yet to be taken seriously as one of the tools of the Society's institu-tionalisation, for over a century the RGS has had a tradition of exhibition and display.[32] Indeed, exhibitions continue to be an important part of the Society's offering, taking up a key role in geographical education and outreach.[33] But yet, even a cursory exploration of the history of cultures of display at the site indicates a demonstrable shift in recent exhibitionary practices. In recent exhibitions organised by the RGS, developed often in collaboration with scholars and artists, and shown in its dedicated Pavilion Gallery (including *Creative Compass*), the Society's cultures of display have notably moved towards offering a critical and reflexive per-spective on the production and display of visual culture, and artworks at the Society.[34]

Taking over Lowther Lodge its current home in 1913, the Royal Geo-graphical Society arrived late to South Kensington's cultural and intellec-tual scene. In moving to the site, the RGS took up a place at the heart of London's established "exhibitionary complex."[35] Next door to the Albert Hall, close to the iconic site of the Great Exhibition, and the museums and colleges of South Kensington, Lowther Lodge was in the midst of London's learned sites and key loci of cultural display. Bennett, reading this larger cultural cluster through a Foucauldian framework, suggests that these were institutions of exhibition, rather than confinement.[36] In a clever inver-sion of the geographies of Foucault's *Discipline and Punish*, he identifies

the mechanisms of these institutions as ones of the exhibition of bodies and objects, rather than their withdrawal from the public gaze. Thus, in these spaces, objects and bodies gradually transition from enclosed and private domains to progressively open and public arenas, wherein, as Bennett notes "through the representations to which they were subjected, they formed vehicles for inscribing and broadcasting the messages of power . . . throughout society."[37]

A recognition of cultures and powers of display and their possibilities, can be witnessed in the Society's renovations of their new premises. Lowther Lodge was already well appointed with spaces of display, having afforded the Lowther family display space for their art collections and their own amateur efforts, but over the next century the building was subject to even further renovations. The result was the provision of a range of spaces of display, including a "Geographical Museum" wherein the Society could exhibit its collection of the visual and material cultures of exploration, and by extension, communicate its heroes, rewards, and regulations.[38] The Great Hall, once providing the Lowther's with "a dignified and artistic setting in which to entertain their elegant friends," became under the ownership of the RGS, a museum to exploration.[39] Lord Curzon details the conversion of

> the entrance hall, and indeed the ground and first floor . . . into a museum, where may now be seen the portraits of all, or nearly all, our gold medallists during the last eighty years; paintings, photographs etc., connected with exploration in different parts of the world; and the personal relics of great travellers.[40]

The display of the Society's visual culture of exploration did not stop there, however, for Lord Curzon also included amongst his renovations, a photograph room, of which he was especially proud. This was a space he envisioned

> where we can not merely deposit our thousands of photographs, already collected in albums or transferred to slides, but can give a continuous exhibition—changing from time to time—of photographs associated with particular expeditions, subjects or parts of the world. The camera is now a scarcely less valuable ally of the geographer than that of the plane table and the theodolite, and I have long thought that our society should be able to exhibit to any applicant, photographs of remote but important parts of the world.[41]

The display of the visual cultures of exploration—from photographs to films, large landscape oils to incidental sketches in the margins of log books or travel diaries—has continued to be an important feature of the Society's activities. This programming was particularly vigorous in the aftermath

of the Second World War, but also more recently with the "Unlocking the Archive" project.[42] The latter project focused on rendering visible and accessible the Society's extensive collections, producing an online catalogue, and enhancing the accessibility of the physical collections at the Society. The project also included the development of the Pavilion Gallery, and the provision of an ongoing programme of exhibitions to occupy it.

Amongst the range of exhibitions that have taken advantage of the Pavilion Gallery since it opened have been a series that have involved geographers, often in collaboration with artists. One of the most visually striking of these was the contemporary art installation *Moving Patterns*.[43] Developed by artist-geographer Helen Scalway, together with guest artists, geographers and collaborators from The Victoria and Albert Museum, the exhibition drew the RGS into the dialogues around the "fashioning of diasporic space."[44] Conceiving, as the collaborating geographer Phil Crang writes, of "cosmopolitan space as a displaced sensorium," the drawn works in the exhibition were based on fieldwork conducted at sites around London, including the Victoria and Albert's South Asian Textiles collection.[45] As a result, the RGS was enrolled into spatial conversations that recalled its place in the global circulation of people, goods, and objects, and the practices of commerce and collection in the course of Empire.

Along rather different lines was the exhibition *Hidden Histories*, curated by two geographers alongside a team from the Society.[46] *Hidden Histories* deployed a combination of visual culture sources and text to engage with the institution's archive in order to rematerialize and re-embody mainstream narrations of empire, exploration, and the discipline.[47] Staging a scholarly exploration of paintings, sketches and photographs, the exhibition engaged the audience in an unseating of the hero narratives that have, for so long, dominated the telling of disciplinary history. In place of the roll call of great men, the exhibition explored the role of porters, locals and a range of other intermediaries, in the production of visualisations, and thus in the making of geographical knowledge more broadly.

Hidden Histories, and indeed *Creative Compass*, can be understood in dialogue with those critical histories of geography—whether feminist or postcolonial—that have been inspired by Foucault's positing of a relationship of power/knowledge. As such, there has been an ongoing attention to exploring who creates geographical knowledge, and the revelation of the "power lines within the palace" of academic geography as a means to combat the telling of exclusionary disciplinary histories.[48] As a result, the narratives of exhibitions, their content, and the processes of their research and staging proffer the means for reflection on our telling of disciplinary histories, a querying of the epistemological basis of "proper" geographical practice, and an assessment of the progress, both within scientific circles and beyond, of geographical science.[49] In what follows, I want to explore

the contributions *Creative Compass* can make to such critical storyings of site and knowledge production.

UNDISCIPLINING CARTOGRAPHY

Sitting in the middle of the gallery floor, beneath the gaze of the disembodied explorers, was Poitevin-Navarre's sculpture *X and Y* (foreground, Figure 1.2). The piece, which has its origins in the artist's desire to map her genetic heritage across the globe, offers a powerful meditation on the scientism of cartographic practices. At first glance, the minimalist form of *X and Y* reinforces the "the trim, precise, and clean cut appearance . . . that lends to the map an air of scientific authenticity and persuasive character that reaches beyond the technical limits of the map itself."[50] The sculpture consists of a simple square white plinth standing only eight inches from the ground, upon which is set a circular wooden disc. Rather than plotting across a spherical globe, the sculptural work mimics conventional map projections to the extent that it renders the world in two dimensions. Split across the middle, and with a tiny white disc marking its centre, the wooden disc is etched with landmasses that in places are very recognizable, but elsewhere are almost impossible to distinguish. In her etching, the artist has created a cartographic projection that superimposes the "ghostly demarcations of continental coasts" of the northern and southern hemispheres to present an uncanny representation of the world. Tracking the making of the work—as the artist developed her ideas—gives an important insight into the critical impetus of the piece. Exploring Poitevin-Navarre's making processes produces an understanding of these etched lines and their overlapping traceries as a making present of the processual nature of mapmaking. More particularly, this is a rendering visible of the "messy inceptions" of mapmaking, what has been called in the techno-scientific context, the "cobbled togetherness of visualization practices."[51]

Implicated within the sculpture are two forms of mapping, on the one hand, mapping as a "state" science, and on the other, Poitevin-Navarre's desire to map her ancestors' movements across the globe as a means of exploring her genetic heritage. Sending away her DNA for genetic mapping, the results came back as indeterminate, un-locatable. Initially disappointed and challenged by this confounding of her cartographic intents, Poitevin-Navarre, on working in the RGS map library, was struck by the resonance between her own indeterminate mappings and those maps she was finding within the archive.

The two maps that form the graphical basis for *X and Y*—Guillaume Delisle's *Map of Hemisphere Meridional and Septentrional* (1714) and Philippe Bauche's *Map of the Globe centred on the North Pole and superimposed on the South Pole* (1746)—were made as part of the French National Cartographic Project, and record part of the search for the Solomon Isles.

Delisle, Cartographer Royal of France, was unsure as to who, Gallego or Dudley, had the correct coordinates of the Isles of Solomon, reputedly the source of riches, so he recorded them in the two locations. These locations form two of the markers on Poitevin-Navarre's wooden map. More than this, Delisle was also unsure as to the final position of a number of southern continental coastlines, so these he left unfinished too, with edges trailing away. Whilst on his map, Bauche, Delise's son-in-law and pupil, imagined the globe as transparent, allowing an appreciation of the curve of the earth, as the Society's description notes,

> it is centered on the North Pole with the location of landmasses drawn whilst imagining that the globe itself is transparent. This means you can see North America curve towards the North Pole at the same time as seeing the tail of South America curve towards the South Pole.[52]

The confusing coastlines of *X and Y* are constituted then from the overlapping forms of these three representations of cartographic contingency and uncertainly. Poitevin-Navarre's etching of landmasses onto the wooden disk layers these two state sponsored—"Royal"—cartographies, together with her own scientifically indeterminate genetic mappings, creating a combination of superimposed continents, tentative tracings, and confused island locations. The effect is to install within the institutional space a gentle reminder of ongoing processual nature of the making of maps. An elegant framing, but also a challenging, of the teleological narratives of a cartography focused on "a halting but unstoppable progress towards an unachievable nirvana of accuracy."[53] Furthermore, in drawing to the fore key moments of uncertainty in the process of mapmaking, in rendering visible the unfinished, the contingent, and the just plain unknown, *X and Y* typifies the project, which I would suggest we find across the exhibition more broadly, of "undisciplining cartography."[54]

"Insurrection of the Knowledges"

Cartography's "enshrining" as a modern discipline was long recognised to rest on the rendering of a "sacred" dichotomy between art and science, a dichotomy that enable the scientism and institutionalisation of cartography.[55] As Woodward explains, this was based upon an essentialist distinction between "art as a basically synthetic, autographic and creative," and distinguishable from, indeed antithetical to, a scientific method which was, "analytic, independent of the scientist and is reportage."[56] Harley was one of the first to point out the need to break down these binarising distinctions within cartography.[57] For Cosgrove, the recognition of the "continuous and complex conversation" taking place between art, science and cartography, even into the twentieth century when the "distinctions between art and science seemed so complete," was key to thinking through the potential of mapping practices.[58]

For Krygier, similarly, overcoming the fallacy of this dualism is crucial to making sense out of what cartography has been, but also what it is becoming/could become.[59] Sketching the outlines of such a project, the latter argues that in recognising the "something emergent" from collaborations between artists and scientists we need to attend to "the process of understanding and knowledge construction, the manner in which ideas are shaped and clarified, and the ways in which we come to know and re-know our world."[60] The "doings" of cartography thus become an important area of concern, with understanding of mappings-in-the-making, past and present, forming the means to work over unhelpful divisions and their pre-sorting of knowledge forms.

In X *and* Y, artistic processes are less one side of the art-science binary, than a critical tool through which we can work away at it. Artistic exploration and process become here the means to explore commonalities between artistic and scientific forms of mapping. Instead of being the "other" of scientific forms of mapping, artistic practices proffer the means to make present within the space of the institution a narrative of mapping that includes the place of uncertainty and subjective decisions—a critique that perhaps gains more force by being conducted using the products of one state sponsored cartographic project, found in the collection of another.

If X *and* Y asserts mapping as provisional and contingent process, then in the following sections I want to go on to examine the exhibition's further presentations of maps-in-the-making. Engaging with key themes from within the critical cartographies literature enables a consideration of; the fleshy situated practices of mapping; the types and forms of "data," its materialities and the emerging challenges of heterogeneity and volume; and a set of reflections on the co-constitutive relationships between mapper, data, and space, and their implications for understanding both the production of maps, but also the latter's productive force.[61]

THE GAZE FROM SOMEWHERE

Scholars have argued that many histories of geography tell of a discipline that "what ever it was, was almost always done by men."[62] Women were not, as histories of the Royal Geographical Society make clear, always welcome at the Society. Indeed, there were bitter battles pitched over the admittance of female fellows, which did not become standard practice until 1913, thus standing in tension with the presence of Queen Victoria, not only as a female head of state, but also as patron of the Society.[63] Women were, of course, actively engaged in the production of geographical knowledge, a contribution that was obscured for decades by the gendered regulations of the RGS.[64] The "place" of women within geography was a site of specific tension during the nineteenth century when the epistemological status of the discipline as a "manly science" was under question within academic circles. Maddrell sums up the issues succinctly when she observes that while the

Figure 1.3 Money Dress, Susan Stockwell, 2010 (© Susan Stockwell, 2010. The Creative Compass Catalogue, Royal Geographical Society (with IBG), London; supported by Arts Council England; photography: Sir Colin Hampden-White).

place of women in geographical knowledge making remained hidden, faceless, it did not threaten the male hegemony of travel or the society itself.[65]

In the installation of the exhibition we find a powerful resonance with these studies of the gendered nature of geographical knowledge production. This is most clearly witnessed in the dialogue staged between the recognisable faces of male explorers gazing out from the sails, and the faceless but thoroughly embodied female forms of Stockwell's dress pieces. The drama these works play out within the exhibition space enacts a version of Mary Louise Pratt's (1992) Imperial Eye—that is, a "the monarch-of-all-I-survey" modality of seeing and describing, in which "explorer-man paints/possess newly unveiled landscape-women."[66] Standing beneath the gaze of the masculine explorers these clothed bodies, created from territorial representations, recall all those discourses of feminised nature and territory. Here landscapes are worlds to be "conquered" and "penetrated," activities undertaken by men, lands imagined and described as female.[67]

As much as they recreate the symbolism of the conquering gaze, these works also reterritorialise the worldly practices of "manly" science by way of clothed feminine forms. In doing so they introduce into the spaces of the exhibition, and by extension the RGS, the site of the marked body and the "modest witness."[68] The situation of sight within fleshy, multi-sensory, desiring bodies, in contrast to the absencing of corporeality enacted through the god's eye trick, is an enduring current of geographical critiques of vision, and has long found its sharpest articulation in feminist work.[69] In their tracing of a generalised female form, the dress sculptures serve as an assertion of the countless women whose impulses of exploration and will to knowledge were writ in terms other than those sanctified by science, empire, and power. The form of *Money Dress* (2010) is styled after the 1870s dress worn by female explorers that Stockwell encountered during her work in the archives. It might look confining and restrictive, but modifications to the sleeves and the loosening of the fashionable bustle and heavy material enabled women to move with relative ease. In their specific forms, these sculptures can be interpreted as a reminder of the embodied practices and sensuous dispositions of exploration, as well as the movement of gendered bodies into and through "the field."[70]

The tension the exhibition installation animates—between masculine figure heads and faceless female forms—can be aligned with that increasingly large body of cartographic literature and practice that recovers not only the erased subjectivities of those being visualised and surveiled, but also the practices of the visualising subject.[71] And, these are visualising subjects, whether the individual professional cartographer, the collective community groups engaged in participatory geocoding activities, eighteenth-century explorers—masculine or feminine—or the artistic mapmaker, that are embodied, materialised, technologically mediated and that have agency and ethical responsibilities.[72]

If the dress forms invite us to consider the embodied nature of exploration, then the faceless nature of these embodied forms situates them as

"anonymous witnesses."[73] The impetus is thus less to recover stories of spe-cific famous, female geographers, reversing their erasure by the discipline's patriarchal lineage, and in so doing, simply replace the recognisable faces of Stockwell's printed male faces with female figureheads.[74] Rather, in their anonymity, the female forms are suggestive of an army of unrecognised, marginalised creators of geographical knowledge. This is a set of figures, in common with Harley's non-cartographic army, and *Hidden History's* marginal figures and intermediaries, who in their recovery provide not just an assertion of other ways of knowing—just add women and stir, as Rose puts it—but in being made present they come to challenge the very episte-mological foundations of knowledge making practices.

As such, then, we can understand *Creative Compass* in line with a whole series of replies to Harley's demand for the exploration of mapping as a social practice. He was concerned that we reform the link between the content of the map and its cultures of production, a link that, as he saw it, scientism had set asunder. The exhibition can be understood to take up a place alongside research that develops biographical details, or conceptua-lises cartographical practices by way of Foucauldian explorations of the relations between power and the spatial-temporal organisation of things and people.[75] Or, alternatively, it can be understood in relation to research that turns to Butler's assertion of the value of attending to everyday and mundane practices, or the dreaming, desiring cartographers of those influ-enced by Deleuze and Guattari.[76] It is not just, however, in the context of the figure of the cartographer that *Creative Compass* develops its critiques, for, as I go onto explore, across the exhibition there is also a querying of the materialities of maps and their data, and an examination of the deployment of tools and technologies within their production.

FABRICATING TERRITORY

Installed in one of the Society's many glass-topped, plan-table-sized display cases, were a series of measuring devices, rules, and gauges collated from both the Society's archives as well as from Poitevin-Navarre's own trea-sured collection. Both artists delighted in the equipment and paraphernalia of exploration that they encountered within the archives, as well as the accompanying stories they located within explorers' accounts. Of particu-lar note for the artists were Livingstone's Compass and the East African slave chains he would show in his antislavery talks, Caroline Routledge's hat, and photographs of Mary Kingsley.[77] Beneath glass, framed by the case, the aestheticisation of these objects and others suspends, but simulta-neously reinforces, their function, affirming the vital place of such tools in the geographical trades of surveying and cartography.

Within the workings of historical and contemporary cartographic work-shops, Harley found a scientific chauvinism that apparently "untainted by the social" had "edged art off the map," black-boxing mapping processes

in what he described as an "incarceration of coordinates."[78] Early critiques of the making of visualisations tended to characterise the mapmaker as a manipulator of signs and symbols, whose arsenal consists of rhetorical devices of selection, omission, simplification, classification, and the creation of hierarchies and symbolisation.[79] More recent critiques have turned to explorations of the place of technology and tools, and to querying our understandings of data, as they explore both the production of maps, as well as the productive force of mapping.[80]

The "conversation" the exhibition creates between the tools of mapping and the artworks presences the map as a material, crafted object. Stockwell's favouring of so-called "female" techniques and materials— working with ribbon, embroidery, folding, and quilting—styles mapmakers as the literal fabricators of territory. While recalling the cloth that would once have been used for maps, and the ornate tapestry and embroidery that would once have picked out the detail, Stockwell's maps should not be dismissed as decorative or "cosmetic."[81] In these works politically contentious territories, such as Afghanistan (see Figure 1.4), become islands—in this case, constructed from U.S. dollar bills—on seas of dark canvas, their outlines demarcated by the repetitive zig and zag

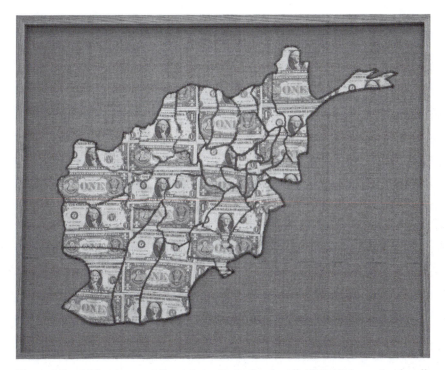

Figure 1.4 *Afghanistan—A Sorry State*, Susan Stockwell, 2010 (© Susan Stockwell, the Creative Compass Catalogue, Royal Geographical Society (with IBG), London; supported by Arts Council England; photography: Sir Colin Hampden-White).

of stitches and ric-rac braiding. Contested internal borders are formed from variously weighted lines of thread, some dense and knotty, others barely present, constituted by puncture marks and single lines of almost invisible cotton. Above and beyond the specificities of representation and political critiques these fabric maps mount, what is of interest to this examination of the exhibition's imaginary are the materialities of mapping they assert.

Collaging carefully chosen juxtapositions of materials, fabrics, and threads, the strategic materialities of Stockwell's fabric maps resonate with recent turns in critical cartography that consider the materialities of mapping practices and query data in the light of the changes brought about by the geoweb.[82] Rendering mapping practices akin to collage, Stockwell's works draw on the critical force of the latter's operationalisation of the democracy of heterogeneous materials and the overlaying of the contingent fragment. As an artistic form collage, and its crafty-cousin patchwork, have a well researched and theorised legacy as material performances of democratic, radical practices, enacting conditions of instability, contingency, and change.[83] It is exactly these traits that Elwood and other critical cartographers embrace when they observe the effect of the geoweb and volunteered geographic information on geovisualisation processes. Indeed, Goodchild describes these processes in terms of a shift from curated data sets—with all their accompanying ideas of the expertise, order and institutional control—to a process more akin to "patchwork."[84] The movement here is from a relationship premised on conceptual order and control, note the museological metaphor, to a metaphor that evokes the materiality and processes of making. With patchwork comes a querying of the nature of sources, and a materiality of making processes that enacts a breakdown of previous formats to proffer a contingent, less rigid, malleable form of mapping.

Querying Data/Different Forms of Data

As with *X and Y*, Poitevin-Navarre's *Proustian Map of London* (Figure 1.5) is, on first look, a technical map. Its pared back base map appears akin to the institutional backgrounds across which might be mapped the increasing amounts of personal geographic data that are held on us all. But yet, this map is perhaps more akin to an answer to Wood's call for humanistic cartography, he suggests, "unlike contemporary academic cartography, a cartography of reality must be humane, humanist, phenomenological . . . it must reject as inhumanly narrow both the database and the subject matter of contemporary academic cartography."[85] The *Proustian Map*, in data, subject matter, but also mapping technique is perhaps moving us close to the humanist cartography Wood desires.

Map art is most commonly embraced by critical cartographers within that "second blow" of new mapping practices. These new mapping practices

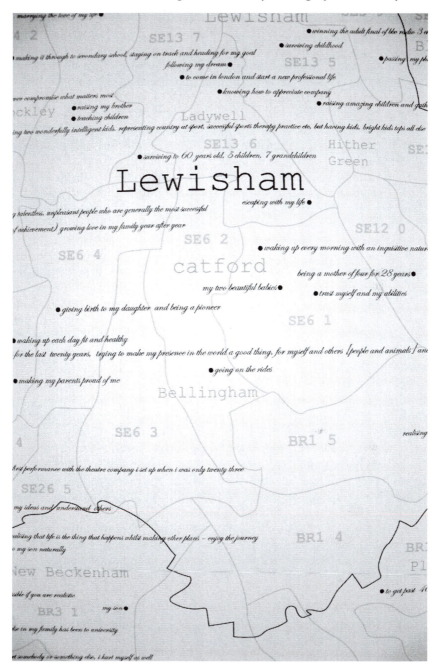

Figure 1.5 Proustian Map of London (Land of Achievement) (detail), Agnès Poitevin-Navarre, 2010 (© Agnès Poitevin-Navarre, the Creative Compass Catalogue, Royal Geographical Society (with IBG), London; supported by Arts Council England; photography: Sir Colin Hampden-White).

are often taken to refer to a broader "technological transition" wherein a mixture of open source collaborative tools, mobile mapping applications, geotagging, and volunteered geographic information combine to develop new techniques of geovisualisation.[86] Poitevin-Navarre's map perhaps fits less easily into that sense of new mapping practices than other artistic maps might. So while many artists turn to these new technologies, especially the capabilities of GPS linked GIS systems, the forms of geographically volunteered data, and the latest abilities of the geoweb to enable the "non-expert" to create and manipulate maps, Poitevin-Navarre creates a collage of older and newer methods. So, *The Proustian Map* juxtaposes the decorative scale and form of antique wall maps, a number of which hang around the Society, with the clean-cut appearance of an institutionally developed base map. She further complicates her visual form with the addition of baroque-style inscriptions that chart volunteered personal information across this clean-cut base map.

Poitevin-Navarre's map is the result of a four-year geo-tagged survey, conducted first with friends and family, and then on the internet, with participants enrolled by word-of-mouth and by way of links from other blogs. The replies, over a thousand, were anonymised but were plotted according to the post-code the respondent was asked to supply when they filled out the survey.[87] Poitevin-Navarre considers that her participants "give the artist the gift of information," and she in turn wants to give them an alternative record of their lives and their places: to let them put themselves on the map.[88] *The Proustian Map of London* is one of a series of Proustian maps Poitevin-Navarre has created, all of which are named after the party game, *Proust's Questionnaire*, which in turn owes its name to the French author. Poitevin-Navarre's artistic process mimicked this game, in which participants answer questions about their personalities, ideals, and aspirations. Describing herself as the people's confidant in their journey through the city and through life, Poitevin-Navarre asked them to respond to questions about their greatest achievement and their ambitions.[89] Receiving results that varied from specific achievements, "getting to Cambridge University," to the more abstract "to be a little wiser every day," these replies were plotted in curling script, jarring with the rectilinear font on the base map. The result was a sequence of anecdotal maps that plot humanistic landscapes of emotional relations, and the everyday personal explorations and achievements of lives lived.

Poitevin-Navarre's decision to map achievements was, in part, a response to the particular cultures of achievement she saw celebrated at the Royal Geographical Society. Located to the left of her wall map was an accompanying piece, *Fellow Artists/Fellow Muses* (Figure 1.6). The piece was inspired by the Society's medal tables, which celebrated great geographers and medel winners, including the artist Thomas Baines, by inscribing their names in a gold painted table in the original entranceway to the Society at the top of Kensington Gore. Musing around the word "fellow," referring

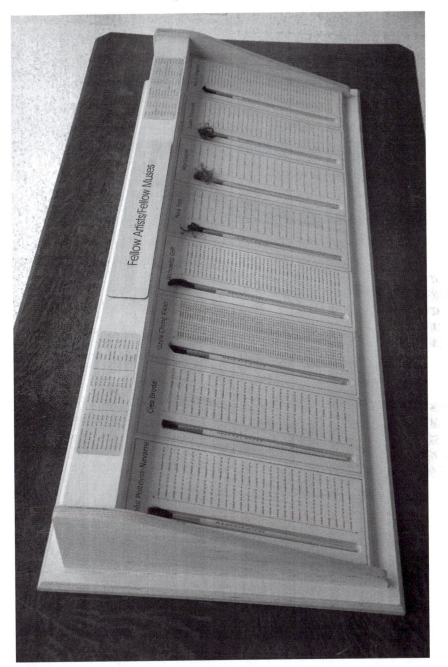

Figure 1.6 Fellow Artists/Fellow Muses, Agnès Poitevin-Navarre, 2010 (© Agnès Poitevin-Navarre, the Creative Compass Catalogue, Royal Geographical Society (with IBG), London; supported by Arts Council England; photography: Sir Colin Hampden-White).

here to the Society's membership, Poitevin-Navarre's work continues her exploration of personal, rather than political or institutional achievement, although there are clearly overlaps. Here, on a polished dark wood table, with ornately carved legs, and on rolling castors, reminiscent of those found around the Society, she installed a wooden display case.

About four-feet long and divided into eight sections, the case was tipped towards the viewer like a lecture theatre rostrum. At the head of each section is the name of a female artist, below this a list of coordinates, beginning with birthplace. These numerical maps of lives lived out by latitude and longitude, record in abstract the geographic movements if not the particularities, of the geobiographies of Poitevin-Navarre and seven "fellow" female artists. Next to these listed lives, Poitevin-Navarre has installed a paintbrush tipped with locks of their hair, referencing the tools of these women's trade, the historical traditions of personal keepsakes, as well as contemporary narratives of DNA testing in her other work. In setting together the disembodied genealogies, the geobiographies of achievement, and the assertion of personality and embodied presence in the form of the paint brushes, Poitevin-Navarre is not seeking to resolve or replace one way of knowing with another, but rather is setting up a tension which continues to play out in the wall map.

Describing mapmaking in her project as "a tool of the people," Poitevin-Navarre's subject-centred sense of mapping practices resonates with the qualitative and participatory forms of mapping practices that have been key to the second of critical cartographies "blows."[90] Within the context of technoscientific mapping practices associated with geographic information science, we find practitioner-scholars, especially feminist scholars and those who embrace qualitative GIS, exploring how technologies and mapping practices can be reworked. They seek to enable space to be made not only for other subject positions but also for the sorts of qualitative data—gained through interview and ethnographic work—that surrounds the embodied, emotive experiences people have of places.[91] This recent generation of mappers have embraced, and indeed, moved beyond Wood's calls for humanistic mapping, as they engage not only with the embodied, emotional, and affective lives of mapped subjects, but move toward enabling these subjects to play a greater role in the processes of mapping and the decisions around what and how to map.

Poitevin-Navarre is working here with a volunteered, selective census of sorts. As such, based on questionnaire data, rather than on interview or ethnographic work, *The Proustian Map,* both engages with more qualitative forms of data, whilst not quite moving away from more standardised modes of data collection. Indeed, in contrast to some of the uses to which map artists have put contemporary mapping techniques and technologies Poitevin-Navarre's work remains closer to traditional mapping practices. Further, she complicates these as her methods of data collection call to mind the sorts of volunteered geographic information and geolocated data

that has come hand in hand with the rise of Web 2.0. Such increasingly democratic practices are proffering further challenges to the once hard-wired epistemologies and practices of scientistic mapping conducted by trained experts.[92] But yet, Poitevin-Navarre's project does not enable this level of participation from those who answered her questionnaire: the artist has still decided what and how to map, even if the content is beyond her control. In sum, what she produces here is a collage, if not in material form then certainly in the different types and practices of mapping she develops. Her methods, data type, and mode of presentation, from the contrasting fonts to the varied experiences of mapping, sets in play a set of tensions that activate questions around what and how we map.

These tensions are further emphasised in the viewing experience that Poitevin-Navarre configures in the gallery space. Looking at the map implicates the viewer in a whole sequence of different scopic regimes. On the one hand, to really explore these maps you need to move in close, to engage in detail with the surface of the map and its writings. These feel like intimate engagements as you read the personal details of people's lives, pinpoint locations, and resist the urge to trace words with your fingertip. But your experience of the map is both limited by the narrow field of vision created through the necessary proximity to the map, and by the parts of the map that are located too high to read. The information in the city's northern quarters, positioned near the ceiling, can only be accessed through the use of binoculars. To view these portions of the map is to be enrolled in a scopic regieme that, in its slow scanning of territory, replicates the visual traditions of the "gaze" with all the associated implications of mastery, and of the secure viewpoint of the "scientific observer" assured of his capacity to see the other with a wholly objective and neutral gaze. The result is a juxtaposition between the surveying of the wall maps, a mode of god's eye view, and the forms of everyday and personal knowledge that are encountered on close-up readings. In the midst of this tension, Poitevin-Navarre keeps in play the many different forms of mapping and their power relations that the exhibition implies.

CONCLUSION: CARTOGRAPHY IS DEAD! LONG LIVE MAPPING!

"Cartography is dead! Long live mapping!" argued Wood, Pickles, and others in the early years of the new millennium.[93] And indeed, ongoing theoretical and practice-based developments seem to be hammering home the nails in cartography's coffin. *Creative Compass*, thus, is in good company with its critique; a critique that is located at what might be considered to the heart of, to take advantage of a perhaps overly simplistic word play, "Royal" Cartographic science. For Pickles, it is precisely the tensions between the consequences of a capitalised, institutionalised, and totalising "royal" or "state" science and the more open possibilities of mapping as social

practice that are of interest.[94] Working from the baseline that understood cartography as bound up with forms of disciplinary power and biopolitics that shaped and produced particular subjects, he explores how "it may be possible to develop new cartographies and geographies . . . by changing the way we think about the cartographies we have."[95] And, it is this sense of changing our ways of thinking about existing cartographies that this analysis has found with *Creative Compass's* cartographic imaginaries.

If map art, especially that made in the last decade, can be firmly situated alongside the second of critical cartography's two blows—the promotion of new mapping practices—then what is interesting about *Creative Compass* is how, by way of its situated institutional critique, it entwines the second of these blows with the first. The source of this critique lies, to a large extent, in the situated nature of the making and display of the artworks: conducted in the midst of the traditions of the Royal Geographical Society, the critique of mapping practices comes alive.

Moving beyond the specificities of mapping, what we see here are artistic practices, and in particular the experience of an exhibition, its curation, and development, opening up a critical space at the heart of disciplinary knowledge production. As such, the exhibition can be seen as a critical vehicle, less for the institutionalisation of geography, than for critical reflection on its practices and progress. It would be misleading to reduce this too simply to the situation of art as a means for asserting the subjective, the personal, the crafted, and the amateur into scientised spaces and practices. Rather, the exhibition could be understood to keep the field of cartographic production in, as Crampton describes, tension.[96] As such, and following Pickles's broader justifications for exploring and critiquing a history of spaces and cartographic production, the exhibition provides the means by which we can *both* look again at existing knowledge making practices and, in turn, prompt the development of new ones.[97] In the following chapter, which explores the project *Connecting with Gertrude*, I want to extend this idea to explore how arts practices can form the basis for formulating other ways of knowing. The chapter discusses a project which combines both specific details of the changing place of art forms in the making of geographical knowledge, with a more expansive methodological and epistemological imperative that explores how art works can offer forms of knowing based on imaginative connections and affective resonances.

2 *Connecting with Gertrude*
Woven Threads and Written Traces— Crafting Disciplinary Histories

GERTRUDE BENHAM AND AMY HOUGHTON

1931, just outside of the "realm of eternal snow" in the Himalayas, Miss Gertrude Benham (aged 62) sat peacefully knitting in her tent.[1] Benham's outwardly eccentric practice of knitting and embroidering in some of the most inhospitable climes of the British Empire was both a pleasurable pastime and an economic necessity, and more besides: "I am never lonely," she notes in one of few surviving letters, "in my spare time I knit or do embroidery, of which I am very fond. I spend a great deal of time in painting and sketching."[2] Benham's diverse making practices enabled her travels; selling and trading her own work as well as tools, calico and threads supplemented her small inheritance and helped her to finance eight circumnavigations of the globe. Having learnt mountaineering skills under her father's tutelage in the European Alps, where she climbed "practically every important mountain," Benham set off in 1904, after her parents' death, to travel the world.[3] As well as being the first person to ascend a number of peaks in the Canadian Rockies, Benham's most notable achievements were extended expeditions in Africa, including being disputably the first European woman to climb Mt Kilimanjaro (in 1909) and the ten years she spent off and on in India between 1909–1931.[4] In addition to enabling her travels, Benham's making practices, shaped her encounters with the communities she passed through, formed the basis for her relations with scientific institutions in the UK, including the Royal Geographical Society, and created the coordinates of her collecting agenda. The result of the latter was a collection of thousands of handcrafted objects—jewellery, costumes, accessories, metalwork, lacquer-ware, ceramics, toys, and religious articles—from around the world.

Benham desired to be thought of as a geographer. "I wish" she wrote from Kashmir in 1913 to Sir John Scott Keltie, then Secretary of the British Royal Geographical Society, "I could do something to qualify for one of the RGS medals."[5] Keltie, congratulating her on her achievements replied, "you really have done the most wonderful journey, single handed, and a woman . . . I think next time you come home if you would

not mind taking a little instruction . . . you might do something really useful for geography."[6] This evocation toward "proper" geographical practices, as Keltie described in a later letter, remained a theme of their sporadic correspondence over the next few years. Detained in England by the war, in 1916 Benham applied for a fellowship to the RGS, to which women had only been formally admitted three years previously after much controversy.[7] Her nomination was based on her extensive travel experiences, but also, interestingly, on the value of her topographic "mountain sketches and ethnological collections."[8] But Benham's fellowship was short lived, she resigned the following year, angry that her skill set was, she considered, undervalued by the increasingly professionalised Society. Very little written evidence of Benham survives; she died at sea in 1938 before she could begin a planned book of her travels, and bombing in the Second World War destroyed her self-archived trunks of letters, diaries, and sketches. However, while textual evidence might be slight, mainly focused on small collections of letters documenting her interactions with institutions like the Royal Geographical Society, Benham is survived by her large ethnographic collection. The collection resides in Plymouth City Museum where she chose to deposit it before she departed on her final voyage.

Against one wall of the gallery stands an ornate wooden table with beautifully turned legs and a single drawer, beside it sits an old wooden cane seated chair. To the left is a wicker basket and two large spools of yellow and umber thread. On a shelf sit three cream spools of yarn, in the basket some smaller brightly coloured skeins. Sitting on the table is a wooden loom, as well as a pair of scissors and a shuttle. Visitors to the exhibition are invited to sit down in front of the loom and pass the shuttle back and forth, contributing to the creation of the cloth. Working the loom, the flat screen monitor inset into the table comes to life. As the shuttle of the loom is passed backwards and forwards, the ornately woven cloth on the monitor screen begins to unravel. Coming to life through the actions of the audience, the animation slowly unpicks the threads of the fabric on the screen to reveal a photograph of an ornate cloth beneath. The cloth being unraveled is a facsimile of that in the photograph, the original fabric having been collected by Benham during one of many trips to Madagascar.

Made in Madagascar (Figure 2.1) is one of five works made by the artist Amy Houghton during her *Connecting with Gertrude* project, a fifteen-month residency at Plymouth College of Art (2010–2011). Drawn to people, places, things, and practices that are outmoded, abandoned, or sidelined, Houghton deploys a combination of found objects, stop-frame animation techniques, and contemporary craft practices to repopulate forgotten spaces, reanimate overlooked objects, recover radical figures, and recall lost souls.[9] Her past projects have explored the experiences of workers in a shoe factory, now a community centre; the intimate histories of an intricate lace dress whose unpicking tells a personal family history;

Figure 2.1 Made in Madagascar, Amy Houghton, 2011 (image courtesy of the artist, Plymouth City Art Gallery, photography: Trevor Burrows).

and, in this case, the biography of an obscure, largely forgotten twentieth-century female explorer. In each of these projects, Houghton approaches the tellings of these biographies of people and places by beginning from objects—a dress, a pair of shoes. In the case of Benham, it is objects from her collection—her pair of leather walking boots, an intricately woven cloth, a photograph of a tattooed woman, the handwritten pages of a faded sepia-toned notebook—that Houghton begins from. If the various titles of Houghton's works map the geographic expanse of Benham's travels, then it is through an engagement with Benham's collection of crafted and every-day objects, and her annotated catalogue of them, that Houghton, and her audiences get to know Gertrude. Connecting material objects with written traces that criss-cross the globe, Houghton tracks these objects through Benham's records, imaginatively spinning the weave of a story that enables a biography, of a form, to be created for Gertrude Benham: maker, collector, and geographer.

INTRODUCTION: WOVEN THREADS AND WRITTEN TRACES

This brief introduction to Gertrude Benham and to Houghton's art installation above draws out the threads in this chapter, threads that consist of two intersecting stories of getting to know Gertrude. The first story is Amy Houghton's, and it is a story of an artist using objects from Benham's

collection as prompts to weave a contingent and partial narrative of people and places, past and present. The second story is my own tracking of Benham, a story that includes both discussions with Houghton and analysis of her artworks, and archival research on Benham and her objects.

Benham's own story would be of interest enough, bringing into view, as it does, questions of the production of geographical knowledge—by whom, how, and where—at the turn of the twentieth century, an often overlooked era within disciplinary history.[10] Further, and what is particularly interesting for this discussion of creative geographies is the partial lens that Benham's story offers onto the changing status of art within geography during that era. Told however, by means of the intersections of Houghton's art works, studies of material culture and cultures of collection, and archival research, this is a story that gains more expansive methodological and epistemological impetus. For, it is a story the joins a series of recent efforts by geographers who have turned to various forms of creative practices to enrich their tellings of the histories of people, places, and the discipline.[11] In its interweaving of archival and artistic practices, this study offers one possible answer to calls by Driver, amongst other scholars, to develop "other ways of writing the history of geography."[12]

In examining Benham's geographical practice—her travels and activities as an artist and a collector—this chapter resonates with the recent rescaling of the maps of disciplinary history toward those "small stories" that tell tales of marginal figures and knowledge forms.[13] Such tales promote a programme for exploring and recognising knowledge production amongst "grass-roots practitioners" who are variously revenant to the mainline tales of people, places, and disciplinary histories, practices, and epistemologies. Such tellings of marginal tales often push at the limits of institutional archives and conventional sources, requiring instead engagements with remnants and remains, with unofficial archives and constellations of objects, and creative collecting and archival practices.[14] Further, these minor stories demand an embrace of alternative epistemological models through which our geographical knowledge making can proceed.

"How" muses digital art and media theorist Laura Mulvey, "does newness make oldness come into the world?"[15] Reflecting on the tendency for digital media artists to use contemporary technologies to presence pasts, Mulvey raises an important question as regards how we think through the sorts of histories that can be told by way of artworks. There are at least two different forms of answer to Mulvey's question, one is based in a technical "how" that explores the mechanics and techniques by which the work was made. A second is concerned with epistemological querying: a "how" that requires that we consider the forms of history and the modes of knowledge that are being performed by the artworks.

In the case of Houghton's project, the answer to the "how" I want to explore here is centered on the complex of texts, objects, and animation pieces that Houghton's project, and this chapter, assemble. Key here are

both generative acts of looking and connecting and Houghton's practices of "unmaking." Thwarted by a lack of factual material on Benham's life Houghton is unable to carry out more normative modes of painstakingly piecing together pasts by way of enigmatic remnants. Historical engagements couched in languages of "excavation" or "retrieval," accompanied by the sense of a pre-existing story awaiting the retelling, fall short here. In their place Houghton devises a way of working that is a response to the problems posed by the fragmentary evidence of Benham's life. Her solution is a form of "unmaking," offering meditative material engagements with Benham's objects by taking them (in this case replicas) apart. The inverse of devaluing these objects, Houghton's creative destruction is a powerful act of material and meaningful making that is perhaps less concerned to engage with the particularities of people and place, than it is to explore the creative fabrication of biography, and what it means to embroider material and imaginative connections between people, places, and things.

The remainder of this chapter will draw together artistic threads and archival traces creating "constellations of sites, subjects, experiences, and sources, dating from both past and present."[16] As Lorimer notes, such constellations are one "means to embrace a creative bibliographical dimension in geographical research."[17] Oscillating between Houghton's aesthetic and my archival investigations of Benham, the discussion both details the particularities, where possible, of Benham's story, whilst also reflecting on how it is that we think about the status and creation of the histories and stories we tell. In doing so it performs a particular, and hopefully, engaging way of getting to know Gertrude. Ahead though of these discussions I want to open out both the challenges posed by Benham's biography, or lack thereof, and the mode of working by which this project proceeded, and situate discussion in the context of geographical and art theoretical scholarship on creative engagements with collections and archives.

MAKING MEANING

The overarching story this chapter tells is one of geographical knowledge created on the margins of the discipline, and thus knowledge-making caught up in the ongoing negotiation of disciplinary boundaries. More specifically, Benham's story can be situated within both the narrating of feminist geographies, as well as the telling of tales that counter heroic geographies with everyday doings and sayings, and match professional geographies with those generated by supposedly untrained amateurs. To tell this story is to make space within the histories of geographic thought for recognition of the productive force of difference, to formulate "an analytic space which can articulate boundaries, distinctions and disjunctures instead of erasing them."[18] In its telling therefore, this is a story that is not just about the particularities of Benham's life, it is also about bringing into view some of the

negotiations around what counted/counts as geography, and importantly, the place of artistic practices within the increasingly scientised framework of twentieth-century geography in the United Kingdom.

Benham's is a story that is difficult to tell. Women travelers, especially independent ones like Benham, would have experienced their gender as one of the most significant categories in terms of their access to the world, to education and to employment, and as vital in the conditions of the production and reception of their geographical work.[19] As feminist historians of geography have made clear, "women's knowledge, practices and achievements were long missing from the history of geography: with scientific and colonial exploits framing the male, the metropolitan and the celebrated."[20] The challenges to the ongoing project of the telling of a feminist historiography of geography have normally been cast in epistemic terms, with geography's disciplinary gatekeepers controlling who and what was understood as geography, especially at the turn of the century when, as we saw in the previous chapter, the preservation of the homo-sociality of the RGS was bound up with the threat to geography's status as a "manly science."[21] Thus the feminist project, with respect to disciplinary history, as well as more generally, has been cast as a movement beyond the recovery and assertion of the stories of women, to actually unsettle and reformulate the very ground and means across and through which these stories are told.[22]

In Benham's case, absence from geographical history rendered epistemologically is compounded by the loss of her self-collated archive of papers, paintings, and diaries, stored for safe keeping in a trunk in Plymouth, and then lost, believed likely destroyed in German bombing raids on the city during the Second World War. Further, Benham can be aligned with the large number of middle and upper-class British women who travelled abroad at the end of the nineteenth and early twentieth centuries, and who in the course of their travels produced a "complex array of discursive representations of self in writing."[23] Unlike many of these women, Benham died before she could complete a promised book-length travel diary or record, like those produced to such great acclaim by Isabella Bird, Mary Kinsley, Mary Hill, and others. Her principal form of written self representation is therefore a series of edited notices detailing her travels that she sent to papers around the world, including the *English Times* and the *New York Times*. Details from these releases are replicated in longer papers written for the *Madras Journal of Geography*, notices in the RGS's *Geographical Journal*, as well as in her sporadic correspondence with officials at the RGS, the British Museum (Natural History), and the India Office.[24] This writing largely takes the form of choronological accounts of her travels, and a sort of narrativised logbook of the details of her destinations and her modes of transport. These writings also often detail the financial costs she incurred during her travels, with Benham emphasising her ability to travel very cheaply and resourcefully. Two longer interviews, for the *Times* and for a book (*Women in Modern Adventure*), flesh out Benham's life a little further.[25]

Studies of women's historiographies, whether in geography or elsewhere, have often supplemented explorations of the travelling practices and experiences of these women told through their written accounts or letters, with an array of visual and material culture sources, such as dress.[26] For geographers these "alternative" sources have, proved rich sources of missing information, provided alternative perspectives through which to animate individual biographies, and enabled the connecting up of the complex locations and intersecting networks of Imperial lives. In the case of Benham, it was her ethnological collection held in Plymouth that has been key for scholars, and is especially important for Houghton's engagement with her life.

Collections and Archives

In the project of getting to know Gertrude, alterative sources and creative practices sat alongside the more "traditional" spaces of collections and archives, both of which have become well-occupied theoretical sites by geographers of late. Thinking through the spaces and practices of collection and archiving and creative responses to them, proved invaluable to both connecting with Gertrude, but also to thinking through the epistemological model that this project developed.

It is through Benham's ethnological collections, or as she calls them, her "treasures" or "curios," that we get to know her best. Currently held in Plymouth City Museum, the collection amasses thousands of handcrafted objects, mostly everyday objects although some are ceremonial, and many are associated with the spaces of the home—for example, jewellery, costumes and accessories, metalwork, lacquer-ware, ceramics, toys and some religious articles. Using a grant from the National Lottery Benham's collection has recently been curated to form the basis for the Museum's "World Cultures" display.[27]

Resonating with current scholarship on collections, the approach developed by Houghton, and within the project more generally, was one that explored both the individual objects that constitute the collection as well as exploring the collection and its cartographies as a whole.[28] Treating the collection as artifact brings into view the relations between the constellation of objects and the subjectivities and collection agendas of individuals. In place of the conception of individual objects as storying particular pasts this is to recognize and appreciate the co-constitutive entanglements of the biographies of things and people, places and institutions.[29] Exploring the collection as a whole is to become sensitive to its cartographies, thus, we should attend to the movements of the collection and its meanings in different contexts. So, and in an interesting echo of Nash's writings on images, we need to explore the origins and destinations of the objects, but also examine processes of their circulation, and the multiple sites of acquisition and display in between.[30] Propagating from such an appreciation of "travelling" collections, is an awareness of the effects this has on the idea of collection narratives.[31] In other words, to appreciate the mobilities of

the collection is to register the denial of narrative capture. Instead, it is to require us to embrace cultures of collection that understand that collections will continue to take new forms and meanings long after the period of their establishment.[32] Such ongoing meaning making is key here, for engaging with Benham's objects involves thinking through their origins, the practices by which they were collected, their circulation through Benham's home, multiple periods of storage, reconditioning and display, and their replication and current enrollment in Houghton's work.

Theorizations of the archive take up and develop this appreciation of the complexities of mobile objects and their relationships to collectors and interpreters, and it is from here that we can begin to engage with some of the modalities of the project as a whole, and its epistemological concerns. Responding to demands of subject, source material, archival space, and shifting epistemological terrains, geographers have, of late, sought other ways to engage—in theory and in practice—with the archive.[33] Often these solutions are immanent to the practices and experiences of archival working, and are articulated by means of theoretical languages of order, disorder and excessive material presences and absences. As such, they foreground "bodily performance, the mobility of materials and the interplay between generating accounts and the ongoing process of interpretation."[34]

One of the principal ways geographers have responded to the animated and agentive archive is with an embrace of creative practices, together with their accompanying epistemologies. This creative archiving takes its most distinctly artistic turn to date in DeSilvey's examination of how the "ironies and inconsistencies" of artistic collection practices equipped her to cope with the "sheer perplexity and promiscuity," the "anxious" questions generated by the materially and semiotically unstable things she was trying to archive, where normative discourses of the archive failed her.[35] As such, artistic practices offered both curatorial strategies for dealing with material excess, and the critical impetus to think through how "unruly . . .materialities work back on our ordering principals to suggest other ways of knowing and doing."[36]

The challenge posed by Benham's scant archive is, however, less one of excessive material presence and disorder, than one of absence and the need to deal productively with partial and incomplete stories and constellations of contradictory information. Direction can be taken from Hal Foster's exploration of art's "archival impulse."[37] For, if one tendency of artistic practices, and that DeSilvey taps into, has been the pursuit of archiving and collection as a critical artistic strategy—using material excess to challenge grand narratives, to assert the local, subjective or fragmented document— then Foster is concerned to develop something a little different. He is more interested in a strand of work that deploys the partial archives to construct purposively incomplete, but nonetheless potent historical narratives that are driven by a logic of connections. These archives are focused on proposing new orders of affective association, and in doing so making space for the movement and endlessness of thinking. This forms an important point

of purchase on Houghton's work, for it isolates for attention the power in the partial archive's presentation, analysis and construction of alternative histories; histories based on provisional and personal encounters—obscure traces, unfulfilled doings, incomplete projects. The logic of archival relation here is "to connect what cannot be connected" rather than a will to totalize or to tell singular stories by way of affirmative associations.[38] The agency of archival materials, practices, and spaces are understood as generative of new points of departure, and this creation of "newness" is elevated over the desire to fill gaps or complete projects. In short, the material and textual remnants of people, places, and lives lived—here Benham's collection and her textual traces—are situated as "promissory notes for further elaboration, or enigmatic prompts for future scenarios."[39]

To elaborate by way of an example, artist Tacita Dean offers an iconic case study of contemporary art's "Archival Impulse." Like Houghton, her work proceeds through a series of idiosyncratic probings of particular figures, objects, and events. Reflecting on her project *Girl Stowaway* (1994), Dean offers an interesting stepping off point from which to begin to think about the development of Houghton's project and my own involvement with it. She writes,

> it [a boat journey] had a beginning and an end, and exists as a recorded passage of time. My own journey follows not such liner narrative. It started at the moment I found the photograph, but has meandered ever since through uncharted research and to no obvious destination. It has become a passage into history along the line that divides fact from fiction and is more like a journey through an underworld of chance intervention and epic encounter that any place I recognize. My story is about coincidence, and about what is invited and what is not.[40]

In this passage, we see Dean taking up the voyage that is the topic of her piece *Girl Stowaway*, and using the linearity of this literal journey as a metaphor to contrast with the processes by which her artwork proceeds. In doing so she intersects the form and progression of the two journeys that constitute the piece, on the one hand the illegal ninety-six-day voyage of Jean Jeinnie (Girl Stowaway) from Port Lincoln, Australia, to Falmouth, England in 1928, and on the other, the very different form of journey the artist took as she "reconstructed" the details of Jeinnie's voyage. Beginning from the chance finding of a photograph the journey of artistic process proceeds, as Dean narrates it, by way of contingency, incompleteness, and a form of intellectual and physical meandering, taking in sites from flea markets to coastal locations. This was a process driven as much by Dean's own imagination as by questions and directions generated by the photograph, its chance finding and her subsequent following of its leads; connecting the unconnected to insert new narratives in her re-telling of Girl Stowaway's story.

Connecting with Gertrude involved Houghton and myself in similar weavings together of paths of connections between past and present, proximate and distant, threading together people and places across time and space, and firmly enmeshing us in relations with things and technology. Beginning from the objects in Benham's collection, working apart and together, we traced Benham through her collection and through the scant archival material, interviews and published accounts. Houghton, following threads of Benham's making practices, began to correspond with other makers, adding new facets to the story as she researched techniques and acquired the objects she needed. She connected with Benham and others as she went by means of sharing practices and techniques of making, and through amassing the collection of machines she wanted to use to drive the animations in her installation. Houghton's processes proceeded through logics of social connection and material accumulation.

Dean's processes and indeed her installation of *Girl Stowaway* proceeded through a similar logic of accumulation. Producing her own archive of sorts—containing amongst other things an eight-minute 16-mm film of her exploration, as well as postcards of the ship Jeinnie made her journey on, and its wreckage off the Cornish coastline—Dean required the audience to enter into the matrix of text and objects, to make their own connections, and in doing so to mimic the artist's own process. In a similar way, Houghton's work collects together a series of found objects, and animations across the installation, only she goes a stage further in implicating the audience in this skein of connections. Like *Made in Madagascar*, each of the five pieces of work in Houghton's exhibition involved the audience in an activity of socio-material connection; working a loom, operating a sewing machine or a printing press, the audience powered the animations that engaged with objects from Benham's collection. Houghton writes during the development of the installation;

> I have been thinking about the threads that connect people through time and place . . . there would be a series of machines, i.e. treadle sewing machines, typewriters etc that operate? Trigger animations? The audience . . . participants would operate a machine that would trigger an animation . . . A journey of connections would be made, the user would have the agency to control the digital works through the mechanical devices. Forms of string and objects related to string tie this network together.[41]

The connections made during the processes of research, both Houghton's and my own, are mirrored in the form of the installation: a set of ongoing connections, endlessly multiple connections, with any one piece connected to any other by way of cognitive and machinic linkages. Houghton maps,

for example, relations between *Made in Madagascar*, whose loom not only activates its own associated animation, but also activates the animation in *Made in Taiwan*, another piece in the exhibition, this time based on a photograph showing the tattooed face of a weaver woman from the Atayal Tribe. *Made in Taiwan* is also linked to *Made in Tibet*; with the sewing machine in the latter also activating the animation in the former. The two pieces are further connected by way of machinic similarities: the same mechanisms driving the sewing machine in the latter as do the cine-camera in the former. Alongside the plotting of points, and the fixing and determining of the orders of Benham's life, what is brought into this space by the form and operation of Houghton's installation are mutations of connections and interconnections: disclosures not of singular truths but of the movements and endlessness of thinking.[42] This is, as the discussion will now explore, to fold together multiple tellings—through archive and art objects—of Benham's story. The result is not just to assert the place of a marginal overlooked figure within geography's disciplinary history, but also to begin to rework the very basis upon which we tell these histories.

"THAT FEMININE PASTIME": EXPLORING BENHAM'S PEAK PRACTICES

Made in Tibet (Figure 2.2), one of the five artworks in the exhibition, pairs a Singer sewing machine, complete with its treadle stand, with the animation of a leather walking boot. Sitting down at the sewing machine, stitching through the pieces of leather and cloth that the artist had left neatly stacked in a basket near the machine, the animation on the inset screen begins to come to life—dark brown leather tapes around the shoe come loose, the small stitches around the worn leather sole start to come undone. Gradually the boot comes to pieces.

We begin then from Benham's objects. The leather moccasin boot, slightly larger than life size, lies on a white background; filling the screen it is given an important status as an object. Like the other five objects Houghton works with, the boot is made present as a semi-sculptural thing, carefully laid against a neutral background as if in a collection case. The camera occupies an interesting role in these works, for here it is a tool of making and discovery rather than one of replication or retrieval.[43] By way of Houghton's stop frame animations—thousands of photographs stitched together—Benham's objects become points of meditative thought and erudition, as the camera explores their surfaces, opening them up and laying them bare in an examination of texture and materials.

The subject of this stop-frame animation is one of Gertrude's leather walking boots from Tibet. The boot like a whole series of Benham's other objects, is at once both a practical object—a key part of her travel

Figure 2.2 Made in Tibet, Amy Houghton, 2011 (image cour-
tesy of the artist, photography: Trevor Burrows).

attire—but also one of her many hundreds of "curios." Worn, as Benham
records in her "catalogue," "on my tramps to Leh," these boots offer a start
point for thinking through what we can term after Morin, Benham's "peak
practices."[44] Located in northern India, Leh was historically a busy Hima-
layan town on the Silk Route from China. Benham visited the town dur-
ing a long walk in summer of 1919, from Nini Tal (west of the Neplanese
border) to Leh along what she described as the "Hindu Pilgrimage Route."
As Howgo notes this is an extraordinary journey of which Benham was jus-
tifiably proud.[45] Following the archival trail prompted by engagement with

Benham's boot, we find her negotiating long-standing tensions between travel, exploration, and scientific fieldwork, tensions further complicated by her desire to be an "official scientific explorer." We also see her navigating the "highly complex, ambiguous and contradictory" set of gendered subjectivities that researchers have identified as the experience of other nineteenth-century female travelers.[46]

Benham's repertoire of making practices, principally sewing, sketching and flower collecting accord with those of any number of travelling ladies during the era, and like the telling of many of these women's stories, the situation of these creative practices in relationship to their practices of travel, exploration and the geographical establishment was anything but simple.[47] For a start, Benham was rarely to be found practicing these "feminine pastimes," as she described them, safely ensconced in the "room sized empire" of the bedrooms and drawing rooms of valley-based hotels and lodgings.[48] Instead, these making and mending practices, together with her sketching and botany, were part of her suite of "peak practices," conducted on her "tramps," rather than while waiting for the return of male explorers. Her letters and interviews offer entertaining accounts of her erecting her camp-bed on narrow rocky shelves and happily knitting away, or taking to her tent in the midst of blizzards to while away the hours knitting whilst storms passed.[49]

Benham's self-stylings, in her writings and interviews, share much with those of other female explorers of the era. On the one hand, she exhibited a certain feminisation of self. During repeated attempts to persuade the India Office to let her enter Tibet by a restricted route, for example, she describes herself as a "very quiet and harmless traveler," gainfully occupied in "making a collection" of mountain studies for the RGS "and collecting plants for the South Kensington Museum."[50] This is a rather exaggerated set of claims, given that by this point she has resigned from the RGS, and as notes on her personal file in the India Office record, her strident attitude and obstinacy combined to make them observe that she was "not the sort of traveler we want in the region."[51] On the other hand, like many of her female peers, Benham asserts her moral and physical superiority, she described how, on being deserted by all her guides in a snowstorm on Mt Kilimanjaro she "shouldered her English women's pride, packed it in her pocket and soldiered on." She fleshes this out in longer interviews in which she presents herself as the archetypal female explorer, giving practical advice about the day-to-day experiences of travelling based on her application of "feminine" knowledge and skills to her activities. Her answers are full of witty retorts, of modesty in the face of adversity, and of helpful remarks on modes of attire, and practical tasks such as acquiring guides, staying safe from wild animals and sickness, as well as on the supplies needed to outfit a successful trip.[52]

For Benham, however, her feminised pastimes, so characteristic of Victorian travelling women, are far from the leisure pursuits they are for some.

Rather, they are more akin to survival practices, and are a key part of her self-styling as a self-reliant and resourceful traveler. In a letter to Dr Alfred Barton Rendell, Keeper of the Department of Botany of the British Museum (Natural History), written from Srinagar, Kashimir in October 1919, Benham begs forgiveness for the imperfections in the twenty-six sheets of plant specimens she was sending him. She cites the ongoing challenges of finding reliable servants and describes herself as "jack of all trades as well as sketching, botany and writing." She continues by noting that she has had a "very hard time, with my sketching, writing and camp work in addition to the daily march, generally about eight or nine hours or more, the day seemed full up."[53] The use of personal correspondence to flesh out lives lived on the road is commonplace within studies of women travellers. But in Benham's case, the details of what she ate, how it was prepared, how she slept, how far was walked, and what the weather was like, are less about forming a detailed and engaged travelogue to send home to her nearest and dearest. Rather, these accounts are designed to emphasize to those in the scientific and exploration community, especially those who might find her employment, how resourceful a traveller she is. Comparing herself to other male and female travellers, sometimes by name, Benham aligns herself professionally and personally as more economic, resourceful, and self-sufficient, something she hopes will curry favor with Royal Geographical Society, amongst other groups.

The Practice of "Pure" Geography: From "Topographical Mountain Scenes and Ethnographic Collections," to "Sketches And Curios"

On 5 June 1916, having been delayed in England by the outbreak of war, Benham was successfully elected as a fellow of the Royal Geographical Society, taking advantage of the Society's recent vote in favour of admitting women. Her application, proposed by John Scott Keltie and seconded by Arthur Hinks (then RGS Secretary) lists her as a traveller, and under the qualifications Keltie wrote, "has crossed Africa from SW to W and has travelled within the Himalaya, Japan, New Guinea and the Pacific Islands. Made many sketches of scenery and made interesting ethnological collections."[54] Benham was unable to meet the costs of entrance to the Society, and the finance committee agreed to waive her entrance fee. The reason for such a waiver at a time of significant impecunity for the Society is described on her nomination form as being "in view of the topographical value of your studies of mountain scenes in all parts of the world."[55] As Keltie notes to Benham, this was almost unheard of, and should be taken as a symbol of the high regard with which her work was held.[56]

To explore Benham's intersection with RGS is to engage with the struggles, which had came to a head in the last few decades of the nineteenth century, regarding geography as subject matter and as method, especially in relation to the "powerful claims of its sister sciences."[57] These were far from a simple set of questions, not least because the Society at the time was an arena of

different knowledges rather than a site of singular focus. As Driver describes, the Society was cross-cut with tensions between the different constituencies it co-joined as a result of its "hybrid role as a social club, learned society, imperial information exchange, platform for the promotion of sensational feats of exploration."[58] Two particular points in Benham's history illustrate her negotiation of these changing understandings of the discipline: firstly, a short sequence of letters between Benham and Keltie, written between 1910 and 1913 during Benham's travels in Kashmir, and secondly, when she resigns her fellowship less than a year after taking it up. In both cases, we see slippages between Benham's sense of the "geographical," her desire to be an "official scientific explorer" and how it is that the RGS of the early twentieth century is shaping and understanding geographical science.

"MORE GEOGRAPHICAL THAN ARTISTIC"

In a series of letters written to Keltie from Kashmir, Benham shapes her identity as explicitly geographical, not only in terms of her exploration practices, but also her sketching, which importantly she emphasizes as "more geographical than artistic," implicitly aligning herself on the side of science.[59] She is assured of the geographical value of her sketches by others, she notes, because of "their illustration of contrasting geological formations."[60] She writes further to Keltie, aligning herself with the RGS's promotional and educational role saying, "I feel I have already done much to spread the knowledge of geography, as people often tell me they have learnt more from me than they have in school or in books."[61] Keltie, ever the gentlemanly correspondent, praises her travels, but politely suggests that she might need more training to be a "proper" geographer,

> you have really done the most wonderful journey, singled handed and a woman . . . I think next time you come home if you would not mind taking a little instruction from Mr Reeves, and also acquiring some knowledge of geology, botany and zoology, you might do something really useful for geography. You do not need to get any profound knowledge of these sciences, but just as much as would enable you to spot the different kinds of rock forms you met with, and enable you to collect plants, although it would be rather difficult for you, I dare say, to collect animals and skin them. Still you might so something more than simply enjoy yourself. In fact it might add to your enjoyment. You say you wish you could qualify for one of the Society's medals. Well there is no reason why a woman should not do so. You are still young and have plenty of time before you to accomplish anything you set your mind on.[62]

This exchange dramatizes the RGS's ongoing anxiety surrounding the untrained traveler, as it tried to shrug off its amateur and dilettante image in

the face of the increasing professionalisation of the discipline in the late nineteenth century, and the crystallisation of academic subjects in the early twentieth century.[63] It is unsurprising that Keltie, a leading figure in the development of geography at this time, would be so insistent on the standards of, what he called in another letter to Benham, "purely geographical work."[64] Keltie does not dismiss Benham out of hand, but rather sees her as a geographer-in-the-making, urging her, like other women before and since, to become trained by the Society. For Keltie, geography is very much a science, indeed he writes "all the best geographers, have approached the subject from the side of Science." The training he is advocating here casts the geographical skill set firmly in scientific terms—zoology, geology and botany—the latter in particular a common scientific practice for women during the previous centuries. [65]

The RGS had long debated whether the "provision of advice to the untrained traveller" was something that it should do at all. As researchers document, for some there were worries over whether "geography pure and simple could be made a subject of intellectual training."[66] Whilst for others the idea of "training" resonated with the increasing specialism of the sciences in terms of a growing sense of precision and of instrumentation.[67] Indeed, at the height of anxieties around the RGS's shaping of itself as a learned society, an unpublished document notes that to countenance the value of research by undisciplined travellers would be "inconsistent with the character of the Society, especially in times of increased provision in every department of Scientific research."[68] But yet, there was clearly a balance to be struck around scientific specialism and what was regarded as the "business" of the geographer. For, when Freshfield came to rewrite the *Hints to Travellers* manual in 1893, he suggests that we see "travellers as well as geographers, becoming familiar with the idea that their business is to furnish a picture of the earth such as it is."[69] Such a picture required more than the specialist eye confined to one branch of knowledge.

In the light of the circulation of these debates at the time, it is enlightening to return once more to Benham's nomination form, written in Keltie's hand. Benham initially believes that it is her travels that render her eligible for admission to the society, and she is partially correct. As Halford Mackinder acknowledges, even in the early twentieth century "most people would have no use for a geographer who was not also an adventurer and explorer."[70] But, whilst Benham's travels are clearly important, it would be a mistake to overlook the importance of the second element of the phrase on her nomination form "made many sketches of scenery and made interesting ethnological collections."[71] Here we see Keltie aligning Benham with the so-called "new geography" at the time, wherein, it is the "picture of the world" she builds up, through artistic practice, but also through her collecting practices, that are important to her gaining her fellowship.[72]

The status of Benham's topographical sketches and ethnological collections are far however from assured. As the RGS continues to hone its understanding of the discipline during the early twentieth century, the scientised status of Benham's documents and objects slips, with them becoming understood merely as "sketches" and a "collections of curios," a

firm beginning, but not quite an appropriate contribution to geographical knowledge.[73] These debates come to a head around Benham's submission to the *Geographical Journal* of a paper on the Volcanoes of Africa. Offering sketches, water-colours, and written descriptions of the changes in the shape and size of volcanic cones, Benham hoped the paper would be an important contribution to the journal.[74] Gauging both Keltie's and Hinks' remarks, however, the paper was thoroughly representative of the sort of scientific geography "observation and delineation of topography," that they wished to orientate the discipline firmly away from.[75] Benham's paper was, as a result, rejected and unfortunately in the chaos caused by the war the copy was lost. Benham, infuriated by the rejection resigned her fellowship from the RGS in the belief that her skill set was undervalued. Keltie tries to placate her, gently reminding her that she had previously made her "sketches and collections of curios" purely for her own enjoyment, and that should she be trained she could achieve much more. As he writes,

> the paper you submitted had no doubt much of interest in it, but I think is more suited to an ordinary magazine or to form part of a book (like Mary Hills') than to the RGS. I am quite sure that if you put your mind to it you could do quite good geographical work and I hope the results of your next expedition will prove this.[76]

This episode neatly illustrates the formal lines being drawn during the era between what would once have been considered within the remit of geographical practice—travel literature and sketching—and what was coming to be understood as "good geographical work." At one point, Benham's travels and sketches might have garnered her greater attention, but as a self-consciously evolving site for the practice of scholarly geographical science, the RGS was concerned to uphold certain scientific standards. Whilst patrolling these disciplinary boundaries, Keltie also wished to be helpful, and in an illuminating comment that reveals the changing nature of fieldwork and the increasingly recognized position of women within the academy, he notes, "apart from the geographical work which you might do, you, as a woman, could have special opportunities of studying the characteristics of native women you come in contact with."[77] Whilst Benham does not provide us detailed ethnographic studies, what she does provide us with is her collection of curios. Through these we are provided with both a lens onto the places she travelled and onto her own knowledge making practices. It is an exploration of this collection, its presence at Plymouth City Museum and principally in Houghton's project, that preoccupies the remainder of this chapter.

MADE IN MANY COUNTRIES

On a sturdy wooden bench in the middle of the gallery stands an old metal machine, closer examination reveals it to be a letterpress. Above

it on the wall was a monitor on which, framed in white, was a double-page spread from a lined, sepia-toned notebook, pages filled with columns of neat writing. Each page of the notebook has two columns, one of numbers, the second, written against each of the numbers, contains details of the objects collected. Moving in close, the descriptions can be read; object 166 (2): "cotton cloth, woven on small hand loom, used for making garments, n, nigeria."[78] As the audience work the letterpress on the table, the text on the page starts slowly to unravel, as if it were thread.

Figure 2.3 Made in Many Countries, Amy Houghton, 2011 (image courtesy of the artist, photography: Trevor Burrows).

Perhaps more so than any other of the five other sculptures *Made in Many Countries* (Figure 2.4) brings together all the different implications of making we find within the installation. The notebook that forms the basis for the piece is Benham's own personal catalogue of her collection, and as such it folds together her making practices, those of the women she encountered and whose objects she collected, and the practices of the archivists whose writings can be seen here layered on top of Benham's own. Further, the inclusion of this layered account of practices within the exhibition also implicates Houghton's making practices and those of her audience within this set of connections. Beginning from this piece I want to take a closer look at the narratives of Benham's collection practices it fosters, but also to move away from Benham's story to focus on the artworks, and the particular form of making/unmaking that they, and the installation develop. The latter is important, because by engaging with the form and mechanisms of Houghton's installation we are able to explore some of the more transferable ideas around the possibilities artistic practices proffer for critically engaging with the form and types of histories and knowledge more generally.

Collection Narratives

Amassing objects in the early decades of the twentieth century Benham was working, as were the growing number of personal collectors, many of whom were women, in the wake of the colonial "salvage era" of the nineteenth century, and the closing decades of the museum period, that saw the formation and growth of specialist ethnographic museums.[79] As we see in the shifting descriptions of Keltie's discussion of Benham's collections—from ethnographic collections, to a personal collection of curios or treasures—the boundaries between personal, and more institutionally and scientifically framed collections were often complex ones. The presence of catalogues and her letters and interviews provide, as others have noted of other collectors, important details of origin, context and the provenance of her objects. And, as with a number of other personal collections, this accompanying "data" on the objects would have eased their passage from home to museum.[80]

Houghton's "unpicking" of the text on the pages of Benham's catalogue draws our attention to this document, the nature of the data that it includes and what it can tell us about the collection. Overlying Benham's own notes are written traces of the movements of her collection and the different archival practices that have ordered and sorted it over the years. Exploring the layering of the marks on the catalogue evidences these multiple curatorial engagements. On top of Benham's carefully written texts and drawings are more recent red marks, over these we find further scrawls, including "India?" a blue-biro record of speculation on the sites of collection. Elsewhere, someone has written in a smaller print with the rectangular neatness of block-capitals the archive numbers "134.25.258."[81] Houghton takes on this palimpsest, but rather than add a further layer of inscription, her

treatment of it requires that we engage with it both as an important and valued part of the collection in its own right, but also that we are reminded that it is a very partial record of the collection and its objects. For, as the audience rehearses their own mechanical inscription process, carried out via the letterpress that drives this particular animation, Benham's own letters, words and pictures slowly fall away from the page. As the traces of Benham's objects slowly disappear, leaving their own ghostly shadows, the page remains marked by the traces of the multiple processes of archiving, curation and display the collection underwent.

What propogates from Houghton's meditation on the catalogue, is a consideration of the intersecting spaces and subjectivities that coalesce through Benham's collection. Like any number of personal collections at the time Benham's was small scale, and in the context of the large museum collections, non-specialist.[82] This is not to say she collected indiscriminately, rather from her catalogue and her letters we can understand Benham's collection as shaped by a whole sequence of factors; aesthetic tastes, the gender of the collector, the duration and direction of her travels, her financial status, her encounters with the local communities she was staying in, and the portability and durability of the objects she collected.[83] We find that, like many women of the era, Benham's collection is mainly constituted through personal, decorative and household objects, rather than say hunting and fishing equipment. She was especially drawn to embroidered objects and other handcrafted items especially if these displayed fine workmanship. From her records the collection does not appear to be a systematic sampling or an endeavor to collect comparable objects from different places. Rather, she collects by interest and opportunity, her letters and interviews detailing encounters in which she trades with the women whose houses she lodges at, and where she is able to see objects in-the-making.[84]

Like many collections amassed by women, one of the first sites of display for Benham's objects was her home. Unlike many of these collections, however, Benham's retained its ethnological context and scientific framing. Rather than stripping objects of their origins and rendering them "domestic," Benham created exhibitions of her objects to which she invited Hinks and Keltie.[85] In such a context the objects remained an active part of Benham's shaping of her scientific persona, standing for time spent in faraway places, encounters experienced, hardships endured, and knowledge gained. But, Benham's collection serves other purposes too, and her catalogue is more than a record of location and a seal of authenticity, it is also a snapshot of the practices of making and decoration in the communities she passed through, and a record of the use of the objects that attracted her.

The collection Houghton encounters in the Plymouth City Museum is one that is negotiating its multiple statuses as a scientific and ethnological collection, but also as a very personal collection that reflects Benham's fascination with embroidery and decoration. Indeed, it is the stitched and crafted nature of Benham's objects that Houghton engages and celebrates in her own

works, and in doing so animates for us Benham's own interest in the materialities and modes of making of the objects she collected. The description next to object 167 reads, for example, "cap, made and worn by men (the ridges made by biting the material with their teeth) n. Nigeria."[86] Object 173 meanwhile, is "embroidery for woman's dress Balluchistan a) fronts, b) pocket c) cuffs," and is accompanied by a simple but effective drawing of the dress, illustrating where the embroidery would be placed on the yoke, cuffs and skirt.[87] In the case of other female collectors, scholars have considered an attention to crafting process to offer a window onto the sorts of field encounters that these collectors were having.[88] Accounts in Benham's letters reinforce such resonances, detailing how staying in the houses and spending time in the domestic space of women in the places she passed through was a key source of objects for Benham.[89] Doubtless, such encounters are interesting in terms of the practice of fieldwork, as well as for the particular information they provide, but for this analysis it is the foregrounding of "making" that the collection draws attention to that is most important.

Making/Unmaking

I want now to return to *Made in Many Countries*, and the casting of the catalogue as artefact that Houghton develops in this work. The remainder of this chapter will explore how this particular piece of work, and its

Figure 2.4 *Made in Many Countries* (detail), Amy Houghton, 2011 (image courtesy of the artist, photography: Trevor Burrows).

relationship to the exhibition as a whole, draws our attention to the modes of making/unmaking that Houghton adopted. I am especially concerned to explore these works in answer to Mulvey's question regarding "how" it is that newness can make oldness come into the world?[90] The answer here will be twofold, in both cases focusing on artistic practices and audience experiences, in the first instance I want to briefly recount the mechanical processes of the work, but as a larger portion of this section will explore, in the second instance, I want to examine the particular epistemologies that Houghton's artistic explorations develop.

To return then to Mulvey's question of how contemporary digital media techniques and technologies presence the past. Key to the answer in Houghton's case is her implication of processes of making and unmaking. Houghton's artistic process involved her researching the objects, making replicas of them, and then undertaking practices of unpicking, dissolving, unraveling, and etching away. These processes were recorded in thousands of digital still images which were then stitched together by way of computer-aided animation programs to create a recording of the process of the object's "unmaking." So, for example, Houghton sketched and photographed Benham's boots in order to make a replica pair. She then proceeded, over the course of a number of weeks, to unpick this replica stitch by stitch. After each unpicked stitch she took a photograph, such that when these digital stills were recombined in sequence the boots would appear to be coming apart, intricate step by intricate step. The author of their unpicking, the protagonist of the handed maneuvers by which the objects unravel remains unseen in the video. Instead, in the exhibition, Houghton's installations make connections between the actions of the audience—as they operate looms, sewing machines, and so on—and the processes of material unmaking in the animations. Such that it is the viewer who appears to be the force behind the unmaking of these objects, their collective acts of material creation ironically driving the painstaking, repetitive, unpicking of Benham's objects.

These processes of unmaking form a meditation on the materialities and practices of making that are so important to both Benham and Houghton. In addition however, this focus on process develops a particular sense of history and of narrative time that is implicated within how we tell those biographical stories. Working, as Houghton describes "at one remove" from her objects, either by deploying photographs or fabricated models, she was already working with destabilised representations, traces of objects that call into question any sense of a stable "excavation" of meaning. Further, we could interpret the simultaneity of making and unmaking within Houghton's pieces as a continued disturbance of any sense of a stable historical story. The actions of the works unraveling and unpicking develop a sense of the partiality and fragility of connections that unsettles the normative movement of narrative towards a singular destination. Houghton's dwelling on processes therefore, can be considered as a refusal of closure and an

end-point, and thus as a laying open of the path to creative proliferation. It is to such an understanding of the particularities of this unmaking process, that I turn next, exploring it by way of the idea of "sculptural film."

Presencing Process

Exploring the concept of sculptural film enables an understanding of knowledge making that Houghton's animations develop.[91] Drawing from the perspectives suggested by Foster's consideration of arts' archival impulses explored earlier, I want to explore these animations in terms of their refusal of closure and end-point, and the openness and endlessness of thinking that they imply.[92] Belonging neither to the tradition of film, nor of sculpture, sculptural film enables reflections on key characteristics of both mediums. As such it proffers a conceptual dismantling of both the sculptural object— requiring a querying of its materiality—and of film, foregrounding questions of objects, of processes and of the experience of time and space in film. In the case of Houghton's work there is value in both the more palpable materialist dimensions that sculptural films offer, but also in how these films operate as vehicles for different narratives of time. In sum, then, via a critique of the materialities of sculpture, the temporalities of film, and the attention that sculptural film pays to the audience experience, I want to examine the ideas about knowledge production that the installation develops. What emerges is a sense of knowledge making that proceeds through an endlessness of connections, presencing the inability to see a singular whole, and the movement and ongoing nature of narratives and thoughts. The result is an installation that thoroughly resists the telling of singular stories and the creation of fixed, affirmative associations.

Understanding Houghton's animations as sculptural films situates them in the register of sculpture, thus replacing narrative expectations and the domination of a storied pictorial sequence, with film that, in taking on the conditions of sculpture, becomes more palpably materialist. Film thus becomes a medium for thinking about materials and for presencing process within which a particular temporality is bound. To unpack this, the limited narrative of Houghton's animations work toward the unpicking of the object; starting from the whole object and gradually taking it to pieces, and when this is finished, the film restarts. Gestures of unpicking and undoing are articulated over and over again, the repetitive motions of the slow unpicking of the individual stitches of boot or cloth, or the unraveling of words, letter by letter, become doubled in the endless looping of the animations. As the processes repeat over and over again, these objects become suspended in the process of unpicking. This logic of repetition can be interpreted, following Krauss, as developing a "logic of pure process," that over and over again subtends the present moment, never quite resolving into a narrative shape, "occurring in time but it does not move to termination. . . since there is no proper destination so to speak."[93] Whilst the unpicking of the boot is suggestive of the temporal—in that action proceeds

through stages—this, despite a suggested end-point, is a temporality that has little to do with narrative time. Working the loom and watching the simultaneous unpicking of the boot occurring on the screen alongside, brings the works thoroughly into the present, offering "the flattened temporal horizon of an extended experiential present."[94] If the films progress each time towards the material disarticulation of the object in question, the restarting of the film always thwarts this as a final destination. Instead this is "not a time within which something develops, grows, progresses, achieves. It is a time during which the action simply acts, and acts, and acts."[95]

If the critique of film that sculptural film mounts enables a consideration of the temporal element of Houghton's animations, then the sculptural element is not only engaged by way of the palpably materialist dimension of the animations, but also by the attention directed to the embodied experiences of the viewer.[96] Exploring these audience experiences further extends the epistemological arguments being made here. That the spectator is undetermined in gallery space is a given; thus, Houghton, like many artists, necessarily surrenders, to some extent, the ability to control certain dimensions of audience experience; in other words who sees what and how much, in what order, and so on. Despite the directions over the temporalities and spatialities of audience experience set by the logics of the work—in this case their interactive elements—audiences will often leave before the end of a film, some pieces will be witnessed over the shoulder of others, some "viewers" might never participate in the working of any of the machines, others will only witness the works partially from across the gallery space.

The interaction of Houghton's five pieces of work within the installation maximizes however, the possibilities of seeing the pieces over and over again from different places and different points of view. Repetition enters the viewing experience, as moving around the space the viewer is invited to make connections between the works, as one animation makes another piece work, and so on. These connections draw the visitor around the space, inviting them to experience, to explore, to animate and then go back and review and re-experience, thereby creating all sorts of associations with the other works in the space. The possibilities of seeing things over and over again, opens up spectatorship in ways that is not always possible with longer duration cinema, but further, it also combats the sense of a solidified narrative history. These experiences ensure that you never really see the "whole" of the image in any single particular way, but rather have repetitive experiences, all of which will likely be subtly different and many of which will be partial, with the result the whole becomes literally impossible to experience.[97]

CONCLUSION: AFFECTIVE ASSOCIATIONS AND AN ENDLESSNESS OF THINKING

As a way of connecting with Gertrude, this chapter has woven together the different threads of Houghton's aesthetically focused project, and my

own work in the archives and on Houghton's processes and projects. The outcome is, in the first instance, the partial and provisional recounting of a story of one woman, her making and collecting practices, and her brief intersection with the Royal Geographical Society. Through this lens we not only glimpse details of Benham's life, but also fragments of the development of geography as a discipline in early twentieth century Britain. Interestingly, in this investigation of creative geographies, Benham's is a story that also frames an understanding of the place and value of artistic practices for geography in that particular era. In addition though, the intersections of objects from the collection, Houghton's artworks and my archival research, has given the telling of this story more expansive methodological and epistemological impetus. As such, it is linked into a suite of recent efforts by geographers who have turned to creative practices to enrich their tellings of the histories of people, places and the discipline, but further, it also provides the possibility to reflect on the politics and understandings of knowledge that underpin those histories.

Engaging both textual and aesthetic interpretation together allows, it has hopefully been demonstrated, for an engaging and performative way to approach the project of getting to know Gertrude. The generative account presented here attempts to mimic the way that within Houghton's project, and my own participation within it, "new orders of affective association [emerged] however partial and provisional, and acknowledge their limited ability or desire to link firmly to a singular event to specific images."[98] Less a project of reconstruction than a project about generation, *Connecting with Gertrude* actually became a lesson in reorientation, moving away from affirmative associations with their tellings of singular histories, towards instead the forming of "historical, political and aesthetic links between objects and events and numerous representations."[99]

Houghton relies on these connections, and their endless proliferation, to tell her story of Benham. What she presents are less fixed and directed certainties than they are endlessly proliferating sets of connections that the audience can engage, enjoy, and take up to ponder as fiction, imagination, and speculation. In so doing they might perhaps pause to reflect on the instability of narratives of history and memory, and hierarchies of knowledge. Indeed, the embodied, situated practices of craft that Houghton's work formulates, creates an imaginary of knowledge as a manifold, woven from countless threads: an entanglement of relations between humans, things, and technologies that enmesh us in the world.[100] While the installation's endlessly proliferating connections points us towards the partiality and contingency of all our ways of knowing.

This is, all told, a turn away from artistic engagement with archives cast in terms of belatedness, to archival engagements thought through in terms of becomings. This is to recognize in things possible scenarios for alternative kinds of stories, whether these be tales of social relations or, as is the case here, of knowledge production. *Connecting with Gertrude* therefore, was a project that turned sites of excavation into sites of production, and

in doing so made space for the movement and endlessness of thinking. This is, following Foster, to pose "anomic fragmentation as an option, not only as something to represent, but to work through and propose new orders of affective association, however partial and provisional."[101] In doing so, we find a space and a role for art, not just to critique existing forms of geographical knowledge production, as we saw in Chapter One, but also to begin to develop some collaborative and insightful possibilities for ways that we can not only understand how geographical knowledge could be otherwise, but also to create it otherwise.

Part II

A Geographical Turn?

Placing Production, Producing Sites

RECONFIGURED GEOGRAPHIES: FROM STUDIO TO SITUATION?

The phrase "from studio to situation" captures what is generally recognised within the art world to be an important reorientation in the geographies of art in the light of arts' expanded field.[1] Furthermore, it indicates the uptake, as key art-world analytics, of questions that could be regarded as inherently geographical. At the heart of these developments lies the imperative to "locate" artistic production and consumption, and more specifically a desire to parse closely the relationships between art and site.[2] This has come about as a result of an exponential increase in artistic practices for which a specific localised "situation" or "context" is variously understood as impetus, inspiration, research subject, and medium for art making. Indeed, exploring art-site relations has become a unifying analytic across a range of twentieth-century art practices, from minimalism through to urban interventions, community, and public art, as well as so-called new genre public art, and perhaps most recently relational aesthetics. This importantly involves not only complicating the geographies of artistic production and reconfiguring the place of the studio in art world networks, but also the place of the gallery too.

In this introduction to part II of the text, I want to bring this geographical turn together with geography's own engagements with questions around the location of artistic production and consumption.[3] If the phrase "from studio to situation" is understood in the art world to denote a relatively recent shift from the generalities of studio practice to more situated and localised artistic concerns, then within geography the phrase has a more expansive scope. Indeed, it could be taken to denote a recognition of the breadth and complexity of the relationships between a piece of art, and the often multiple sites of its production and consumption. As the introduction indicated, and indeed the chapters throughout this volume follow up, to

query the relationship between the sites and spaces of arts' production and consumption, and those it re-presents and produces within its "frame," is often key to geographical scholarship. Such fields of inquiry are far from restricted to twentieth-century art; instead, they encompass mediums and time periods, such that the relationships between art and location are, for geographers, as relevant for inquiry into eighteenth-century landscape painting as they are for exploring contemporary site-engaged participatory arts practices.[4]

In what follows, two perspectives on the geographies of art—locating production, and producing site—are, somewhat artificially, disaggregated. Without wanting to deny the importance of linking both these perspectives, to engage them separately allows for distinctions to be drawn more easily between the nature and form of the site engagements art works promote. Indeed, it is generally recognized across art world literatures that what is required is a critical language and methodology that enables engagement with the nuances and variety of art-site relations.[5] Amongst its features, it is considered important that any such framework is equipped to grasp the shifting conceptualisations of site, place, location, and in particular, to "unravel the implications of this work beyond the specifics of time and place."[6] What follows draws perspectives from geography, and from art theory and practice to lay the ground for such a framework, sensitising us to some of these questions around the relationships between art and site. These relations are given more form in the three empirical chapters that follow. I want to begin however, by reiterating the forces that compel us to study these forms of art-site relations.

Why Art-Site Relations Matter

If the drivers for the current interest in art-site relations come from within the art world, as it seeks new interpretative frames and languages for art made in the context of its expanded field, then they are coupled with trends beyond art theory and practice that enroll these forms of art. Perhaps two of these most demanding of our attention concern the instrumentalisation of art, whether by the political left, or by academics concerned with critical radical social theory. In both cases the enrollment of arts practices continues long-standing debates around aesthetics and politics and, as a result, gives an added imperative to a close understanding of art-site relationships.

Artworks and artistic communities have a well-recognised role to play in urban regeneration, with urban aesthetics and the social formations of art worlds long being seen as a valuable tool of both capitalism and the state.[7] In recent decades, artists are increasing understood less as object makers than as cultural service providers.[8] This reconfiguration of artworks to include as their driving force the formation of localised social encounters opens up possibilities—especially around art events and participatory

activities—that have led to artists becoming differently situated within the political portfolio. As a result, artists are being funded by organisations and governments around the world on the basis that they will do "social work" in a range of different settings.[9] So prevalent has this become, that artists are being dubbed "social Band-Aids," with this artistic provision of social "goods" extending the civilising influence of the nineteenth-century art gallery.[10] Thus we find a range of projects wherein art is understood variously as catalysing community cohesion or assimilation, providing youth training and development, or addressing environmental issues, often negotiating these relations in concert with a range of community groups and institutions.[11]

In an interesting, if controversial parallel to this enrolment of art by political institutions we find a revivification of art as a figure of opposition, with the "artistic turn" in critical radical social theory sharing in the celebration of the transformative potential of art practices.[12] Here art's active and eventful status as, "actually be[ing] ways of living and modes of action within the existing real" is seen as a means to move, it is claimed, beyond inherited, state-based forms of public art.[13] A range of diverse political imaginaries—most often the minatorean politics of Deleuze and Guattari; the possibilities of sensuous Marxisms; the transversal ethico-aesthetics of Guattari, and Badiouian inspired aesthetic communisms—have informed this trend, all of which offer scholars understandings of the "transformations" that art is understood to effect.[14]

Hailing art in the name of radical politics is, of course, to evoke the spectres of long standing tensions between politics and aesthetics. This relationship simultaneously casts aesthetics as a powerful form of embodied liberation, as it opens the door to sinister formulations of affective citizenship.[15] Equally, there is the need to be wary of artists' enrolment of social cause and political endeavor for the enhancement of their reputation, to achieve funding ends, and for commercial gain. Notwithstanding these reservations, and the responsibilities that inhere within any alignment of art and radical politics, these practices can potentially inject critical energy into geography-art engagements, giving these studies a renewed place and urgency in the context of critical human geographies.

To locate arts practices as a potential field of political action, of whatever form, is to raise the stakes on the studies of this work. It is, in some respects, to bring the import and responsibility for the conduct of these politics down on artists' heads. By the same token, it makes more urgent the investigation of the relationships between art and its location, and the dynamics of arts' engagement with its site. The three empirical chapters that follow address these questions through very different artistic mediums, so in the remainder of this introductory section I want to lay the ground work for the critical formulations of art-site relations these chapters contain by addressing firstly questions of "placing production" and secondly those of "producing sites."

PLACING PRODUCTION

Artistic production has long been recognised to be a situated activity. Indeed, the geographies of artistic production, especially in the context of broader creative processes, are a well-studied topic. Thus we find the sites and spaces, and spatial distributions of artistic production being explored via a range of methodologies, and to a variety of ends that move far beyond the studies of individual works or exhibitions that are the focus of this text. These range from detailed historical studies, "geohistories" of the international diffusion of artistic materials, styles and techniques, to the sociologies and development of an arts school or colony, as well as ethnographic studies of the practices of studio production.[16] In a very different vein, research driven by economic and political imperatives is also concerned to investigate the spatial distributions and sociologies of the creative economy in the form of networks, clusters, and scenes.[17]

Perhaps unsurprisingly, to explore the locational imperative of art is to quickly become aware that the geographies of artistic production are complex and manifold. As Bain notes artworks are, "embedded within the culturally constructed context of the art world and is [are] located within the place-based culture of the studio, the home, the neighbourhood, the community, the city and the nation."[18] Further, as Nash makes clear, while we can take account of artists' and curators' intents, it is also important to consider "the relationships between the initial time and place of the images production, the location and places figured within the works, and the endlessly variable arenas through which they circulate."[19] It is beyond the scope and remit of this text to engage with a comprehensive survey of the geographies of artistic production and consumption, but what is important here is to understand how the relations between the form and content of artworks and the geographies of their production and consumption have been examined. Establishing this background sets the scene for an engagement with the variety of art-site relations found in theory and practice, and proffers thoughts regarding the understandings of place, site and location that underpin them.

Producing Content

To find explanatory force in the relationship between the form and content of artwork and its place of production dates back to antiquity, and to Hippocrate's writings on the deterministic relationship between temperaments and the geographical location of people on earth.[20] Such environmentally determinist approaches can be tracked in Vitruvius' first-century writings on architecture, and through into Ruskin's nineteenth-century writings on the place of landscape and culture.[21] They can also be traced into twentieth-century writings, including in Nikolaus Pevsner's classic essay on the geographies of art: "Englishness of English Art."[22] Following such perspectives forward is to register important movements away from the environmental determinism that conditioned such early understandings.

In his sensitive and detailed account of what he terms the geohistories of art, Kaufmann details an approach to the study of art that has much akin to the approach to the relationship of material culture and place taken by the Berkeley School of Cultural Geography.[23] Concerned to reject environmental determinism, Kaufmann explores the impacts of the specificities of place on the development of artistic styles, and the deployment of particular materials and techniques. Attending to cultural factors he examines how forms of art diffuse, with styles and practices persisting or petering out according to changing mobility practices and economic and political relations. Indeed, Kaufmann's studies of, the changing meaning of identity in relation to place, the role of place and time versus ethnicity, the significance of artistic centers versus peripheries, and artistic diffusion signal some of the key geographies of artistic production in recent years. But yet, these recent studies, perhaps unsurprisingly, show the influence of geography's evolving discussions of place. Such that, across this research place is understood as in process, and particular localised practices are almost always understood to be part of complex, often globally strung sets of networks. Further, the relations between place and artistic production are conceptualised at a range of scales, from the shifting global geographies of the art scene, driven by geopolitical events, the historical studies of the contextual development of a particular art scene, or the role of the local in the development of the content of a particular painting or play.[24] In Rogers's work, for example, the lens of a particular theatre production offers the means to tell spatial stories of artistic production that link localised practices of writing, casting, rehearsing, advertising, and performing into global production and performance networks.[25]

Aside from such studies, the road less followed within studies of the geographies of artistic production is that which leads us toward the micro-geographies of artistic practices, whether this be artistic encounters with the street-level sites of urban interventions (see also Chapter Four, this volume), or with the landscapes in which artists work. As Daniels and Ryan respectively explore in relation to eighteenth-century painting and Imperial photographic practice, understanding these en-plain air or in the field encounters can be an important part of how it is that we understand their force and the importance of these visions of the world.[26] For, to understand the "work" art does at a site, as Part III will unpack, we need to begin, I would suggest, from a sense of the encounters—both those of the artist, and those of the audience—that constitute that work. One place where these sorts of explorations are already being conducted is in relation to the studio space, and it is here that I now turn.

From Studio. . .

The studio has long been understood as a privileged site of artistic practice and also as a valuable site of generalised creativity, encompassing processes of transformation, performance, production, and transmission.[27] As such,

the studio has been much studied as a site of the coming into being of both the artwork and the artist as practitioner-subject.[28] Despite its role as a locus where artistic process is made present, recent studies have demonstrated how the studio is not, and never has been, comprehendible as a discreet, atomised place of production. Rather, it is a mobile—"materials and implements on the move"—highly connected space, linked into networks, spaces, and places networks of artistic production and consumption in which it plays a functional role, for JWM Turner the studio was more a state of mind than an actual place.[29]

None of this, though, is to deny the value of the studio as a privileged site for exploring the material and intellectual transformations that constitute an artwork, but also those transformations in subjectivity that are brought about by the processes of art making. Indeed, what valuably emerges from a number of studio studies is a reinforcement of the complexity of the creative labours of the artist, with ethnographic studies and artistic accounts situating the studio variously as, a space for reflection, a room for study, an experimental site of material and conceptual transformation, a space for the construction of self and identity, within and without an art world, and an ongoing archive of practice.[30] Common across these studies is the recognition that the studio has always been a part of wider artistic networks. These have included the home, the field, the lab, as well as the position of the individual artist's studio within larger "creative clusters," and the role of collections of studios in urban regeneration, and the place of the studio as at once also a site of display and a painted scene.[31] In short, the studio becomes situated as a space of practice in relation to a whole series of other sites of collection, documentation, rumination, development, and information.

In its complex geographies and its presencing of practice, the idea of the studio space focuses attention onto what could be called the micro-geographies of artistic practices: the materialised "doings," the embodied practices and the sayings and unsaid elements of the creative process, the collections of objects and papers, and the processes of inspiration. We see the beginnings of studies of these different elements and their intersections in explorations of the mobile studios and their relationship to the visual modalities of Imperial photographic regimes. We also find them articulated in studies that explore the turn to *en plain air* painting, enabled by development technologies and commercialisation, whether in the romantic mountains of Wales or the frontier landscapes of the United States.[32] Indeed, studies of landscape art have come to focus on the nature of artistic-landscape encounters, often unpacking the relations between studio practice and landscape-based works. Very different types of landscape art have been understood in terms of the relationships artists build with the landscapes that are variously their subject and material source.[33] What emerges is a close attention to production relations, whether this be the intricacies of Humphrey Repton's Red Books,

or the setting of an easel in the landscape, or the embodied experience of the artist as they move through the landscape, whether on foot, by cart, or by air.

As this range of studio studies, but also the accounts in Doherty's collection of artist's texts, articles, and artworks indicates, the movement from "studio to situation" should perhaps best be considered as merely the latest in a series of processes which deterritorialise the spaces of artistic practice, and which turn analytic attention to the geographies of art's production and consumption.[34] But yet, this is not to deny the value of the studio as a space that enables us to attend to doings, sayings, and intersecting cognitive, embodied and material practices that constitute artistic process. This section has explored a set of ideas around the placing of production that operate rather distinctly from those encompassed in the shift from studio to situation. It is in the light of these questions of the understandings of place and site, and the close attention the studio gives us to the sayings, doings, and thinkings of artistic practice, that I want to now turn, to consider the idea of "situation."

To Situation . . .

Art history's and theory's attentions to questions of producing site and placing of production have been more circumscribed than the widespread presence of these analytics within geographical scholarship would suggest. This is, in part, down to one of the predominant historical arcs within which contemporary "situated" practices are located. In this telling these practices are set against a modern sculptural practice. The latter is characterised by placeless, nomadic work that had absorbed its pedestal, and in this material and formal maneuver was assumed to have absolved itself from interpretative relations dependent on location.[35] Set in counter-point to this tradition is recent art that is the product of a situated, rather than studio-based practice. Art's self-conscious engagement with the specificities of site emerged as a result of a number of factors. These include, the epistemological challenge to relocate meaning from the autonomous art object to the relationship between the art object and the contingencies of its context; the radical restructuring of the Cartesian subject by the posing of an embodied phenomenological subject; and a desire on the part of artists to resist the forms of the capitalist market economy, which articulate art objects as transportable and exchangeable commodity goods.[36] Thus, site becomes a common denominator in practice and analysis concerned with a range of different mediums, from minimalist-inspired installation art, to community and public art concerned with political activism, as well as the social narratives of recent formulations of relational aesthetics.[37]

The valorisation of ideas of "site," "situation," "location," "context," and "place," often used interchangeably, is not just, however, to assert

a shift in the spatial distribution of production, nor is it to realise the need to situate, or contextualise interpretations of artworks.[38] Rather, it is about a coming to terms with art settling into a qualitatively different relationship with "site." As Krauss puts it, "the specificity of the site [/space] is not the subject of the work but—in its particularity of the movement of the viewer's body-in-destination—its medium."[39] Here she is referring to minimalist works, but the tension she develops between site as subject and site as medium is important to thinking through art-site relations more generally. There is far from a consensus however, as to how to deal with this relationship. Looking across a range of studies is to witness site understood in multiple ways; from a physical space (wherein the artist is engaging with the physical attributes of a space), to, by contrast, site understood in terms of social and humanistic explorations of place and the local. Of late, conceptions of the social "site" have become popular, understanding site primarily by means of community, as have studies of site as the discursive spaces of intellectual debate and as the psychic spaces of self.[40] Often, this variety is elided into a sweep of change that has, perhaps unhelpfully, claimed to see a movement from a physical site to art engaging with a "discursively determined site that is delineated as a field of knowledge, intellectual exchange or cultural debate."[41] In what follows I want to begin to draw out some of the differences and tensions within these understandings of site.

Consuming Situations: Derritorialising Consumption Practices

Importantly, such discussions of "site" and "situation" not only concern artistic production, but also the geographies of consumption. For, as a work becomes more situated in its production, its conditions of consumption have also tended to become more specific in time and space. Indeed, there is arguably a reconfiguration of the place of the gallery within art world networks which, as with the studio, requires that we complicate the geographies of gallery spaces, and their relationship to sites of artistic production. Alongside the recent assertions of the geographies of gallery spaces, we need also to consider how, like the studio, the gallery is also just one of many sites within the longer history of the deterritorialisation of artistic display.[42]

With these geographies of consumption comes to the need to work over understandings of the audience—whether they are within or beyond the gallery space—in light of the productive force of the work. For, as place becomes neither simple backdrop nor subject, but active context and content, the audience become not so much viewers as participants. These geographies of consumption unfold in two ways. On the one hand, there is a fetishisation of the "originary" aesthetic experiences of an "in the moment," "in the place" audience, who witnessed-produced the situated work.[43] On the other, is a "secondary" audience, often by far the largest,

and the increasing variety of modes—e.g., artist's books, documentary installations—through which they are able to consume such spatially and temporally specific work.

As recent scholarship on the now common tendency to "re-create" sited minimalist works, especially land art, has made clear, such recreations are not as simple as merely moving a "situated" work, or even taking photographs or making videos of it *in situ* to be shown or replayed. For the seemingly unproblematic relocation of these works from desert landscape or urban plaza to gallery space puts at risk their core values.[44] Such relocations render the site-specific nature of these works, considered so fundamental to their making—as Serra infamously suggested of his minimalist sculpture, "to move the work is to destroy the work"— merely the artist's personal choice.[45] The relocation from landscape or community to gallery space risks breaking down the once active critique of relations between site, viewer and art that the works performed. Rendered inert, as Kwon details with respect to minimalist works, the process of encounter with the work once staged becomes stripped of political efficacy, presented merely as content to be consumed.[46] Central to these questions of the geographies of consumption, is therefore the issue of how to conceptualise this relationship between a work's specificity in time and place and the demands of an art world that assumes that a piece of art will have a more mobile and enduring form. For such a mobile form enables display—helping to create artistic reputation and enabling critical scholarship—but it can also be about enabling the situated artwork to participate within the global art market.[47]

As such, the development of "situated" arts practices brings with it multiple geographies, and the need to be aware of the many sites of a site-specific work, and the relays and tensions that develop between the expression of the piece's localised specificity, and its more mobile forms. Scholarship on performance art, for example, frames these queries in terms of loss. Such research understands performance through an ontology of disappearance, in recognition of the differences between the sensuous immediacy of the experience of these works, and the subsequent accounts and re-presentations of this work after the performance event which are conceived of in terms of "lack."[48] This perspective raises further questions around the nature and possibility of an "originary" experience, as well as the potentialities of a whole sequence of artistic productions—like the artist's book explored in Chapter Five or the photographic sequences explored in Chapter Seven—that have grown up around these increasingly spatially and temporally specific forms of practice, and that may conceive of these relationships as other than secondary and through terms other than those of loss or lack.

Perhaps key amongst these formulations of the "other" sites of situated work is Robert Smithson's development of the idea of the "non-site."[49] Best known for his land artworks, such as *Spiral Jetty* (1970), Smithson wrote,

I was sort of interested in the dialogue between the indoor and the out-
door . . . I developed a method or a dialectic that involved what I call
site and nonsite . . . (it is a back and forth rhythm that moves between
indoors and outdoors)."[50]

In developing this relationship between the landscape-based forms of
works like *Spiral Jetty* and the site-based explorations of his other works
and his "non-site" pieces—sculptural objects developed for gallery dis-
play—Smithson is directing us toward the heart of this tension, and one
that need not be posited as a lack. Indeed, as Rendell points out, the very
distance and difference between the "original" site and our current con-
sumption of the work, either in images or artist's films, "allows the work
to resonate in more speculative ways, that indeed the imagination of the
audience might today be the most potent place land art occupies."[51]

Smithson is clearly not alone in formulating a complex of works within
which an audience will experience his sited land art pieces, and in drawing
out, by way of these works, the differences in production and consumption
experiences across these sites. Meyer attempts to formalize these differences
by way of a distinction he makes between the literal, or physical site of the
works production and consumption—a singular area in a precise location,
such as Salt Lake City, Utah, in the case of *Spiral Jetty*—and the functional
site, which, it seems might exist as a record of the literal site. The functional
site is an aesthetic site in its own right, as well as one that in some senses
situates the literal site not as an originary site, but as one site of meaning
making amongst many. As he describes the functional site, it is "a locus of
overlap of text, photographs, video recordings, physical places and things
. . . it is a temporary thing, a movement, a choice of meanings."[52]

What all these discussions indicate, and what the three chapters collected
in this part as well as Part III develop further, are the many means that artists
are using to make site-specific and ephemeral practices at one and the same
time both increasingly localised whilst also able to be mobile. Where perhaps
this is most interesting is, as the artists book explored in Chapter Five illus-
trates, where artists create mobile experiences that in some sense re-create
the experience of the site-based work, rather than merely represent the work.
Above all, what emerges from the shifting spatialities of art developed by arts'
expanded field is the need to pay closer attention to the geographies of arts'
production and consumption. If this first section of discussion has focused on
the geographies of artistic production and consumption, then the second part
of this discussion is going to move onto querying the artistic turn to "situa-
tion" in terms of its productive force, its production "of" sites.

PRODUCING SITES

If geohistories move us beyond a deterministic relationship between art
and site, but situated practices point towards the need to continue to take

account of the localised, situated doings, sayings, and thinkings of artists and audiences at multiple sites, then key questions remain those around the "work" that art can be understood to do at the sites of its production and consumption. The role of art in developing geographical imaginaries of people and places, discussed in Part I, has clearly been a key part of how art has had a role in "producing" places and sites. We saw this with the enrollment of art within geography's topographic and interpretative traditions, wherein imaginaries of tropical places, but also English rural idylls circulated around the world, shaping landscapes and mental imageries as they did so.[53] Indeed, a wide ranging body of research, from geography, english and art history as well as science and technology studies, has explored the power and place of artistic practices in developing our geographical imaginaries.[54] This is brought right up to the present, and situated in a neoliberal context, in research that examines the power of the arts in forming the urban imaginary of key cities around the world, often as part of wider discourses of place branding.[55]

Geographers still turn to artistic practices for their geographic imaginaries, perhaps less often in the service of particular localised understandings, than for the epistemological imaginary of place that creative practices are understood to enable. Perhaps one of the best-known examples concerns the urban imaginary developed through the work of the Situationists, a European-based avant-garde group.[56] Put simply, through an array of different methods, this group, and practitioners working in their legacy, have been understood to develop understandings of the city that propose alternatives to the experiences and organisation of urban space under capitalism.[57] In a rather different vein, we see Till, for example, exploring the potential of artistic engagements with memory-scapes and urban history to proffer the means to open out the complex layers, and emotional and affective burdens of wounded cities for study, and for healing.[58] If Till has worked closely with practitioners to commission and curate works that explore understandings of urban memories, then geographers have also turned to a suite of broader visual culture techniques to enable their production of alternative urban imaginaries, whether this be comic books, photography, or the production of "videographic geographies."[59]

Building from the place of art in the production of geographical imaginaries, and the understanding of the force these can have in the world, I want, in the remainder of this discussion, to take forward the particular trajectory that recent "situated" practices have taken, and that their development offers, with respect to querying the work art can be seen to do at site. Discussion explores this "work" in terms of aesthetic reorganisation of bodies, in terms of institutional and social critique, and as bringing about transformations in sites, politics, and subjects. This is by no means a comprehensive survey, nor does it even begin to touch on the complexities of some of the theoretical and philosophical questions at stake here. Instead, what it does attempt to do is add a geographic querying to the understandings of two key trajectories of art-site relations—minimalism

and participation—in order to sketch out some of the key coordinates through which to explore the "work" art does at a site. Ahead of introducing the chapters that constitute this part of the text, this discussion will close by reflecting on some of the contributions that geography can make to key questions being raised regarding theorisations of site.

An Extended Situation: Activating the Viewer

The key registers for geographical explorations of situated arts practices have been either urban-based public art, or urban interventions inspired by urban spatial theory and anti-capitalist thinking of the Situationists. It is important, however, not to overlook the other routes through which situated practices can be understood. Indeed, it is minimalist art, made in the late 1960s and early 1970s, that is often accredited with the "dramatic reversal" of the placelessness of art under the modernist paradigm.[60] From within the minimalist genealogy of art unfolds a sequence of investigations that brings together an attention to the material constituents of artistic mediums with a consideration of the spatial conditions of perception, and the corporeal basis of this perception.[61] The work of minimalism lay in its radical dismantling of the autonomy that the modernist art object claimed from both its viewer and the spaces of its display. The art-site relation was thus directed toward the creation of an embodied response from the viewer, a relation that was to be singularly experienced in the here and now through the bodily presence of each viewing subject; a sensorial immediacy of spatial extension and temporal duration.

If modernist sculpture was the epitome of art's autonomous self-referentially, its indifference to site was perfectly expressed by its absorption of its pedestal/base, rendering it transportable, placeless and nomadic. By contrast, minimalism and other site-specific works, whether as Kwon notes, interruptive or assimilative, were understood to be situated in relation to an *a priori* environmental context, by which they were formally determined or directed.[62] Often described as "place-bounded," minimalist works were concerned with the physical elements and conditions of a space, be it a gallery, a plaza, or an atrium,

> it [they] took the "site" as an actual location, a tangible reality, its identity composed of a unique combination of constitutive physical elements: length, depth, height, texture, and shape of walls and rooms, scale and proportion of plazas, buildings or parks; existing conditions of lighting, ventilation, traffic patterns; distinctive topographical features.[63]

Furthermore, these were works that were obstinate about location, developing an inextricable and indivisible relationship between the work and its site, by virtue of its configurations of object-space-audience relations.

Describing his infamous piece of urban sculpture, *Tilted Arc*, Richard Serra notes how it was

> conceived from the start, as a site-specific sculpture and was not meant to be "site-adjusted" or. . . "relocated." Site-specific works deal with the environmental components of given places. The size, scale and location of site-specific works are determined by the topography of the site, whether it be urban or landscape or architectural enclosure. The works become part of the site and restructure both conceptually and perceptually the organization of the site." [64]

The site-specificity of minimalism then was a double movement, not only a response to site, "determined" in Serra's words, by its topography, but also reorganising it "conceptually and perceptually." This was about a triad of art object-viewer-site, from which emerged a reordered aesthetic experience in which none of these three elements was autonomous.

Leading minimalist sculptor Robert Morris, in his *Notes on Sculpture*, described this as an "extended situation," in which the viewer, space and object come together in particular orientations. Morris's description points toward the "activation" of the viewer that these extended situations brought about. In other words, the re-embodied and situated audience called forth by minimalist sculpture was to pave the way for the idea of an engaged audience of artworks, the effects of which are many. For, in short, to activate the viewer as an embodied viewer, is also to activate them as a social and political subject, catalyzing the questions of the active art encounter, and forming a vital precursor for the socially engaged and interventionary practices that were to follow.

From Institutional Critique to the Arts of Transformation

Often in discussions of site-specific art there is an assumption that the work in question exists outside of the gallery space, but a kernel of the social and spatial critiques and transformations often attributed to these forms of work can be located in art's critique of the ideologies of the gallery space. Furthermore, these critiques are not just a force for deconstructing these locations, but also are some of the earliest examples of the recognition of art's potential to transform the sites at which it is made and displayed.

Just as geographers have rallied against the natural pre-given sensory body as a means to explore landscape, so within the art world of the 1960s the sensing phenomenological body installed by minimalism was to become that of a thoroughly social subject. And, if the embodied subject was part of minimalism's reorganisation of site, as discussed above, then the social and by extension the political subject installed by later works developed further forms of site-based critique. The impulse was particularly strong on the part of feminist artists who were some of the first to install within the art

gallery not just fleshy, sensing bodies, but also socialised bodies: a social matrix of class, race, gender, and sexuality.[65] The combined effect was to challenge the apparently "innocent" spaces of arts production and consumption, principally the hygiene of the white-cube gallery space, and the accompanying presumptions of a universal viewing subject. To be specific to site was therefore to explore the techniques and effects of the institution as it "circumscribes the definition, production, presentation and dissemination of art." [66] By way of the material being of artworks, and the social performances of artist and audience they presence, these works explore how the gallery-as-institution brought about the disassociation of the space of art from the space of the world, achieving its idealist imperative of rendering itself and its ordering of values, "objective," "disinterested," and "true."

Of course, these forms of institutional critique did not remain confined to the art gallery, but soon spread to other institutions (see, for example, Chapter One), and eventually beyond their confines too. Indeed, we find arts practices understood as abroad in the world, and deploying similar strategies of critique against the capitalist organisation of space, including against the enrollment of art within the site-based hegemonies of urban redevelopment programs, those, "profoundly authoritarian, technocratic mechanisms, transforming cities to facilitate capital accumulation and state control."[67] In her classic account of art and spatial politics of the city, art critic and urban theorist Rosalind Deutsche describes how resituating art projects beyond the gallery space, making them "go public," eroded the aura of isolation erected around art institutions, and countered the supposed universality and autonomy of art. The result was to break down the role of aesthetics as a tool of legitimation within a whole series of oppressive economic and political systems. The social problems of the city became therefore the very conditions of arts' existence, and, in reaching out to new audiences, artworks began to constitute new publics through which to engage and debate issues of social justice in the city.[68] Here art comes to intervene in debates about the production of urban space, and what is more, forms a site for the production of politics, requiring that we consider it in terms of human and nonhuman relations, both antagonistic and cohesive.[69]

Arguably, key to enabling the transition between art as a critique of representational regimes and ideologies, and art as a tool for intervention and engagement have been re-conceptualisations of place and site as in process. Hence, site is no longer understood to be an existing backdrop, a precondition for art as a distanced abstraction, but rather site is understood "as process and as in process."[70] Some arts practices were, and remain, shaped by a sense of art-site relations in which the identity giving and identifying properties of the site are always and already prior to whatever cultural forms might be introduced to or emerging from it.[71] As such, these forms of art remain understood as re-active, as at best cultivating

what is already presumed to be there, albeit caught in the midst of debates about representational politics, rather than potentially generative of new identities, histories, and communities. Indeed, marking out more recent work on art-site relations has been a sense in which art intervenes within and shapes place and people. Geographers have taken up this potential of art with respect to questions of the production of memory and community. Mackenzie, for example, explores community arts practices as localised "labour[s] of becoming" carried out in the context of global networks.[72] Till and De Silvey, meanwhile, extend long-standing geographical work on memorialisation by examining how artistic practices can be part of a recognition of "memory in motion," shaping people and places, rather than an action of unearthing repressed pasts or preserving them.[73] What research like Mackenzie's also begins to do, in common with the study of *insites* in Chapter Five, is to develop the very necessary engagement with what these encounters and relations look like in practice.

Such ideas of art as a force for intervention and transformation are well illustrated by recent geographical work on the possibilities of art in the context of theories of urban space and ecologies.[74] Within such work aesthetics becomes reconceived in a movement away from aesthetics as a set of codified standards, that shapes hegemonic forms of landscapes, and clears away people and infrastructure to impose the "plans of the powerful." Taking theoretical leave from the writings of Marxist theorists Lefebvre and Marcuse, and gaining empirical focus from a suite of twentieth- and twenty-first-century urban-based creative practices, what emerges is an understanding of artistic practices that foregrounds the future possibilities opened up by urban interventions.[75] Thus aesthetic practices become a force for the re-imagination of the spaces and practices of the city; formative of new encounters with difference, interruptions in the conditions and conceptions of urban space and time, and moments of liberation within routine.[76]

A second shift in understandings of the aesthetic has seen a move even further in this direction driven by a reconceptualisation of aesthetics in terms of the social. Curator-theorist Nicolas Bourriaud coined the term "relational aesthetics" to acknowledge the constitution of aesthetics through (human) social relations rather than by way of judgments of beauty or the sublime for instance.[77] In an often-quoted definition, relational aesthetics are "a set of artistic practices which take as their theoretical and practical point of departure the whole of human relations and their social context, rather than an independent and private space."[78] Under such a schema, art is understood as "eluding the alienation, the division of labour, and the commodification of space which characterizes our new networked society," arts thus become a force for change.[79] Key here is arts' configuration of social situations, of encounters within which new "life possibilities" appear to be possible.[80] A barrage of critique has been unleashed on Bourriaud's relational aesthetics, challenging its

historical blindness to the place of the social encounter within decades of arts practice, its lack of antagonism in its conceptualisations of the social, as well as its flaccid inability to transform the social basis of labour, and its affirmation of the fetishism within commodity art.[81] Despite these critiques Bourriaud's ideas continue to hold sway within the art world and beyond, not least for their cogent articulation of art's transformatory possibilities, but perhaps also because a coherent and possible alterative has yet to be proposed.

Theorising Site?

Given these new relations of art to site and their particular potential, the challenge still remains to build a critical vocabulary for engaging with these relations. As the previous sections have developed, to think about site-specific work is, in many current forms, a long way from conceptualising a static, unchanging site with which art engages. Indeed, one of the recent drives behind a whole series of art-site engagements has been precisely to unravel ideas of location as understood as fixed and originary, and to assert instead the mobilities of practice, and the transformative effect of art and site.[82] But yet, the discussion of these relations, and their characterisation remains far from resolved. Such that we see, for example, art world discourse—in a mirror of geography's own frustrations—is a going up and down and back and forth with the global and the local.[83] Ahead of the empirical chapters, I want to indicate a selection of shared issues that preoccupy geographers as well as art theorists and practitioners.

Perhaps one of the key questions art-site relations have faced has been how to conceive of the duration and nature of art-site encounters, and the debate has been marked by the drawing of a not unproblematic equation between the duration of the encounter and the "type" of engagement with site. "Starting from site," or what is often described as a "viral" encounter with place, has become a privileged way of practicing art-site relations. These long durée relations are set, problematically, in contrast to those practices Miwon Kwon dubbed "one-place-after-another."[84] Here Kwon is detouring the words of minimalist artist Donald Judd to denote a serial attitude of the artist to location, wherein a set of practices are thrown over existing physical locations, ignoring the particularities, especially the social particularities, of the site. What emerges across a wide ranging set of studies is an ongoing set of tensions around how and in what form to valorize the localisation and specificity of a piece of artwork.

The move to "situation," whilst it attempts to make space for immanent encounters, has tended to valorise artistic "immersion" and durational engagement. The privileging of such engagements can be understood within the trend Foster described for the artist to act as ethnographer,

and to establish what is, under the classical rubrics of ethnography, perceived to be an appropriate relationship with the "other."[85] For Kwon, such forms of art-site relations are driven by a shift in established values of art—uniqueness, authenticity, originality—from being descriptors of an object, to determining an "ideal" relationship between art and site.[86] As a result places are cast as the locus of authentic experience and as vessels of historical and personal identity. What is prized is the singularity and authenticity that the presence of the artist confers, this not only reinforces the unrepeatability of the work but also indicates how the artist "being-there" is understood to endow the place with unique distinction. A number of researchers have worked to problematise this particular conception of art-place relations. For Lippard, for example, Massey's work on a global sense of place has been deployed to critique the "Lure of the Local," and build a way of engaging with globalised, cosmopolitan, "local" places.[87] Elsewhere, ideas of immersion have been critiqued for the sense they produce that the longer an artist stays the better they will know a site, as if eventually they can "know it all."[88] A further tension within this valorisation of specificity and localisation comes from the operations of the art market, wherein these characteristics can result in work being unproductively situated as parochial, with limited audiences and markets, and hence diminished influence and import.

Meanwhile, in contrast with these valorisations of "location," those artworks that evolve through more transient engagements with place are often conceived of negatively, as symptomatic of the demands of a globalized art network, and its cycle of biennials and art expositions, that demand singular on-site projects in a succession of cities.[89] In place of celebrating the possibilities for exploring questions of impermanence, transience and mobility, these works are often critiqued for their inability (constrained principally by time) to enter fully into the complexities of a given situation.[90] They are understood instead to rely on a generic set of creative solutions and *a priori* assumptions that are imposed indiscriminately onto each site of practice—one-place-after-another. Decried as teleological actions, the assertion of the creative autonomy of the artist has been seen to produce a flattening out of conceptual and affective topography, the site becoming passive rather than "reciprocally productive." At the root of these issues sits a perhaps rather unfounded equation that is being drawn between the temporal duration of engagement and the nature of art-site relations. This is an equation that somehow always seems to suggest that a longer duration enables, and indeed is required for a responsive, contingent relationship to site. But yet, duration has at times led equally to artistic imposition, to assumptions and knowledge claims, and short-term engagements in no way preclude responsive, contingent relationships to site, they just shape, and most likely restrict, the elements of location that can be engaged with.

In addition to the need to break down this over-simplistic equation, there is also a need to engage with the association of set of characterisations with site, the locale and place in relation to a global imaginary. The power of transcendental global logics often passes without critical commentary within both art *worlds* and art*works*. Visual culture theorist Irit Rogoff articulates a key question when she muses, "how to think about place, and site-specific works engagement with it, in a world in which the forces of globalization seem to deny the possibility of a fixed locale."[91] For other artists, the question is an avowedly political one as they wrestle with what they perceive to be the ineffectual nature of their work on issues with a global reach and impact.

As the art world continues to go up and down and back and forth with the global and the local, we find the beginnings of a move toward geographical scholarship as a means to think through these questions. Thus, Massey, Harvey and others are being drawn on to think through art's relationship to flows of people and circuits of capital, to explore the importance of place-based identities, and to examine how globalization is understood to undermine uniqueness and difference, and to conceptualise the implications of the global and the local.[92] Whilst cursory engagements with Massey's power-geometries and Smith's scale jumping offer some means to implicate the local and intimate in the workings of the global, art remains dogged by a sense of site as a static and critically pre-emptive object of inquiry, often casting art as revelatory with respect to hidden mechanisms or assumptions about those sites.

Recent attention to human geographies without scale enables these questions to be developed further. Here, emancipatory force is found in flat, or site, ontologies that seek to understand localised situated practice in and of itself rather than set within a vertically organised scalar imaginary.[93] Attending to site ontologies means working and thinking in the midst of situated sayings and doings, material comings together and disaggregations.[94] As such, it provides a powerful methodological impetus for thinking about art-site relations. Furthermore, such an approach enables new purchase on questions of art-site relations, principally by asking us to think through art as site, and in doing so provides a powerful means through which we can consider the transformative force of artworks and their political potential.

THE CHAPTERS: RELATIONS BETWEEN SITES
OF PRODUCTION AND PRODUCING SITES

So pervasive are questions of the relationship between art and the sites of its production and consumption, that, as the introduction made clear and indeed as chapters in both Parts I and III demonstrate, the relationship between artworks and the sites and spaces of their production and

consumption runs throughout the analysis of artworks. We see this in the institutional critiques developed in Chapter One, in the artwork-viewer-space relationships explored in Chapter Six, as well as the relationship between the primary sites of performance and the secondary sequences of photographs examined in Chapter Seven. The three chapters—Chapters Three, Four, and Five—that constitute this section, however develop close readings of the relationships between art and site, and the work art does at site: in other words of the relations between sites of artistic production and the artistic production of sites. What I am interested to explore in each case is how the artist works practically and theoretically at their site, how they build relations with the location, and frame it within their work. Further, I want to explore how, as a result of, and through these art-site relations, the piece goes to "work" at that location. Furthermore, in each case, it becomes clear that to understand these art-site relationships we need to consider not just the specific localised "situation" of the work, but also the multiple sites of its production and consumption.

Chapter Three begins by establishing the importance of attending to such multiple geographies of art, in this case in the consideration of the installation-performance work *Break Down* (2001) by Michael Landy. With an installation/performance situated in a recently abandoned department store, Landy's piece builds a critique of consumption that is based on implicating/creating at that location a number of other sites normally kept far distant from the shop, namely the factory and the waste tip. Departing from the analytic focus on the installation that normally frames Landy's work, this chapter presents an analysis that enrols studies of the two artist's books, as further "sites" of *Break Down*, in order to understand the particular take on the dramas of capitalism that the work offers us.

Chapter Four explores the urban imaginary of photographer-sculptor Richard Wentworth. Wentworth photographs the everyday creative practices of ordinary people on streets around the world. To understand the "portrait of place" the artist builds, the discussion in this chapter brings together an analysis of image content with an ethnographic exploration of Wentworth's production practices and an exploration of the "frames" within which the work is displayed.

This part of the text concludes with Chapter Five, in which I focus on the art project *Caravanserai (2008–)*. Of the artworks engaged across these chapters, this one is most akin to the sorts of relational arts practices that have become the by-word for site-engaged arts practices today. But yet, in place of what is often a resolutely urban focus of these practices the work understudy here is based in a rural community in South West England. Taking up the challenge of developing a set of methods and a vocabulary that is up to the task of studying these art-site relations, the chapter explores the collaborative production of the artists' book

insites. Situating the development of the book as part of the research process, as offering a lens into the project and its relations with site, the chapter queries the idea of "residency," and addresses the practices and distributed creativities of this project to explore the transformations it brings about at its site.

3 Producing Sites
Michael Landy's *Break Down*

Walking down Oxford Street, London, in early February 2001, it would have looked like business as usual at number 499: the lights were on, activity was visible inside, and people were coming in and out. But the ubiquitous plate glass windows did not present the passerby with the material moments of an ideal life found in other Oxford Street windows. Instead, framed by Europe's busiest high street, was a conveyor belt on which the artist Michael Landy was destroying all 7,227 of his possessions as part of his artwork *Break Down*.[1]

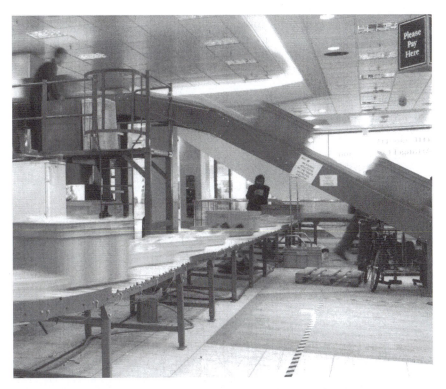

Figure 3.1 Installation view of *Break Down*, Michael Landy, 2001 (image courtesy of the artist and The Thomas Dane Gallery).

On entering the store, the profusion of objects that greeted the viewer formed an unsettling vision of excess rather than the seductive delights of commodity dreams awaiting purchase. For, as well as his choice of site, Landy had retained the trappings of the consumer environment: the escalators, mirrors, and "please pay here" signs. He had, however, ensured that the consumption experience these visitors were participating in was predominantly an immaterial one—consuming an art experience rather than material objects. Landy was most insistent that nothing, "not even a catalogue," could be purchased at the site.[2]

During the two weeks of the installation, visitors to the exhibition space, as well as shoppers as "unwitting viewers" on Oxford Street, could read a huge floor to ceiling list, an audit taken by Landy of all his objects, and then watch the circulation and dismantling of all of these possessions. Electrical equipment, books, furniture, all 398 items of Landy's clothing, his Saab car, his father's sheepskin coat, and 397 artworks by him and his friends (including pieces by Gillian Wearing, Damien Hirst, Gary Hume, and Tracey Emin) were loaded into yellow trays and circulated around the conveyor belt's 160-meter-long figure-of-eight layout. Over time, each object was removed, weighed, recorded, and meticulously disassembled by a team of twelve "operatives" who worked the conveyor belt. Overlooked by Landy, this team of labourers followed a scripted process to breakdown all the objects to "as close to their raw materials as possible."[3] The spectacle continued as the remains were sorted by material type and put through the "Granulator," creating 5.75 tonnes of material that Landy later buried at a landfill site in Essex.[4]

INTRODUCTION: ENGAGING MULTIPLE SITES

We begin with the commodity, in fact with what appears as an "immense accumulation of commodities" in a department store on Oxford Street, the UK's "mecca of consumption."[5] Landy's act of disposal, carried out on what he nicknamed a "production line of destruction," was productive of a number of things: the ephemeral installation/performance work described above, 5.7 tonnes of material remains, two artist's texts, artistic reputation and cultural capital, and a space, literally and metaphorically, for critical engagement.[6] Perhaps unsurprisingly, the analytic thrust of commentaries and discussions of *Break Down* has focused on the work as a critique of consumption and in Landy's words an "examination of consumerism." Indeed, the popular press had a field day during the installation, with such headlines as "Mad Man at C&A" firmly locating Landy's work as a polemic on overconsumption.[7] But yet for Landy, *Break Down* was about taking consumption seriously, about asking open questions about the ideology of consumerism, about as the artists asks "how much of myself is in the objects I own?"[8] For Marxist art critic Julian Stallabrass, *Break Down* was

an "exemplary act of Marxism."[9] What follows will explore how the geographies of Landy's work, namely the sites of its production and consumption (principally the installation and two artist's books), together with the sites it produces (a shop, a factory, a waste-disposal facility), sit central to understanding the particular spin on the familiar story of the exploitative dramas of capitalist production that *Break Down* offers us.[10]

An Exemplary Act of Marxism?

For Karl Marx, the common property of commodities is their being products of labour. But the commodity form betrays no evidence of its worked nature, further, commodities are abstracted from both the material elements that make up their production and from their use value. Marx gives us an example; we see in a commodity, he says,

> no longer a table, a house, yarn or any useful thing. Its existence as a material thing is put out of sight. Neither can it any longer be regarded as the product of the labour of the joiner, the mason, the spinner, or of any other . . . kind of production labour . . . Commodities . . . manifest themselves as commodities, or have the form of commodities, only in so far as they have two forms, a physical or natural form and a value form. The value of commodities is the very opposite of the course materiality of their substance, not an atom of matter enters into its composition.[11]

In this passage we see Marx outlining three elements that get absented from the view of the fetishised commodity under capitalism: it is not a useful thing, it is not a material thing, nor is it a thing that can any longer be understand as a product of human labour. The fetishised commodity of capitalism is, for Marx, a phantom, a cold abstraction. A coat considered as a commodity, to take a famous example from early in *Capital*, is not something that can be worn, it will not keep you warm, it is not something passed down from one generation to another, heavy with personal reminiscences.[12] The commodity is, in short, not a thing but an exchange value, achieving its purest form when emptied out of its particularity and thingliness. Fetishised commodities, like those seen in the shops on Oxford Street surrounding *Break Down*, are less material particularities than supra-sensible values. The work of Marx's *Capital* is to trace these immaterial values back through all their detours, to return us to not only the labour power that made the commodity, but also to the materiality and thingliness of those commodities, to, in short, give the coat back to its owner.[13]

This analysis, will suggest that the workings of *Break Down* resonate with the particular story of the commodity that Marx tells, primarily through its making present of those three elements—use value, labour processes, and material substance—that he found to be absented in the fetishised commodity form. Crucially though, I want to suggest that to arrive at

such an understanding of *Break Down* we need to attend closely to all three of the sites of *Break Down* that Landy produced: not only the installation, but also the two artist's books. For, it is only by attending to all three of these sites that we can reclaim the different facets of the commodity's story, facets that are told by way of the different spaces that are produced at each of these three sites. Furthermore, as an exemplary act of Marxism, it could be suggested that the work should embrace the Marxist maxim, "not just to reflect on the world but to transform it." Thus, integral to studies of the three sites of *Break Down* will be an exploration of the transformations they effect on those enrolled within their production and those who consume them.

The Sites

The fourteen-day installation on Oxford Street has tended to form both the start and end point of most analyses of *Break Down*. Without wishing to downplay the installation, this analysis will emphasize the importance of understanding it through the lens offered by two other sites: the two artist's books that Landy produced, firstly, *Michael Landy: Break Down*, a collection of texts and photographs of the work and its development, and secondly *Break Down Inventory* (hereafter *Inventory*) a copy of the audit that Landy undertook of all the objects before he destroyed them (Figure 3.2).[14] Most interpretations of Landy's work have focused on the fourteen-day performance, and in the process have written these two volumes out of the interpretation of the piece.[15] The installation is, however, only one element of *Break Down*, the two-week performance is a culmination of over three years of concentrated research, during which Landy not only planned and developed the installation, but also laid the foundations for these two books.

Landy's two volumes play a number of different roles in this analysis: they are at once a useful record of research process, and a key document of the installation and Landy's performance, but, they are a lot more than a residual record of the work. In place of understanding these texts as secondary to a primary installation event this analysis explores the two volumes and their content as a key site for the consumption and analysis of *Break Down*. Harvie's evocative account of the installation's "disruption of capitalism" demonstrates how "witnessing" Landy's performance formed his audience as thinking, self-aware consumers.[16] And, indeed, the potential of the installation to enroll and transform the subjectivities of those who experience it is crucial here, whether those involved are the audience, or Landy and his workers/volunteers. In this analysis however, these two texts are equally important sites of the consumption for the piece, as well as sites where the "work" that *Break Down* does can come into view.

To query the "sites" of *Break Down* involves an appreciation not only of the site-specific nature of the installation situated in a "mecca" of

consumption, but also of the materialities and the practices through which the installation was fabricated, and which it enacts, and how these fold within them a whole suite of other spaces.[17] What results are a series of spaces—including the factory—that, while essential to the smooth functioning of capitalism, are normally kept discreet and distant from the spaces of consumption. In a strategy more commonly found within research on commodity-chain geographies, and the practices of anti-consumerist campaigners, we find that production processes and relations are firmly implicated within the once autonomous spaces of commodity consumption.[18] In short, into the ex-department store Landy installs the factory, the waste-tip and the waste-reclamation site, evoking these "other" spaces by means of the furniture, layout, processes, and social codings of the spaces that he develops.

Analyzing the two artist's books, it becomes possible to consider in more detail how the installation employs technologies and techniques to organize, assemble and transform the heterogeneous hands, bodies, and minds of audience, artist, and artist's volunteers alike. For, if commodities have long been understood to play a role in the shaping of identity and subject-hood, then an allied body of literature focuses less on finished commodities, than on the co-implication of capitalist modes of production and modes of subjectivity and existence.[19] Thus, to enrich this exploration of *Break Down's* presencing of the three veiled aspects of the commodity, this analysis draws on Marx, Foucault, and those who read and write in their tradition, to examine how the geographies of *Break Down* contribute to the force of the work in transforming subjectivities and experiences.[20]

To detail these two artist's books a little further: *Inventory* (Figure 3.2), printed in a limited edition of 2,000 by art book press Ridinghouse (co-owned by Landy's dealer), reproduces an "audit" of all 7,227 of Landy's objects.[21] The original audit took the artist and his assistant Clive Lissmann just over a year to create. Divided by object "use" groups, and keeping a running total, the tabulated document is printed landscape, and categorizes, numbers and describes all of Landy's possessions. Each entry includes the very briefest but often most evocative of descriptions: "Object C713 my Dad's sheepskin coat."[22] As well as being published as a book after the event, Landy's object inventory also appeared in several other formats within *Break Down*: *Inventory* in the installation itself and in the other text *Michael Landy: Break Down*. The objects listed were the same on all three occasions, but each reproduction differs in important ways in terms of the format, the numbering systems used, and in the descriptive detail given.

In its visual and textual aesthetic, *Michael Landy: Break Down*, the second of the artist's two books, reflects the nature of the installation: practical, industrial, and above all, very thorough.[23] The format of the volume is a workman-like A5 ring-bound folder rather than a book. The binder is created from a textured hard-wearing plastic, the colour scheme reflecting that of the conveyor belt system. Inside, the sections are sorted and organised

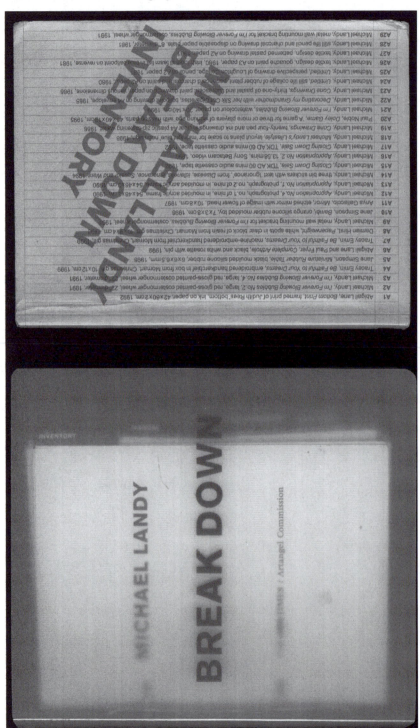

Figure 3.2 *Inventory*, Michael Landy, 2001 (image courtesy of the artist and The Thomas Dane Gallery, photography: Jenny Kynston).

by yellow file dividers, including one entitled *Manual*, which details how Landy wanted the installation to proceed, and another entitled *Case Study*, which features an in-depth description of how the artist took apart a radio. The volume also includes large fold-out plans and images of the installation. Toward the end of this inter-textual collection of sketches, words, and photographs, is a section entitled *Selected Possessions*, which includes pages of annotated hand-drawn sketches of objects that were destroyed, including an sketch of a sheepskin coat.

The analysis that follows draws together these three "sites" of *Break Down* to study the heterogeneous spaces the piece folds together; the shop floor, the factory, and the waste reclamation facility. The discussion is structured by an engagement with each of these spaces in turn exploring how they have been created and the elements of the commodity/object that they present. Above and beyond the analysis of the particularities of Landy's installation, this analysis reinforces the need to remain sensitive to the often multiple sites of contemporary artworks and the important role they play in enabling us to comprehend the critical spatialities and transformative potentials of art. This is to emphasize in short, the need to appreciate the relationships between the sites of the work's production and consumption and those that it produces.

THE SHOP FLOOR

> I was aiming for a big plate-glass window so the process of the sorting, dis-assembling and destruction of the objects will be very public. I want the venue to be as central as possible in a shopping street, close to the big chain stores so that anyone can drop in . . . I like the idea that they will see objects they recognize, maybe something they've just bought, something they have in their carrier bags. [24]

Break Down's installation was multiply framed, it was situated within a temporarily abandoned department store, a building that occupies one of London's prime retail locations, and is located amidst Oxford Street's "cathedrals of consumption," with Selfridges, the archetypal department store just opposite.[25] The large plate glass windows of the abandoned store, so ubiquitous a feature of contemporary consumption spaces, served less to frame commodity dreams than to frame the installation for the outside world. For those within the installation space looking out, the windows framed the territories of abundance beyond, developing circulation and exchange between the two.

Break Down was initially conceived without a specific site in mind, but as the quotation that begins this section suggests, Landy was clear at what sort of site he wished the work to proceed. The project had been under development for a number of years, but it was only on winning the Times/

Art Angel Open Grant that Landy was able to begin to realize the piece on the scale and at the location he wished. Employing a location finding company, Art Angel (the commissioning agency) were able to secure for Landy's use the recently vacated C&A Department Store at the Marble Arch end of Oxford Street, London. [26]

The location was a particularly charged atmosphere within which to install an artwork that took as its focus the practices and objects of consumption and consumerism. Until only a few weeks before the performance, the location had been the flagship store of the Dutch clothing company C&A, from which they had been trading for seventy years. Gradually being squeezed out of the competitive middle-market category in the UK, the company was in the process of closing its 117 British stores. For the month before Landy's installation, the shop had held a huge closing-down sale as the firm sold off stock at the site and elsewhere, the neon signs and banners in the windows reading "everything must go," echoing a previous installation Landy had developed, *Closing Down Sale* (1992).

Layered with the particularities of this location and its temporarily abandoned status, were the generic associations of the department store as a site that makes objects and consuming human subjects available to us in particular ways. Cultural histories of the department store story these spaces as palaces, as havens, as sites that cultivate the fetish of the commodities, and importantly as locations for the shaping of ideal (and less than ideal) consuming subjects. [27] Especially at the turn of the twentieth century, the department store has been understood as the focus of institutionalised consumption, and key in the shaping of consumer culture. [28] Indeed, the department store became a central site in the modern shaping of subjectivities, configuring relations between consumers and objects by way of processes such as browsing, touching, and trying on. [29]

Key within the mechanics of the department store, indeed situating it as part of the exhibitionary complex identified in Chapter One, have been its logics of vision. [30] This concerned not only the internal layouts of the shop, but also the evolution of plate glass window displays, which gave rise to "window shopping," combining the sorts of spectacle previously associated with the 1851 Great Exhibition with the large-scale sale of goods. And, like the Exhibition before them, the department store becomes a site to see, and to be seen—a site, in short, where people learnt to be consuming subjects.

Throughout *Break Down* Landy takes consumption seriously as a transformative social and cultural force. Nowhere is this more clear than in the attention he gives to key texts on consumption during the research process, and how he documents this across the three sites. Texts listed in the *Inventory* included a copy of Marx's *Capital* as well as more contemporary texts such as *Acknowledging Consumption* edited by Danny Miller (1995) and *Consumer Culture and Post Modernism* by Mike Featherstone (1990). [31] Object number R5457 in the inventory is "Consumerism as A Way of Life,

Steven Miles, paperback with underlined text, Sage Publications Ltd ISBN: 080397745X."[32] This text had a prominent place not only in the installation, but also in the two accompanying collages *The Consuming Paradox* and *Break Down Memorabilia*, both of which were reproduced in *Michael Landy: Break Down*. The destroyed copy of Miles' text was the third copy of this text Landy had owned, the author gave him another dedicated copy after the installation, inscribed "To Michael: Commodity? Jesus? . . . or artist? 'Just do it.' Steve Miles." This fourth copy, and its dedication, was pictured in the hand drawn montage of *Break Down* memorabilia Landy created after the installation. The influence of this and other texts is clear within not only the workings of the installation, but also in the ways Landy talks about consumption and consumerism. In the pages included in the research portion of *Michael Landy: Break Down,* for example, selected quotations emphasize consumerism as penetrating all walks of life, situating Landy's work as making the ultimate consumer choice, but recognising that that choice was built into consumerism, and that it was impossible for Landy to stand beyond consumerism.[33]

As a result of Landy's choice of location, a large proportion of the 45,000 visitors to *Break Down,* especially initially, were shoppers: passersby who had come in unawares or had seen the installation from the outside. This was not necessarily a normal art-going audience who would have visited Landy's other works at his dealers or at Tate Modern. Whilst some of his audience left in disgust, many stayed, adding the consumption of art to their other acts of consumption that day. Important though for thinking through the workings of *Break Down* is to consider not just the location, but also how it was Landy manipulated the physical attributes of the site, and the characteristics of the interior of the store. At one and the same time, he made use of the associated codifications and technologies of the department store to shape his audience-consumers' experience and subjectivities, as well as exposing and critiquing these processes by means of installing very different machines and furniture onto the shop floor.

The Consumption Experience: Critiquing the Consuming Subject

> Objects are never offered for consumption in absolute disorder. They may, in certain cases imitate disorder the better to seduce, but they are always arranged to mark out directive paths, to orientate the purchasing impulse towards networks of objects, . . . he (the consumer) will move logically from one object to another. He will be caught up in a calculus of objects, and this is something quite different from the frenzy of buying and acquisitiveness to which the simple profusion of commodities gives rise. (Baudrillard, 1991)[34]

This quote from Baudrillard's *The Consumer Society* hints at the logics of order and visibility that have long been understood to sit at the heart of

the design of shopping centres and department stores. Landy owned this book, and maybe took to heart this description of the role of space and the spatial organisation of commodities within the consumer environment, for his installation certainly reflects many of these logics. Landy retained much of the consumption furniture associated with the shop. In the building's atrium, the floor plan and store directory were replaced by a large-scale version of *Inventory*, only here the comprehensive audit was converted into a taxonomy of goods divided into types. The formerly unobtrusive walkways, once gently guiding shoppers through the store, were covered over by the bulk of the conveyor belt system sitting in the middle of the space. The viewers' movements were stridently directed by explicit barriers and signs, as well as the spatial controls developed by the black and yellow tape. The ceaseless motion of the conveyor belt simultaneously mocked the now still state of the escalator, and mimicked the once continuous circulation of people and goods within and beyond the shop. Landy also retained the mirrors attached to the shop's vertical columns, only rather than revealing the transformative potential of the latest purchase, these mirrors reflected, over and over again down the line of the shop, the dismantling of objects once purchased as hopefully as those the audience had in their carrier bags.

Just as the department store became an iconic site in the visual regimes of modernity, both a site to see and in which to be seen, so Landy's hand-drawn plan for *Break Down* reinforces the importance to the artist of a similar set of visual logics. We see him designing layouts, shaping space to achieve the maximum circulation and visibility of people and objects throughout the installation. The double figure-of-eight form of the conveyor belt was 160m long, and the loops ensured that the spectators could survey the whole event and freely circulate amongst the commodities. The plan notes that Landy wanted the conveyor belt at waist height "so it is easy to view matter," apart from on the sorting platform, which had to have "enough room for workers and spectators."[35] Note how the descriptors are developing the workings of the installation and its spectatorial regimes. Landy was also very specific about the need for three groups of objects to be visible on the conveyor belts: i) the whole and identifiable objects, such as the magazines and toys in their coded plastic bags (Figure 3.3), ii) partially broken down objects, whose original form is made clear by the presence of identifiable parts such as the sole of a shoe or a football team badge, and iii) the trays full of shredded and granulated materials.

In his hijacking of department stores' rhetorics of order, visibility, and circulation, Landy creates a consumption experience that renders present in the space the normative behaviours associated with that space. In short, the experience of the work forms several different types of consumer. There were, for example, the confused consumers, for so effective was Landy at

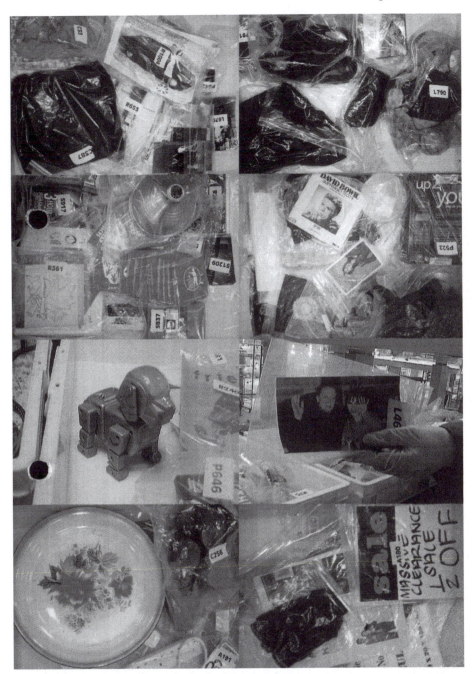

Figure 3.3 Break Down (detail a), Michael Landy, 2001 (image courtesy of the artist and Thomas Dane Gallery).

mimicking the consumption environment that many did not register that the mode of consumption had shifted. Landy was most insistent that "the only thing you can take away from this is your experience of it, it does not get commodified, it is not for sale."[36] This experiential mode of consumption was not registered by many visitors who remained unaware of the shift in the use of the shop. Landy recalled in a number of interviews how "little old ladies would bring back clothes that they had bought from the C&A closing down sale. We would have to explain to them that they would not be able to get their money back or exchange for other items."[37] Other audience members ignored or challenged the installation's resistance of commodification, with one man storming out after being told nothing was for sale, not even a catalogue.[38]

If, on the one hand, Landy frustrated the normative, ideal consumer-subject created by the department store, on the other he also evoked a suite of alternative consuming subjects. These included the shoplifter—around 50 objects were stolen from the installation—long considered to be a function of the logics of visibility associated with the department store.[39] Another group of consumers developed behaviours more often associated with pre- or extra-capitalist environments, such as bartering and trading, as they attempted to get Landy to let them swop objects on their conveyor belt for their own possessions. Above all however, it would seem that on exiting the installation-store the audience were, if nothing else, more critical consumer-subjects, more aware of the heterogonous meanings and particularities of their objects than they had been going in.[40]

The Mystery of the Equivalence of Radically Different Things

Greeting the audience as they entered through the glass doors that still bore the C&A logo was a copy of Landy's inventory of all his possessions. Printed on large sheets of paper and installed on floor to ceiling panels, the list of everything being destroyed appeared as a macabre and detailed detournement of the store guides that normally offer an overview of the contents of a store and its cartography. In making the inventory Landy had assigned each object an alphanumeric code. Within this code the letters corresponded to objects use "A Artworks, C clothing, E electrical F furniture, K kitchen, L leisure, P perishables, R reading, S studio and V vehicle," the numerals to the unique number each object was assigned within its use-group, thus creating a running total of objects. In this installation version of the inventory, each group of objects was numbered separately and the descriptive element accompanying each object was reduced to include only a few details, often describing brands, for example, object "C318 Baileys of Glastonbury Genuine Sheepskin brown Coat 40" chest."

Such a listing and tabling of objects reduced the heterogeneous particularity and materiality of Landy's objects, presenting what has been

described in another context as the "equivalence of radically different things."[41] The tabulation of this "list of war dead," as it was described, strips the objects of all commentary, offering only an itemized list.[42] One thing beside the other in the list, a taxonomy of sorts is created, the objects, grouped according to their use-value, are bearers here of nothing but their individual names:[43] it is not the "the thing itself that appears, in its own character, but within the reality that has been patterned at the outset by the name."[44] Such a "pure tabulation of things" has been understood in other circumstances as the means by which "confused, useless or dangerous multitudes" are transformed into "ordered multiplicities."[45] The list could be seen as a means to continue the logics of visibility and order the installation was so insistent upon: a deliberate strategy to make the objects "as accessible as possible . . . so people knew what they were seeing."[46] As a technique of power and a procedure of knowledge, the table is an instrument to organize, and hence to master, the immensity of the multiple. Here the possessions and their increasingly disorderly forms are subject to a categorisation that reduces the individual singularities of Landy's objects to the importance of the constituting class.

For Marx, capitalism's leveling actions were based in the capacity of the fetish to render equivalent all manner of different materials, meanings, and uses of objects.[47] In Landy's case, the subdivided list rendered equivalences by means of ignoring use value, ignoring sentimental value, ignoring all material and social particularities, and, even ignoring exchange values.

Such listing is one of a number of devices throughout *Break Down* that carry out a leveling of things: this is reaffirmed in the actions of the performance, the act of disposal in which Landy asserts the importance of treating everything "the same."[48] Landy had initially thought he would destroy only consumer objects, but as he stated "in the end found it very hard to draw the line between those items and my other possessions so I decided to destroy everything."[49] As insistent as Landy was that nothing was for sale, he was equally insistent that he had to destroy everything that he owned, all his possessions, no exceptions could be made for artworks by his artist friends, valued gifts or treasured objects like his grandmother's mincing machine, it all had to be destroyed. "I'm ruthless," he said, "I had to be ruthless. In the end I had to adhere to the idea, the structure, I would have had a terrible sense of regret if I had not destroyed everything."[50]

But yet, even at the point of this radical leveling, Landy undoes the moment of loss and of equivalence. By the very operation of treating everything the same, differences are revealed, differences that are made clear within his artist's books as well as in our own reactions to his actions. For, within the artists text and his many press interviews we find Landy differentiating between objects. To explore these differences, I want to turn first to the section of the text *Michael Landy:Break Down* marked *Selected Possessions,* following this I will turn back to the installation and its relationship to the two texts.

Michael Landy:Break Down—Selected Possessions

The temptation when looking at the two artist's books is to read them straightforwardly as documents of the installation, and its processes. And, while this would not be a mis-reading, it would be one that limited the potential importance of these volumes. For, in addition to offering accounts of the installation and its development, what we find within these two volumes are sets of ideas that are key to the exemplary act of Marxism that Stallabrass understands Landy's work to offer.

Object number C714, as Landy describes it "My Dad's Sheepskin Coat" (Figure 3.4), circulated the conveyor belt like all Landy's other objects, before it was removed, unpicked and finally shredded and buried amongst the other

My Dad's sheepskin Coat

Dad bought the sheepskin coat in the mid-seventies, It must have been just before his accident ('Dad had his accident at the age of twenty-seven the same age as I am now) My Mum payed off the coat in mounthly instalments, It took her a whole year. The Coat was to heavy, and uncomfortable for dad. to wear anymore, I would occasionally trie the sheepskin coat on for size, but, I was very skinny, so the coat made me look, like I had match-stick legs. Once I left home at eighteen, I forgot all about the coat. Then about three years ago, on one of my visits, to see my parents, I discovered the coat again, tried it on, once again, and it fitted!.

Figure 3.4 *Break Down* (detail b), Michael Landy, 2001 (image courtesy of the artist and Thomas Dane Gallery).

commodity-detritus in the landfill site. But, the coat was not like all the other commodities, it came to have a mythical presence during the installation, iconically it was "the last thing to go" during the installation performance, and Landy joked that he would "kill the operative who destroyed it."[51] We find the story of the coat fleshed out in interviews, but also in a hand-drawn sketch and description that takes up a whole page of *Break Down*. The story of the coat with which Landy annotated the sketch, reads thus:

> Dad bought the sheepskin coat in the mid-seventies, it must have been just before his 'accident' (Dad had his accident at the age of thirty-seven, the same age I am now) My mum paid off the coat in monthly installments, it took her a whole year. The coat was to [sic] heavy, and uncomfortable for dad to wear any more.[52]

Across the relay of spaces of the production and consumption of *Break Down*, from the sites of the artist's books, to the artist interviews and accounts that feature in other documents, the biography of this coat is a story told and retold, morphing slightly with each visual and textual telling. The exact detailing of this story, is, in this interpretation at least, less important than the very fact that, by their telling, these tales install a sense of "this" coat. This is less about the biography of the coat as an object *per se*, than about the coat as *Landy's* object. For, the source of the coat's value for Landy, as the description suggests, lies in the strong associations it has with his father. During an interview prior to *Break Down* Landy suggested "destroying that [the coat] will feel like disposing of my dad."[53] His interviews continually highlight the importance of this coat not only in the immediate aftermath of the installation when he suggests "I wanted someone to take it away but they didn't" but also longer term.[54] In another example, in an interview about a subsequent piece of work, Landy recalls,

> eight months later [after the installation] I was out with Gillian in Tescos in Bethnal Green and I saw exactly the same sheepskin coat being worn by a man, maybe one size smaller than my Dad's. I wondered if she did steal it in the end and it was having a second life.[55]

That clothing can constitute a record of lives lived—through places, moments, and events—is, as a range of sociological and ethnographic studies attest, well acknowledged.[56] Drawn into Landy's image of cloth are multiple registers of biographical detail; the family history of an accident and the financial hardship caused, an imagined childhood, a life's passage through a series of spaces, as well as the broader social contexts, of, for example, the plight of the miners and their treatment by the Conservative Government.

This sheepskin coat, is therefore, a very different coat to the one the Marx describes in the opening pages of *Capital*. Landy would not have had to read far within his copy (object R5271 "Capital, Karl Marx, paperback,

Oxford University Press ISBN: 0192838725") to have come across Marx's narrative of the coat, whether equivalent to 20 yards of linen, or "1 coat or 10 lbs of tea or 40 lbs of coffee, 1 quarter of corn, 2 oz of gold, ½ ton of iron = 20 yards of linen."[57] Within this list, Marx is describing not a coat that keeps you warm, or a coat you, Landy, or Landy's father would wear, and certainly not a coat you would value because someone else wore it. He is, instead, describing the commodity in its purest form, as an exchange value that, as Marx suggests reaches this pure form when it is emptied out of its particularity and thingliness. In the context of this list, Marx is interested to develop the exchange value of the coat, its equivalence in labour power. What this list denies is use value but also, as Stallybrasses narration of Marx's coat observes, that "history, memory and desire might be materialised in objects that are touched, loved and worn."[58] As a commodity the coat is given a transcendental value that erases both its making and the wearing.

This sense of things as personal possessions, with "sensuous varied objectivity," rather than as "homogenised objects," is reinforced by the *Selected Possessions* section of *Break Down*. These pages are full of hand-drawn, almost cartoonish sketches of objects, that like the coat, are drawn in black felt-tip, and many of them, like the coat, are annotated. To appreciate this constellation of objects involves orientating and re-orientating the folder in your hands, moving it forward and back to read the scrawled annotations written up-side down or off-centre. The impact of these pages comes as much from the form and technique by which Landy renders these possessions, as from the memories and stories of the commodities they narrate. The material processes of hand drawing—rather than say photographing, or even verbal description—proffers a means to indicate the personal value that this range of objects afforded Landy. Hand-drawing can be understood here as a fetish of process, and a form of artistic self-presencing, these same characteristics adding to the aura of authenticity conferred upon the memories and meanings of these objects.[59] Landy has taken the time not only to record these objects but also, in the case of the coat, to describe and to sketch them. The painstaking movements of hand and pencil capture and render durable the intimacy between artist and his objects.

Such hand-drawing also creates however, by means of common treatment, another rendering of the equivalence of radically different things. Personal mementoes such as a "love fax" sent between Landy and his girlfriend, Turner Prize-winning artist Gillian Wearing, are reproduced alongside images of furniture or cat toys, and souvenirs from holidays. Included amongst these quickly rendered sketches are simple, and often partial reproductions of valuable oil paintings and prints that Landy had owned. These are valued not because of their uniqueness as art objects, long challenged, as Walter Benjamin suggests, by the age of mechanical reproduction (especially interesting as these works are prints), but rather these artworks were valued for the personal links they string between

Landy and their named makers; his friends, colleagues, and lovers. The value of these objects entangles Landy's biography with larger systems of cultural or economic value. For example, artworks by Tracey Emin, Gary Hume, and Damien Hirst are valued as birthday presents or gifts rather than as works of art by renowned artists worth many thousands of pounds.

In their liveliness, these objects recall the eloquent objects of disposal tales, inheritance yarns and salvage geographies and their reciprocal, creative relations with people and places.[60] A good example from Landy's text is a Jim Reeves tape. The annotation beneath the simply sketched cassette reads, "the song old tige would make me cry as a child."[61] Landy fleshes out this memory in an interview when he recalls using the song as the "backing music to the funeral of a cat."[62] Elsewhere in the narratives of his objects, Landy recollects how "in happier times" the tape was put on when his father came home from the pub on a Sunday afternoon and they would all dance around the sitting room.[63] Such was the evocative power of this memory that when his father came to the installation Landy played the tape and as he recounts "it was like being in our front room again." [64]

The act of sketching these heterogeneous objects problematizes the boundaries—material, political, and aesthetic—between object type and value. As such, objects resist being sorted into pre-formed categories: the mass-produced, the handcrafted, the infinitely disposable or the precious, instead, they are rendered equivalent here through their meaningfulness and Landy's choice to immortalize them in his sketches. In the discussion that follows, focusing on *Break Down's* installation of a "factory," and an industrial atmosphere, I want to explore a rather different perspective on these objects, and the shaping of subjectivities that *Break Down*, and by extension the processes of Capital, carry out.

A FANTASY FACTORY

> At work bays 1 and 4, the possessions will be removed from the storage boxes and transferred onto large yellow trays. . . the yellow trays are to be kept on the conveyor circuit at all times. . . it takes approximately fourteen minutes for a single item to make a full circuit. . . Some large items may be placed directly onto the conveyor. However, this is only to be done with the approval of Michael Landy. . .The possession will be removed from its self-seal bag and carefully broken down into its material categories. Each possession will be dismantled in a manner suitable to its construction. For example, a radio will need to be unscrewed (Landy, *Michael Landy:Break Down*).[65]

Dominating the conveyor belt space, and clearly visible for the duration of the installation, was the increasingly dismembered hulk of Landy's red

Saab. The car, an icon of the Fordist production line, together with the surrounding conveyor belt reinforced those descriptions of the installation as a "fantasy factory," and the "industrial atmosphere" noted by one ex-production line worker.[66] This kaleidoscoping of production and consumption is a maneuver akin to the geographical imaginaries of the commodity chain and "follow the thing" literatures that look backwards from the point of consumption to offer a spatialised, and sometimes politicised, account of capitalism's uneven production of space.[67] Thus, in the combination of machines, bodies, and processes that the installation develops we find a presencing of the practices and spaces of production normally kept distant from those of consumption. Combining an analysis of the installation with an exploration of Landy's accounts of process enables an examination of how the workings of the installation reproduce, in some small way, and over a contracted temporal horizon, the transformation of subjects associated with capitalist mode of production. Thus, what we find in the installation is not only something that looks like a factory production line, but it is also a rendering of the spatialities, materialities, and force relations that have been understood to constitute the "quotidian standardization and coercion of a capitalist factory."[68]

Disciplining Bodies and Spaces

We can start from the plans of the conveyor belt that Landy included in *Michael Landy:Break Down*. These depict schematic diagrams showing an aerial view of the belt's double figure-of-eight, making clear the distribution of space that Landy was looking to create. Four work bays are designated alongside a sorting platform, and in a table in the text, Landy details the "Work Bays and Sorting Platform functions;" work bay two was reserved for the "shredding and granulating; and here the granulator was placed," whilst work bay three was designated "motor vehicle dismantling."[69] Instructions in the *Manual* section of the volume detail that work bay four was to be used for the "dismantling of electrical items and reading materials," whilst work bay one was "for dismantling all possession other than those listed below."[70] The fifth area outlined on the plan is the "sorting platform" which is, as the instructions describe, for "separating dismantled possessions by material."[71]

The plan of the conveyor belt suggests a particular sense of the enclosure of the activity within the space of the shop, an enclosure created by the machinery itself. But further, the space is also a partitioned space, with each of the divisions—in this case, the loops of the conveyor belt—forming functional sites to which are allotted particular uses. These enclosed, partitioned, and coded sites (to borrow from Foucault's discussion of the discipline found within the spaces of the factory, the monastery, the military camp, and the school) develop not only a spatial arrangement of production, but also the distribution of bodies and

activities.[72] For, in addition to this ordering of objects and processes, the plan details how this particular layout is also intended to "separate workers from spectators."[73]

Within the installation, each individual of the twelve-strong volunteer team had his or her own place, and each place its individual volunteer in a spatial organisation bent on producing the optimal configuration of bodies, processes, and machines in order to achieve the particular processes Landy desired. Discipline proceeds through the distribution of individuals in space, something we clearly see here, as Landy distributed his operatives around the installation according to their different functional jobs.[74] Included early in the *Manual* section was a set of guidance notes detailing the "General Staff and Organization Structure," laid out as a table, whose columns read "area" "position," and "function," the notes detail "operators," their "functions," and the spaces they are presumed to occupy.[75] For example, at work bay four, we find four "Operators:" the Senior Operator, the Data Input Operator, and two Dismantling operators, whose "functions" are respectively, "dismantling and monitoring schedule," "data-base maintaining" and "dismantling."[76]

This system of discipline is configured right down to the division of ranks, "operatives and overlookers."[77] The "Senior Operator(s)" are given tasks such as "monitoring schedule," whilst Landy's own role is detailed as one of "overseeing the whole project."[78] And indeed his allotted place is the sorting platform that, as his diagram notes, "overlooks the whole event." Walking along this platform, Landy, as overseer, could carry out supervision that, following Foucualt, was both general and individual, he could follow the production process, but also "observing the workers' presence and application, the quality of work, compare workers with one another; classify them according to speed and skill."[79] Further sections of the *Manual* indicate how key "procedure" is for Landy, as carefully scripted instructions recount how he wants the dismantling of possessions to be undertaken. The instructions conclude, for example, with a discussion of, "sorting the dismantled components on the sorting platform," the shredding and granulating of the possessions and the sorting of the shredded and granulated material.[80] As he writes;

> the trays containing the shredded and granulated material will be weighed on a platform scale inside the work bay. These data will be recorded and put on to a separate spread-sheet by a trained Operator. The trays continuing the weighed materials are to be returned to the conveyor. They can only be taken from the conveyor with the approval of Michael Landy.[81]

It was a carefully scripted and spatialised procedure, aimed at knowing, mastering, and assessing workers and objects.

Producing a Labour Force

The spatial organisation of the installation and its codes of practice, resonates with descriptions of how, in the modern factory, "a variety of technologies and techniques are employed to convert heterogeneous bodies, hands and minds assembled there into a calculable commodity called 'labour power.'"[82] Through the procedures Landy laid out, and the spatial distribution and operations of the machinery, Landy's workers are attached firmly to the production apparatus (which here constitutes machine-conveyor belt and process). The volunteeers move where the apparatus needs them to go, they are subject to its rhythms, in short, the installation machinery imposes on them the "sentence of reality" that it requires to constitute them as a labour force.[83]

Within the installation, Landy creates a complex space that is at once architectural, functional, and hierarchical. By spatial design and detailing of procedure, individuals are carved out, but also operational links are established, and as Foucault suggests,

> in factories that appeared at the end of 18th century the principle of individualising participation became more complicated. It was a question of distributing individuals in a space in which one might isolate them and map them; but also of articulating this instruction of a production machinery, that had its own requirements.[84]

Such disciplining, notes Foucualt, following the description of a division of labour of a factory, is an art of rank, a technique for the transformation of arrangements. It individualizes bodies by a location but does not give them a fixed position; instead, it distributes them and circulates them in a network of relations.[85]

Describing them by "function," naming them "operative," and dressing them identically in a uniform of blue boiler suits, Landy displays an apparent "indifference to the skill, background, gender and ages of the bodies at work," an indifference to biological capacities but also to training, dispositions, and characters.[86] As Read explains, the historical mutation of labour under capitalism is not only the displacement of the scheme of labour from the human body to the machine, but is also a transformation in the organisation of knowledge.[87] Knowledge is deterritorialised, and the labourer is but one organ of the collective labour force, performing any one of its subordinate functions: as Landy writes of the Operatives whose position is "dismantling operator," their role is to also "be flexible to assist in other areas."[88]

Exploring installation design and processes by way of the two artist's books, resonances are found between the mechanisms of the factory Landy created, and recent work on the micro-politics of capital, the production of affects and the transformation of subjectivities within factory environments.[89] This is to find, albeit across a shorted time frame, that the installation organizes spaces, and as such announces the kinds of bodies that were also seen to be the products of the factory system. These are bodies that over time would

become routinised to changing relations of exertion and stress relative to the increasingly rationalised and intense production speeds.

That we can find within *Break Down* an exploration of labouring sub-jects is not really surprisingly given the extent to which "work" is an ongo-ing preoccupation of Landy's. On the dole and deemed by the government "unproductive," in the 1990s Landy was forced into training schemes and interviews for jobs for which he was overqualified.[90] In response to this, and his father's situation after his accident, Landy created the installation *Scrap Heap Services* (1996), which involved the formation of a fictitious waste disposal company of the same name. The company's stated aim was to dis-pose of people no longer thought of as useful to society, and it featured the "catchy" slogan, "we leave the scum with no place to hide," mimicking the right-wing presses' attitude to people they viewed as "unproductive."[91] In this "scathing look at the idea of 'useful employment,'" Landy's principal task was to cut out and polish thousands of small metal figures from cans.[92] These figures eventually filled a room at Tate Modern, the gallery that now owns the installation.

Just as *Scrap Heap Services* saw Landy spending days in the repetitive man-ual labour of cutting out and polishing metal figures, so in *Break Down* we find Landy pondering once more on working processes. There is a much lon-ger analysis to be made of Landy's particular ideas of work, especially in the context of critiques of artistic labour that can and have been developed. Here though, the focus is *Break Down,* and the question of its production of hetero-geneous sites. In the short-term workings of the installation, we do not witness the industrial pathologies that have been formulated through the long duration of the dynamic politics of the conveyor belt/assembly line and its workings on labourer bodies.[93] Rather, *Break Down* operates at a different pitch, the sites it produces in turn producing the spatialised regimes and practices of control that direct us towards the insidious power of capitalist modes of production to produce modes of organizing space and shaping subjectivities.

As evocative though, as Landy's re-creation of a factory floor is within the West End of London, looking at the mechanisms and processes of *Break Down* as recounted in the artist's books, there is a further site that is evoked at the Oxford Street location. Examining the *Research* section of *Michael Landy: Break Down,* opens up a third site that Landy created at his Oxford Street location—in this case, less a factory, even one bent on dis-assembly, but rather a waste disposal facility, whose focus is on recycling and reclamation.

THE WASTE DISPOSAL FACILITY

> There is a physical relation between physical things, but with com-modities, the existence of things qua commodities and the value rela-tion between the products of labour that maps them as commodities, have absolutely no connexion with their physical properties and with the material relations arising therefore (Marx, 1867).[94]

If reading through the manual sections of *Michael Landy: Break Down*, together with exploring the installation apparatus, installs in that abandoned shop on Oxford Street the spaces of the factory, then analyzing the *Research* section of the same text suggests that the work produces a further set of spaces: those of the landfill and the waste disposal facility. The presence of these spaces within the installation is perhaps clearest in the huge sacks—5.4 tonnes worth—of carefully sorted material waste that Landy creates. This waste was buried in an unknown landfill site somewhere outside of London, rather than, as some viewers suggested, being bagged up and sold.[95] As with the discussion of the factory spaces, the focus here is on the details of his process that Landy provides us with. In this case, this enables us to explore the particular critique of commodities that is developed, here focusing on recovering the materialities of these objects.

The key to understanding the spaces of waste disposal within Landy's work lies in the *Research* section of *Michael Landy:Break Down*. In the collage *The Consuming Paradox*, for example, made from Landy's recycled research material, the artist included magazines such as *Recycling Weekly*, several guides to industrial facilities, and copies of *The Recycling Hand-Book*.[96] He also included various materials he collected during visits to waste reclamation facilities, and a guide to a facility that has a similar layout to that of the installation. The section also contains edited portions of a leaflet entitled "Vehicle Recycling Information Sheet," and reproductions of photographs Landy took on visits to waste reclamation facilities. Landy had the apparatus designed by a company whose slogan, displayed on the conveyor belts, was to "provide solutions to the waste handling industry," and whose colour and design mimicked those he had seen on his visits.

The comparison goes beyond appearance though, in an interview where Landy's processes are described as those of rewinding manufacture, he suggests that the processes of the installation are actually more akin to the "identification, separating and sorting" he witnessed at the waste reclamation facilities.[97] This offers us an alternative reading of the logics behind Landy's disciplining of his objects, for his is clearly not just any old breaking down of objects, or even a reproduction of factory processes, but rather one that proceeds by carefully dismantling these things, dividing them into their material components, and sorting the resultant materials.[98]

Recent research on material culture and our relationships with our objects displays a reorientation, with a growing body of work focused less on consumption—and a looking back from the point of view of consumption to recover the processes and geographies of production—and has focused instead on fast-forwarding through object use to their disposal, often considered as an object's "end point," or the point of object death.[99] Across this work, disposal is viewed as an ongoing process, which can offer a lens onto the value of these objects, but also as a process bound up with the production and performance of the subjectivities of the owners of these objects.[100] As explored earlier, Landy's disposal can certainly be understood along

Figure 3.5 Break Down (detail c.), Michael Landy, 2001 (image courtesy of the artist and Thomas Dane Gallery).

these lines, as he draws and details the intricacies of the entanglements of his objects and his life. Attention here is focused however, on how Landy's act of disposal, in addition to telling us specific stories of objects and owners, was also able to turn attention toward the matter and materiality of his commodities—their substance—the third of those dimension of the commodity which Marx suggests gets written out.

If Marx's phantom commodities were distant from their owners and their makers, then they were also distanced from their physical properties and material relations: "the value of commodities is the very opposite of the coarse materiality of their substance, not an atom of matter enters into its composition."[101] It is exactly this "course materiality" that Landy's installation, understood though the logics of a waste disposal facility, presents. The spatial organisation and disciplining found within the "production line" extends beyond the operators to the objects, and further through the processing of their material components after their disposal. Returning to

the account in the *Manual*, and focusing on its description of the treatment of Landy's possessions enables the development of a more detailed examination of how it is the installation engages its audiences with the substance of commodities.

Landy pays intricate attention to the breaking down of his possessions. The alphanumeric codes not only sort the objects by type but also determine what bay the object is to be dismantled in, what is more, it is against these codes that all the particularities of that object's material make-up are logged on a data sheet. Each of the work bays has a dedicated Excel spreadsheet pre-loaded onto a PC terminal, the entries on the spreadsheet correspond only to the possessions to be dismantled in that bay. Landy suggests this will "reduce the possibility of inputting incorrect data onto the spreadsheet." The instructions continue by detailing how the weighing and recording of possessions is to proceed.[102]

In this context, the object inventories (both in the text and on the installation wall) form an audit, an organisational mechanism that orders the transference of the commodities to the conveyor belt, their removal, breakdown, and the logging of the weights of their component parts in a spreadsheet. Foucault draws attention to the growth of organised knowledge throughout the nineteenth century in the form of timetables, taxonomies, typologies, registers, examinations, and tables, and explores how such schema facilitate the control of large numbers of bodies within regimented space.[103] Whereas for his inventory Landy sorted his objects by use, once the objects had begun to be broken down, the sorting mechanism switched to that of material category. The process was carefully controlled, with each coded object group allotted a bay in which dismantling had to take place, this process was cross-checked and assured through the assignment of a dedicated spreadsheet to each bay, discussed above, a mechanism that helped to "ensure that the objects and materials remain separate."[104] Landy lists the material categories as "ceramics, glass, metals, organics, paper/car, plastic, rubber, synthetics, liquids, wood, other." He also includes examples of the material results, recording the car as being "750 kg metal 550 kg plastics and 50 kg glass."[105]

This sorting and separation continued throughout the process, and instructions indicate that even after dismantling Landy intended that the material categories be kept separate as they went through the shredder and into the granulator. During *Break Down*, the operatives were required to carry out a procedure of material sorting similar to that Landy had witnessed on his visits to a waste reclamation facility. The instructions detail, for example, "one operator removing only plastics another removing only metals."[106] The separated material then went down chutes into awaiting bins. Again a comparison between the waste reclamation facility and *Break Down's* apparatus can be made. The final stage was the shredding and granulating of the separated materials, "each material will be granulated separately in order to keep the potential for cross-contamination to

a minimum."[107] This process resulted in the bags of materials that were weighed at the end of each day. Throughout the installation, the broken-down material form of the commodities was very present on the conveyor belt. To complete the rewinding process objects were to be broken down to "as close to their raw materials as possible."[108]

The systematized, meticulous, and methodical processes of Landy's destruction belies the "disorderly" operative effect of the act he was carry-ing out.[109] Landy instructed that the "dismantled parts" of the broken-down objects were returned to the conveyor where they would "circulate amongst the whole things."[110] For Stallabrass, writing on rubbish, the ruined mate-rial form of trashed commodities betrays their function as wish symbols, reasserting their natural or physical form.[111] Here, however, we can see that it is less ruined form that matters, and more the gradual processes of the waste-disposal facility that Landy was mimicking, for it is this that renders visible the materiality of the objects, the very stuff they are made from.

CONCLUSION: PRODUCING SITES

For Marx, the point was not just to interpret the world, but to change it. As an "exemplary piece of Marxism,"[112] *Break Down* could be expected to be part of this changing of the world, the making of new worlds, or at least forming new experiences of and "new orientations toward the world." This analysis of Landy's work has hinged around its production of sites, exploring the piece by way of an analysis that takes account of not only the installation, but also the two artist's books. Exploring these three sites of *Break Down* enables a tracing back through the detours of the objects, to return to the labour power that made the commodities, and the materialities and thingli-ness of these commodities, to, in short, give the coat back to its owner (and its maker).[113] Exploring the sites and experiences produced by the work finds res-onances between the workings of Landy's piece and recent arguments around the micro-politics of capital. And, whilst the factory floor risks becoming a dangerous fetish in an age in which capitalism is understood to have extended well beyond the walls of the factory to encompass all of social space, *Break Down* in its mimicry of the processes and forces of capital, offers a powerful exploration of its capacities. Further, it encourages us to examine the force of art to shape subjectivities, in this case, both of the workers, but also possibly of the audiences who experienced the three sites of the work.

Above and beyond the particularities of this piece of work, what the analysis of *Break Down* has demonstrated is the value of a close explora-tion of the sites and spaces of art works. To understand the critical force of the spatial heterogeneity that *Break Down* developed—in other words, its folding together of the usually spatially distanced, incommensurable spaces of factory, landfill and shop—what was needed was a study not only of the installation site, but also the two artist's books. By attending to all three

sites it became possible to explore how the installation went to work at its particular site, harnessing the social structures, material forms, and spatial organisation of the shop. Further, it also enabled an examination of how it created at that site encounters with other sites—the factory, the waste tip—that effected transformations on objects, spaces and audiences alike. By considering the multi-sited nature of *Break Down*, we are enabled in our understanding of how the artwork goes to work on the artist, on the volunteers, and on the audience, as well as in our appreciation of its processes and geographies. In other words, we need to appreciate the intersections of the sites of arts' production and consumption, with its production of sites. Chapter Four will extend these questions of the multiple sites of an artwork to consider another artist's processes of making and display. In this case, querying how the geographical imagination is not something that is only pictured, but also something that is performed in the making and display of artworks. Thus, the following study of Richard Wentworth's photographs emphasizes the content of his images together with a querying of the geographies of his practices of making and display.

4 Framing the World

Portraits of Place, Richard Wentworth's Urban Imaginary

INTRODUCTION: A PORTRAIT OF PLACE

October 2002

Walking up York Way, Islington, London, going north from Kings Cross, the landscape was one of transition. It would have been easy to pass 66 York Way without noticing the art installation, to walk right on by the outside of this ex-garage-cum-general plumbing supplies store—sitting along from a mini-cab firm, several greasy spoon cafes with peeling paint, and a derelict car park—were it not for the large letters reading "IN OUT" painted like a road instruction in the doorway.[1]

Richard Wentworth's installation *An Outstanding Area of Unnatural Beauty* (2002), which those letters invited you to enter, took as its focus the sense of urban evolution and upheaval that pervaded this area just north of central London. In a letter to the site-specific art commissioning agency Art Angel, who supported the installation, Wentworth remarks on the area's instability, Kings Cross, he notes, has a "grand reputation for transience. . .I have sometimes wondered if the place itself could be fugitive, like a very speedy geology. Can a place migrate? Deserts do it."[2]

Crossing the floor of the abandoned building visitors to the installation could ascend a makeshift stairwell that Wentworth had constructed from a transport container he requisitioned from the Isle of Dogs. From the top they can either look back out over the installation, or take up the view over London that was afforded by the periscope that Wentworth has installed there. Looking through the lens, the nineteenth-century terraced houses of the suburbs stretched away into the distance, foregrounded by the glass buildings and cranes of the immediate city skyline, even more proximate is the frontier of urban regeneration at Kings Cross itself. These narratives of horizontal and vertical expansion are enfolded with the city's subterranean geographies, the raw gashes cut into the surface during the building work revealing cross-sections of concertinaed colours of soil and rock, the exposed pipes and ducts overtopping the untouched strata below.

Turning away from the periscope, the viewer is provided with the ideal vantage point from which to look out over the installation. On the building's deeply scored and grooved walls Wentworth had installed a multitude of mappings, from airplane flight paths to taxicab routes, as well as a series of maps of subterranean London, old maps and charts of the London Underground, of buried rivers, cables, and electricity ducts. The temptation, in the face of this particular "picturisation" of Kings Cross, as Wentworth calls it, is to formulate an aesthetic of urban excavation, to interpret this collection of images as a presencing of hidden histories.[3] But yet, Wentworth's attitude to the pasts of his objects and places is more complex than making them, however unstably, present. In place of the recovery of unstable and unexpected lost pasts, of histories pushed down, covered over or turned away from, Wentworth enfolds these multiple pasts within ongoing layers of continual change. It is this that is the lynchpin of his urban imagination: an urban environment predisposed to begin again, and again, and again.[4]

The form and mode of the installation and its progression are as important as its content for developing Wentworth's imaginary of a mobile, transient city of intersecting and overlaying flows of people, goods, ideas and resources. As Lingwood, the director of Art Angel wrote of the commission, "there was a sense that this would be a project that would accumulate and develop over time. That it would not necessarily open in a finished form."[5] This description emphasises the processual and interventionary nature of the piece, pointing us toward the importance of the work's morphing and changing with its "audience," as they became enrolled within it, whether this was as part of mass ping-pong games, or within the extensive public programme that spilled out into the local area.[6] Wentworth's selected cartographies were augmented by the maps made by gangs of geographers and urban theorists who, responding to the spirit of the installation, set out to delight in discontinuity, urban contingency and open-endedness.[7] Indeed, such was the force of the installation and its ongoing mutations, that when its twelve-week period ended Lingwood remarked, "its life was prematurely cut short. It was still growing." Wentworth echoes this when he notes, "I am still terribly disappointed in many ways that we closed it when we did because it had hit a stride."[8]

Wentworth's urban imaginary has much in common with those that characterise the city scribings of geographers and urban theorists from the late twentieth and early twenty-first centuries.[9] His interplay of views culminating in a street-focused imaginary finds a shared perspective with recent urban scholarship that has drawn eyes to the crumpled margins and dusty interstices of the modern city.[10] This is combined with a sense of the city understood in terms of horizontal and vertical extensions and intensities, the depths and layers of the far from rational tangles of infrastructures and urban natures that constitute the metabolic and political ecologies of the city.[11]

Intersecting the eagle-eyed view with that of the political potentials of the human subject on the street has resulted in two perspectival trends, one that has seen an attentiveness to the emotional and affective experiences of urban spaces, the other that foregrounds the previously overlooked dimensions of

everyday practices as part of the production of urban space.[12] In both cases, the street is occupied as a site of resistance, proffering other ways of knowing and being based on assertions of feeling and doing, of the affective and aesthetic, and of the small-scale tactical actions by which people can engage with and co-produce urban space. These urban imaginaries draw attention to the most prosaic of urban landscapes, with their everyday practices and taken for granted technologies, and raise questions regarding the place of such urban incidences in the production of cultural meaning, the forging of social identity, and even political resistance in the modern metropolis. As Pile observes, "where-ever we look power is open to gaps, tears, inconsistencies, ambivalences, possibilities for inversion, mimicry, [and] parody. . .At the heart of questions of resistance lie the questions of spatiality—the politics of lived space."[13]

Art and Urban Imaginaries

Arts practices have long been part of the forging of urban imaginaries. It is an often careful pacing of the street and an attention to street level activities and politics, that have come to dominate these arts practices.[14] Coupled with this focus on the street level is a sense of possibility, or the street as a site not only of resistance, but also of intervention and transformation. Andrea Phillips describes artistic walking practices as, "a choreography that is inflected with but not controlling of the social," it has, she continues, "an unfinished air, it works as if to be a proposal, not even a maquette or a map."[15] Part of the draw, as Pinder notes, is the apparent ordinariness and modesty of these actions that relinquish fantasies of control and in doing so develop modes through which urban spaces can be occupied as sites of political responsibility and arenas for political engagement.[16] As such, artistic practices became part of the re-tooling of the urban as a site of possibility and creative potential, developing a route to imagine and forge other possible urban worlds.[17] Many such artistic practices, often termed "interventionalist," deploy creative methods "so as to question, re-function, and contest prevailing norms and ideologies, and to create new meaning, experiences, relationships, understandings and situations."[18]

Artistic practices have come, therefore, to proffer the means to think and practice urban space "beyond the closures of the present."[19] Pinder elaborates upon how past creative visionings of the city develop a form of utopian urbanism in the twentieth century that is not just based on the city as a fixed form, but, following Harvey, promotes an understanding of the spaces and times of the city as an ongoing production, and in continual transformation.[20] Drawing together Harvey's ideas on spatial and temporal process and form, Levebvrian production of space and the avant-garde creative visions of new cities (such as Constant's *New Babylon*) Pinder suggests such urban visions, "operate more along the lines of interruption, intervening in conceptions of urban space and time, and opening up opportunities for those spaces and times to be lived otherwise."[21] Art, understood such, becomes about "provocation, stimulating

responses and encouraging critical reflection and action."[22] Thus, and in a spirit that continues into his examination of the arts of urban exploration, Pinder develops the potential of artistic practices for proffering the means to both make sense of city-making practices, and to intervene in the ongoing and unknown nature of these practices.

Such an approach is to foreground the city, and as we shall see the street, as a space-time of encounters, celebrating local, situated doings, and the oddities, absurdities and also the banalities of everyday life, promoting fractional objects and particularities over stable, complete orders.[23] There is a trick here, Amin and Thrift make clear, in attempting to remain close to the phenomenality of practices without relapsing into the romanticism of the everyday and action for itself.[24] This chapter explores the means by which Wentworth's artistic practices develop such an urban imaginary. Wentworth's installation, a description of which opened this paper, is a very good example of the sorts of interventionist stances that have become common building blocks for such "alternative" contemporary urban imaginaries. For, offering an "cartography" of the area generated by local residents alongside the artist, and encouraging people to occupy their community and urban space differently—whether this be through ping-pong tournaments or urban explorations—Wentworth's work resonates with a number of artistic interventionary practices. What is of interest in this chapter is however, less these perhaps now rather standard forms of participatory and interventionary practices, and more to query how Wentworth's photographic practices contribute to this urban imaginary. In particular, I want to explore the relationship between the subject of his photographs and the practices of their making and display and the importance of this relationship for building his urban imaginary. Quieter, and less outspoken in their political intent, these photographs build a rather different set of urban politics than those found within "interventionist" art practices, but one that this chapter will suggest is arguably no less insistent in its critique or full of possibilities.[25]

Photographing the Urban

The analytic focus of this chapter remains on Wentworth's urban imaginary, but shifts away from the installation to the artist's ongoing photographic series *Making Do and Getting By*. This sequence of thousands of photographs made over the last four decades provides the most sustained development of Wentworth's urban imaginary, and also enables a close focus on the intersection of the geographies of photographic production and consumption.

A useful distinction for this analysis is that between the artist-photographer and the artist who uses photography. Hatch describes a continuum between the photograph as end in itself and the more conceptual use of the photograph as a "modular component in a larger endeavor."[26] His observation recalls two key points in photographic analysis. Firstly, to remain aware of the biographies of the photographs under study, biographies that will encompass the conditions and practices of a photograph's making and its post-creation

storage and display. And secondly, Hatch's approach asserts the importance of exploring how it is that the photographs sit within an artist's wider working practice. Wentworth certainly sits on this continuum; his photographs are rarely ever seen as individual images, but rather are subordinated both to his sculptural practice, for which they are "rumination," and to the series as a whole. In the context of the latter, the individual photographs are but a part of a narrative that has been over thirty years in the telling, yet Wentworth resists the organisation of the thousands of images into any sort of series, instead an iconic formalism binds images from across the world. In analyzing the urban imaginary that Wentworth builds it is not enough, however, to analyze this iconic formalism. Rather, it is important to consider two other facets of the photographs that Hatch draws attention to: firstly, the particular positioning of his images that the artist develops, and, secondly, the geographies of the production of these images and the multiple sites and modes of consumption that propagate from these geographies.

Wentworth's sculptural practices, whilst forming a minor part of this study, are perhaps the works for which he is best known, and offer invaluable pointers toward the modes of analysis appropriate to his photographs. In his sculptures Wentworth assembles everyday objects, from plates, to step ladders, cigarette packets, glasses and old-style steel dustbins. These sculptural arrangements exhibit a tension-filled play of objects, held together by the artist's hyperawareness of matter and forces, and the ability for objects to hold their shape, to balance, to be in tension with one another. This is less to meditate on object uses, past or present, but rather to draw attention to the potentialities and materialities of these objects. This attention to what objects can do, to the forces that hold them in relation, is also a common subject of Wentworth's photographs.

It is important not to overlook the cues that Wentworth's material sensibility, as expressed in his sculptural works, gives us for thinking about his photographs beyond their content. Too often, it has been contended, we suppress our awareness of what a photograph "is" in material terms in order to see what it is "of."[27] In considering Wentworth's photographic practices though, we need to retain this sense of photographs, like sculpture, as three-dimensional objects, not just two-dimensional images. There are, in short, inextricable linkages between the meanings of the images and the form of the photograph as an object that is produced and displayed. Just as analysis should attend to the surrounds of landscape images in interpreting their visions of landscape—whether this be the frames of paintings, the boxes of peepshows, or the tents, curtains, and structures of the panorama—so there is a need to attend to the supports and surrounds of Wentworth's images.[28] These are less "frames" in a material sense of wood or metal surrounds, but are rather the framings supplied by Wentworth's artist's books and his self-curated exhibitions and talks: a sequence of surrounds that provide both narrative but also material form.

What this adds up to, in short, is that to explore Wentworth's urban imaginary, is to examine not only the content of the photographs, but also to question how the materiality of the images, and the practices, technologies,

and politics of the processes of their production and display perform this urban imaginary. In other words, to consider Wentworth's images is not just to consider image *qua* image but also to examine the material and practices for, and of, their production and display. This form of analysis is perhaps especially important because Wentworth's is an urban imaginary that focuses on propagating new urban futures and possibilities, but his medium is photography: a medium more often associated with the capturing of past moments or the pauses in passage of people, objects, and places, than with future-orientated sensibilities.[29] Implicating subject and content of the images together with their modes of making and display is to build an understanding that combines photographic practice precisely with that sense of possibilities and on-goingness in the world.

Taking up these ideas the discussion that follows falls into two analytic sections. The first explores the images Wentworth made of Caledonian Road, London, one of the principal geographical sub-groups of images found within his larger photographic sequences. Caledonian Road, or Cally in the shortened affectionate form used by its residents, of which Wentworth is one, runs parallel to York Road, the location for the installation that opened this chapter. This is Wentworth's home turf and the street has long formed one of his principal subjects. The second analytic section will work across the whole *Making Do and Getting By* series, investigating the iconic solidarity that draws the artist's attention in locations from London, to Berlin and Valencia. If the focus in the first section is on exploring how Wentworth's urban imaginary is developed through the his modes of artistic production and the materialities of production and display, then the second section focuses more on image content, and explores the politics of Wentworth's work. Enrolling the audience in his installation slotted the latter smoothly into an established mode of artistic intervention and participation. But yet, something else is going on in the image series, and using Hawkins's exploration of the "arts of transience" enables an engagement with the affective force of objects that sits at the heart of Wentworth's urban imaginary, and from here enables an unpacking of what its politics might consist of. [30]

CALEDONIAN ROAD

> From its outset the Caledonian Road "goes" from the mainline terminus at Kings Cross and tries to get north. As soon as it leaves Kings Cross it becomes strangely indecisive and for a while you are not quite sure what it wants to do, until finally just above the station it decides to zoom uphill to Pentonville Prison. (Wentworth, 1997)[31]

"Turn your trash into. . ." written in rectilinear blocky capitals, cuts wonkily across the top of the photograph (Figure 4.1), the three points of the

Figure 4.1 Caledonian Road, Richard Wentworth, undated (© Richard Wentworth, DACS 2012).

ellipsis linking the joined up curlicues and double colored "Cash," which follows, almost anticlimactically after all that potential. The shop sign is off-centre in the photo, the top of the "c" of cash is partly cut off. The last is a function of depth, with the near-ground of the photo cut square to the front ends of three plastic crates of carefully sorted and stacked glassware, vases and jugs. The picture is framed on the left side by the backs of a wall of fridges, what Wentworth calls "white parapets," constructed by one shop owner to mark out his territory, the cabling and elements spilling out into the space.

Behind the two rows of plastic crates, order of sorts is still maintained, although it is a formal order that sees a marble-topped table sit in front of a precarious looking shelf stack, topped with dumbbells and weights, on the other side, a barbell rack and a weight-training machine. Next to these, almost mocking the abandoned attempts at health and vitality they represent, sits an incongruous folded wheelchair, footrests neatly touching. This show of metal and leather is hemmed in on one side by the just visible base and top of a wooden table, the swirls of its ornate base a contrast to the metal framings. Behind this motley crew, and leaning against the metal shutters of the shop, one stripy settee achieves the superhuman feat of holding the other perched on its upturned arm.

Looking across the sequences of Caledonian Road images there are two sorts of patterning at work. Firstly, a "formal" patterning within the images themselves, like that detailed above; a rudimentary object organisation, sometimes by form, sometimes by function, at times by colour or size. Across a sequence of images of this shop, and others like it, Wentworth photographs the unofficial politics and grammars of display: objects attended to in terms of their formal and material properties—size, shape, colour, form and so on—rather than as things comprehended through their social use. Wentworth confirms his interest as a formal one when he rejects descriptions of his work as a commentary on lived experience, he prefers instead to understand his images as driven by an attraction to orders and pattern.

A second patterning found within the series is a conceptual one that provides the visual expression of Wentworth's repeated observations of the city as an animated specimen that he is unwilling to fix or to pin down.[32] If, on the one hand, these photographs mark pauses in passage; both the artist's own, as he halts his daily walks to and from his studio to take these photographs, but also the passage of the objects that he captures, as they sit in front of shops, or on the streets. Then, on the other hand, the image series develops a sense of things in motion. This sense emerges from a combination of, an iconic solidarity constituted through the artist's attention to the properties of objects, his attraction to particular sites and genres of urban spaces, and his methods of making, in particular his approach to seriality.

Wentworth remarks "I always turn right outside of my house and end up on Caledonian Road, which means I am constantly able to monitor just

how out of control it is."[33] Over the three decades he has lived on Caledonian Road, Wentworth has taken many thousands of photographs during his day-to-day journeying around the neighborhood. As he narrates, the "accident" of where he lives presents him with, "a run of nearly a mile on a single road whose various characteristics combine under the one heading, "the Cally."[34] This mile, he continues, contains the "most significant phrases and measures of the Caledonian Road between the two landmarks of Pentonvillle Prison and King's Cross Station. Somehow it's a totality, a continuum." Wentworth spoke of "calibrating" the city through the exposures of a roll of film. "Thirty-six exposures," he says, are "a kind of diary . . . a narrative frame by frame . . . a manageable amount, readable but not epic."[35] It is this calibration, this monitoring, that enables him to bring into focus the city's constant mutability. Thus, across the series there is less a sense of fixing a particular history so much as an examination of how change, flow, is part of the urban condition. It is Wentworth's calibration of the city—his crossing and re-crossing of this terrain with footsteps and photographs—that enables him to detect temporal and spatial urban patterning, observations of trends, rhythms and repeats, that are born from his repetitive journeying in the area, and that sensitize him to the changes within the city, to its transient forms.

In its thirty-year duration, Wentworth's ongoing photographic archive of Caledonian Road casts a sidelong glance at the passage of time: individual moments of value assessment, photographed outside the shops and in the street, string together into an archive of change. This unofficial archive presents a visual impression of the transient economic climate of the area, and of the continual flows of materials and goods through the city. The continual churning of things—reinforced here by that banner, "turn your trash into . . . cash"—is part of what draws him time and again to these sorts of marginal and overlooked spaces. This continuous shifting of values is moderated by the fact that, whilst born of the artist's ceaseless motion, the photographic series is also a product of familiarity. Wentworth's photographs and his commentary—the result of consistent and constant observance and a distillation of trends and repeats—give rhythm to this continuous change. The result is a sense within the photographs of the slow accretion of change rather than to the seismic shift of the "new"; attending to endless repetitions, which over time and across the series accumulate to sensitize us to differences, modifications and variances. To understand in more detail how this sense of urban transition is built through photographs, the discussion that follows is going to explore Wentworth's processes of making and how he frames his images.

Walk-Talks: Lessons in Looking

In 2005, I went on a series of walks with Richard Wentworth. I was not the first geographer to walk with Wentworth, and he has led many walks since

that academics have been moved to write about.[36] The walks I attended were part of a series of events to accompany the opening of Wentworth's retrospective exhibition at Tate Liverpool. They took the form of walk-talks, offering lessons in looking as Wentworth led us around the city. As we moved from suburbs to city-centre we were encouraged to see the city as Wentworth did, as he talked, pointed and photographed, we began to inhabit his particular imaginary, to develop an "eye" for the Wentworthian urban.

It was not skills of composition, light or tone that we were being schooled in here, but rather the artist's particular way of framing the world, of what it was that caught his eye. Cartier Bresson, describing the "artless art of photography," isolates the artisty of the decisive moment, wherein the photographer seizes the opportunity to frame the accidental and incidental, isolating it from the banal moments that surround it.[37] On these trips, Wentworth is accompanied by his rather battered analogue camera that he has loaded with a thirty-six-exposure film, which he tells us he will get developed at Boots (the chemist). The expertise of the artist, thrown once into question by the mechanical action of the camera, is queried again by Wentworth's self-conscious snapshot oeuvre, but the figure of the "expert" is once more asserted in the act of selection, the choice to frame certain urban incidents.

Navigating these unfamiliar Liverpudlian territories with the help of local guides, Wentworth gravitated toward places and images that shared an iconic solidarity with those in his Caledonian Road series. In the city centre, it was incidental urban patternings and their undoing that drew his lens: disrupted pavement lines, out of kilter cobble stones, drainage features left high and dry by changes in street level, and mismatched period details on buildings. As second tour took us, by coach, to the city's edges and to a northern version of Caledonian Road, here, in the suburbs, we walked along streets of boarded-up shops, explored cemeteries and poked around in discarded urban lots. Directed by the artist, we were encouraged to identify those things that did not fit, that disturbed urban arrangements for good or ill. Talking of displays outside the secondhand shops and the hardware stores on our tract of street, Wentworth spoke eloquently of "trading outside of city walls," and in echoes of observations made on Cally, he admired a "strange collection of things that don't really quite function inside the city."[38] Celebrating such alternative economies of the city conducted on street corners and out of skips, outside of the more obvious retail sites, the artist displays a delight in these precarious forms of disordered objects, an everyday material anarchy of sorts.

Photographing the Everyday

The choice of the vernacular and the everyday as subject matter, has long been twined with a particular photographic mode. Ed Ruscha's "iconographic choice of the architecturally banal," for example, corresponds,

Buchloh suggests, with his, "devotion to the deadpan, anonymous, amateur-ish approach to photograph form."[39] Looking at Wentworth's practices there is a similar pairing of subject matter and mode of photographic practice. In Wentworth's case the concern is less with the architecturally banal than the everyday and offhand, but, just as Buchloh finds with Ruscha, a laconic type of photograph, "explicitly situate [ing] itself outside of the conventions of art photograph, and outside of the venerable tradition of documentary photog-raphy; concerned photography" so Wentworth's form and situation of his images is deliberately that of the off-hand and incidental. [40]

In describing his images, Wentworth shrugs off any conscious or con-ceptual drive behind their creation. According his photographs an almost incidental status in the context of his broader artistic practice, he describes their taking as habitual, a barely-conscious observational mode that none-theless he ascribes an importance to, situating these images as part of his broader conceptual "intake," his artistic metabolism.[41] Resistant to the fashioning of what he describes as a "template that fits over the world," he refuses the status of his images as anything as coherent as a collec-tion, or as a series, wishing as he does to reject any suggestion of guiding themes or organising features that come with such a sense of structure.[42] Elaborating, it becomes clear that it is the intentionality, the consciousness of organising thematics that the artist wishes to resist. Denying any active decision making process, he describes his photographic practice as ruled by accidents and habit, a product of accidental inhabitation, of the rhythms and routines of daily routes to studio, shops and the gallery. This situation of artistic practice in the context of quotidian urban circuits is worlds away from those artists for whom planned interventions or epic walks, facilitate transgressive intents or proffer environmental performances.[43] Instead, like those eighteenth and nineteenth-century artists for whom walking was a part of the daily business of life, perambulation offers Wentworth a period for evidence collection and rumination.

Wentworth's serial manner of producing many thousands of images flatly refuses the representational mode of the singular and celebrated image, and his treatment of these images post-shoot, reiterates the sense of the offhand, and reinforces the critical effect of the self-conscious seriality of the photographs. Stored en-masse in drawers, the many thousands of images (often in slide form) are collected together although far, as Went-worth makes clear, from collated or archived in any order. They are labeled by date and time in accordance with the diaristic approach that the art-ist also favours for his titles. He once noted, "If I died tomorrow no one would know what to do with my slide photographs—most of them aren't even captioned."[44] The photographs therefore, by means of the mechani-cal mode of the camera, the artist's choice of subject matter and the sheer number of images taken, seem to distill the aura of modern life as a series of endless, repeats. But yet, and in a tension first noted by Barthes, the end-less reproducibility and the apparent exchangeability of these images, is

countered by the fetish of the artist having been there to take the pictures.[45] For, it is through the combination of the artist's eye with the sheer mass of his images, that we are able to observe patterns and repetitions across the series, and further, that we can discern the little differences, variations, and modifications that are what drive Wentworth's urban imaginary.

As with Ruscha's photographs, however, it is not just the mode of artistic practice that is key to the conceptual development of the series, but also the artist's choice of presentational mode. For, as the following section will explore, Wentworth's choice of "frame" for his photographs is in keeping with the tenor of discussion so far, rarely are the images on display in the sanctified spaces of art galleries, rather, Wentworth's most common form of presentation is the format of the photographic essays or his "Calendonian Road talks."[46]

Storying the City: Talk-Walks

Wentworth repeatedly expresses dislike for the inertness of his individual image as objects. Indeed, where they begin to come "alive" is when they are organised into series, either in books, photo essays, or as this section will explore, when they are projected and given the artist's voice over in a slide lecture.[47] For, it is when framed such that it is possible to appreciate the similarities and differences, patterns and their disruptions, that are what attracts Wentworth, and what enables him to envision ongoing change and restlessness as the urban condition.

The "Caledonian Road talk" first emerged as a format in 1995 when Wentworth spoke to a class at St Martins School of Art, London.[48] In this instance, he noted that he was interested in engaging with the globalised world through showing that the world outside our front doors was the most exotic of all. A year later he gave a second talk in the Cubbitt Gallery and he has given a number since.[49] These events take the form of talk-walks, intertextual journeys narrated by way of slides of Caledonian Road, accompanied by spoken stories and punctuated by the click of the slide-projector as the artist advances from one image to the next. Indeed the visual punctuation, the accumulation of connections, ideas, and narrative threads as Wentworth leads a journey through the images is such that you are never quite sure whether what is said about each picture has the status of the "talk" or an extra aside the artist decided to include in the improvisational course of his reflections. Just as with the walk-talks, there is a shared iconic solidarity across the images used within a single talk, but also, across the series of talks we see the same sites, the same objects and the same formal gestures of ordering appearing over and over again.

As such, Wentworth's photographs, like Ruscha's, announce their own reproducibility and exchangeability, and assertively so.[50] But equally, his visual and textual narratives provide a sense of a huge archive of images— "another year goes by, I photograph another Christmas tree"—as well as of the careful selection of any given subset of photographs he shows.[51] Such

that, when Wentworth comes to "arrange" the images, either during the course of these talks or in his artist's books, there is a sense neither of total randomness, nor tactically arranged data. Rather, what comes to the fore is a tension between the anonymous reproducibility of the images and, as Barthes notes of photography more generally, the "utterly personal stake in having-been-there," that is infused by the very seriality and diaristic mode of these images.[52]

There is a sense that these talks could proceed through the slides in any order, each time the images are narrated by Wentworth they are essentially the same, but slightly different. As such, numerous different paths are taken through the vast image collection, but each time it is roughly the same sort of path we follow. As a series of banal moments appear one after the other, what is most interesting, and what this format brings to the fore, are the minor disturbances; occasions of interest generated by the seriality of the project and its systematic nature. Wentworth's daily perambulations foster a form of close observation, a mode of repetitive, recursive, urban fieldwork that succumbs to endless repetitions, and in doing so sensitizes artist, participant and audience alike, to "novel" situations, slight differences, small variations and modifications that point towards change as the urban condition.

The Space of the Imagination

If we return to the misaligned banner in the photograph that opened this section, "turn your trash into . . . cash," we can see how its imaginary of possibilities is played out metaphorically within these objects. The sad sofas and abandoned weights have ambiguous futures, oscillating between, on the one hand, their status as "trash," traded by ex-owners for cash, whilst on the other, in the space opened up by the ellipsis, they have the potential of becoming something else. Crang, writing on a set of documentary photographs of ship-breaking practices in Bangladesh, explores how these images picture the "instability" of things. In the place of the stable "being" of these waste ships, he argues, via Deleuze, that these images picture their "becoming," or rather, what he finds to be their material unbecoming.[53]

Wentworth, when asked about the relationship between his attraction to discarded objects and Walter Benjamin's suggestion that we can read the world through its fragments and forgotten bits, does not demure.[54] Instead, in what is typical gesture for him, he forms an accumulation around the idea, both acknowledging its resonance with his work and moving it on, taking the idea forward in a new way. In his reply, he celebrates the small, and the fragmented, enjoying its centrality to Benjamin's suggestion, but he is less enamored with the relationship that is built here with the past. Instead, he emphasizes the "the enormous space that comes with them (these objects), which is the space of the imagination."[55]

In dwelling in the space of the imagination, in taking photos and presenting them in such a way that they are more about opening up the possibilities of

what these objects could be than what they are, or have been, Wentworth formulates an urban imaginary that refuses the "closures of the present."[56] What emerges from the geographies of the works' making and presentation, as well as the content of the images, is an aesthetic of the world-in-the-making, "it is in-action, it is all that is present and moving."[57] There is apparently no last word here, only infinite becoming and constant reactivation. To understand this better, and to consider the political possibilities of this, discussion will now consider these ideas in relation to the broader photographic sequence within which the Caledonian Road series sits, *Making Do and Getting By*.

MAKING DO AND GETTING BY: IMPROVISATIONAL CREATIVITIES AND THE ARTS OF TRANSIENCE

Kings Cross, observes Wentworth is a "place of doings," but in fact, all the locations he photographs are places of doings. Having fore-grounded the making and display of his photographs in the previous section, the following discussion will focus a little more closely on the subject and content of the images. I am interested, in particular, in the identification, across the many thousands of images in the *Making Do and Getting By* series, of an iconic solidarity—a poetic of common practices, skills, and affordances that links together images taken across the world. See, for example, the propping, stacking, balancing, and blocking in photographs such as *Alt Moabit* (1994) (Figure 4.2).[58]

Figure 4.2 Alt Moabit, Richard Wentworth, 1994 (© Richard Wentworth, DACS 2012).

Despite being devoid of people and of "picturings" of the actual act of doing, Wentworth's photographs are, it could be suggested, less about objects per se, than about what people have done with them, or indeed could do with them. His are images always concerned with the entanglements of humans and nonhumans, whether these are patterns, "gestures of politeness," or instances of creative reuse in the moment.[59] Following on from the object futures posed by the ellipsis in the photograph that focused the discussion of the Caledonian Road images (and the secondhand and discarded objects that populated that series) discussion in this section is concerned with the repetition of photographic incidences focused on capturing the creative reuse of objects in unexpected ways. Far from unwanted, disposed of objects, Wentworth pictures improvisional creativities: transformations of objects in the flow of the world, as the world keeps moving on; a hanger or a saucer keeps a window secure; a pen is a makeshift bolt; books prop a table leg; and balanced chairs or pieces of wood are barriers and territory markers.

In title but also subject, the *Making Do and Getting By* series develops links with the spatial politics and the theories of practice of French polymath Michel De Certeau. Elsewhere I have developed an understanding of the creative reuses of objects that Wentworth pictures as a De Certeauian programme for "attending to the spatial practices of people."[60] Particularly useful was the distinction De Certeau makes between the terms "strategy" and "tactics." In his book *The Practice of Everyday Life* (notably subtitled "Making Do") De Certeau understands strategies in line with institutions and structures of power, strategies are those practices that delineate an imposition of power through a disciplining and organising of space.[61] Tactics, on the other hand, are ruses, unconscious, precognitive practices by which people make over the world. It is such "tactics" that I argued we can see in a number of Wentworth's images.[62] While such an interpretation situated Wentworth's photographs in the context of contemporary urban theorisations, and enabled a politicised take on his work to emerge, what it was less effective at taking account of was the types of objects the artist was interested in and the nature of the entanglements of nonhuman and human being framed in these photographs. Here, I turn instead to current ideas of about disposal, rubbish, and waste as a means to think further about Wentworth's photographs and the politics and ethics they enable.

Photographing Doings and Becomings

As a wealth of literature attests, until recently the social life of things (their meanings and values) "has long squeezed out consideration of their social death."[63] Over the last decade, however, we have seen a growth in the studies of the sites and practices of discard and disposal, as well as explorations of the critical potential of discarded objects themselves. One important track of these studies has been to interpret, following Benjamin and others,

rubbish and discards as fragments through which the past can be read.[64] Taking a different tack are those for whom discarded objects are interpreted in terms of process and potentiality. Indeed, discarded objects, or rubbish, often thoroughly spatialised as "out of place" materials, have from Mary Douglas (1984[1966]) onward, contributed much to our understandings of the nature and dynamics of material transformations, of bounding practices, and the formation of subjectivities and identities of people and places.[65] It is this latter suite of ideas, and their articulation in Hawkins's "arts of transience," that suggests a future-orientated frame within which to understand the content of Wentworth's photographs and their building of an urban imaginary based in becoming and object evolutions.[66]

For a long time, rubbish studies were haunted by a sense of the objects' pasts, with discarded objects enrolled in disposal ethnographies, and salvage geographies becoming the means of making present absent pasts or untold stories.[67] Wentworth works, however, with a rather different understanding of rubbish. Clearly the histories of some of his objects are important in his images, as for example, representative of "the era of our industrial competence," a time he continues, "when Britain had the competencies not only to make (do) but also to mend."[68] Indeed, at times he skirts nostalgia when he turns to other objects and suggests they carry with them the "smell of Old London" and a certain "Valor/Ascot/Raleigh/Aladdin moment."[69] But such historical reckonings are not the impulse behind his urban imagery, he is not looking to narrate those lost pasts, particular or general. Rather, in his work there is something more akin to recent rubbish theorists who foreground a focus on the future possibilities of objects, and their transformative potentials with respect to both themselves and their associated subjects and spaces.

There is an increasing recognition of the force of what Colloredo-Mansfeld terms "matter unbound:" the result of the failure of specific and fixed understandings of objects to "cope with the social effects of these increasingly ephemeral, highly fluid and immaterial interventions within the material world that sustains us."[70] Under such perspectives, materiality "floats free" from the calcification of object meanings and a stable, engrained sense of an object's presence, opening out ideas of objects as unfixed in status, in form and in materiality. Rubbish? Waste? Trash? Cash? These ideas have had a number of different impacts: such engagements with the material and semiotic instability of rubbish and sites like ruins have developed interesting epistemological critiques, focusing on, for example grand narratives of history and heritage.[71] In terms of the object histories, this has involved a sense of these as neither self-evident nor stable, instead these meanings are hard won, often in fact spun, with owner/archeologist/geographer/artist enfolded in the co-construction of the biographies of people, objects and places.[72] Alternatively, this ethos can also project forward enabling object possibilities and potentialities. This can be seen in studies of secondhand shops (like those Wentworth photographs on Caledonian Road),

car boots sales and charity shops, which develop these as sites wherein the aftermath of disposal is not that of destruction or decay, but rather these are sites of new beginnings. What such ideas often revolve around is reframing of relations with disposed of objects in terms less of de-valuation than of restoration, care, mindfulness, creativity and generosity.

In this embrace of the fecund, whether this be in relation to objects, sites, or epistemological critiques, rubbish and discards come to proffer sites where, for example, "the becomings of new forms, orderings and aesthetics can emerge."[73] Where this potentiality has been most forcefully expressed, and most carefully parsed to date, has been in the context of what Gay Hawkins has termed the "arts of transience."[74] By way of a micro-political attention (following Foucault and Deleuze), to the conscious, affective relations between waste and human subjects she calls for a new orientation towards our waste materials.[75] In doing so, she not only refigures how it is we can think of discarded objects, but also pulls into focus the need to conceptualize the agency and transformative potential of human-waste relations.

Revisiting the meanings of waste in our everyday lives, Hawkins is concerned to engage with the, "complexities, paradoxes and visceral registers that mark our relations with rubbish."[76] She is interested to move away from relations cast in terms of moral economies of recycling and waste management, relations that are based on a separation of waste and self, and in illusions of mastery. In the context of the reconstitution of the subject/object relations brought about by convenience and commodification— meaning we have the capacity to dispose without concern—Hawkins is concerned to understand a rather different orientation towards waste. In the place of codified practices of waste disposal, the rules and norms of object use guided by external authors, Hawkins attends to a human-waste relation that is based in the forces of an ethical life, in aesthetic encounters, in visceral moments and in situated engagements. For from these, she argues, propagate other possibilities for subjectivity and inter-subjectivity: what have been called, elsewhere, movements of becoming.

In an interesting development of Hawkins's ideas, Gregson et al. examine the geographies of these arts of transience. In their ethnographic study of the ship-breaking practices taking place on the beaches of Chittagong, Bangladesh, they suggest that it is not just a sense of imagination, of exceeding existing ways of seeing or knowing, that enables these forms of object encounter, but that the situated classification and categorisation of materials matters too.[77] For them, the light regulation of materials and wastes of the Bangladeshi beaches, while bringing with it dangers also enables a certain mutability of these objects and an exploitation of their possibilities. There is perhaps a similar lightness in regulation in the spaces that attract Wentworth's attention, either locations "outside of city walls," or those sites overlooked within them. Akin to Hawkins, but in contrast to the ship breaking explored by Gregson et al., Wentworth is drawn to the everyday and the domestic, and in his images there is a focus on intimate

relations between people and objects that engages with the situated, relational sense of object-person interactions.

Materiality is key for the sorts of ethical object relations found in both Hawkins's and Wentworth's imaginaries of rubbish and waste. But, if the former is interested in the visceral experiences of waste—such as smelly compost—then the latter is concerned with a rather different register of materiality. Looking at the propping, the wedging, the balancing and the stabilizing of the *Making Do and Getting By* photographs, we find object assemblages whose fabrication is not solely human and not wholly conscious (see Figures 4.2 and 4.3). Indeed, at the heart of these arrangements, and of our appreciation of them, is a lyrical materialism that foregrounds the apprehension of an object's material affordances (an instinctively grasped relation between humans and materials). Wentworth observes how the object arrangements he captures are based in a "very well developed physical sense about the material characteristics of things, of the strengths and weaknesses of, for example a cup, tire or a coat hanger."[78] The photographs, like *Alt Moabit,* centralise objects apprehended as dense, blunt, pliable, rigid, understood as bending like this or able to bear that weight.

It is the material properties "grasped in a moment" that form the basis of the human-nonhuman encounters seen in these images. As actions "devoid of foresight" they have, the artist suggests, "an instantness about them."[79] The situated "in the moment" practices Wentworth photographs result from the experiences, habits, and routine practices of the body together with material capacities, intensive internal properties and emergent capacities dependent on context. Furthermore, they are testament to actors and relations, densities and pliancies working on the "corporeal sensibilities and affective planes of the perceiving bodies."[80] Just as Hawkins looks to escape the mastery of coded practices of recycling and to break us away from the norms of object use, so the everyday social-material assemblages that draw Wentworth's eye are "transient unstable events," rather than "durable heavily reproduced structures" or even the imaginative re-workings of found objects.[81] As such, Wentworth overlooks the meanings of the objects he photographs in favour of a focus on practical doings of bodies with objects.

In other words, Wentworth's re-valued objects are not re-valued for what they mean but what they do, or rather what they could do and what people could do with them. He offers us the chance to engage with the material and affective potential of discarded objects, to reconfigure their relations to us over and against those of the over-coded rules of waste management, and of what objects are supposed to be *for.* Instead, in Wentworth's images we see the aftermath of what has been described in another context as "unexpected intensities, peculiar sites of indifference, new connections with other objects."[82] The result is the generation of "affective and conceptual transformations that problematise, challenge, and move beyond existing intellectual and pragmatic frameworks."[83] What these photographs are imaging is the relational and emergent imperatives of material forces in

which the "thing-ness of things, bodies, objects arrangements, are always in the making."[84]

CONCLUSION: EVERYDAY CREATIVITIES

The study of Wentworth's urban imaginary that this chapter has built explores how it is only in considering *both* the content and form of Wentworth's photographic series, *and* interrogating methods of making and display that we are able to unpick the particularities of the artist's urban imaginary. Wentworth's is, as this discussion has explored, an urban imaginary that is based on a sense of the possiblities and potentialities of urban space, its ongoingness. Such an imaginary of place might not sound like one that can be easily "pictured," in a sense of understanding this as meaning being captured within a frame, but here is where attending to the materialities and practice of photographic making and display is key.

As this discussion explored, Wentworth is concerned to open up spaces for the imagination at the heart of existing urban practices, for drawing attention to what could be, and as such his imaginary resonates firmly with those urban politics that are commonly found within relational and interventionary urban aesthetics. Where Wentworth differs, however, is in his concern less with artistic practices as enabling the audience to perform these future possibilities, but more by how he directs our attention to the everyday creative actions that are already happening in the world. And it is precisely this form of modesty, in both the everyday actions of people, but also in his own artistic practices that characterizes Wentworth's imaginaries, both of urban space, but also of his work. Talking of this distributed creativity, Wentworth describes himself as instigator rather than as creator, as "just another person on the street," the project just an occurrence in some part of London; that "gathering an extraordinary set of people, objects, moments, seasons and different times of day together into one place."

This chapter has demonstrated therefore that what is needed analytically is what might be thought of as a hermeneutic understanding of the content of the works, alongside an analysis of the practices by which they are made and displayed. This is a discussion that has manifold value for geographers exploring art and the urban imagination. On the one hand, it continues the work done by urban geographers who turn to artistic practices for their understandings and performances of the politics and ecologies of urban spaces, and the possibilities for these to be made otherwise.[85] On the other hand, it also provides important lessons for those geographers who might wish to deploy artistic and visual culture practices to extend and deepen disciplinary understandings and engagements with both localised specificities of particular places as well as broader epistemological questions around place. In such a context this analysis has reminded us of the need to attend to not only the representational politics of the content of the places we

decide to picture, but also the importance of considering the practices of making and display we employ when we use such creative methods.

Building on these ideas, in the following chapter, the final of part two's explorations of the geographies of artistic production and consumption, I want to turn to consider the collaborative production of the artists' book *insites,* and its role as a methodological means to study the art-site relations developed by the art project *Caravanserai.* In doing so, the artists' book as a means of knowing place and project, enables an exploration of both a vocabulary (visual and textual) and methodology that might be useful in researching and understanding art-site relations.

5 *insites*
On Residency and Collaboration

IMAGINE

Written in grass at the entrance of the Treloan Campsite, Cornwall, UK, was the word "imagine" (Figure 5.1), a shadow grass exaltation to campers and artistic visitors alike to think, act, believe, and feel. This was a call that summed up the creative and imaginative imperatives that sat at the heart of *Caravanserai*, the site-based socially engaged art project located on the campsite. *Caravanserai*'s stated aim, as its artistic instigators Annie Lovejoy and Mac Dunlop describe, is to envision a creative way to engage with issues that resonate with the local area. They want, as the project slogan

Figure 5.1 insites: a notebook (detail a), Annie Lovejoy and Harriet Hawkins, 2009 (image author's own).

goes, to "draw attention to what is on the doorstep,"[1] and they begin their creative practices from a desire to explore the site, rather than to use it as the backdrop upon which to articulate an already formed creative vision.

In response to their site-based investigations they designed, alongside local participants, a suite of participatory, performative, and experiential activities, and a selection of sited works that take more permanent material form.[2] Their intention was to imagine, but also to enact community and the local differently. *Caravanserai* meaning, "a place where caravans or companies of people meet, a place of shared exchange and conviviality," configured, suitably, a calendar of social events—from craft-based activities to local history workshops and environmental fairs—which brought together campsite and local community. These events were so popular that many are now in their third year of what is fast becoming an annual programme. The project's most intensive period of activity to date, and the period of my most focused research, summer 2009, saw a huge range of "community" events, including what Lovejoy calls "do tanks:" workshops based around boat-building, knitting, willow-weaving, hurdle and charcoal making, and raft building for the local village regatta day. There was also a set of events based around promoting local food and provisioning, such as wild food walks and shared meals, and a creative programme that included film screenings, local history and storytelling evenings, and fireside readings during which the whole community was invited to share their work. Accompanying these events, the project developed a series of permanent sited works, including the installation of land poetry, artworks (like *Imagine*), as well as the development of communal spaces, principally an allotment garden.

Evolving from over a decade of Lovejoy and Dunlop's semi-permanent residency at the caravan site, *Caravanserai* is based on their observations, interactions, and co-existences at the location, but collaboration and co-production with local and visitor communities is also vital to the project. Summing up her conceptualisation of the relationship between art and site, Lovejoy keenly emphasizes the emergent relationship between the project and the complexities of the situation, describing it not so much as "in" or "about" a place as "of it."[3] Placing weight on her durational engagement with the site, she attempts to work over those art world models based in the assertion of *a priori* assumptions about place, or the indiscriminate imposition of generic creative solutions onto a location.

Caravanserai is, thus, an excellent example of the model of artist as a "context" producer, as well as (or sometimes rather than) content provider.[4] As a mode of art making, this is entirely contingent upon the insights derived from interactions with human and, although less often acknowledged, non-human others. As such, the project can be aligned with those myriad examples of contemporary participatory art that are based on a vision of de-individuated artistic practices—forms of distributed creativity that, as Kester and others make clear, aim to be to be open, inclusive,

and communicative (rather than individualist, elitist, and institutionally located).[5] The aesthetic objects and land-art style interventions the project made into the campsite landscape, many of which will remain for years to come, have done much to enhance both the aesthetic appeal and environmental ethos and practices of that space. These objects and landscape aesthetics are, however, only part of the story, and it is important not to overlook the legacies of the project events: the communal gathering and the shared purposes; the negotiation, the reimagining, and the creative engagements with space; and the sense of belonging, ownership, agency, empowerment, and self-esteem that these events foster.

In summer 2009, I spent several continuous weeks in residency at *Caravanserai* doing ethnographic research, and I continued to collaborate with Lovejoy during that summer. Over the next few years I spent time observing and participating in some of the project's ongoing events. In this chapter, I want to use these experiences, and the collaborative artists' book, *insites*, that the summer's ethnography resulted in, to begin to explore some of the key issues raised by these increasingly common forms of situated, socially engaged arts practice. What this enables is a set of explorations around what a methodology and analytic vocabulary for these forms of art work, and the study of their relations to site and community, might look like.[6] For, as outlined in the introduction to Part II, as socially situated practices become increasingly common and increasingly politicised, it is important that we parse more closely the ideas of "site" and models of the "social," that these projects work with. Important tasks for this chapter are to outline the research mode that was used to explore *Caravanserai* and to examine the relationship the project develops with site and community; running through both discussions is the idea of residency, which, as I want to go onto explore affords this study manifold dimensions.

Residency

As a stepping off point from which to study *Caravanserai*, the idea of residency affords manifold possibilities. Firstly "residency," in art world terms, frames a set of questions about the artist's relationship to a site of production. As a term it has come to denote a particular, often demarcated, period of time spent away from a normal place of work, to practice in the context of a particular institution, organisation, or place.[7] The reasons motivating such residencies are many; it could be the generic work-space and resources a site provides, or it could be that the engagement and exploration of a particular site is the point of the residency. In the case of *Caravanserai*, residency takes shape as "dwelling" in relation to Lovejoy and Dunlop's own durational, embodied, and engaged relationship with the site, during which the campsite was their primary home for long periods of time.

Further, within the context of their their dwelling at the site, there is the perhaps more conventional artists' "residency" programme they developed.

This programme enables visits from invited artists, poets, writers, craft-makers, and scholars. It was in the context of this programme that my own stint as a geographer-in-residence at *Caravanserai* developed. My residency occurred in blocks of time from a few hours, to several days, and three-week periods over the course of eighteen months, and its the purpose was to catalyse conversations, and explore with Lovejoy the relationship between *Caravanserai* and its location.[8]

To be a "geographer-in-residence" at *Caravanserai* was to invert what are perhaps the normative terms of artistic-geographer relations, wherein artists are resident amidst the spaces and structures of geography departments, or are invited onto geographical projects.[9] Foster and Lorimer capture the tenor and thrust of many of these collaborations (reprising common figurations of the artistic avant-garde artistic) when they describe artistic practices as a disruptive force to the normative practices of these spaces, as explored here in Chapter One.[10] At *Caravanserai* though, I would hazard that the impetus was very different: for, to be a geographer-in-residence was to have the opportunity to think amidst Lovejoy and Dunlop's own creative occupations of place. To work from the middle of a set of art-site relations offered an exciting chance to develop a responsive methodology through which to explore these particular art-site orientations.

The experience of my own residency prompted a set of questions around what it meant to deploy the concept of residency in relation to explorations of art-site engagement. Residency, on the one hand, can be associated with dwelling, and thus with a particular intellectual framework and spatial imaginary that valorises durational engagement and a sense of immersion, and perhaps a rather regressive attachment to place.[11] But, this is an intellectual heritage that is being reworked by recent philosophies of place that find in dwelling not a static mode seeking to tap into and preserve a past, but rather a "rich, intimate way of exploring the connections of place."[12] Developing these ideas in the context of *Caravanserai* suggests that to think art-site relations through residency is to navigate key tensions that sit at the heart of these questions, namely the need to negotiate a tightrope between an over-valorisation of immersion and engagement as inherently good, as set against programmatic forms of production, wherein the artist's *a priori* assumptions and projects are imposed upon a site.[13]

A third understanding of residency concerns its situation as one of the key local issues that *Caravanserai* explored. In early conversations Lovejoy and Dunlop held with the campsite owners, it had become clear that one of their preoccupations was how to "find ways of building links between the campsite and local community."[14] This was primary over other aims such as "building new income streams for the campsite, and finding ways of integrating campers into eco-projects being carried out."[15] As Lovejoy and Dunlop were aware, to cast binarised differences between locals and the campsite community was unhelpful, as were further associated tensions around permanence and immobility versus ephemerality and transience.

For, in both cases, this was to oversimplify the complex temporalities and spatialities of community relations, and equally the solution, as they were aware, did not necessarily lie in sweeping over, and turning away from these tensions. Ahead of unpacking the particularities of the details, and how Lovejoy and Dunlop chose to engage with these issues, I want to spend some time considering the methodology adopted in this research. In particular, I want to address the collaborative production of an artists' book that was an integral part of this research process as well as an "output."

RESEARCHING RESIDENCY

One of the challenges, but also one of the most interesting facets of researching socially engaged practices like *Caravanserai* lies in their reworking of our specular relationships with art. This involves reconsidering the terms and conditions of the visual, and the reconfiguring the definitions of form and aesthetic that they demand.[16] As such, these works pose important challenges to the methodological resources of modern art theory, demanding new modes of interpretation that ask different questions from those based in judgments of form and composition. Instead, key questions become those around art-site relations, and, as the "social" becomes one of the coordinates of a new aesthetic, so the forms of social encounter the works develop become an important point of query.[17]

Exploring the gradual accretion of social exchanges, events, and interactions within and amongst the network of artists, writers, and local community members associated with *Caravanserai* requires a rather different analytic stance and skill set than one equipped to question the physical condition of objects and their production and consumption.[18] What such "socially" based forms of art demand is a methodology and an analytic vocabulary that is capable of addressing the varied temporalities and social experiences of collective, collaborative interaction, intervention, and creation. This includes taking account of verbal and non-verbal encounters that occur amongst the members, the durational commitment of the artist, and the varying temporalities of the individual events and social relations. And this is to retain rather a human-centric accounting of such relations.[19] All of these facets of the work pose challenges to the art historian, challenges that a social scientist is perhaps well equipped to tackle.[20]

In the case of *Caravanserai*, my research encompassed a range of different modes of engagement, from participant-observation and ethnographic research, to ongoing email exchanges with artists and participants, as well as recording and analyzing the numerous blogs edited by Lovejoy and the distributed network of creative practitioners involved in the project. Such an ethnographic engagement with the ongoing evolution of these projects, catalysed here through my residency, leads to the kind of "closer rapport" with practitioner and work that is often considered key to studying these

forms of art, and is identified as often lacking in more "traditional" art historical analytic methods.[21]

Key within this research process, and developing from my ethnographic involvement with the project, was the collaborative production of *insites,* an artists' book that I developed with Lovejoy during the summer of 2009. This book was at once part of the research process, but also had status as an aesthetic output, and was part of project outreach, with copies being distributed to the local community. *insites: a notebook* is a five-inch square, palm-sized, artists' book. Produced in a limited edition of 1,500, it is covered in stiff black cardboard, with the fifty-two pages of photographs, sketches, and text building a discussion of and performative engagement with the relationship between art and site. Aesthetically and conceptually the book consists of two key sections, the first is focused around exploring the different ways of knowing the site that *Caravanserai* involved. The second section, by contrast, is focused more on the ways the project went to work at the campsite, from creating the communal spaces to organizing the events. Each of the two sections is constituted by a number of conceptual sequences, some are very short, only a couple of pages, others are much more sustained, crossing up to five double page spreads. It is a selection of these sequences that structure the core of this chapter's exploration of art-site relations.

Artists' Books

Artists' books have a complex history, encompassing a whole series of different formats and modes, including, perhaps most importantly in this case, the book's documentary potential.[22] Artists' books can be unique, singular forms, or they can, like *insites,* be a multiple—wherein an artist will produce multiple editions of a single work.[23] Some books are standalone pieces, others like *insites,* are situated in dialogue with another piece of work, the latter often an ephemeral event-based work, such as a performance, or as in this case, relational arts practice. The production of this book, was an exercise in learning to explore and articulate the relations between art and site. It was a form of material and expressionistic investigation that was bound up with building a vocabulary for exploring art-site relations that was as much visual as it was verbal. The process of producing the text also enabled Lovejoy and myself to think together around and across the project in ways that inform much of the analysis which follows. As such, the book, much like Lovejoy's engagement with the site, is based neither in claims of a seamless integration with the project and the site, nor on absolute distance from it. Instead, it was understood to produce a space in which we/I could shift between engagement and observation, immersion and reflective distance, and where modes of thinking, engaging, and describing the site and *Caranvanserai* more generally could be developed.

One of the first things to note is that the making of the book became an integral part of the process of researching *Caravanserai* and its relationship

to site. Collaborating with Lovejoy to develop the content of the book—creating and editing the images and the text—was a vital part of my research process. It involved talking with Lovejoy and walking and exploring with her, taking photos and drawing together, swimming in the sea and digging in the garden together, reading the books and looking at the artworks that interested her, sharing articles from art theory and geography, as well as looking back through her a sketch books and reading pieces of written work. Reflecting on the editorial process in the context of using video making as a participatory methodology Parr observed how, "the edit itself was. . . an effective methodological medium through which collaborative meanings and understandings. . . were emergent."[24] The same was true of the process of making *insites*. If generating the material for the book was a process of collecting data on the project and its relationships to site, then editing the material, selecting what we wanted to use, framing and building the narrative through the text, was part of honing understandings of the art-site relations of the project. Further, discussing the aesthetic of the book, its design and layout, together with how its format could shape the encounter with the audience it orchestrated, enabled a form of working with Lovejoy in the midst of her processes, and an identification with and participation within what she considered to be the central dynamics of *Caravanserai*.

A second and important point to make about artists' books in general and *insites* in particular, is that artists' books have become an increasingly common medium in relation to otherwise largely event-based or temporary art forms. It is well acknowledged, as noted in the introduction to part II of this text, that one of the challenges of displaying "situated" works in the gallery space, or at any site secondary to the participatory experience of being involved, is to negotiate the shift in experience that this entails. So called "secondary" contexts of display are often understood in the light of a "reduction" in the experience of the art work, with the embodied, participatory experiences at the site, being only partially captured in gallery-based "picturings" that are based primarily in a visually captured "spectacle," whether the latter is achieved via photograph or video.[25] Little is done, in other words, to convey the nature of participation or collaboration that went on at the site, the result, is a productive tension between the book as a "textual paradigm," and the work of art as an event and as a set of relational aesthetics. Thus, one of the challenges *insites* had to address was how to create in textual form the ethos that underpins *Caravanserai*'s mode of collaborative working.[26]

In response, *insites* does not aim to represent *Caravanserai;* instead, it looks to provide a space both for its exploration, that in place of merely reproducing a suite of images of events and activities at the project site attempts to develop the same sense of generative engagements, contradictions, and possibilities as were found in the course of the project itself. This was not without its challenges, not least because, in contrast to the ephemerality and relationality of the social relations that characterised

Caravanserai, the book's objectness is pronounced. But yet, making use of the artists' book's capacity to be a highly malleable, versatile form of expression we attempted to find ways that worked beyond a sense of straightforward visual or textual representation, in order to re-create and evoke (as opposed to mimetically represent) the sorts of relationships to site that were desired.[27] Within the physically finite space of text and images we sought to create a book that was interactive by nature and in definition, that fostered processes of reading and looking designed to draw the audience into a rich web of associations that were constituted in part by the readers themselves as the volume unfolded in space and time. We wanted the reader to encounter the book, in a similar way that the participants were asked to encounter the site: presenting an open, interactive space, rather than a fixed and closed space of the singular story of experience.

We built therefore, an aesthetic experience that mobilised very different ideas of intersubjectivity, affect, identification, and agency than those we might normally associate with the textual format of a book.[28] We wanted to create a volume that partook of, and developed, the same sorts of creative, generative, open-ended relationships between the viewer and the text as *Caravanserai* attempted to create at the site. In doing so, we draw parallels between the audience as participants of site-specific work, and broader critiques that desire to "activate" viewers and readers, whether of artworks or texts.

Taking cues from key sections of *insites* the remainder of this chapter is going to explore the central elements of *Caravanserai*. It turns first to an exploration of the ways of "knowing" site that were important to Lovejoy, using these to reflect on art-site relations by way of the ideas of residency and dwelling. The chapter then takes up "residency" as a local issue and explores the role of the allotment garden and the craft-based events *Caravanserai* catalysed as a means of addressing these community-based issues. The chapter ends by returning to reflect on the idea of engaging with site and community that the project develops, exploring how Lovejoy and Dunlop embrace the challenges of difference, and the tensions across the community rather than seeking to cover over and turn away from those tensions and differences.

WAYS OF KNOWING

Investigating Lovejoy's way of "knowing place," and how it was she wanted the project to cultivate a relationship between members of the community and the location, was one of the key questions that we addressed in the making of *insites*. The book begins with an extended sequence (Figure 5.2) that foregrounds Lovejoy's commitment to engaging with the empirical specificity of site and situation. Hers, however, is an empirical specificity that takes form in a visual and material assemblage of different ways of

I am in an unfamiliar place... Momentarily what the map tells me bears little sense of where I think I am

(John Newling, Essays: 93)

Figure 5.2 insites: a notebook (detail b), Annie Lovejoy and Harriet Hawkins, 2009 (image author's own).

knowing. As such, the pages of the notebook collage modes of mapping with information about local histories, local narratives, myths and lore, as well as craft traditions. These ways of knowing resonate with key characteristics of dwelling, "a time deepened embodied experience, the experience of rootedness, the richness of things together *over time*, and the valuing of local distinctiveness."[29]

insites begins from cartography, in the form of an image suite that grafts an historical map of the local area over an enlarged colour photograph of the Gramscatho rocks, a mineral complex around 390 million years old consisting of slates, silts and grits, together with the quartzite seams that underlie the locality. The next two pages (Figure 5.3) continue with cartographic explorations, annotating an aerial photograph and including a coastline map of the area. The sequence then enters a new mode, offering a textual and visual elaboration on ideas of deep mapping as,

> attempts to record and represent that grain and patina of place through juxtapositions and interpenetrations of the historical and the contemporary, the political and the poetic, the discursive and the sensual: the conflation of oral testimony, anthology, memoir, biography natural history and everything you might ever want to say about a place.[30]

Visually re-creating this ethos of deep mapping by way of the collage aesthetic the book adopts throughout, the sequence continues. A visual segue of a footpath that bisects the caravan site, extends out from the Ordnance Survey map of the site to lead the viewer across the page, where, by way of quotations from Tim Ingold and others, a conversation is created between mapping, wayfaring, and storytelling.[31] Over the next few pages, cartographic symbols and practices—as enshrined in the OS map—become first combined with, and eventually give way via a visual blending to, other ways of knowing place, whether this be local knowledge of "secret" pathways, or tales of a sea serpent. The sequence closes with a quote from the artist John Newling: "places that seem to exist somewhere between a previous state and the possibility of a new one."[32] For Lovejoy, Newling's discussion, superimposed over images of shifting movements of water and the resulting changes in coastal landscapes, was a way to muse on the epistemological shift of moving from cartography to more local ways of knowing, and toward an assertion of places as unfixed, as ongoing and in motion.

What was manifestly clear from my time working on the project was that Lovejoy celebrates a durational, embodied, and engaged relationship to site. Lovejoy cultivated, and so we tried to create in the book, a sense of the situated, sensuous embodied knowledge of a place that develops around a rich, intimate organic togetherness of beings and things.[33] As the sequences within *insites* frame, the artist's getting to know her site was not only that

Figure 5.3 *insites: a notebook* (detail c), Annie Lovejoy and Harriet Hawkins, 2009 (image author's own).

of facts and figures, myth and lore, but also of exploring and being sensitive to the affective topographies of her location. As she investigated the history of the site, got to know the local people, lived there year in year out, experienced the comings and goings of the campers, got to know the regulars, planted gardens, and presented events, she learnt the microgeographies of the site and peoples' daily patterns of use as well as developing her own.

Caravanserai is thus a product of the durational commitment that Lovejoy and Dunlop made to a shared time and space that forms the underlying structure of *Caravanserai*.[34] This is more, though, than a commitment of time; it is also a commitment of self to the relocation of life into a new neighborhood space for years. For Lovejoy and Dunlop's biographies have interwoven with that of Treloan over at least the last decade. Since 2003, they have had their own caravan at the site, and what began as a cherished space for them to come and recover from work, eventually become the site of some of their most sustained productivity. Coming in the last few years to be in semi-permanent residency on the site, based there during summer months and visiting regularly during winter months, they live in one caravan on the main site "Arthur's Field," and since 2008 have had a second caravan, "the project caravan" that they use for visiting residents. Perhaps most symbolic of the duration commitment and ethos of *Caravanserai*, is the development of the project's allotment garden and the building of pig arcs, thus beginning to cultivate Middle Close, the second of the three fields that leads from the campsite to the cliff path and thence to the village.

Lovejoy is thus engaged in developing art-site relations in a very different way to Kwon's perceptions of "one-place-after-another" relations, or those art-site relations that find the artist to be "out of place."[35] For Lovejoy's role is less one of interloper or provocateur, setting out to produce a counter-mapping of a site, or to expose the contingency of conventional forms of knowledge or identities at work there. Such roles are undergirded by a lack of artistic "belonging" as enabling problematic claims to "reveal," and so to challenge identity. In place of an aesthetics that looks to disturb, expose, uncover or impose, Lovejoy is seeking instead, it seems, to catalyse collective production, and to elaborate on what it might mean to effect some form of transformation in the condition of the site itself.

Questioning Duration

How to formulate the relationship of the artist to place stands as a central question here. For, if Lovejoy's valorisation of a durational engagement with place is key to her work, it is problematic to align this too closely with a relationship premised on being somehow so immersed within a place so as to engage it in a romantic way as "authentic."[36] Critics are divided on how to deal with arts' durational engagements with a place. On the one hand, such relationships are seen as the antidote to "one-place-after-another" works, that impose creative formulations onto a site. On the other hand,

however, Bishop is well known for riling against the repetitive stream of placatory works that she finds to be a product of these durational relations to place.[37] She seeks, instead, something akin to Kwon's "wrong" place that posits a more critical relationship of art to site and place, a reading that engages with site "against the grain," that formulates what she explores, after Laclau and Mouffe, as an "antagonistic" democracy.[38] She argues against the uniform assumption that all relations are inherently good, and that what emerges from relational art is therefore based on comprehensions of community as immanent togetherness, and the ideal of subjectivity as a "whole."[39] In place of Bourriaud's microtopian communities with something in common, Bishop argues for a more politicised account of communication based around relational antagonisms, that replace the unified subject as a prerequisite for community-as-togetherness with an artistic experience more "adequate to the divided and incomplete subject of today."[40] This is a social antagonism that is predicted not on social harmony, but on exposing that which is repressed in sustaining such a semblance of harmony.[41]

A rejoinder to such critical approaches to an artist's durational engagements with site is to consider Lovejoy's residency in the context of the new philosophies and politics of place and landscape that have taken up and developed the formidable intellectual trajectory of dwelling.[42] Dwelling was once most often associated with the terms of authentic rural life, embedded in the land and developed through the toil of those who work, build, and so dwell there.[43] In recent times however, dwelling has shrugged off this association with the retrospective and static, the uni-dimensional, becoming extended to offer the means through which to explore the "intimate rich, intense making of the world, where relations of things and people, fold into practiced formations."[44] As such, dwelling has come to offer a means for thinking place as in process, within which engagements with place become part of a dynamic fluid context, this stands in contrast to a building perspective, wherein ideal human constructs are imposed, built onto the world.

Applying this dwelling perspective to artistic residency develops an understanding of it as involved in thinking and living in a space, as works being formed in the context of a being-in-the-world which in turn effects that forming. As such, then, to be resident, to dwell, is understood as to engage with the interactions at the site, interactions that are always contingent and coexisting with moments of relative integration and immersion.[45] The artist here is less a sole interloper-agent, developing her own particular intervention or imposition; instead, creative agency becomes distributed and negotiated amongst a whole range of participants of the site. For, the mode of perception here is not instrumental, site is not a resource for the enactment of an artist's priori vision, or a goal already in mind, but rather it is engaged via a mode of perception often described as anticipatory and open.[46] It is this form of perception of place that enables Lovejoy to consider the potential of locations around the campsite for reconfiguring social

relations and to recognise the sensibilities and configurations of gesture, inflection, and enunciation that are required to bring the different communities together in space, if not in sensibility, through events orientated around creative practice.[47]

While Bishop may desire an antagonistic approach, to develop residency following these new philosophies of dwelling is less to suggest that the only alternative to overt antagonism is one of smoothing over relations or covering over difference. Indeed, we should guard against any approach that sees the recognition of the relations that sit at the heart of an intimate, rich, and intense making of the world as somehow always "moral" or "desirable." For, such relations can take "bitter, tragic, and contested forms, just as they can take harmonious and hopeful forms."[48] Where we see this most clearly is in Lovejoy and Dunlop's engagements with questions of residency in terms of the local community around the Treloan Campsite. Adamant that they wish to remain open to the generative complexities of a given site they are concerned to be able to recognise the problematics of context, without sacrificing the ability to work productively within the community. *Caravanserai,* therefore engages head on, with all the contradictions that exploring the community threw up for them. It is to these contradictions, and how they played out in the project, that the chapter now turns.

RESIDENT POPULATIONS

Residency was not just a mode of artistic practice in relation to this project, it was also a key issue within the local community, marking a site of tension between the latter and the campsite where *Caravanserai* was based. As Lovejoy and Dunlop note, there has been a tendency to think of the caravan site as having a rather different relation to the location than the village of Porthscatho. If the campsite was understood as a site of transiency and motion, and viewed in a parasitical relationship to Porthscatho, then the latter, becomes, by contrast, a static, continuous site, "original" and "authentic." But, as Lovejoy and Dunlop observe over their decade of engagement with the site this, "easy distinction [between village and caravan site] is disrupted by the many layers of community in which people come and go, stay for different amounts of time, either through desire or need, and are differently in motion through the site of the village."[49] The relationship between campsite and village community is further complicated by the high proportion of local dwellings that are second homes, with absentee owners who largely only occupy the properties during summer months, and leave them vacant for the rest of the year. This has knock-on effects, not only exacerbating the seasonality of employment in Porthscatho, but also reducing the housing stock and raising the prices of what dwellings are available. As a result of rising house prices and rents a number of local people have taken up permanent residence on the campsite.

Aware of these tensions, and working within their midst Lovejoy and Dunlop, rather than taking sides in the discussion aimed, to explore, "the interdependent relationship between local residents and visitors, between village and campsites and between many local networks and societies."[50] In the place, then, of what Kester has described as the "juxtapositional logic of subjects," Lovejoy and Dunlop are not directly combative but neither do they try to smooth over differences within the community, or to somehow overlook the divisions within the local groups.[51] Instead, community and community consciousness, and the tensions within it, are seen and practiced as something to be explored, This was a project concerned—as the following three discussions of sited works, project events, and pages from *insites* will explore—with developing community connections. More complex than a naïve desire to smooth over differences in the social fabric of the village, theirs is an awareness of the malleability of community, as something that could, and should, be reshaped, redeployed, and experientially and experimentally tested by the means of artistically configured spaces and events.

Sited Works: The Garden

One of the key sequences towards the end of *insites* concerns the community garden constructed in "Middle Field" (Figure 5.4). During the process of making the book, we spent much time labouring over what to include in this sequence, for the garden was one of the foundational sites, almost the testing ground of the larger *Caravanserai* project. As Lovejoy and Dunlop describe, working here was a sort of "preparing the ground," as relations were built between campsite owners Pete and Debs and the artists through shared labour.[52] The hours spent choosing a plot, developing it and marking it out, and the conversations that developed as a result, framed and formulated a joint commitment to the wider project. Furthermore, the evocative sense of an ecology of place, and an organic thinking that concerns itself with the interconnection of things, society and environment infuses how Lovejoy and Dunlop write and talk about the project more broadly.

It is a short sequence only two spreads long, but across these four pages, images and text show the development of the garden, from the marking of the plot to the erection of polytunnels and the planting out of the first seeds. The photographs and sketches of garden development are gradually overtaken as the sequence progresses by images of activities around the campsite that focused on the socially productive role played by the food produced in the garden. Within *insites*, and indeed the surrounding accounts of the project, the focus fell on the conviviality of sharing garden produce. Lettuces, tomatoes, beans, root vegetables, and so on form the basis for organised social events, such as community lunches and FEAST, a local food festival held at the campsite. In addition, and important not to

'its got me trying to unravel my thoughts about place

Practical consciousness of a present kind,
in a living and inter-relating continuity. Williams, 1977

We sat at the fire extracting the fibres of nettles, for such tough stems you
would respect sore hands, but the plant exudes a rich nutrient a softening balm

Figure 5.4 insites: a notebook (detail d), Annie Lovejoy and Harriet Hawkins, 2009 (image author's own).

overlook were the quieter encounters, the personal connections made and reinforced by the giving of gifts of produce.

In this context, *Caravanserai*'s garden develops numerous productive possibilities in the passage from seed to table. Importantly, however, we should not overlook the importance of the process of "gardening" itself. For, if the garden has become a popular site of geographical engagement of late, whether this be the community garden, the school garden, the allotment, the orchard or the suburban lawn, it is precisely because of its possibility as a site for collective and individual transformation through practice.[53]

Studies of organised garden projects, from the institutional frame of the school or the prison, to that of activist and community organising, often foreground the practice-based production of individual and collective subjectivities.[54] Gardens in these figurations are the site of intimate and material relationships between humans and nonhumans, but they are also a site where ecologies of place and personhood have been foregrounded, with gardening becoming a practice of individual, social, and spatial transformation.[55] These ideas come together around a micro-politics of self that is an important part of larger social changes and macro-political projects, but also around a politics of becoming in which new forms of subjectivity might be cultivated.[56] A range of theoretical registers have been used to understand these spaces and practices, whether it be a Foucauldian disciplining of neoliberal bodies and subjects, or the possibilities of Deleuzian affective geophilosophies.[57] Crouch's studies of allotment gardening, for example, discuss the ritualised and habitual performances he finds at these locations, exploring how the apparently unremarkable labours and the physical proximities of gardening can have a transformative currency for individual subjects.[58] In a similar vein, we also find activist, guerilla gardening practices considering cultivation in terms of the production of new forms of subjectivity through unexpected shifts in visceral and affective registers. Breaking embodied practices out from their usual, sedimented patterns, such shifts free subjects up to act on other possibilities for becoming. Therefore, to engage with gardening is not just to engage with the material transformations and energy processing that converts seeds, sunlight, and water into plants, instead, we can question, following Kurtz, what else is produced here, what multiple meanings, practices, knowledge and identities where bought to, produced in, and taken away from this garden by its organisers and their participants?[59]

In this light, *Caravanserai*'s garden is not just a source of free food, an experimental site for exploring the latest perma-culture techniques, or a source of produce that worked its way onto the shared tables, the project's fireside sessions and into a whole series of village events. Indeed, as I watched and participated in the working of the garden, tidying, planting, and picking produce, it became clear that it was a space for multiple exchanges. For some campers, it was a site where they or their children could go and let off steam, in some cases it was a therapy space, with people losing themselves and their troubles, at least temporarily, in the repetitive

actions of hoeing, weeding, and raking. During direct and indirect dis-
cussions that I was involved in as I weeded, and worked over the soil, it
became clear that relations and encounters, often with lasting impact were
being formed through these shared working practices. For as productive as
these exchanges were of hospitality, the garden itself was also an important
site of dialogue, with gardening practices enabling communication—verbal
and nonverbal—across community groups that might not otherwise have
met, let alone found connections through shared practices.

Lovejoy's conceptual artistic labour can be entwined, then, with the
pragmatic, applied labour required to develop and maintain the garden.
The labour within the garden is grounded in a practical project, but this
labour is not realised or subsumed solely in the final produce, but in the
participants' own transformed consciousness of self and community.[60] We
could suggest, therefore, that the physical, discursive, and haptic experi-
ences of shared labour amongst Lovejoy, the residents, and the community
members in their design and cultivation of the garden was part of the cre-
ation of a rupture in everyday practices from within which new identities
and shared consciousnesses could emerge.[61] To explore the dynamics of
these exchanges in more detail, I want to take a closer look at the craft-
based events that *Caravanserai* generated, and the commentaries offered by
their participants on how "this helped the community get together."[62]

The Power of Making: Doing/Learning/Making

Reoccurring throughout *insites* is a knotted and woven skein of nettle
string, one length of many made during the course of my time at *Cara-
vanserai*. In one particular sequence (Figures 5.4 and 5.5), the individual
strands take us from the end of one section exploring place and into a
sequence that introduces the sorts of craft-based activities that the project
coordinated, picturing making nettle string, willow coppicing and hurdle
making. This sequence explores the collective efforts at learning, trying,
doing, recording, and transmitting of craft practices that were instigated by
artists-residents, by way of books in the project caravan, but more often
by working and learning alongside members of the local community.

For Lovejoy, this sense of being and learning through doing, was integral
to her ways of knowing, but it also provided her with a powerful metaphor
for thinking through the relationship of art and site, as she explored the
implications of the "weave of work and the weave of the world."[63] Talking
about her arts practices, she observes,

> a way of thinking about responsive arts practice is through an understand-
> ing of context as the weaving together (con- with texture- to weave) . . .
> within this in-habited weave art as a process of doing (intuitive, relational
> negotiational practice) place is implicitly philosophic.. and made explicit
> as past 'doings' evolve into current understandings and explorations.[64]

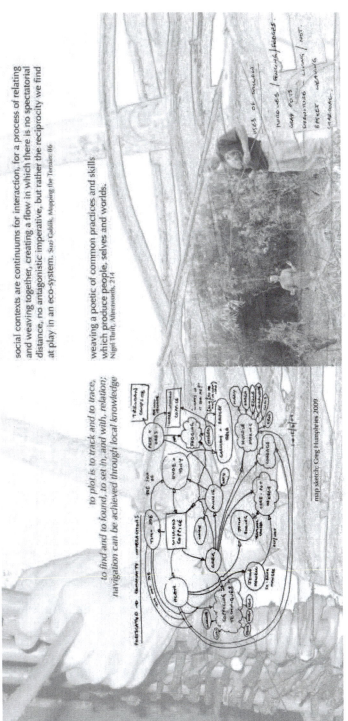

social contexts are continuums for interaction, for a process of relating and weaving together, creating a flow in which there is no spectatorial distance, no antagonistic imperative, but rather the reciprocity we find at play in an eco-system. Suzi Gablik, Mapping the Terrain: 86

weaving a poetic of common practices and skills which produce people, selves and worlds.
Nigel Thrift, Afterwords, 214

to plot is to track and to trace,
to find and to found, to set in, and with, relation;
navigation can be achieved through local knowledge

Figure 5.5 insites: a notebook (detail e), Annie Lovejoy and Harriet Hawkins, 2009 (image author's own).

Figure 5.6 insites: a notebook (detail f), Annie Lovejoy and Harriet Hawkins, 2009 (image author's own).

Art is thus woven with context, in a very material metaphor that sees artworks firmly implicated within the makeup of places, less part of knowing and engaging with a preexisting site, than one of many elements that constitute location. Choosing to foreground ideas around a "being-through-doing," and looking to foster a "practical conscious of a present kind, in a living and inter-relating continuity," the project engages with the ongoing tensions around craft practices. On the one hand, craft practices are still, especially in common formations, associated with a romanticised harking back to an earlier way of life that has been lost in the face of modernisation.[65] On the other hand, the understanding of craft practices that *Caravanserai* engages could be thought of as more akin to recent practices that view craft in the context of larger discussions of the power of making: making as a means of social engagement, and the cultivation of new relations and subjectivities.[66] In their most basic sense, craft practices at *Caravanserai* have a utilitarian purpose; for example, willow hurdles are used as organic dividing screens between campsite plots, as well as as windbreaks for campers and for vegetable plots. As with *Caravanserai's* allotment garden however, there is a need to move beyond output orientated discussions to begin to focus on the relations formulated through the "doing" of these activities.[67]

The penultimate double page spread of the sequence on "doing" in *insites* includes a diagram drawn by resident Greg Humphries (Figure 5.6). Humphries had come to *Caravanserai* on a post-graduate placement scheme from Falmouth College of Art, spending just over a month off and on in residency over the summer of 2009. Here, in a hand-drawn map of sorts, he plots some of the relationships with the local people, places, and practices that he developed in the course of his exploration of his interest in "local" doings. To plot here is to track and trace, to navigate by way of relational knowledge; physical locations are denoted by a square, to which are linked people (in ovals)—Greg, Annie, Hattie—who in turn are connected within a network of activities—coppicing, crab pots, hurdle making—all set in cloud forms. What we find here is an envisioning of relational aesthetics, a reproduction of just some of the myriad relations through which Humphries's artistic practices were constituted.

Fleshing out this diagram with anecdotes and stories Humphries told around the campfire and on his blog, suggests how the process proceeded serendipitously, as connections occurred by chance and contacts snowballed, taking him from one location, one practice and one person to the next. Though local enquiries Humphries learnt of a willow plantation that was overrun, and in the course of acquiring permission to work in this local plantation from its owners, and then beginning to clear the site, Humphries attracted the attention of local resident Allen Collins. Talking to Collins and the community, Humphries learnt that the willow in the plantation had traditionally been used to make crab pots for the Porthscatho fishermen to use, with around 200 being made in the village each winter. As Humphries and Collins learnt to coppice, the last living resident of

Porthscatho familiar with the particularities of local tradition of willow crab pot making and whose father had sourced willow from their coppice, died. Seeking help locally they eventually found someone to teach them the skill in a nearby village. During the summer of 2009 they cleared and regenerated the plantation and in the process coppiced enough willow for a hurdle, a peg loom, some crab pots and a fedge (a French hedge) that could protect the allotment garden from the easterly winds. With older willow Humphries made charcoal for *Caravanserai*'s communal barbecues and banquets. Several years on and they are still removing willow from this site, and last winter started to hold a series of "do tanks" at Treloan to teach campers, local residents and visiting postgraduate art students how to make crab pots "the local way."

Humphries foregrounds these skills as being about an, "experiment in preserving knowledge," and he describes the shared pleasures of watching them "flower and re-live in a community that can value them."[68] But yet, what was important was less, it could be hazarded, the recovery of these skills *per se*, as it was the connections formed by the nature of the "recovery," relations that were as material as they were social. Vital to this process is the nature of craft as different from *techne* or technical written know-how, by way of its cultures of doing and telling, and the importance of the specific conditions of a given site and the aggregated wisdom of its inhabitants over time.[69] So, as Humphries writes next of a set of annotated diagrams describing the processes of willow weaving,

> much can be gained from communicating the method of crab pot manufacture in this way, but really you have to learn directly and practically from someone who knows how to do it. Like so many of these dying skills it is a case of learning through doing. Of making mistakes, being corrected and refining your skills[70]

"Learning directly and practically" became more, though, than just a refinement of material skills and a shaping of material; it was also to bring about changes in subjectivities, individually and collectively. Firstly, Allen Collins observed that "one day that changed my life . . . between them [Lovejoy and Humphries] they have revealed a passion within me to work with raw materials."[71] As Collins continues to narrate the effects of the project and to demonstrate his ongoing interest in working with willow, he describes not just a specific set of skills, but a changing sense of the material world around him and how he can interact with it. From comments made by Collins and others who participated in willow-weaving workshops, the process emerges as a shaping of minds and knowledge with new know-how, as well as a set of changes that are corporeal too, as hands become worn in particular ways, and muscles over time become shaped and sculpted by increasingly familiar routines of work.

In Humphries's case, these bodily transformations were important, but so too were a set of considerations around his changing artistic practice and subjectivity. If Collins's narrative suggests a cultivation of dispositions towards raw materials and their working, then a second set of transformations relates to Humphries' artistic practices. His introduction of "willow coppicing as a living skill back into the Porthscatho community" was not only about the development of a skill set and the production of a particular aesthetic object, it also brought about a transformation in his modes of creation and aesthetic practices.[72] Through his project residency, and as manifest in his diagram (Figure 5.6), we see Humphries reflecting on his role as part of a creative collective, working with, alongside and for others rather than as a sole practitioner."[73]

Important to Humphries, but missing from that diagram, due to the point in the project at which he drew it, were a whole series of community events that propagated from his experience of willow coppicing and weaving. These occasions included specific willow workshops, or "do tanks," focused on skill development such as hurdle making and crab pot weaving, as well as other non-willow orientated events, such as "gathering the threads;" a "make do" meet that focused on a range of textile recycling activities. This collective crafting also extended to a fleece knitting workshop that saw looms set up in the fields during the Treloan summer festival, enabling everyone to participate in the collaborative production of cloth. Reflecting on these events and participating within them, a number of people commented on how they "brought the community together," with many events including a mixture of participants from the local community as well as campsite residents, holiday-makers and people from the surrounding villages.[74] Commenting on their experiences, participants offered thanks "for giving people the opportunity to try something new together," with one noting the events effects of "bonding the village, the people in it and the people that come to visit," observing "I have never seen so much love toward others."[75]

As with the gardening, it was the physicality and shared "doing" that became key to how these craft skills came to have effects on the community. This is a connecting that rests on craft knowledge as discursive and transmissible; skills that can be taught and passed on, and it was in the doing and passing that relations were catalysed. The shared physicality of labour and connections wrought by simply being in the same place at the same time, were enhanced by the shared sense of learning and teaching.

There is much more to be said here about the forms and practices of craft, and about the connectivities it promoted in this and other projects, but, in this focus on the relationships between art and site, it is enough here to recognise *Caravanserai's* creation of spaces where people could work together differently, potentially transforming themselves through that collective labour.[76] It seems these "crafting" events enabled a form of connectivity, a co-labouring physically and collectively that strung connections

between generations living and working in the village. The crafting techniques of interest here are, therefore, less a functioning as a fixed tradition to be recuperated, or even that in coming together to do things opportunities were opened up for cross-community exchange, but rather craft is being put into play here as a cultural practice that can be amended, transformed, and reconstituted. Despite the need for further empirical research on the transformations such collective participation brings about, here, in common with other projects there is a plasticity to craft as a form of social architecture that is being mobilised to reshape village and campsite protocols, to create experiences and events.[77]

WORKING WITH TENSIONS

Describing the different forms of community, engagement, connections, and relations that *Caravanserai* developed might suggest that what Lovejoy was producing was a harmonious community, ignoring as she did so the very real divisions across the communities she was engaging. But, if Bishop desires of art an antagonistic relationship, to refuse such tough, disruptive approach should not be assumed as automatically favoring the harmonious collective.[78] Talking about these issues, and thinking them through in planning the book sequences, it becomes clear that Lovejoy is very concerned, as are a large proportion of the local artistic community, to offer a frank acknowledgement of the challenges faced by local residents. The imperative to guard against falling into the aesthetic trap of reflecting and reproducing the ideologies of the rural idyll, and the romantic imaginary of living and working on the Cornish coastline is an open topic of discussion amongst members of the Cornish arts community. [79] This idyll is not, however, to be replaced, in Lovejoy's project at least, by a sense of pulling back an aesthetic veil to reveal hard times in the local community. Rather, Lovejoy seeks, as other local artists also do, to bear witness instead to the complexities of the social relations within these communities. In this case to acknowledge the contradictory forms of negotiation, recognition and disavowal that mark the different community groups and their needs.

A sequence within *insites*, and one of the earliest to take shape in the design process, focuses on residency as a community issue. The sequence, (Figure 5.6) clearly a function of Lovejoy's durational commitment to the location, begins with two photographs of North Parade in Porthscatho, one taken in 2004, the other in 2009. In the first image, the view is of community land, designated by a district council sign, whose "No Dumping" message has been ironically ignored by the use of the sign to prop up an abandonned mattress. On the facing page, with the horizons lining through, is a photo from the same spot five years later, the sign now reading, "Private no Parking Please." Taken at a different time of year, there are weeds growing around the sign, but the image represents the dramatic shift that the community

has undergone over those five years. The area is a prime tourist destination, and one of the most expensive areas for property in South West England, and every summer its resident population of 900 swells to many thousand. Later pages in the same sequence reproduce part of an article from a local newspaper detailing how the second homes of millionaires now outnumber those of local residents. A local historian puts this figure at 85 percent of the housing stock being used as second homes or holiday lets.

A double-page spread that follows soon after continues to animate this debate by way of a popular local story that was recounted to me on a number of occasions as I worked in the garden and walked through the village, as well as by Lovejoy herself. This story was of a local man who burglarised the empty second homes in Porthscatho and nearby Gerrans, taking only left-over food "cheese, bread rolls, vegetables and biscuits."[80] The same man reportedly walked the thirteen miles to Truro to claim benefits only to be turned away because he had no appointment. The sequence ends with a photograph of a sign that one local resident made for their council house.[81] Reading "Hotel Spendide" the sign is a wry commentary on the effect tourism has had on the social makeup of the community, leaving some residents on low incomes in dated and dilapidated state housing stock, while incomers either stay in expensive boutique hotels or buy up other properties and convert them. Instead of making work that passes judgment on these social relations Lovejoy and Dunlop explore the divisions and differences within the local groups and conceptualise campsite and village space as fluid. Through their events they create the conditions for different gatherings of bodies within the community, not to try to force or coerce social cohesion, but rather to encourage a sense of community consciousness, and the tensions within it, as something to be explored, experientially and experimentally tested and maybe as something that can be reshaped.

CONCLUSION: ESTABLISHING AN ANALYTIC FRAMEWORK

Against a backdrop of the multiple ways that art-site relations have unfolded, this chapter focuses on a rural-based example of an art project that could be situated within the context of what has been called "relational aesthetics." Beginning from the idea of "residency," and its manifold articulations within the project, this chapter has explored Caravanserai's engagements with site. Drawing on a contemporary politics of dwelling that emphasizes connections and relations this chapter has examined the form of social relations that the work develops. In the context of debates regarding these aesthetically catalysed social relations as antagonistic or as working toward the constitution of a harmonious collective, the perspectives on the politics of dwelling proffered here cut in both directions. On the one hand, the artists have no desire to smooth away differences, or to turn away from clear points of conflict, but at the same time they are not looking to make

such points of discord the focus of their work. Instead, their energies are directed toward the configuration of a series of encounters that recognise the context of these conflicts and the social differences that constitute them. There is more work to be done to parse the form and kind of these social relations, and to develop longitudinal studies that explore the effects of these encounters over time.

If one of this chapter's aims was to develop an examination of art-site relations, then linked to this was the need to experiment with and develop methodologies that would enable such studies. On the one hand, this research was informed by ethnographic techniques, by time spent at the site, but what was also deployed here was the potential of collaborative engagements for enabling research in the midst of these forms of arts practices, and for helping to build a vocabulary and a framework for such studies that is as visual as it is verbal. The effect of working collaboratively and ethnographically was to place me in the midst of Humphries's diagram, and in the midst of art as site. This enabled me to explore it not just as the picturing of a set of connections the project operationalised, but rather to think it in terms of the distributed creativity through which *Caravanserai* proceeds. Authorship no longer resides with Lovejoy and Dunlop, but rather with the manifold agencies that the work is constituted from, and that it harnesses, whether these are human, animal, or concerned with the forces and matter of the earth.

Normative discussions of creative agency have tended to settle out in a reductive distinction between authentic avant-garde art practice, wherein the artist retains creative mastery, and a reviled community-based practice that insists on the "debilitating surrender of all claims to authority and authorship on behalf of some naïve ideal of social unity."[82] Under such terms creative agency only retains generative power when it is consolidated in a single individual, once shared, distributed, exchanged, or negotiated within a larger social body its critical acuity is dissipated. The study of *Caravanserai* would perhaps suggest however that creative agency is able to be de-individuated without diminishing either its criticality or its transformative power.[83] This is to suggest that creative insights can still be generated through "less propriety forms of compositional agency, agency that is fluid and transpositional over the course of the processes of creation." As such, it is a function of a range of different comings together at a site, from the material forces and agencies of the earth, to the situated doings and sayings of the artist and others engaged in "producing" the work.

The emphasis thus falls on both research method and artwork alike as acting in the midst of "immanent, material connection between bodies and unfolding, situated practices."[84] In this context, we can understand *Caravanserai* as a thinking of site from the "inside" a following of intensities as they enroll events and objects, and a "testing of various pressures and intensities that go into a site's composition."[85] Artistic practice here is imagined as unfolding, extending through the cumulative experience of moments of

interaction, and negotiation, of conflict and reconciliation. Without wanting to too simply collapse Lovejoy's artistic practices into recent geographical developments in forms of site-based social investigations there are, it seems, a number of commonalities that can be taken forward here as we continue to reflect on and build a vocabulary and set of methods for exploring art-site relations.

Part III

Remapping Bodies
Substances, Senses, Spaces, and Encounters

BODIES IN GEOGRAPHY AND ART

Writing in 1970, Willoughby Sharp, in a now iconic piece for the magazine *Avalanche*, described the exhibition *Body Works* he had recently curated at the Museum of Conceptual Art in San Francisco, California.[1] The essay, subtitled, "a pre-critical non-definitive survey of very recent works using the human body or parts thereof," identifies a series of different ways artists had used bodies, their own and those of others, in their work. Exploring eleven different uses, the essay notes the body as sculptural material, the body as tool, the body as place, and the body as prop. What was key for Sharp was not just the presence of the body *per se*, but rather how artists put bodies to work within their art practices, in short art became an exploration of what human bodies are and what they can do. Bodies thus were not just the subject or content of the artwork, but were canvas, brush, frame, and platform, reworking traditional concerns with self-portraiture in the context of the changing philosophical terms of the subject.[2] Artistic investigations queried, via material and technical means, the ephemerality, contiguity, and temporality of human bodies, overturning essentialist notions of identity and eroding the sense of the physical and mental self as finite atomised forms. Performance, sculptural and digital media pieces, as well as more recently art-science works, interface with debates around messy, fleshy, corporal materialisms, the becoming of human subjects, and open out queryings of body/world relations and encounters.

The project of the body is, in short, one that has dominated twentieth and twenty-first-century art. It has come to be important not only for how artists use and explore bodies within their work—as subject and content, as Chapter Seven explores—but also for the increasing enrollment of the

audience within the experience of the works, presencing them as embodied and agentive beings. In short, and as Chapter Six will explore in more detail, this was to install the viewing subject as a mobile multi-sensory body in space, in contrast to ideas of the disembodied gaze of the viewer. Indeed, from the progressive rejection of "idealist" space and a self-present viewer brought about by classical nudes and marble reliefs, to installation arts' orchestrated configuration of spaces, objects and embodied subjectivities, art has engaged in a critical project to create spaces of distributed agency, action and encounter. The artist's activation of the body does not allow its audience the luxury of an "objective stance," rather it commands a bodily, as well as an imaginative, empathy from its viewers. Developing this idea, Jones and Warr propose a "shared ontology" of body art, noting how the involvement of the artist's body compels the audience to look to, and with their own bodies, as well as their eyes, to feel on their pulses as well as to rationalize and interpret.[3]

The body, once at the periphery of geographical concerns, has, under the influence of epistemological shifts—namely critiques of the abstract and disembodied tenor of geographical research—come to be "very much part of its conceptual and methodological core."[4] The presence of bodies, as "volatile combinations of flesh, fluids, organs, skeletal structure and dreams, desires, ideas, social conventions and habits," within geographical research, is of course not new.[5] Indeed, geography has been engaged in a vast project that maps and remaps bodies, and bodies that are not solely human. Amongst the extensive theoretical and empirical reach of this work are the phenomenological bodies, existential spaces and life worlds of humanistic geography that emerged contemporaneously to the artistic explorations discussed above, and that are recently being challenged and extended by post-phenomenological critiques. Thus amongst the bodies that populate contemporary geography we find; the Spinozean body, a corporeal conceptualisation much beloved by non-representational theorists; the working over of the phenomenological body into the worldly entanglements of the post-phenomenological body; as well as the volatile bodies and vital materialisms of feminist scholars and bio-philosophers.[6] The latter asserting the location of human bodies amongst other bodies in an attention to the forces and matter from which they are composed. Of course, the recognition of the embodied nature of geographical knowledge making has also had a vast temporal sweep, extending from historical studies of enlightenment and pre-enlightenment exploration practices, including some of the ideas outlined in Part I, to auto-ethnographic and historical accounts of the sensory and emotional nature of fieldwork situations.[7]

There remains, however, a number of key questions around "how and in what ways the body is geographical?" and an acknowledgement that "there is much we still do not know about how the relation between bodies and geographies might be understood, experienced or experimented with."[8]

Commonly, following Spinoza, the geographical body is questioned in terms of what it can do, and one of the principal things bodies do, for geographers, and for certain groups of artists, is space. It is through bodies that we live and know space, and I would argue, through art we find the resources to study the form and dynamics of these spatial doings of bodies.

For geographers, the movements, experiences, learning practices, and cultural conventions of dancing bodies have become a key means through which to address a number of corporeal questions.[9] In particular, dancing bodies have formed a crucible for thinking through the relationships between representation and non-representation. Reworking the former as practice, these dancing bodies—whether doing the rumba, executing contemporary choreographies or learning intricate ballroom dance steps–have been part of the broader address to practice-based thinking, embodiment, and the considerations of distributed agency that underpin the far from singular projects of non-representational thinking.[10] Here, I am less concerned with dancing bodies than with the substance, possibilities, and capacities of those bodies put to use in artworks, and the figurations and forms of the body made present by the audiencing of varied works.

Discussion in this third part of the text is concerned to explore how shared artistic and geographical explorations can offer purchase into how bodies can be understood and experimented with. This does not mean that we all have to get up and dance, or in this case make artwork, but rather it is to argue that attending to the artistic use of bodies, and exploring how experiencing art makes our own bodies present to us in particular ways, can aid our corporeal enquiries.

Ahead of the two empirical chapters that constitute this section, I want to address key intersections of and geographical preoccupations with bodies. Firstly, I want to review how the making and experiencing of art offers a powerful means by which to map, and remap, bodies and their geographies. This is a large and complex theoretical field, but the review developed here examines the possibilities art offers geographers concerned with bodily materialities, sensory organisation, bodily boundaries, and excesses, in addition to an exploration of how it is that bodies "do" space. The empirical focus of the following chapters enables elements of these questions to be pursued in more depth. Secondly, I want to intersect discussion of artistic experiments with the body with recent creative and experimental geographies that enroll the body in the practices of geographical knowledge production. Discussion will focus on exploring the limits, demands, and possibilities of such experiments, and examine how it is that the arts have come to form a particular model for geographical methods. This discussion will close by engaging with the demands that such methods place on practices of dissemination and "writing-up," exploring what lessons art writing might have for geographers concerned with writing their research through their body and writing the body into their work.

REMAPPING BODIES

Critical engagements with vision were one of the central tenets of late nine-tieth and twentieth-century art, and paved the way for the wholesale proj-ect of the body that was to come later. Simply put what artistic practices offered was an embodied and material vision that disrupted the reductive understandings of sight associated with European post-Enlightenment rationality; an era dominated by a detached, objective overview.[11] As Cos-grove wrote in the introduction to his book *Geography and Vision*, "the conventional classification of five discrete senses, while intuitively appealing in that they relate to distinct organs and locations in the body, seems to be heading towards the scientific oblivion of the four Aristotelian elements."[12] As he goes on to note, this insight has considerable implications for those interested in spatial cognition.[13] The value of artistic explorations as a means to work over these cartographies of the spaces closest in, remap-ping bodily geographies as a result of sensory and epistemological critiques, has been well recognised by a number of social theorists and philosophers beyond geography.[14]

Geography, challenged by the lingering, modernist sense within the dis-cipline that art is "for the eye alone" was relatively slow to embrace the potential of art within a broader sensory project.[15] Of late, however, there is a recognition of the possibilities of artistic practices as forming a "lab" for sensory exploration, with the picture, the gallery and the installation all forming spaces for encounter in which the human body and the cartogra-phies of its spaces and senses are made available for study.

Interestingly, however, such studies have never been as reductive as to merely reverse vision's hegemony by means of a subordination of sight. Rather, the principal thrust of research has been to explore how differ-ent artworks pose variegated modalities of vision. Common across these accounts is the location of vision within a fleshy, multi-sensory body, and an exploration of the materialities and temporalities of sight.[16] Across these studies we see the benefits of artistic practices as offering the means to enable us to explore the dynamics of a remapping of bodily senses, and a recalibration of the sensory hierarchy, engaging the relations of both the external senses as well as the internal senses. Indeed, as Chapter Six elabo-rates, rich resources are offered for such studies by the spatial and plastic arts of installation and sculpture. Here, artistically created spatial expe-riences are understood as sense labs, enabling us to rethink geography's "argument of the eye," by way of questions of the mobile body as well as the mingling of sight with other senses. To date, geographical studies in this area have examined the "invisible architectures" of sound installation, the place of smell within exhibitionary geographies, or the intersections of touch, vision, and even hearing, in haptic experiences.[17]

Many of the studies of artistic sensory mapping, especially those carried out by installation or environmental works that set out to create sensory

experiences, have focused on the resources offered by phenomenology, in particular that of Maurice Merleau-Ponty.[18] This is in part due to the preoccupations of both art and geography with lived experience, and the historical role of phenomenology within both disciplines (explored further in Chapter Six). But yet, there is something anti-phenomenological about some art practices, and especially those that have emerged recently around the deployment of cutting edge techniques in science and technology in their making. What is meant by the anti-phenomenological here is the sense in which some artworks proffer the means to liberate affects, sensations and percepts from lived, embodied experience.[19] In other words, art has the capacity to engage us with things and experiences beyond how it is we could actually sense or experience them; in short, opening us up to the non-human and other human worlds beyond ourselves. In moving us beyond the capacities and affordances of human bodies, and opening us onto not only other experiences of our selves, but also other beings—machines or animals, for example—artworks deterritorialize us from the familiarity of our own being in the world. As Bryant puts it, our own affects, and affective capacities, are transformed by means of our encounters with art. As a result, we learn to see a bit more of our own blindness, learning not to confuse the world as we encounter it with the world as it is.[20] Both Chapters Six and Seven seek to move in this direction, with phenomenology providing a start point that is soon exceeded, with discussion in Chapter Seven raising issues around the politics and ethics that can ensue from such openings onto the world.

Bodily Substance and Boundaries

It is not just a remapping of the senses that arts' bodily project has investigated, but also a consideration of bodily boundaries, and an increasing awareness of the fleshiness of human bodies, their very stuff and materiality. The abject and formless bodies of Kristeva and Bataille have long been thematised within the art world, often through material explorations of leaky bodies, the porosity of bodily boundaries, and the associated unstable subjectivities and identities.[21] More recently, the potential of such critiques is most clearly realized in interdisciplinary studies of arts' deployment of scientific technologies and materials in the context of theoretical explorations of the being and becoming of bodies in post-human worlds. [22]
In theoretical orientations that risk underplaying the dramatic extensions these works can offer to lived experiences, arts' post-human explorations are often situated as merely the latest development of arts' phenomenological endeavors. The possibilities enabled by digital media arts practices coupled with scientific techniques, for example, enables artists, who in turn allow their audiences, to explore the dynamic intersections of the senses, the "plasticity" of the human brain and neuro-art histories, and nano-scale explorations of bodies.[23] Thus, via shifts in scale, material and

context—using everything from human tissue, to nano-scale "images" of skin—art practices are making our bodies strange to us, mounting challenges to the body as a discrete fleshy container and heightening our awareness of our corporeal vulnerabilities.[24] Materiality is often crucial here, with animal tissues, semi-living tissues and human skin or individual cells all offering art the means for corporeal inquiry.[25] Sterlac, a performance body artist, famous for suspending himself from the ceiling by means of eighteen hooks passed through his flesh, as well as implanting an ear on his arm, positions the body as neither object, nor subject, but as transformable, evolutionary matter in flux, keen that bodies "are made ambiguous and permeable."[26] Often, the experiences orchestrated in the virtual and physical environments art works create propagates an address to ontological questions of the relationship between bodies and worlds.[27]

What this bodily-engaged work adds up to is a concerted exploration by artists of the geographies of the body, and the mapping of its senses, substances and boundaries. This is a corporeal cartography that goes against the grain of accounts of art that assume a purely visual based form of participation and perception, an atomised, separate subject, or even an art based solely in lived experience. As a result, artistic explorations and audiences experiences of the same, offer a rich resource for thinking, experiencing and experimenting with the composition of bodies and their boundaries.

Remapping Bodies: Theorising Spaces and Staging Encounters

In addition to remapping bodily senses and boundaries, we also find in arts' project of the body an ongoing preoccupation, in common with geography, with how bodies "do" spaces. One of the implications of an interest in the body within geography has been a concentrated effort to make more explicit the embodied qualities of geographical knowing, and in doing so to take seriously the claim that spaces and places are always lived "through" bodies. In what ways, McCormack asks, "are cultural geographies also corporeal geographies?"[28] That is, in what ways do bodies participate in the processes through which we make sense of the world both individually and collectively?[29] Art, indeed like dance before it, enables us to inhabit and experiment with the making and remaking of lived spaces in different ways.[30] Thus to undertake research about artistic bodies, and about bodies through art, is not only to think about the spatialities and spaces of our bodies, but to think with and through the spaces and encounters of which these bodies are generative.

Heidegger, in a series of essays and speeches dating from the 1950s and 1960s, explored how sculpture can demonstrate for us how we belong in—dwell—in the world.[31] His texts cumulatively build into an aesthetic theory that is based in a "worlding" of sculptures that affords a sense of how the bodiliness of bodies is co-originary with their worldiness.[32] Space is thus not

an empty container for discrete bodies, but rather Heidegger suggests that the body is shown in its interaction with sculpture, to be already beyond itself in a world of relations. Thus, art and its activation of viewers offers a model by which to conceive of space as a material medium of relational contact, in which the present body occupying empty space is replaced by "something more participatory, collaborative, mediated and welcoming;" bodies thus move past themselves, to communicate and commingle in the physicality of the world.[33] For Mitchell, a Heideggerian scholar, the philosopher's artistic reflections build on his thinking of the limit as that which marks the beginning of the thing not its end. Things, he suggests, begin at their limits, for it is here that they enter into relationships with the rest of the world. The "limit" here is not a border of containment or confinement, but one of introduction, tying the thing into its surroundings.[34]

Heidegger offers us but one example of philosopher's use of art for thinking body-space encounters and being in the world, but artists too have often put philosophers to work to think through body-art-space relations and develop conceptual and material vocabularies through which to explore these. Chapter Six explores one of these intersections in more depth when it takes as its start point 1960s minimalism's conceptualisation of arts' "extended situations" via Maurice Merleau-Ponty's thinking of the relationships between bodies and lived worlds. The philosopher's early work became an important part of artistic understandings of the embodied, ontogenic relations between bodies, artworks, and sites. What geographical studies that utilize artistic practices and work in a number of ways have too often failed to take account of is that, in many cases, the thinkers, theory and concepts that we take to our analysis of the art works, are ideas that the art world has already thoroughly involved in the development of its ways of working.

Where geographical research on art has made its most significant inroads into questions of art and spatial encounters, to date, has been in studies of artistic and audience experiences of landscapes and urban space. Key here is research on the sensuous, psychic, and subversive urban engagements of Situationist International, and work made in the shadow of this group.[35] Examining art "taking place on the street. . .exploring and intervening in the city" through guided walks, maps or ludic activities these studies take [urban] space "seriously as a sensuous realm that is imagined, lived, performed and contested," at a time when resources through which to accomplish such embodied, affective understandings were far less prevalent than they are now.[36] If minimalist artworks can be critiqued for their installation of a naïve, ahistorical or depoliticised phenomenological subject, focusing on "natural," "pre-given" embodied subjectivities, then these more socially situated projects clearly negotiate the embodied subject in other ways.[37] Butler's study of "listening" to urban landscapes, for example, posits a consciousness of sensing that is simultaneously social, political, historical, and experiential.[38]

Walking in these works becomes connected to creative concerns to read, understand and remap the geographies of the city and our corporeal relations to it. Pinder analyses a sound art piece by artist Janet Cardiff that literally takes place on the streets, finding meaning through embodied enaction.[39] Through the embodied experiences of urban space configured by the work alternative epistemologies and urban imaginaries emerge. The sound piece is understood to engage with the condition of the city, and is able, in doing so, to retain a sense of plurality, of a multiplicity of stories. This is no simple sense of the inter-connectedness of views and voices, it presents rather, the need to appreciate how urban experience involves engaging with a multiplicity of perspectives, precluding any "simple linear narrative as information and memories jostle amid a shifting present."[40] But this is not just about rendering cities differently legible, but also about how these works come to speak of "the difficulties of reading and knowing the city" where representation "has been thrown into doubt and become a focus of anxiety."[41]

If "experiencing" art enables us to attend to ideas of space and the body's empowerment and entrainment within space, we can also consider how the act of "making" art can accomplish similar conceptual work. We see this clearly in Crouch and Toogood's study of the embodied, everyday knowledge of abstract artist Peter Lanyon.[42] They examine both his paintings and writings to reflect on his immersion in place though bodily exploration of that experience. Painting is posited here as geographical knowledge making, and as "a continuous process fed by sensation." This is to rework the distanciation of visual knowing of the landscape, and in its place produce a "tactile knowledge" that opens up the place of corporeal presence in geographical knowledge. In their account abstract painting becomes the means to reconcile the contradictions of self-immersion in sensation and experience with the political concerns of Cornish culture, place, and identity. This is a geography they emphasise as being made with both feet, generating knowledge through personal experiences of places that include people and lives as they were inscribed upon the land. This is a walking that enables an unfolding experience of landscape, but it is also a standing and feeling on the earth, "the coarse grained imprint of the foot, as the ground rises and falls, supported or contradicted by the experience of balance, and in turning, sweeping the body along, bending, rising, making new contacts and connections with the immediate place."[43] This is an art "constructed out of experience and returns to experience" bodily-informed knowledge sensing changes in the land's surface.[44]

Art thus proffers a rich way that geographers can respond to calls for "the cultivation of a mode of perception that dwells in the midst of things." This is to posit both the making and the experiencing of art as holding within it the potentials for refiguring the spatialities of the body and its environment. Art, therefore, as able not only to open up, but also to create, new spatialities and temporalities that carry with them a potential for

creative encounters with the affective, precognitive and non-representational aspects of the world. Art then becomes one mode of producing the "thinking spaces" that enable geographers to take seriously the onto-generativity of moving bodies, helping us to grasp and to investigate the lived, concrete, immediate fleshy actuality of bodies and the possibilities opened up by moving beyond them.

RESEARCH AND WRITING WITH THE BODY

Bound up with the shared possibilities art offers as an empirical focus *for* research on the body, is the role that art's body project takes in enabling a querying of the body as a tool *through* which research is done.[45] Geography was long argued to be methodologically emaciated in regard to its own bodily project, "[w]e simply do not have the methodological resources and skills to undertake research that takes the sensuous, embodied, creativeness of social practice seriously."[46] Geographers were lambasted (by geographers) for an "unwillingness to experiment with techniques that go beyond the now canonical cultural methods: in-depth interviews, focus groups, participant observation of some form or other."[47] As Paterson notes "getting to grips with unusual bodily sensations and subsequently attempting to articulate them revealed [s] both epistemological and methodological difficulties."[48] Indeed, as Mike Crang observes, there had long been a significant gap in geographer's learning through the bodily sensations and responses that occur as an inevitable part of the embodied experiences of the researcher, catchily, he suggests that "touchy feely" techniques have perhaps not been touchy feely enough.[49]

In the intervening decade, however, there has perhaps been some corrections made to this gap in methods for studying the senses. If a range of visual culture techniques from photography to videography have grown to accompany (auto-)ethnographic accounts, then there is also a sense in which, as discussed in Part I, arts practices too have been found to offer a model for alterative methodological engagements.[50] For, if the body has become an important instrument or tool within the researcher's tool kit, then the particular value of practicing the arts—whether this be dance, drama, music, or indeed experiencing of artworks—is in their positing of the body "directly in the field as a recording machine itself . . . knowing that writing these nervous energies, amplitudes and thresholds down is feasible, as such jottings become legitimate data for dissemination and analysis."[51]

While there is still a long way to go in geographer's sensory studies—including studies of the internal somatic sensations, and the "sensuous dispositions" that attend to the new ways of feeling that arise from intersections of technologies, disciplines, and practices—it seems that a certain level of competency has been achieved.[52] And that the practice and experience of the arts has played an important role in moving beyond the much maligned

limits of current methods and their implication within a scientistic episte-
mological stand point. What has perhaps been less addressed, and as Pat-
erson and others make clear, comes hand-in-hand with these methods and
their theoretical situation, is the demands of writing and expressing these
sensory investigations.

Writing Bodies into and through Research

One of the outcomes of the investigations and experiments on and with the
body in geography, and in art theory and practice, is a heightened atten-
tion to writing practices—to how it is that we write these research and art
encounters. A growing number of geographical texts are turning to, if not
a form of "creative" writing, certainly writing practices that aim at the
expressive and experimental in their format. One of the intentions of these
practices has been to install within writing the "space time, spacing-timing
experiences" of everything from dance workshops, to musical instrument
playing, to experiences of landscape, urban exploration and arts practices,
to, in short, "enliven the repertoires of ways in which geographies are cre-
atively enacted."[53] Such aesthetic and embodied practices of writing, like
those of any writer enact space too, they "performativly contribute to the
stretch of expression in the world . . . to foster and inflect it rather than
trying to own it . . . to enter the stream to contribute to its probings; this
is co-creative, an artistic endeavor.[54] We are not, in short, outside space or
the research situations we engage, but are slab bang in the middle of them.
Thus, it is fitting for us to think hard about how it is we might write up
these accounts so they engage such a situation rather than, reproducing in
our writing practices, the very epistemological distancing that we are try-
ing to work against.

In an emergent body of texts that reflect on art writing we find a similar
reaction against the production of "dry and distant texts" that write out
emotion and affect in their accounts of the experience of art.[55] In their
place, these texts performatively install an art-writing that experiments
with styles and textual forms that enable the researcher/writer to evoke the
ambiguities, complexities and durations of "looking" at and experiencing
the art under study.[56] In response to her idea of arts' "interactive principle,"
Bal, for example observes that art writing should be centrally concerned
with the *work* that art does in the encounters between artwork, audience
and world.[57] Good art writing, should, she continues, lead the reader back
to artwork, not try to be a substitute for these objects, but to unpack facets
of the work, and point out other dimensions of the many ways of think-
ing about each art piece. Bal wishes to move art analysis beyond bounded
questions of art historical linage to a querying of what it is that a work is,
means and does, in a present time of viewing. For her, an openness to the
work of art being "social as well as the emotional, cognitive and affective
processes" is the "the most adequate subject of art-writing," and it should

replace frameworks that only contend with questions of iconography, connoisseurship, or contextualism.[58] Bal argues, that critical writing practices need not only to engage with what we see, but also with the kind of seeing, or experiencing that is involved in thinking about artworks.[59] What emerges is a form of aesthetic awareness that informs writing practices and requires that we bring together, within both analysis and writing, body and mind, viewer and work.

To explore such modes of writing is to turn away from the idea of "writing up," and rather to develop forms that are less orientated towards capture and a sense of a straightforward presentation of ideas and evidence. Some geographers have turned to alternative technologies of representation, such as film, to create an "apparently more embodied experience there and then in the time and spaces of presentation."[60] But yet, this is to somehow suggest of images something more than words, but perhaps it is more useful to acknowledge that like words, the registers through which images are understood can be shifted such that, like words, images are less fixed containers for ideas than forms of expression.[61] This is therefore, to experiment, as *insites,* the artist's book in Chapter Five did, with "different . . . modes of expression (. . .), ones that *apprehend* rather than *represent* the world, modes that employ the full range of senses and evoke the kinaesthetic character of a being in world that is always becoming."[62]

Humanities and Social Science scholarship offers a wealth of experimental writing practices to explore. This ranges from the *écriture féminine* practiced by feminist scholars, through to the rise of auto-ethnography and the sensuous scholarship of anthropologists, as well as the growing prevalence of more general creative and experimental writing, sometimes "info-writing," across geography.[63] In the latter work the prose essay becomes a textual playground, often shifting between critical theory, fiction and autobiography. The footfalls of "sentient topographies" and a careful attendance to at times unruly things, develops an intermeshing of styles which foregrounds the interplay of writing positions, subjects and contexts.[64] Poetic forms and lyrical statements evoke intensities of affects and percepts, creatively conveying encounters with landscape, materials and multiple subjects that have been configured by coordinates of "motility, materiality and mutuality."[65] Bound with the poetics of such practices is often an insistent politics, albeit one that is quieter in form and impulse than many representational politics. For, from these writing practices often emerge diffuse and unsteady articulations and entanglements of self and research subject.

Taking a rather different stance towards a politics of writing Jane Rendell, in her book "Site Writing" argues for writing, like critique before it, as a thoroughly spatial practice.[66] She calls for a putting of the sites of engagement with art first, rather than the art-works themselves. As a result, the practice of art writing, and indeed critical writing more generally, becomes one in which engagements with the "material, emotional, political and

conceptual" sites of encounter, in this case of an artwork's construction, exhibition and documentation, are the focus of attention. This is to develop "a site writing project where the boundary between subjects and objects is more porous and arguments are made not only directly, but indirectly, through association and implication."[67] Rendell performs this by way of a psychoanalytically informed field of practice that oscillates, in a far from defined way, between the stance of critical writing on works authored by other artists, and her own "creative" writing and curatorial practices. There are numerous other possibilities here for geographical writing practices, whether concerned with art, or otherwise that seek performativly to put the conditions of these encounters at the heart of their theoretical and stylistic endeavors.

In their varied form these explorations demonstrate how we can think harder about how it is we write about our engagements with art, and how it is we might begin to take account of spatialities and affectivities, and the "event," of creative writing practices themselves. As such, the form and style of the writing itself takes a greater part in theoretical practices, whether these concern art, or are about the more general deployment of critical-creative writing practices within geography. In querying art and art writing, and in pondering the methods for thinking through embodied, affective encounters with artworks, these investigations have wider impacts. These impacts concern not only geography's creative writing practices, but also the terms under which the discipline experiments with a broader arsenal of creative methods as part of its expanded field. [68]

In the two empirical chapters that follow these questions about writing are addressed most clearly in Chapter Six, which explores how experiencing artworks can activate bodies, enabling a thinking-feeling exploration of the body in which artwork forms a kind of sense lab. The chapter takes the form of a narrative account of an experience of an installation created by the artist Tomoko Takahashi. The account binds creative forms of auto-ethnographic reflections on the installation experience, with critical and theoretical reflections on that experience and what it could contribute to our thinking-feeling of space, and to geography's "argument of the eye." Chapter Seven focuses on how the performance-land artist Ana Mendieta uses her body, or a maquette of it, in her earth-body works. I am interested here in how the encounters the artist stages and re-presents between her body and the landscape, enables a querying of the relations between the materiality of the body and the animate matter and forces of the landscape and environment.

6 The Argument of the Eye
Installation Art and the "Experience of Experience"

ENCOUNTER 1: MY PLAY-STATION

From across the even green lawn of Kensington Gardens, London, I can see the Serpentine Gallery, a 1934 tea pavilion banked on either side by large French windows opening onto the clean-paved terrace that runs the perimeter of the building. Historically a place from which to view the landscape and to be seen in and by society, today, as a gallery of contemporary art, it is a site at which vision is regularly disassembled and reconstructed on other terms.[1]

Making my way across the gravel path, I pass beneath the gallery's pediment and a few minutes later enter the installation. In this artist-created space, focused eyes move across an expanse of amassed objects with a pressure, scope and periodicity more tempered, spaced, and intense than before. I do not so much gaze on this artwork as an empirical object; rather, I experience it as I move through the series of spaces that make up the work.
Each time I enter one of the installation's four rooms—Garden, Kitchen/HQ, Reception, and Office—I am assaulted by a material mass of objects: an unsettling visual profusion of forms, colours, and texts. I am aware of myself amidst objects: I see encounters between dinosaurs and cows; soldiers act out accords with skittles, fences and gates knot in mutual support; planes arrive amidst trucks, boat hails baby bath. At times, objects seem to forgo their atomised, solid state. Materiality becomes multiple and fluid as objects pool, flow across the floor, and gather in corners or collect beneath tables. The streams of cards, books, and games converge, flooding into one another and engulfing the gallery, lapping at the walls, overwhelming the imagined confines of the artist's chalk floor marks. At times, I feel corralled by things: forced into doorways, along paths that form islands within the objects. These routes are never narrow or precipitous, but somehow feel so. This sense of precariousness seems to wrong-foot me. I navigate wearily. Bending over, straining to glimpse a snakes and ladders board, I feel unsteady, never really but almost tumbling into the mass of objects barely confined at my feet. There is a density of objects and of experiences that evades description, the state of mind it fosters is inconclusive, precise

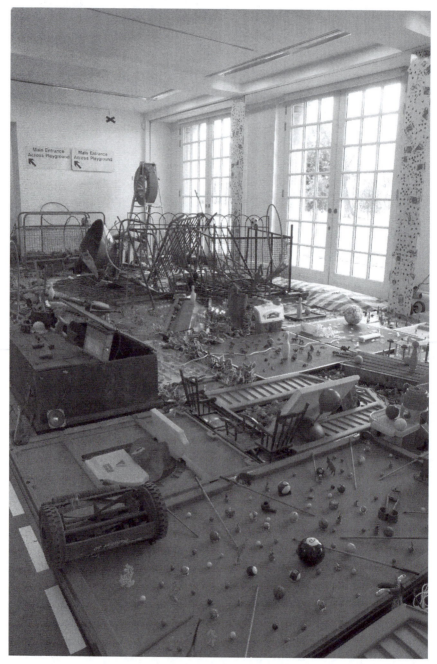

Figure 6.1 My Play-Station, Tomoko Takahashi, 2005 (image courtesy of the artist, the Serpentine Gallery, and Rosalie Doubal on behalf of Miss Varind Ramful).

impressions can slip away as soon as registered. A sharper but somehow more effervescent consciousness emerges.

GEOGRAPHY, ART, AND VISION

Vision has long taken a central place in geography's imaginary of itself as a discipline. From Mackinder's description of the discipline as a "special form of visualization," to millennial questionings of "how exactly geography is visual?" we witness the power that the visual holds.[2] But yet, these more recent attentions to the visual come on the back of the assertion of the "empire of the senses," the outcome of at least a quarter century of critiques of vision's hegemony and its accompanying epistemological associations.[3] Indeed, in recent times, to assert that geography is a "peculiarly visual discipline," is to be firmly aligned with the varied critiques of the visual—e.g., post-Enlightenment, aesthetic, feminist, and postcolonial—which went to work to bring about an epistemological overhaul in our sense of sight.[4] Thus there are a series of research programmes across the discipline—studies of power/knowledge within critical cartography, ways of seeing within techno-scientific geovisualisation, and questions of representation and embodiment in landscape and art—that challenge the associations of vision with the "god's eye trick" and which reformulate our sense of sight.[5] Across these varied research projects, discussions of geography as visual are brought together with explorations of visualisation as something geographers do and have done. But yet, there is still more space for thinking about what the "visual" is. For, whether studying the visualisation practices of others, interpreting visual cultures, or producing visualisations, exactly what modalities of the visual are informing these analyses has been, and remains, key.

In this chapter, I return to art as the means to engage with geography's "argument of the eye" and to open up some of these questions in light of reconfigured understandings of sight.[6] Landscape art has long proffered an important empirical entry point for engaging with the gaze, whether this be cast in terms of the Marxist duplicity of the landscape or feminist interventions into the masculinist politics of such oversights.[7] Studies of abstract painting, from Briget Riley's colour field Pop Art, to Peter Laynon's British landscape abstracts, have further complicated the nature of a disembodied gaze, while research into photographic practices has offered the means to materialize and temporalize it.[8] In this chapter, the experience of encountering the installation *My Play-Station* (2005) by artist Tomoko Takahashi, a description of which opened the paper, returns us to art as offering a purchase point into geographers' critical accounts of sight. I am interested in exploring the modalities, techniques and economies of vision that the installation makes present, as well as the figure of the subject that such an account of vision demands. For, if the god's eye trick rested on a detached,

separate coherent subject, then these modes of vision bring with them alternative formulations of the seeing subject. This chapter explores what such a worked over account of vision might look like, it examines the role art can play in developing such an account of vision, and further, queries the sorts of methodological approach and writing practices that might be useful to adopt in pursuing these questions.

Activating the Viewer

Installation art has much to recommend it to the geographer. Not least, that to experience an installation involves installing one's body and in particular being installed as a body, twining together spatial politics with an embodied visual politics. Claire Bishop, describing an "active" installation art suggests it, "differs from traditional media (sculpture, painting etc.) in that it addresses the viewer directly as a literal presence in the space. Installation art presupposes a viewer whose sense of touch, smell and sound are as heightened as their sense of vision."[9] Three trajectories coalesce from within key research on the history and development of installation art. Firstly, that installations aspire to the formation of a more direct relationship between the viewer and the work of art, as Bishop's description above suggests. Secondly an installation often presents itself to the viewer in fragments. This frustrates the sense that the piece can be seen all at once, and suggests rather that it must be explored and examined in a process of engagement that is primary to the "activation" of the viewer. The third common trait associated with installation art is the use of found objects and materials to create the environments the artist wishes. Whilst I have explored the latter with respect to Takahashi's work elsewhere, in this chapter I am concerned with the former two traits, and the critical spatial sensibilities instigated through this configuration of bodies, spaces and objects.[10]

To read the history of installation art and its development throughout the decades since the 1960s is, as the first two traits outlined above suggest, to witness emerging dialogics between artist, viewer and artwork. Whilst, on the one hand, and as Part II has already outlined, we can understand the history of minimalism's disruption of the autonomy of the art object firmly in spatial terms, on the other, we can understand that history as laying the ground work for installation's activation of the viewer. For within minimalism's critical project of artistic production and consumption sits the aim to install the audience within the gallery space: to bring into the consciousness of the audience an understanding of the experience of art grasped not as a solely intellectual act, but by the complex perception of the body as a whole.

As Bishop summarizes, "many artists and critics have argued that this need to move around and through the work in order to experience it activates the viewer, in contrast to art that simply requires optical contemplation (which is considered to be passive and detached)."[11] Bearing

with, for the moment, that perhaps unhelpful dichotomy, according to this analysis the act of "entering" the work of art is sufficient to enable a movement beyond art consumed through "optical contemplation" to form an "active subject." But yet, entering an installation does not, in and of itself, necessarily disrupt viewing as a principal mode of reception, and as such there is a risk of overplaying claims to the creation of an immersive, embodied, multi-sensory spectator. Further, what is also often overlooked in these discussions is a more complex engagement with the mechanisms of vision and the idea of the subject that is "activated" by the installation. Indeed, whilst nuanced questions of the modalities of vision and modes of spectatorship are not uncommonly addressed with respect to Dada's anti-retinal stance, as well as in considerations of embodiment and immersion with respect to digital media art, and sound art, these questions have tended to be overlooked in studies of installation art.[12] To engage with these mechanics is to explore the terms and conditions of installations' active seeing subjects. This is a move that gains specific importance when we consider how the active viewers of installation art have often become the ground upon which scholars move to consider how art practices more generally can convene active engagements within the social-political arena.

Such an understanding of installation as offering an "experience of experience," of art as bringing us to our senses, is central to this chapter. This is to explore how artworks encourage us to feel and experience in specific ways, and in doing so involve us in the material production of our own subjectivities. Understood thus, artworks call a certain form of spectator into being, and it is the form of this spectator that I am interested to explore here. If the experience of installation art is one of the breakdown of the autonomy of artwork and space—firmly interweaving viewer, space and art—then the question I want to ask here is what sort of sensing, seeing subject is being brought into being in this process?

Becoming a Seeing Subject

"Immersive" is a descriptor often applied to installation art, and it is in the midst of the installation's instigations of the enfoldings and accumulative immersions of bodies, artworks, and surroundings that this chapter's argument unfolds.[13] The phenomenology of Maurice Merleau-Ponty has long been a touchstone for understanding the immersive nature of installations, whether this be for theorists of contemporary work or art historians looking to minimalism.[14] Of particular importance has been the philosopher's key text *The Phenomenology of Perception* (1945), wherein it was argued that we come to know ourselves, and the world around us, in relation to our own bodies. Indeed, it was argued by Krauss, that for minimalist artists in the 1960s this "became. . .a text that was consistently interpreted in the light of. . .ambitions toward meaning

within an art that was abstract."[15] Whilst Merleau-Ponty's philosophy is most frequently associated with painting (especially Cezanne's work), for sculptors such as Robert Morris and Richard Serra his work offered a solution to the failure of the disembodied eye, and to the Cartesian insistence of an empirical distancing between self and world.[16] As such, it helps to account for the complex relationship between the environment and our embodied being in the world.

In the establishment of a relationship between space, sculptural object, and viewer, a relationship Fried was famously to denounce as art's "theatricality," Merleau-Ponty's work was to become key.[17] Robert Morris recommends the latter's text to Fried by virtue of its assertion of the kinesthetic and tactile dimensions of experience, Morris cites a key passage in a letter to Fried, "our own body is in the world as the heart is in the organism; it keeps the visible spectacle constantly alive, it breathes life into it. . .and with it forms a system."[18] In describing sculpture's formulation of an "extended situation," Morris notes that,

> the better new work takes relationships out of the work and makes them a function of space, light, and the viewer's field of vision. The object is but one of the terms in the newer aesthetic. . .One is more aware than before that he himself is establishing relationships as he apprehends the object from various positions and under varying conditions of light and spatial context. [19]

At the time such understandings of the relationship between a sense of sight and the body, and between body, art-object, and exhibition space, challenged the dominance of Clement Greenburg's formalism, and undercut arguments regarding the rhetoric of the optical within art history and practice, overthrowing that idea that art was understood as "for eyesight alone."[20]

If Merleau-Ponty's phenomenology has been important to recent geographical work on the body, these studies have tended, in contrast to previous humanistic geography (and minimalist art and theory), to move beyond the philosopher of *Phenomenology of Perception*, wherein we see the sensations and experiences being "given" to a centered, embodied subject.[21] Critics have considered the latter to offer merely the re-situation of a disembodied eye-mind into a kinesthetic, perceiving fleshy body.[22] In the place of such a pre-given, natural subject, coherent, contained, and upon which the existence of sensations relies, Merleua-Ponty's later works, as well as those of his critics—principally Irigaray and Deleuze—offer us other opportunities.[23] The most important of which, in relation to this chapter, concern the need to work over a sense of the coherent embodied subject, and to challenge the perhaps rather over-simplistic tendency to place a detached contemplative mind into the fleshy container of a feeling body. Such a re-anchoring of the subject into a

situated, contained body creates a coherency that the experience of the installation explored here calls into question.

The remainder of this chapter is structured through four further encounters with Takahashi's installation that will unpack some of these ideas in more depth. As the exploration of the installation progresses, the discussion tracks from the detached contemplative subject that the piece pulls into existence and then frustrates, towards the phenomenological understandings of embodied subjectivity: in other words, a lived world of situated bodily beings. But yet, even as the experiences of the installation replace the disembodied gaze with embodied economies of looking, vision simultaneously becomes incorporated within conceptual and historical fields: to move through the installation is to move towards an en-cultured sedimented subject, and so to move away from a primordial state of sensory innocence. Further, however, this figure too becomes inadequate to the experience, for as the closing stages of the argument outline, the experience of the installation refuses the presence of a centered, coherent sensing, immersed subject, demanding instead a subject that is less clearly defined and demarcated. From amidst the critiques of the visual rhetorics of the art gallery emerge inter-corporeal relations and subjects that come to be, modes of subjectivity that propose the mutual permeability and the mutual creation of self and other. Ahead, though, of the empirical discussion, it is worth reflecting a little further on the methods and writing strategies that will be used throughout the discussion.

Researching and Writing the Body

I went to the installation to research ideas of rubbish, but as I spent more time there the force of the experience focused my attention elsewhere. Engaged as an embodied subject, my body became both the "instrument of research," and its subject.[24] The feeling was akin to the reversal of terms Thrift countenances when he flips "participant observation" to "observant participation," implying in that movement an empirical involvement with practices, embodiments and materialities.[25] The effect is to foreground an attention to immediate experience in the practice of a suite of "localised tactics for research that operate [s] in close proximity to its object either by tracking and questioning intently the role of object-to-body relations themselves and/or more precisely because it is achieved through the body itself."[26] This is to take the body very seriously, and to try do so with a "microscopic intensity and attention to its borderless and controlling fluidity that unfolds it and continually places it within the ecology of its material surroundings."[27] Indeed, the focus and sense-making of this mode of research comes from thinking through explicit bodily dispositions, such that "the body is definitely thought through and present in the research itself as the locus of sensory

appreciation prior to the resultant sensation's interpretation via exist-
ing knowledge, discourse, practice and bodily discipline that structure
somatic experience."[28]

But, it is not just that the body is present in the processes of research
that arguably needs to be acknowledged here, for accompanying these
methodological developments are challenges to the academic condition-
ing of response and engagement. Geographer's often post-rationalised
accounts of a range of "in the moment" experiences of, for example,
landscape, rock-face, and sea-scape, come to be written through the
body, and in that process of inscription, the body is written into and
through the accounts.[29] Such "wordings of worlds" are performative,
in that they write into being experiences themselves, reaching toward
evocative accountings that both detail scene and experience, and "push
at words to evoke for the reader some of those experiences."[30] Thus, to be
responsive to the particular experiences of the installation is to attempt
a writing style that moves towards a similar orientation to subject and
text, exploring how to evoke the inter-corporeal combinations of the
installation's material, symbolic and sensuous elements within my criti-
cal accounts. As a result, this is less an act of writing about an installa-
tion to describe and tell it, and more the practicing of a writing that is in
relation to, and in dialogue with the piece, a form of writing that is in its
own way creative and productive.[31]

Vision and subjectivity become entirely entangled through the embod-
ied-writing as style practiced here. Hailing the legacy of the performa-
tive writings of feminist philosophers Helen Cixious and Luce Irigrary,
writing itself becomes a site for the exploration of a multiply produced
self and an historically located and embodied consciousness: a sensing
subject that is written into being alongside the experience of the instal-
lation.[32] Successfully executed, such embodied inscriptions allow for
notions of subjectivity, presence, absence and agency to be explored a
little less encumbered by humanist baggage. For, as subject-object bina-
ries collapse, so too does the notion of an *a priori* locus of being and
intentionality, and alongside this, the individual, detached subject. As
a result, within the critical intimacies of such accounts, room is made
for the play of differences and space is carved out for a multiplicity of
reading positions. These attributes of writing are vital, for there are,
as we shall see, displacements within the field of vision. Herein lies the
further value of such writing practices, for, with the critical intimacies
of embodied writings comes a double bind: the negotiation of simultane-
ously producing, but also, vitally, destabilizing presence. For such writ-
ings formulate a deconstruction of the certainties of metaphysics—of
truths—in the same maneuver with which they are inscriptions of one's
being-in-the-world, allowing for the dethroning of the mastery of a sin-
gular textual account.[33] But such a strategy is also to try to write, at

once in the context of theory, but also against the direction of a given set of ideas, against the sense of wanting to align, to triangulate too easily and neatly a relationship between experience and theoretical telling. The imperative instead, is to try to explore, to excavate slippages between what was experienced, and what the theory is saying. For all this, however, in practice it is much easier to write into an account the mastery of the singular subject, to insert the fetishism of clarity into what is written, much harder is to write against the grain of teaching, to write accounts which not only demand space for, but also enact the overflow of meaning, structure and argument.

ENCOUNTER 2: *KITCHEN/HQ*

Handed a telescope by the gallery attendant as I walk in, putting it to my eye I survey the room. It seems strange. The space is not that large, and, after all, what distant horizon am I going to survey. Objects litter the floor. A magnifying glass—like that the person over there has—would be better. Still, I return the telescope to my eye, my world contracts and detail expands. I scan quickly, straining for something from within the mass to hold my attention. I adjust the focus and pick out a five of diamonds. Sweeping across the wall I trace the run of the cards to the corner of the display case, follow them down to the floor, across an old typewriter and over some cards and board games. Continuing the arc, my eye piece is suddenly filled by a knee, a shoulder, some binoculars, stumbling, a little disorientated, I remove the telescope from my eye and notice the man with the magnifying glass is now bending closely over the cards on the floor. Lifting the telescope once more I continue to sweep, an old-school surveying of terrain. My growing mental inventory of things that I see now includes people. Scanning this terrain I capture others in similar viewing acts, I am at once a part of the landscape, viewed and viewing—I see them, seeing me—the effect is a little unnerving.

There is another strange disjunction. On the one hand, the terrain that I am surveying is clearly bounded, the walls of the gallery presenting a "severely foreshortened horizon." On the other hand, however, unlike the computer game system that is evoked by the piece's title, *My Play-Station*, the more I explore, the less clear the bounded edges seem. The work is full of objects. Nothing is present that tells me I am not supposed to see everything, yet it is clear that I cannot. There is no dominant narrative rather a whole series of lighter suggestions surrounding each object. Any one could assume prominence or recession. There is much at the edges for attention to take in, and the more I look, the more the objects and meanings proliferate. The longer I look, the less surely I grasp the totality. Indeed, the more impossible such an attempt even seems.

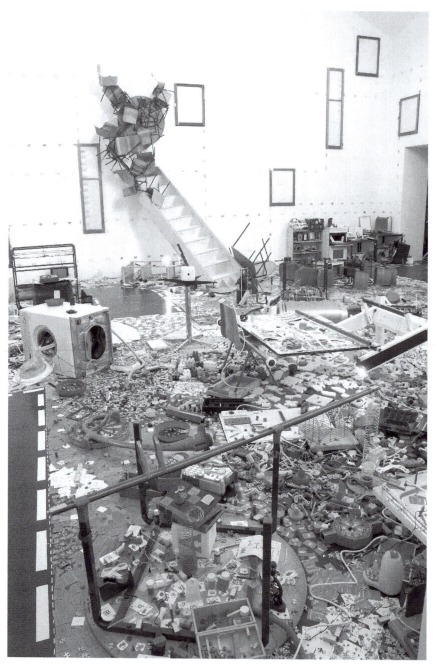

Figure 6.2 My Play-Station (Kitchen/HQ), Tomoko Takahashi, 2005 (image courtesy of the artist, the Serpentine Gallery, and Rosalie Doubal on behalf of Miss Varind Ramful).

Immersion

We begin in the midst of the installation, and with an experience that, from the outset, signals the myriad of visual economies at work in this space. In place of perception as part of habitual background consciousness, it is pulled to the fore. The art gallery is, as we are repeatedly told, a modernist space of sight: a "visual apparatus extraordinaire."[34] It has become a culturally codified space whose architectures and social conventions produce the scopic regimes that construct an optical logic of detachment and the sovereign gaze.[35] As such, the white cube gallery space was, and is, understood as an accomplice not only of a retinal art, but also of the associated logics of the look with its accompanying epistemological and ontological relations. This same contemplative, detaching distancing is summoned by the telescope within the installation, a technology of distance par excellence, indeed, a facilitator of the god's eye tricks mobilised by generations of "masterful" male colonial explorers.[36] As such, then, we find a mutual reinforcement of a disembodied gaze, a seeing subject rendered autonomous from that which is being surveyed. But yet, despite these two assertions of specular modernism, the experiences of the installation thoroughly refute these particular visual modalities.

Within the Serpentine Gallery, I was presented not with framed images to look at, but with environments to be moved through, their scale and internal complexity such that they could not be grasped by the sedentary gaze. With paths directing you into the thick of things, as objects filled the room, climbed the walls and spilled out of the galleries, the installation forced a position that refuses the locus of a stable, sedentary and autonomous seeing subject, possessive of an overview.[37] To even pretend to view the installation standing outside of it, beyond it, would be a fallacy: a viewer without a viewpoint, without a body, without a spatial position was not admitted here.[38] Instead, the spectator becomes a performer of sorts, an actor whose agency and subjective position is restaged by the experience of the installation.

The experience is one of active and drawn out exploration, it is, "through proprioception, the sense of dimensionality and motion in space" that I understand Takahashi's environments.[39] Eyes assaulted by the installation's myriad materialities, I lost the ability to ground myself, this temporary loss of spatial orientation disposed of any lingering sense of a "conventional" logics of viewing. Overview was disavowed by the inability to grasp the scope of this densely detailed world all at once, I consume the work, as Bishop suggests, in fragments: the shift of feet, the flick of the eye, the twist of waist, the shift of weight and the turn of a head; an environment and an experience that unfolds through movement.[40] This is to begin the work of replacing the detached subject with one enfolded within the world of the installation, it is to the terms of this immersed subject that the discussion now turns.

ENCOUNTER 3: OFFICE

I turn and walk out of Kitchen/HQ and move back into Reception and then down a small corridor. As I walk away from Reception into Office, light recedes. It is only a matter of four, maybe five steps—no distance at all—but yet the whole atmosphere changes. Overhead, external light is gone, darkness infiltrates this landscape, paths are partially obliterated, the surfaces of objects have dissolved, the colours absorbed, things have lost their separateness, co-joining in new world forms.

The sense of seeing, being seen, and what I can not see is more acute here. Rather than arrayed across the floor, as they were in Kitchen/HQ, objects here are stacked. Piled up, they function purely as a mass, architectural in scale. A series of spot lamps attract attention to the carefully arranged grottos of objects within these stacks. Light becomes a compositional element. To quote Klee, "the eye follows the paths that have been laid down for it in the work."[41] Here, however, I have shafts and spots of light rather than charcoal lines or hues of paint. I do not look with this light but according to it. Permissive of my look, this light directs, focuses and frames my material experiences. I draw back from inspecting the tableaux and continue to circle the stacks. As I navigate Takahashi's object towers, I am repeatedly forced to move towards and away from them, to peer amongst the groups of objects and to bend over and peek through holes as areas are plunged into darkness or blocked from view. I am caught in a continuous cycle of shifting my focus to the, middle, fore, and backgrounds. Disembodied spectatorship is impossible as I bend and twist to view the work. As I watch others contort, maneuvered by the manipulation of the lights into particular viewing positions, their spectatorship, like mine, is literally held up for viewing as itself part of the work.

Decentring the Subject

Denied. Delayed. Directed. The above extract is an account of a withdrawal, a withholding, of the visual experience. Moreover, sunk in the depths of the dark, I watched others forced to bend and contort to view the objects, straightening up, pulling back, kneeling down, moving on. My viewing of the artwork becomes a witnessing of seeing, the spectator's look staged for a consuming of optics. So far, the installation encounters have focused on immersion, have privileged presence, enfolding subjects and artworks as a means to disrupt the detached viewer. But, the agency of the installation in its manipulation of vision suggests otherwise. Changes in light, installation mood, object form, and arrangement, "configurations of motion and materiality" equally bring into consciousness the labour of vision and our failures to execute the "god trick" of the all-seeing eye.[42] This is a co-constitution of self and installation that can

Figure 6.3 *My Play-Station (Office)*, Tomoko Takahashi, 2005 (image courtesy of the artist, the Serpentine Gallery, and Rosalie Doubal on behalf of Miss Varind Ramful).

only ever be partial. I am hailed here as a subject not only by that which I see and experience, but also by the demonstration of the limitations of my looking. No longer does this experience seem that of a coherent and stable subject, coincident with the artwork-world. Rather, the subject produced by this particular experience is one that challenges the figure of a coherent, contained subject. We are directed, therefore, to question the figure of the anchored subject installed in the world, and by which there is a world, we are directed to question how it is that such a subject becomes the means to constitute the given: the sensations of the artwork. The experience does not feel as wholesome as that of a contained, coherent subject, a dynamic subject yes, but there is a destabilization of that bodily subjectivity as coherent and contained.

Displacements within the Field of Vision

The more I moved through the half light of the space, my viewing first denied by the descending darkness then permitted but directed, the more I become attuned to the modalities of my looking, the dimensions of seeing rendered visible in their own right. I was confronted with a series of situations of coerced vision, as paths of sight are laid by light in other wise un-delineated murky spaces. Vision, in this encounter, becomes bodily labour. Bending, twisting, moving closer as object contours emerge graspable in the dissipating gloom. Beholding, by necessity, becomes a dynamic appreciation. Only by moving do I ease the installation's frustration of my view. Experience unfolds as I engage and submit myself to the work's coercion—moving towards and away, circulating around it. Alphonso Lingis writes "the sense of sight can be taught and acute in the depths of the dark."[43] But what unfolds, rendered clearly here through the occasional lines of light, was the experience of not being able to see and, centrally of never being able to see it all: the presence of things withheld, not seen, was almost palpable. Through this manipulation and orchestration of a light-scape, the installation forms the conditions for the consideration of the constitution of vision. Light was recovered as part of the knowledge about seeing, a component in the relationship between sensation and matter. Moreover, travelling between the natural light and the artificially lit, cave-like interior of *Office* stimulated an attention to what cannot be seen: the ever-present displacements within the field of vision.

In the semi-darkness, the drama of concealment and un-concealment makes visible the act of looking itself, and moreover its limitations. Elsewhere in the installation it had been material excess—the mass of objects tumbling, lapping at the walls—that had frustrated the totalising view. Through these material coercions the perceptual purity of vision is disturbed, the understanding of the gaze as authoritative, as bodily detached, as objective, as immediate, as all seeing, is further disassembled. What is more, in the inability to

see "it all" attention is drawn to the continual marking of fields of vision by displacements. For all the immersion and sensory accumulation of previous extracts, what this room sets up is not the unity of viewer and viewed, but a series of denials, things we cannot see. Artwork here refuses a "comfortable" immersion: coincidence of self and world breaks down. What is forced to our thought is the experience of a dynamic embodied spectatorship. Lacking a centre, an anchor, a horizon or a complete sense of perception, we are kept aware of the dynamically embodied workings of spectatorship.

A Thing Amongst Things: Installation in the Midst of the Visible

Despite feeling engulfed by objects the scale of Takahashi's created spaces is not monumental, her installations take part of their immersive power from being keyed into the intimacy of the body, but also that they are a thoroughly socialised experience. Repeatedly during the installation experience, I caught sight of other people looking at the ground or the walls, through binoculars, magnifying glasses, hand lenses and, occasionally, caught them looking at me. These encounters rendered inter-subjectivity apparent; as just something else to be looked at it became hard to maintain a sense of self as a viewer separate from the situation, possessive of a masterful overview. Thus, wandering through Takahashi's collection was to enter a dialogical relationship with the objects found there: bodies became made present as things amongst things.[44]

The experience of the installation fosters the awareness of a co-constitutive relationship between self and objects. It is not only that I do not gaze from a distance upon the object worlds of Takahashi's collection but rather am within, among, and amidst them, but that as such I am not just installed as "a natural perceiving subject, a pre-linguistic, pre-cultural lived body possessed of inherent perceptual arrangements and faculties."[45] In the place of the sort of pre-given subject that enables the world, as Morris said quoting Merleau-Ponty "our own body is in the world as a heart is in the organism . . . it breathes life into it," we find something more co-constitutive.[46] In the relations between subjects and objects, seeing subjects and installation, neither is pre-given and neither exists apart from the other. Instead, the experience is one of interrelations with materiality of installation and its spaces, the dispositions of bodies, senses, forces, one's own embodied pasts, the socio-cultural relationship with objects and the inherited visual regimes of the collection. There is, then, no "individual" embodied experience, but rather an inter-corporeal emergence of subject and installation.

In *The Eye and Mind,* Merleau-Ponty suggests that a painter sees trees, but the trees also, in some sense see the painter.[47] The experience of the installation renders literal his argument that to see is also to be open to the possibility of being seen, "he who looks must not himself be foreign to the world that he looks at." There is, in this situation, a sense of the fundamental interchangeability of the "stuff" of the subject with that of the

object. As soon as I see, it is necessary that, "the vision . . . be doubled with a complementary vision or with another vision: myself seen from without, such as another would see, *installation in the midst of the visible'*."[48]

Merleau-Ponty's point here is ontological, however; his claim is more than that everyone who sees is capable of being seen (by someone else). Rather, as his later texts develop further, the attribution of visibility to the visible as well as the seer is not here an anthropomorphism, but is an argument about Merleau-Ponty's concept of flesh, about a (non-identical, non-substantive) "materiality" shared by the subject and objects of perception. This reversibility is, Merleau-Ponty notes, asymmetric and furthermore is "always only potential or immanent."[49] Introducing common "flesh" into this account of vision (mirroring similar maneuvers made in studies of film and digital media as well as in geographies of landscape) brings with it the capacity to turn the world back on itself, to induce its reflexivity, to fold it over itself such that subject and object are interlaced one with the other, not externally but through their reversibility and exchangeability, their similarity-in-difference and their difference-in-similarity. [50]

This merging and un-decidability of seer and seen, subject and object develops the installation as a site of the ongoing, co-constitutive production of both the seeing subject, and of itself. The terms of viewing here can only be understood to be embodied and relational: I am part of the artwork/world and coexistent with it: constituting but also constituted. The artwork, world and myself as sensing subject, are not found, pre-given as objects, but rather are made through experience. The body of the perceiving subject—me—is given form and content through the exploration of the surrounding objects, but, in the terms of Merleau-Ponty's, phenomenology at least, it is also that by which there are objects. As such the viewer is not possessive of a detached sovereign gaze but rather is, in part, formed by their look, "an essentially incarnate reality, bound to and produced within corporeal and social context."[51] Understood in this way, the experience of the spaces of an installation becomes a thoroughly creative one, one of many ongoing moments of production and of mutual imbrication that is inconceivable apart from their materiality and corporeality.

The remainder of this chapter takes up these ideas, and explores how it is that the installation does not merely install us as subjects within experiencing, active bodies, but offers other understandings of subjectivity. The experience of the installation becomes one that enables an exploration of the more unstable subjectivities that emerge from the "criss-crossing" of the seer and the visible, from the "indeterminacy of the boundaries of each of the senses, their inherent transpossibility and their refusal to submit to the exigencies of clear-cut separation of logical identity."[52] Indeed, it is this movement of "criss-crossing" that articulates the scenario of a dynamically embodied, immersive spectatorship.

ENCOUNTER 4: OFFICE/KITCHEN HQ

Back in the installation and I am slowing circling the stacks of objects. Blinded by darkness, my skin traces the spaces of temperature with an uncanny precision. The faint breath of the gallery temperature system weaves up from the floor vents. The cool air from an open fridge wafts about my legs, attention drawn, pupils dilating, I bend into the belly of the thing. Cold air moves across my cheek and I can hear the motor. I inspect the compasses and cars, keyboards, and a typewriter laid out within. Uncoiling, I move away from the light, returning once more to the dimness. The click of heels reverberates across the floor.

I finish the circle of the objects and am drawn by a wedge of light out into a viewing area for Kitchen/HQ. By now I am wondering almost in a reverie, inspecting objects and trying to make connections. The intensity of concentration is beginning to take its toll. Eyes adjusting to the brightness, I bend closer to the objects in front of me, inspecting the open recipe books arranged on the sink unit to my side. I hear a long drown out "BEEP" and then another. Reading disturbed, I start to scan the field of objects. In a strange play of sensory presence and absence created by the visual multiplicity of objects, acoustic revelatory presence is held in tension with the visually hidden. Guided by ear, my eye sweeps the floor, searching for the source of these sonic announcements. It rakes through the piles of objects, searching for the flickers of light or small vibrations, sights to help me locate those sounds.

"BEEP"—It goes off again. I keep searching for the point source, eye and ear straining to triangulate. A sonic envelope is created as the sounds resonate reverberate and decay through the space. "BEEP." There it is again. Finally, I locate it to the timer on the washing machine. Ears now become sensitized to sounds suddenly made present. I begin to pick up the continuing undertones of the installation, not melodically sonorous but rather electric. Bleeps, whirs, hums, pips, machines with repetitive mechanical/aural ticks, this background noise—the ground of perception—that I had previously been unaware of.

In Excess of the Optical

Such was the nature of the installation's acoustics that, just as nothing could be found to dominate the visual field, so sonically nothing governed. In straining to make sense of sounds, to separate out and order that acoustic terrain, hearing, like vision, was forced to my attention. As I move through the installation, I am enveloped and immersed into a sonic envelope through which noise emerges and sinks back before decaying and building again. Sounds form a dynamic flux creating the dimensions of the room moment by moment as I move. This is especially acute in the darkness of *Office*, where sounds alert me to hidden areas at first unseen. Once more my body is subject and object: I listen through as well as to

my body. Attuned to intermittent bleeps and clicks, in the spaces between I become uncomfortably aware of my own noise. Corporeality is made animate and present as a proprioceptive hearing of oneself; the inhalation and exhalation, the lump of the throat in the swallow, the heavy exhalation of a body bent on concentration, the thudding and pulsing of blood, which we are so often unconscious of, suddenly becomes here present, I try to quieten myself.

The multitude of mechanically produced clicks, whirs, hums, and beeps that sound repetitively through the installation are "out of place" within the gallery's disciplinary technologies. The space of the art gallery has normatively been understood as a space of sight, its "single sense epiphany" a spatial rendering of the philosophical disgrace of the separation of the senses.[53] As a result the ocular-centric white cube gallery offers a particularly interesting site in which to create and to contemplate the richly variegated sensual world. The omnipresent "noise" of Takahashi's installation muddies the clarity of a unified seeing self and, like other installation works, draws attention to an understanding of art, of experience, which is in excess of the optical.

Variegated Sensory Experience

What rose into consciousness during the installation was a sensuously rich and variegated experience in which ears and eyes are differently attentive, and yet importantly attentive together. Hearing the sounds of the installation, I would look and move to locate the source: triangulating sight and sound, a "synergistic totality is the rule," hearing with eyes as well as ears.[54] Marks, identifies a similar experience in her analysis of film and digital media, a "haptic hearing," that "usually brief moment when all sounds present themselves to us as undifferentiated before we make the choice of which sounds are most important to attend too."[55] The term haptic is more normally associated with a hand/eye sensory affectivity, but here it is acknowledged for a more general lack of sensory opposition, for an understanding of the sense organs that rejects any subordination.[56] Such synaesthesia transforms the modalities of both vision and hearing. As Ingold observes "it is the very incorporation of vision into the process of auditory perception that transforms passive hearing into active listening."[57] In the installation the obverse is also true, the incorporation of audition into the process of visual perception, makes the latter, too, more active.

Throughout the art encounters different senses rise out of "habituated perceptual background" only to fall away again.[58] In order to understand this contemporary argument of the eye it is important not to underestimate the importance of this synaesthetic dance of the senses, which has variously been described as a mélange, "cluster, clump, confection or bouquet."[59] As Lingis points out, "the sensuous elements are not there as a multiplicity that has to be collected or as data to be identified, but as depths without

surfaces or boundaries. Each sense informs the others in a common behavior project."[60] Takahashi's installation brings these variegated sensory experiences to the surface. The spaces and materialities of the installation issue a series of calls and denials to the senses, embedding this sensory mingling within the power relations of the senses that inhere in the art gallery's inherited cultures of the visual.

But yet, there is more at stake here than simply a re-installation of vision as but one of a number of senses, for also at stake here is the sense of a contained coherent seeing subject. For what occurs could be viewed as the triangulation of the viewer amidst a field of sensations, a body-subject that is open to and opened by sensations that pass through her/him; sensations upon which she/he is unable to "attain the perspective of a disembodied consciousness capable of rational synthesis."[61] Rather, these sensations generate a kind of invisible drawing in which audience and artwork are captured in movements that exceed their boundaries. Instead of being reconfirmed as a coherent subject that rationally synthesizes sensations, and orders them according to particular positions on the body, the viewer becomes opened out as a passage point. We see here a fundamental challenge to the figure of the embodied viewer as that which "keeps the visible spectacle constantly alive."[62] Instead we consider how it is that sensations exist independently of the body, not depending on a human body to perceive them, and furthermore, not neatly cohering any body that does receive them. Rather, there are sensations that challenge the organisation and ordering of the senses, even if they are acting together. It is to the effects of these "transpossible" senses, and independent sensations, on the seeing subject that the final section now turns.

ENCOUNTER 5: GARDEN

Back in Garden, I walk slowly along the path looking down at the beds arrayed around me. I am drawn here not only to the formal and structural properties of the objects, the spaces that configure the object arrangements, but also to their tactility. I do not touch, not because anything physically prevents me (there are no barriers, no glass, only hashed white lines, as on a sports pitch). I do not touch, not in art galleries, not unless explicitly invited to. I do not touch, but I do see. My eyes function here as sense organs, gathering information, but also as sensory organs visually fondling the objects, stroking them, feeling the smoothness of a wooden handle, or the jagged edges of a blade. Eyes touch the blunt ends. I weigh the density of these things. In the materiality of the tools, in their smoothed surfaces I see a "consistency and a reliability" that works through the years. A wooden handle, worn by the assiduous hands of owners, its tactility re-marking and pacing the space of numerous generations. Through it, I shake hands with those who have gone before.

Figure 6.4 My Play-Station (Garden), Tomoko Takahashi, 2005 (image courtesy of the artist, the Serpentine Gallery, and Rosalie Doubal on behalf of Miss Varind Ramful).

Economies of the Look: Touching with Eyes

I did not touch those tools Takahashi included in her installation, not in fact because anything physically prevented me, but because we do not touch in art galleries. At least not unless explicitly invited to do so, permitted by signs, rather than the call of an artist's tactile objects.[63] I felt those tools, however, my eyes sensed their weight, their textures.[64] There is a thinking of feeling here, and a knowing of experience that is formed from the blending of what is seen with what was once felt. I did "not know about the surface, volume and mass" of these tools "by sight alone but by sight synthesised with memories of tactual kinaesthetic perceptions."[65] The properties that once weighed heavy in hands were seen but also felt through eyes. Here, then, is a reversal of the normal work of the hand as optical prosthesis.[66] Rather than touching where I can not see, there is seeing where I can not touch, eye accessing an out of reach tactility, rather than hand palpating what vision is denied. Bending closer, I move towards the objects on the installation floor, a tactile awareness of the physicality of these objects and this artwork emerges. The embodied economies of looking enacted in stooping down, the lingering looks and caressing gazes recast the dominance of centralising structures, coherent narrative and the exalted position of the "viewer."[67]

Touch, like hearing, and in contrast to vision, is often "seen" as our way of being amidst the world. Derrida writes a philosophical history of touch as a hapto-centric metaphysics, in which touch is related to presence because of that continuity, immediacy and unity between that which is touched and that which touches.[68] The experience of those tools in the installation draws the modalities of touch into the modes of vision, forming a "haptic visuality," haptic, once more, naming the politics of sensory affectivity in such a way as to prevent the "opposition between the two sense organs."[69] Whilst the inscription of the subordination of the senses is resisted, vision—in becoming haptic—is not propelled away from the optic, rather the visual is reconsidered as a component of sense.[70] This is a mutuality but, importantly, not an equivalence, of hand and eye. In looking at those tools the visual is made in some part tactile, touch's active and expressive, reactive and responsive ambiguities are admitted into the argument of the eye. The visuality that emerges is informed by those characteristics of proximity, openness and engagement that come from the admittance of the modalities of touch, and the other senses, within an understanding of vision.[71]

Furthermore, this is to break down the visual as a component of sense, in other words no one sense can be understood stably in a fixed position on the body, or available for any recognised channel, rather we need to understood how the fixed locations of the senses are disrupted, and come together and move apart in different ways. This is an argument of

the eye that requires a remapping of bodies, less however, to replace the neat ordering of the five senses with a new set of connections and coordinates, but rather to accept that such transpositions of the senses will mean that attempts to coherently order, fix and map bodily geographies will fail.

This is also to refuse to allow for the existence of a fixed stable subject in relation to their encounters with the world. For, turning back to the tools and the experience of perceiving them, of wanting to touch them, we can explore the installation as making present bodily encounters with worlds as, following Massumi, a "life dynamic."[72] Returning to the experience of the looking-feeling of those objects, we can consider how, when we see an object, we see its qualities, we see, for example weightiness through texture. Neither volume nor weightiness are themselves visible, but, as Massumi notes, we do not, not see them when we see an object.[73] In-fact, we see weight and volume, we see all sorts of object qualities that are not actually visible when we "see" the form of an object. Massumi explains,

> the form [of an object] is full of all sorts of thing that it actually isn't- and that actually aren't visible. . . when we see an object's shape we are not seeing around to the other side, but what we are seeing, in a real way, is our capacity to see the other side. We're seeing, in the form of the object, the potential our body holds to walk around, take another look. . .the form of the object is the way a whole set of active, embodied potentials appear in present experience: how vision can relay into kinesthesia or the sense of movement, how it can relay into touch. The potential we see in the object is a way our body has of being able to relate to the part of the work it happens to find itself in at this particular life's moment. What we abstractly see when we directly and immediately see an object is lived relation- a life dynamic.[74]

This is a thinking of perception in perception, in the immediacy of its occurrence, as it is felt; a thinking-feeling in visual form. This is normally back-grounded, we think-feel many things about these tools, their volume, that they have a back, or sides hidden by other objects, pressed against the floor out of sight. But, such a thinking-feeling usually passes unnoticed, veiled by the actions that the object is enrolled within. In Massumi's terms, we let the "vitality affect," the "uncanny" apprehension of the qualitative dimension, pass unnoticed.[75] Perhaps unsurprisingly, in our everyday experience of tools we orientate ourselves toward the instrumental aspects of action and reaction but at the cost, Massumi suggests, to a relational aliveness to the world; we live out of perception, rather than living in it.[76] In suspending the use function of these tools, in enabling us to experience them, the installation becomes a way of enabling us to live in perception, to see an explicit experience of what otherwise slips behind the flow of action

and is only implicitly felt. The installation is, in these terms, a making present of the imperceptible.[77]

CONCLUSION

In this chapter, installation art practice has been investigated for the critical spatial sensibilities and sensitivities that its configuration of objects, bodies and spaces brings to our attention. What emerges in the intimacies of encounter brought about by the installation's manipulation of body, objects and space is an "experience of experience," and an understanding of installation art as an enfolding of self and world.[78] An argument of the eye is developed here through pondering the "shifting sentient encounters" and the "fuse [ing of] mental and material landscapes," that the installation brings about. This is an animation of the experience of art through an intimacy of conduct and encounter that builds a sense of sight as corporeal and conceptual, embodied, but also embedded in history and culture.[79] Such re-contextualisation of art and the disruption of its visual essence of is not however a rejection of the retinal but rather aims to reconfigure the understanding of (art) experience as one of sight alone. Built from the tactile, kinaesthetic, and proprioceptive awareness of the physicality of the installation, this argument of the eye centralises inter-subjectivity, involving the senses as a synergistic totality: the resulting visuality is informed by those modalities of proximity, openness and engagement that emerge from the admittance of the modalities of touch, and the other senses within those of vision.

My experience of installation work is not passive but participatory. As viewer, I shared in and performed the space of the installation dialogically: the experiences of the installation were productive of the subject, just as my lived body becomes the site of the production of art. However, as the progression of the installation encounters demonstrated, this was not only an account of an ever more immersive and enfolding experience nor was it one of sensory accumulation. For alongside the central role of bodily presence and the sensuous, tactile and experiential being that the installation draws out, it also configures our awareness of absences, of displacements within the fields of vision, and the break-down of a coherent subject. The seeing subject that emerges is less a discrete and stable container, organising the senses, but rather is a passage point for senses, and in presenting the appearance of a life dynamic, it can make the imperceptible appear.

In building this "argument of the eye," this chapter has hopefully offered a persuasive account of the potentiality that the experience of artwork offers to the broader geographical project of the body. Further, the essay has also demonstrated the value of the use of the body as an "instrument of research," and attempted to meet the demands that this

makes upon a writer. In response to these demands, I have tried to centralise the artistic encounter within this analysis, and to write into the examination an exploration of the conditions through which the work was experienced. The move here is towards an acknowledgement of installation as force, agency and process: to try to explore what it means to write about art in such a way as to develop a form of address appropriate to the nature of the art encounters. Principally, this is to begin to convey in these forms of writing a recognition of the productive force of art encounters.

In the following chapter on the work of body-earth artist Ana Mendieta, I want to continue the theme of art and body encounters, moving away though from the audience's body to consider the effects of Mendieta's use of her own body to make work. I will focus on the artist's *Silueta* series and consider the particular aesthetic encounter with the matters of the body and environment that the series configures for audience and artist alike. I will explore how these encounters engage us with corporeal materialities and spatialities from which could possibly propagate a more ethical relationship with the environment.

7 Points of Contact
The Geographies of Ana Mendieta's Earth-Body Works

A stylised silhouette of the female form is marked in the sand at the tide line, its axis just off parallel with the approaching waves. The water has already started to do its work, one side of the body form is softer, darker, slightly elongated down the beach. On the land-ward side, the curve of elbow and waist are still defined and distinct, the sand surface paler, apart from where the pulses of the waves' encroachment has sent darker material across the body's boundaries, spreading the vivid red pigment from the base of the depression around the figure.

Across a sequence of three closely cropped photographs we see the gradual dissolution of the body form by the repetitive motion of the waves until all that remains are ridges of sand marking a shallow depression. From first to last image, we move from the body form deeply impressed into the shoreline, to the body as surface worked on by water. By the time of the third image, the body is almost indistinguishable from the beach, the shallow depression enclosing a swirl of white foam water tinged with the palest of pink.

The close cropping of these images cuts the figure out of the landscape, but it is aligned horizontally to the surface, its axis according with that of the land, rather than being set vertically within it. That horizontality, the coincidence of body and beach, means the materiality of the landscape fills the frame. The beach is not a background for bodies to covert across or to act within, but rather it is a scene of substance, of textured materiality, of forces and matter. The body form, registered as changing surface, rather than as an individuated subject, renders visible the force and tactility of the waves, their pressing, ebbing, flowing, a dramatisation of the relation between the body, the materiality of the beach, and the force of the water.

INTRODUCTION: ANA MENDIETA'S GEOGRAPHIES

Untitled (Silueta Series, La Ventosa, Mexico) 1976, described above, is one of the hundreds of pieces that constitute the *Silueta* series of Cuban-

Figure 7.1 Documentation of an untitled earth-body work, Ana Mendieta, 1976, Iowa (© The Estate of Ana Mendieta Collection, courtesy of Galerie Lelong, New York, 35 mm color slides).

American artist Ana Mendieta (1948–1985). Made between 1973 and 1980 at carefully chosen sites in Mexico and Iowa—from beaches to archeological digs, woodlands, swamps, and lawns—the *Silueta* series is perhaps Mendieta's most significant contribution to the art world.[1] The pieces, encompassing performance, sculptural, photographic, and film works, are united by the serial use of the form and outline of Mendieta's own body in their making.[2] The origins of these works lie in a series of performance pieces during which the artist positioned her own body within the landscape and asked a select group to cover it with flowers, grass, mud, and other organic materials. These early performance works, often understood as an extension of Mendieta's interest in self-portraiture and studio practices of body transformation, helped the artist to formulate the visual vocabulary and processes that were to underline her distinctive style of what she called "earth-body" art.

During her short career, Mendieta created hundreds of silhouettes through a suite of practices of material addition and subtraction.[3] These practices included her drawing, carving, or digging into the earth, sculpting her body in outline or three-dimensional form, corporeality constituted by an endless array of organic materials, from blood to earth, rocks, twigs, grasses, or mushrooms. As the series matured, the imprinting became more forceful, the artist branding her outline onto the landscape by means of potent mixtures of gunpowder and flammable chemicals. Many of these performances were documented, first by her audiences, and later by the artist herself, in photographs, 35mm slides, or on Super 8 film.

The serial power of Mendieta's repeated formation of a body-landscape relation is key to this study. For the sheer quantity of repetitive actions by which her body, or representations of it, are put in contact with the landscape sensitizes us to the difference—of material and method—within these points of body-landscape contact. In the place of the interminability of the serial practices of minimalism, Mendieta's "endless series" of actions displays infinite variability and extension.[4] As with Wentworth's photographic work explored in Chapter Four, it is by way of this repetition that we are sensitized not only to variations in process, but also to variations of content. What is dramatised through Mendieta's "almost" seriality is the variations in the relationship between between body and landscape that the works are developing.

In response, the analytic focus of this chapter, and its unique purchase point on this already much studied artist, is to weave together two sets of geographies that are found at work in Mendieta's practice. The first of these are the points of contact between body and landscape that her *Silueta's* constitute. These body/landscape encounters will be explored by way of contemporary conceptualisations of landscape that understand the latter as contact, as immersion, connection and coincidence, over and against more classical understandings of landscape premised on distancing and separation.[5] Secondly, and key to understanding these encounters are the

geographies of the *Silueta* series' production and consumption. In other words, and going back to Part II, the relationship between the physical site and practices by which the *Silueta* were made, the modes by which it was recorded/documented, and our experiences of it as an audience now decades distant from the "original" landscape performances.

Viewing Mendieta's work through the lens of embodied cultures of landscape extends the already existing sets of geographies through which her work is often discussed. Important in many recent studies of her work have be the territorial tellings of, what after Nash and Daniels, we can term the artist's geo-biography.[6] Born in Havana in 1948, Mendieta was exiled to the United States at thirteen years old, during operation Pedro Pan, which forced thousands of Cuban children to the United States to escape the revolution. For the next five years Mendieta moved through numerous foster homes and orphanages.[7] The artist repeatedly offers up these past experiences as the ground for her practices, the earth becoming an anchor point and a source of the roots that she lacked because of this traumatic period. She writes:

> I have been carrying on a dialogue between the landscape and the female body (based on my own silhouette). I believe this has been the direct result of my having been torn from my homeland (Cuba) during my adolescence. I am overwhelmed by the feeling of having been cast from the womb (nature). My art is the way I reestablish the bonds that tie me to the universe. It is the return to the maternal source.[8]

Given such descriptions, Mendieta's work was cast, especially in the 1990s, in the context of the critical agendas of multicultural and postcolonial scholarship.[9] As such, her treatment of her body was understood as a response to her particular experiences of suffering, displacement and exile, and so her art came to represent, in art world terms, a whole series of silenced individuals and minority groups.[10]

Notwithstanding the power and importance of these frameworks, Mendieta's practices have a force beyond the autobiographical. A further set of geographies that have come to mark the reception of Mendieta's work explore the productive alignments of her work with feminist discourses of nature.[11] Vital as a reference for Mendieta's work at the time of its making, the artist's alignment of the feminist body and nature has been controversial more recently. This is due to the negative associations that now adhere in the essentialist relationships that shape such comprehensions of her work. For Best, for example, this essentialism relates to Mendieta's deployment of "Mother Earth," and a certain sort of nature goddess spiritualism. The latter supports the traditional link between the feminized body and nature, both gendering nature as female and reinforcing traditional ideas about sexed difference.[12] To understand Mendieta's earth-body relations as a "return" to a feminized mother earth, is but one view through

which to interpret the work. By attending to the variation within the *Silueta* series, it is possible to explore the series, as this discussion will, as creating a set of tensions between bodies and landscape. This is to replace the symbolic framework of Mother Earth with an interpretative framework that understands this relationship less in terms of symbolism, and rather as a rendering visible of an earth constituted by animate matters and vitalist energies.

Theorising Landscape

Landscape, Cosgrove writes, "distances us from the world in critical ways."[13] It, he goes on, defines our relationships with "nature," and offers us "an illusion of a world in which we may participate subjectively by entering the picture frame along the perspectival axis. But, this is an aesthetic entrance not an active engagement with nature or space that has its own life."[14] This chapter considers Mendieta's particular form of earth-body art in relation to a rather different understanding of landscape that has come to focus on active engagements with nature. In short, this chapter will examine how the "aesthetic entrances" into landscape that Mendieta's work fosters, for both herself and her audience, are encounters that promote particular ethical relationships.

Studies of artistic practices once figured highly within geography's theorisations of landscape. Nineteenth century landscape painting, for example, offered one means by which geographers could reconsider the classic Cartesian divide between the "really-real" of the geo-physical landscape, and those things that are "really-made-up" (representations, signs, and experiences), enabling an examination of the relations *between* the two.[15] So we see connections being drawn between aesthetic ideals (picturesque and sublime) and the "material" form of landscape, or via understandings of an "iconography" of landscape as "a cultural image, a pictorial way of presenting or symbolizing surroundings."[16] More recently, however, we find artistic practices largely excluded from geographical theorisations of landscape. This is principally due to their association with a Cartesian gaze, and thus their apparent promotion of a mode of orientation toward landscape that is premised on "the visual contemplation of an externalized scene."[17] At a time when favored studies "activate a space and time within which I [we] might engage and explore issues of landscape, subjectivity and corporeality," this was problematic.[18]

A central challenge to thinkers and practitioners of landscape in recent times has been to understand landscape other than through the Cartesian gaze.[19] To consider landscape, in other words, outside of a epistemological mode based on a separation of subject and landscape upon which mastery and dominance is founded, and a deadening of the world wherein landscape was cast as a pre-given situation, a visual repository of cultural meaning, veiled or mantled by systems of signs. How then to conceive of the

relationship between the human body and the animate matters and forces of the earth is perhaps one of the issues at the heart of contemporary discussions of landscape, and the place of art in exploring this relationship is the focus of this chapter.

The primary force of current answers to such questions has been to foreground theorisations of the relationship between bodies and landscapes, cast in terms of "involved lived bodies."[20] Thus the self-landscape nexus is understood in terms of "ramifying bodily engagements, encounters and inhabitations."[21] Such "embodied acts of landscaping" challenge those understandings of landscape that focus on the gaze as an accomplice and an expression of a classical subject-object epistemological mode.[22] For many, the visual regimes of landscape painting, such as those studied in geography's iconography of landscape had come to typify these latter relations.[23] So, to assert Mendieta's work is to make space for artistic practices once more within geographical studies of landscape. And, doing so is to build on those existing studies of artistic practices that have proffered a means to breakdown landscape's Cartesian settlement, either via phenomenological or feminist psychoanalytic critiques of the gaze, or by means of critical accounts of everyday knowledge.[24]

In addition, however, to alternative considerations of landscape, what are also needed here are understandings of "aesthetics" that are other than as an "entrance." Instead, what this account develops is the possibility for aesthetic engagements to proffer active encounters with the spaces of nature and the earth. Thus, the two empirical sections of this chapter explore Mendieta's evolving earth-body relations through two key tropes: merging and imprinting. If in the first instance, the focus is on the pursuit of those cultures of landscape that privilege immersion, connection and engagement, then in the second instance the focus falls on the investigation of how these works also install non-coincidence, absence and loss in the understanding of these body-earth relations. The result, it will be argued, is the production of active encounters with landscape and environment, even when these are mediated by images of the performances, rather than based on a "being there" within the landscape in the course of the performance, an experience only a few people could have.

Attending to the Geographies of Performance Art

If the primary set of geographies this chapter engages are the earth-body relations Mendieta's work develops, then key to this analysis is the consideration of a second set of geographies; those of the production and consumption of the *Silueta* series. Mendieta's work exhibits some interesting geographies in this regard, like much art that has a performance element—in this case the artist's engagement with the landscape—a key

question is "where" is the work? Is it in the performance itself, the processes that lead up to it, or the making of the documents of that performance? Are the latter merely supplementary records of the fulsome sensory presence of performance, doomed always to fail to capture the richness of those performances and the immediacy of their experiences? Or, are they works of art in their own right? As Part II introduced, answers to these questions have been found in studies that consider the ontology of performance as one of disappearance in space and time. Performances are by their nature ephemeral, and thus the majority of their audience will only experience them in re-presented form.[25]

Attending to Mendieta's series is to see a change in her mode of working, progressively distancing processes of production and consumption, she gradually absents any audience, excepting herself, from her field-based working practices. So, her move to works made in nature—in the landscape—is a movement away from audience, for here her work was witnessed by an incidental audience of "participants," who kept guard, drew around her form, or helped to document her works. Her later decision to use a maquette to shape her body forms in the landscape, in the place of her own body, was a further shift to free her from an audience when she was working, enabling the artist to work in the landscape solo, making and documenting alone.

In her choice of the site as well as her decision to work alone, Mendieta ensures that the documents of her work become important, they "are" the series, the sites of its consumption. This is compounded by the temporalities of her work, for not only are her performances situated in places far beyond the circuits of the art world, but her silhouette forms are deliberately designed to decay. The works are made at actively unstable sites, locations of landscape erosion—shorelines, creek banks, eroding gullies, or temporary muddy islands in the middle of rivers. These works were not intended to mark the landscape in any permanent way, and would soon, in Mendieta's words, be "reclaimed by the earth."[26]

The spatial and temporal limits of Mendieta's series has long raised basic art historical questions, including those around when it started, around what should be included in the sequence, as well as questions of the relationship between performance and documentation just discussed. My analysis steps off from the recently reignited questions around the limits of the series, that fired up once more with the release of Mendieta's "unseen" archive, and with recent curatorial choices made regarding the display a selection of videos as pieces of work, rather than as documentaries, as they had been understood up until that point.[27] Further questions are raised about whether to include only those images the artist chose to print during her lifetime, or whether to include others printed since. The focus here is on the artist's words, images and prints and the videos she made, not so much out of some privileging of art historical intentions, but in the belief that the link the artist establishes between performance and documentary mode is an important one analytically.

POINT OF CONTACT ONE: MERGING

A woman lies naked on what looks to be a recently cut lawn, face down, her arms folded, her head on her hands, legs straight, heels slightly turning in toward one another, one foot splays out over the other grass-stained sole (Figure 7.2). Her body fills the diagonal axis of the image, her back, shoulders, and buttocks are covered with a mat of grass blades, about an inch or so thick. Perpendicular to the artist's body, starting from just below the upper-left corner of the image, the shadow of a torso and head appears. This is the first version Mendieta made of *Grass on Woman*, in May 1972. The shadow is that of one of her colleagues who helped place the blades of grass on her back, and glue them in place with Elmer's glue, leaving her head and legs bare.

The following summer, in 1973, during the summer session of the Intermedia masters that Mendieta was taking at the University of Iowa, the artist went to Oaxaca, Mexico, and developed that first performance into a piece that, for Mendieta, at least, marks the beginning of her *Silueta* series: *Magen de yagul (Image from Yangul)*. At the meso-American site of Yagul, one of the many archeological sites the group toured, Mendieta lay face up, nude, in a shallow depression, some say a grave, whilst her professor, and lover, Hans Breeder arranged white flowers over her body. The

Figure 7.2 Untitled (Grass on Woman), Ana Mendieta, May 1972/2001 (© The Estate of Ana Mendieta Collection, courtesy of Galerie Lelong, New York, color c-print from a suite of five. 16 x 20 inches).

flowers, bought by the two of them in a market that morning in readiness for the performance, covered her head, and her chest, midriff and legs. As the rest of their group stood guard Breeder photographed the piece from a number of different angles, Mendieta later produced a single iconic image of the performance.

Photographs have occupied a far from simple location as documents of performance works. As a form photographs are understood to privilege presence, recording the presence of an artist at a specific time and place and are witnesses to particular scenes, acts, or events.[28] Mendieta, however, in these images is not behind the camera recording, but is rather the photograph's subject, or rather, the subject of the image is the contact of her body with the earth. Key in establishing this focus is the format of the photographs. For the focus of these images is not on the body per se, but on the body in landscape, so the body is set in a depression, at an angle off-centre. Despite being "in" a depression or "on" the grass, the body is not looked down upon by the photographer, nor is the figure upright in the landscape, rather the figures are horizontal, on the same plane as the ground, but the whole picture is tipped up and toward us. Further, the images are closely cropped, disrupting the landscape as background scene, the ground across which action plays out. It is, therefore, the event of the body intimately touching, pressing and pressed back upon by landscape that is the focus of these images.

The content of these images also reinforces the artist's presence within the landscape. Art Historian Mieke Bal, while working on Baroque painting (a rather different era of image making) observes the role of hyper-real details—in her case a stray painted nail upon which once hung a picture—as a force that incites relationships between viewer, artist and event.[29] In the case of Mendieta's *Grass on Woman*, the hyper-real detailing concerns the grass-stained soles of her feet, or the small clots of soil that adhere to her skin. These details are perhaps, under this analysis, as much about questions of authenticity, about establishing that a work happened, as they are important for drawing out the physicality of making the work, the experience of being-in-the-landscape.

Bal observes how hyper-real painted details—in her case a painted nail, here the grass stains, the clots of earth, one foot pointed one flexed—lead the viewer to recreate, to imagine, the circumstances that led up to the detail in question. In the case of Mendieta's work these details lead us to replay the sensuous tactile being-in-the-landscape that was integral to the making of her work: the movements through the grass that stained the artist's feet, the sun warming her body, the smell of the grass and the earth as she buried her face in it, and the feel of the blades across her belly as she lay down. Was it damp? A little cool? Or warmed from the sun? Was she comfortable? Nervous? Did she feel exposed lying naked like that? Vulnerable because she could not see, only sense the approach of others by changes in light, temperature, and sound? The details in the photograph are less the

document of a fixed moment than they encourage us to imagine the artist's experiences of being-in-the-landscape that led up to the moment when the camera shutter clicked shut.

Disrupting the Cartesian Settlement

Cartesianism, as it plays out with respect to landscape, performs and describes a settlement of the division wherein the human subject is distinguishable from the natural object/environment.[30] Far from a completed process, the effect, however, has been, to stabilize, and fix relations between humans, and between humans and the nonhuman.[31] One of the tasks therefore has been to breakdown that division, and thus geographers have turned to the resources offered by phenomenology—most especially Merleau-Ponty's critiques of vision—for thinking through landscape as "being-in-the-world."[32] Ingold's readings of the philosopher have been especially influential. The anthropologist explores: "landscape as not a locality you or anyone else can look at, it is rather the world in which we stand—taking up a point of view on our surroundings. And it is in the centre of this . . . involvement in landscape that human imagination sets to work fashioning ideas about it."[33] This understanding has been a start point for numerous accounts of landscape populated by various sedentary and mobile bodies—rock climbing, walking, sitting, gazing, cycling, growing orchards, herding reindeer—wherein bodily presence is accorded a central role, and studies explore experiences of sensuous, tactile, and experiential being in the co-constitution of self and landscape.[34] As Wylie emphases, this emergence and entwining of self and landscape is not just an object or medium of analysis—but this evolving co-presence assumes an "enlarged ontological role, as exemplary of the very process of being (or becoming) in-the-world through which existence and meaning are themselves vouchsafed."[35]

If we turn to the work artistic practices have been deployed to do within geographical studies of landscape we see here a consistent effort to intervene in the Cartesian settlement. For example, Dubow works over the colonial picturesque by replacing the colonialist as 'Euclidian Emissary' with the colonial artist as a corporal being, living-in-place through perception.[36] Following Merleau-Ponty she characterizes this shift as a movement from "a view on the world" to a "point of view in it" [xiii].[37] Like the artist-subject provided by Crouch and Toogood's analysis of the work of abstract painter Peter Lanyon, this is an artist-subject who "yields into the world."[38] These studies predicated recent investigations of how meanings, values and subjects may be understood to emerge from practices and events *in* the world, such that subjects are "insinuated, wrapped up in and surrounded by its spaces . . . actively liv[ing] the processes of its spatial and visual perception."[39] A further critical intervention was made by Nash who, drawing on feminist psychoanalytic studies of the "gaze," emphasized the

interpenetration of observer and observed. The "pleasure and emotive force which landscapes may provide" disrupted any sense that a preformed subject—whether geographer, landscape gardener, or artist—can truly stand, distanced, from the scene.[40]

The question becomes therefore, what form of relationship between self and landscape does Mendieta's *Silueta* series open us onto. Mendieta writes forcefully and often of her own relationship with nature and the earth, most often in terms of immersion and coincidence. Text she wrote to accompany images in her first solo show of the *Silueta* series at the Coorboree Gallery in 1977 read, "for the last five years I have been working out in nature, exploring the relationship between myself the earth and art, using my body as a reference in the creation of the worlds, I am able to transcend myself in a voluntary submersion and total identification with nature."[41]

Mendieta's language and material transactions of natural mergers was part of a common vocabulary for female artists of the era. Lucy Lippard, curating an exhibition entitled *Contact: Women and Nature,* brought Mendieta's work together with others to explore, what she later described as "their non-combative relations with nature."[42] Lippard was concerned to foreground the intimacy established through materials and earthy orientations that were so very different to the large scale engineering and technically advanced projects of many male artists working at the time.[43] The artists she celebrated did not try to compete with nature but rather placed their work in a subordinate relation to it, "using natural materials rather than trying to battle it out with large size and brilliant colour."[44] The normative lens through which to engage these works was by means of a feminisation of nature, a returning to roots. But yet, here this communion with nature, this coincidence that Mendieta is so insistent upon, can have other interpretative registers too; registers that are revealed further by a close attention to the forms of relations Mendieta builds with the landscape.

Merging: Emerging. Rhythms of Coincidence and Non-Coincidence

If Mendieta's early work asserted a close, visceral and tactile relationship with the earth, an embodied presence. Then in later works in the *Silueta* series there are attempts at a fusion of body and landscape in the visual field that accords with the artist's desire for submersion and total identification. Photographs from Mendieta's archive and notes from her sketch book show the artist exploring different ways of inserting her body into the forms and fractures in trees, or experimenting with various coverings and coatings that would let her blend with them. She writes next to one sketch, "sitting on a tree-trunk merge my body with the base of the tree," as if she seeks in material effect at least, to overcome established boundaries between self and landscape, subject and object.[45]

Figure 7.3 Untitled from *Silueta Works in Mexico*, Ana Mendieta, August 1973/1991
(© The Estate of Ana Mendieta Collection, Courtesy Galerie Lelong, New York, color
photograph from a suite of twelve. 20 x 16 inches [50.8 x 40.6 cm]).

An important piece of work in Mendieta's evolution of this body/earth rela-
tionship is *Untitled* (1976) (Figure 7.3). The photograph is bisected by a
gnarled, dried tree trunk, several feet wide, that projects out, only slightly
elevated over the sluggish creek water. Dead twigs have caught into its end,
and accumulated in the rich dark mud that has settled out of the still, shallow
creek water. This accumulation has ceded new life and vivid green springs
from this muddy sedimentation. In a depression in the tree trunk, easy to
miss on first look, lies Mendieta. Her body is covered in patchily drying mud,
indiscernible from the trunk, aside from the form of her head which clues us
into the presence of the rest of her body. Encased in this muddy sarcophagus
Mendieta lay for hours, until, as a later photograph shows the rich dark mud
has dried, flaked and cracked so that her casing renders her almost indistin-
guishable against the tree trunk. There is a fusion here, at least in the visual
field, of the artist with nature. With the drying of the mud comes the a gradual
loss of Mendieta's form, at first we are unable to isolate her limbs one from
the other, only her outline and her face, and then eventually with the drying of
the mud-case, artist and tree become almost indistinguishable. Landscape in
this image becomes very visceral, about contact, immersion, and immediacy.
In a sense, these images capture the artist trying to establish that "literal con-
nection" she values, a picturing of a merging in which self and external world
come close together, and touch each other. But while Mendieta might reach

towards forms of merging and folding of self into landscape, there is some-
thing in this work, and in other works across the series, that all told, refuses
such a fulsome coincidence of self and world.

In October 1975, Mendieta made the performance *Genesis Buried in
Mud,* documented in an accompanying Super 8 film. Interestingly, the artist
made no still photographs of this work only the film, thus possibly emphasiz-
ing the importance of action in this piece. The film opens with the camera
fixed on the ground, the screen is filled with the rich materiality of the earth,
the textures of the dark loamy soil fill the frame and leaves drift across the
fixed shot. Gradually the viewer is aware that the earth is rising and falling,
animate matter palpitating, moving up and down. Over the course of the
film, the soil gradually settles out and falls away, revealing Mendieta's form.
In this short film Mendieta's earth-body merging becomes complicated. No
longer an attempt to simply deny body form and corporeality, to merge with
the earth, *Genesis Buried in Mud* depicts a body emerging from an animated
earth. As much therefore, as this is a coincidence of body and earth, a conti-
guity of material and body form, it is also a display of non-coincidence, body
form and the animate matter it emerges from: similar but different.

Looking back across Mendieta's work in the light of this piece and its asser-
tion of difference, *Grass on Woman* comes into view rather differently too.
Here Mendieta's body form stands out clearly, contained against the grass,
while in *Untitled,* the artist's mud-covered form at once blends into the land-
scape, whilst on second look, or in the next photograph, it asserts its differ-
ence from it, before blending back in again, and so on. The form of the body
standing out becomes a mark of the irreducibility of the other in this relation,
of the difference between body and earth. Less about immersions and conti-
guity, about picturing a collapse of self and world, these photographs picture
a tactile pressure between body and landscape, a pressure that becomes, as
Boetkzes has explored, about a feeling of the divisions that mark alterity.[46]
Looking across Mendieta's series, is to find that same repetitive motion, an
oscillation of coincidence and non-coincidence of body and landscape playing
out over and over again. Merging works are matched by occasions where the
non-coincidence of body and landscape is asserted. This oscillation occurs
in multiple forms across the series: within the duration of looking at a single
image, within the sequence of images of the film of a single work, as well as
across the variations in the modes of earth-body contact that Mendieta devel-
oped during the life of the series. The tension between a brute materialism and
an animate human body is replaced by a sense of an animate materialism that
is common across body and earth.

The Matter of Landscape

An important part of the refusal of an immersive understanding of body
and landscape, and the particular disruption of the Cartesian settlement
that Mendieta's work enacts is her rematerialisation of the landscape.

Resonating with current landscape scholarship, we find here a breaking down of the tendency to objectify landscape as text, and the unfortunate caricature of painting practices as offering up landscape as an "out-there" mass, looked over and subsequently symbolically organised by the cognitive human agent—a brute background across which to project hopes, desires, and fears.[47] Taking up the idea of "imprinting," this discussion now turns to attend to the animate matters of the earth that Mendieta's work makes present.

If we are to consider subjects and objects as "caught up in the fabric of the world," then we need to consider how to comprehend the energies and intensities that have been redistributed so as to understand subjects such; as intersubjective co-fabrications: *becomings* rather than beings.[48] In other words, we need to explore how we are not just in the landscape but also, as Wylie puts it, "up against it."[49] This is not just an articulation of that tactile pressure formed by the irreducible relation between body and world, but is also to consider how, allied with much of this work on landscape, has been the "vivification of the material presence of landscape itself, in terms of the incessantly elemental and ecological agencies of earth, sky and life."[50] In a broadly vitalist vein, landscape here has a presence, concerned with matters of force, energy, and process, landscape is present and alive in all its ongoing animation and becoming.[51] In existing landscape literature, nonhuman ecologies have perhaps formed the most common way of animating landscape. These have tended toward a focus on animals that are "big like us" at the expense of earth surface processes, microbial action, and the lithic.[52] We do find, although less often, concern being given to forces and materialities allied on or against human action—the resistant rock, the steep hill, the heat or humidity, the pressure of water.

Interestingly, geographical writing on land art, mainly by iconic male artists (e.g., Robert Smithson, Richard Long, Andy Goldsworthy), offers a clutch of papers that do demand, although not in an explicit way, the foregrounding of the matter and processes of landscape and how artists enroll these within their work.[53] These papers present studies of the artistic use of natural materials and processes including water's ebb and flow, land's gradual or seismic shifts, the creep of soil, the decay of organic material, and the remnants of geological and glaciological processes. In such work, artistic practices and materialities come together with critical effect, formulating an aesthetics of mutability whose focus is the destabilisation of any sense of landscape as timeless, fixed, and static.[54] And, whilst none of these literatures are explicitly aligned with cultural geographies of landscape, their attentiveness to the matters of landscape enables a foregrounding of the latter as present and alive, a site of ongoing animation and becoming.

This is perhaps to be expected, for forms of land and earth art take up a place within the minimalist trajectory of site-based discussions that were developed in Part II. Indeed earth works, like those by Robert Smithson, bring into focus the site as a location shaped as much by the "natural"

conditions, materials and forces at work there as by "cultural" forces. As such, and as with minimalism, the experiences of these works suggests earth/landscape not as merely an inert, pre-given spatial envelope in/on which the art object was displayed, but rather the earth is proposed as an active component of the work. Indeed, more precisely, the earth is an assembly of forces that poses a dilemma to the self-enclosure of the modernist art object, and equally to the self-determination of the spectator's perceptual experience.[55] As Krauss's famous phenomenological exploration of sculpture suggests, many classic earth works required that the spectator be entirely immersed within these works to experience them.[56] In other words, earth works finalized minimalism's departure from the disembodied visual mode of modern aesthetic judgment. To render these arguments in the geographical terms of the discussion here, earth works not only require from artist and audience alike an embodied affective mode of engagement with landscape that resonates with geographers recent interests, but furthermore, they point towards the need to consider the animate matters and forces of the earth as an important part of this.

Looking more closely at specific land art practices, from the large scale earth works of Robert Smithson to the architectural constructions of James Tyrell, as well as the earth-body art of Mendieta, a series of authors have promoted these works as exploring the physical engagement with the earth, making visible and tangible the transactions that are undergone between body and earth in the making of the work. Boetzkes goes a stage further in suggesting that, in exploring these points of contact between artist, audience and earth, these works "mediate a visceral contact with nature in order to suggest a way of interacting with it."[57] For Boetzkes, such interactions enable us to register the earth more definitively as a living, changing elemental force.[58]

What I am interested to do in the remainder of this account is to draw out how, and in what ways, these earth works are less about the artist drawing form from matter against the impulses of the earth processes, as we find for example in Goldsworthy's arraying of natural materials. Rather than matter and forces being harnessed and transformed into something called "art," what I am keener to explore is how we can conceive of Mendieta's work as making visible earthly forces.

POINT OF CONTACT 2: IMPRINTING

Returning to Yagul, Oaxaca, in the summer of 1974, Mendieta made a further piece in the *Silueta* series *Labyrinth Blood Imprint*. To make this temporary earth-body work Mendieta lay on the sandy temple floor while Breeder traced her outline. Getting up and working quickly to avoid being spotted, Mendieta scooped dirt from the floor to make a shallow rim that followed the trace of her body outline. She then poured blood that she had

brought with her into the form. No sooner had they finished photographing the piece than the watchman came with a broom and swept it away.[59]

There are productive differences between this *Silueta* and the one made at the same site the previous year. Perhaps of most importance is the shift from the presence of Mendieta's body towards the creation of an imprint.[60] This is accompanied by an important documentary difference. If the focus of the recordings in the earlier merging works were around the ritual preparations the artist made for her "mergings," the mud coverings and leafy blankets she formed, then the focus in the later work is on what will happen after the performance. Rather than being a witness of an ephemeral performance, the audience/camera explores a form that has an ephemeral presence within the landscape as it erodes, or in this case is brushed away.

The combined effect of these shifts in making and recording is to reorientate the focus of the *Silueta* series. There is a move from a focus on the body form in the landscape as end point, to the body form in landscape being the beginning of a process, shifting our attention to the vanishing of the *Silueta*. "Imprinting" thus becomes a key mode of Mendieta's making. By using a cardboard maquette of her five foot frame Mendieta was able to gain independence in her working practices; moving away from having others drawing around her own body she used this maquette to enable her to work solo, carving, burning and sculpting her form into the landscape. Given these characteristics, it is perhaps not surprising that Mendieta's series is often thematised through the register of loss.[61] Building on this perspective, the remainder of my argument will cast this "loss" in the context of a tension between absence and presence, exploring less what is lost, than what is made present by the artist's gradual *absenting* of her body from her work, and by the gradual breakdown of the *Siluetas*.

Thematising Absence-Presence

Exploring Mendieta's work in terms of the tensions between absence and presence offers three stepping off points. Schematically these are firstly, the artist's increasing absenting of her own body from the making of the work as she replaces it with a maquette, enabling her to imprint on the surface. Secondly, and as the opening description of the *Silueta* on the beach at La Vertias in Oaxaca made clear, these sculpted, imprinted forms gradually disappear. Under the influence of natural processes, they dissolve in the water, are eroded by its movement, are blown by the wind or decay and rot, oftentimes returning to the materials and surfaces from which they were made. Thirdly, but far from finally, there is the increasing distancing, the absencing, of the audience from the primary landscape sites of the work's making. Thus, we see Mendieta increasingly working alone, with herself as her only audience, and the documentation the only way the work is experienced by anyone else. The question, though, that haunts these disappearances is, what do these successive absences make present? What do they bring forth?

Mendieta's documentation offers one site at which to begin to answer this question. The most common understanding of these photographs has been their role in capturing the demise of the silhouette as it merges once more with the earth.[62] Nowhere is this more the case than with the series of body forms sculpted from mud and sediment from within rivers: shaping body forms out of mud from the middle of the river, their inevitable dissolution is a function of the ongoing flow of the water. If the photographs studied earlier, with their detail of earth flecks and stained feet, signified the artist's presence within the landscape, encouraging a rewinding back through the making of the work, then the temporality of these later images becomes one of projecting forward. For the future of these *Silueta,* captured in the process of breaking down, or eroding away, is inevitable. The insistent impermanence of Mendieta's forms will result, we know—outside of the still frame of the picture and its arrest of time—in their inevitably breaking down and being, as Mendieta puts it, "reclaimed by the earth."[63]

If, then, as this analysis suggests, the production of art and the dissolution of the *Silueta* are not separated here, there is no finality, the progressive absenting of the figure is tied into the bringing into being of the artwork and the eventual disappearance of the situated landscape-based body form. But, it brings with it the rendering visible of something else, and here I want to return to that sense of a tactile pressure between the surfaces of the earth and the surfaces of the body that Mendieta sets in play when her works resist total immersion. For, whether we are looking at three-dimensional sculptural forms or the apparently more two-dimensional surfaces of body imprints, the bodily forms and enclosures of the imprint come to form a surface upon which the forces and materiality of the earth play out.

Returning then to the description that opened the paper. On the one hand, the sequence of three images captures the dissolution of the silhouette as it is broken down, and the merging of the materiality of the body with that of the earth. In these images and elsewhere, every detail of the site Mendieta is working at and all its natural processes, whether it be the erosion of a rock face, and earthen bank, gully or tree, becomes part of her making processes.[64] This is less however, about the artist harnessing these forces to make her work, but rather the temporary "framings" of her *Siluetas* render visible the animate matters and forces of nature. For the gradual absenting of the form of the body form, also functions to render the body as a surface across which is displayed the animate and forcible elements of the earth.

Returning to the description of the untitled *Silueta* Mendieta made on La Vertias beach in Oaxaca we can see how this plays out more clearly. The photographs might take as their subject the gradual dissolution of the body form, but what they bring into focus is the materiality of the scene, the gradually smoothed sand, the silhouette form losing its sharpness. The textures and substances from which the ground is made, from which the body form is carved are important here, but also, across the image sequence it is the animate forces of the water that become the subject of the photographs. For, it

is the rhythmic ebb and flow of the water, so bound up with larger cosmic rhythms, that the picture sequence renders visible. The changing forms of the *Silueta* become a vehicle, a surface across which the forces and animate matters of the earth are thrust toward us in a way that is hard to ignore.

The earth is rendered here as matter and as animate force, made visible by Mendieta's repetitive ritualistic forming of these silhouettes and their equally ritualistic reclaiming by the forces of nature. The body provides, as Boetzkes has suggested in relation to earth art practices more generally, a surface of visibility for physical processes, and is thus the surface on and through which the countenance of the earth comes into view.[65] And this is an earth that is one of material, forces, energy and processes, present and alive in all of its ongoing animation and becoming.

This making visible of the matter of the earth is rendered more forceful by the composition of the images. Evidence suggests that in later years Mendieta was careful to present her images as singular art objects in their own right, rather than as documentation of her process.[66] Indeed, towards the end of her life the artist was making *Silueta* images she describes as almost life size. These photographs are filled to the edges with close-ups of earth, water, sea, mud, rocks, smoke, feathers, ashes, and so on, recorded in tightly framed and richly textured colour. Their close-cropped focus tight in on the body within the landscapes, resists the separation out of figure and ground that classically characterize landscape. In these imprints the body form/outline does not contain, either in a volumetric sense, or in the sense of control, the volatile earth excesses, but rather is surrounded by, entered into and existed by and through them. In these photographs, the excesses of the earth are registered here on the body, the outline becomes a frame of sorts, thrown around the processes and forces of nature, temporarily composing them, displaying them and making visible these invisible forces.[67]

Presencing Excess

There is, though, a third tension between absence and presence that Mendieta's works engage. And here I am concerned less with the imprint of the body on the surface of the earth than with another process of imprinting that has been so entangled throughout this discussion; the imprints made on the negatives of photographs, the slides and the films that document the works. The role of these images and films in helping us to understand absence and presence, coincidence and non-coincidence in Mendieta's work has been important throughout this chapter, but to end I want to spend some time exploring it further.

That there is a double loss implied in Mendieta's photography—the loss of the artist's body and the loss of the *Silueta* form—is commonly acknowledged.[68] This loss is perhaps more palpable in the photographs than in the film; in the photographs, the end is imagined, whereas in the films, rather as with Houghton's films in Chapter Two, there is an ongoing loop, a

meditation here on process, as the body breaks down over and over again. What was present and then gone in the film, is returned to the landscape and absented all over again as the film restarts. But in the images the dissolution of the body works differently, we are encouraged to imagine the end of the body form.

There is, however, a third form of tension between absence and presence that these imprints develop: one that rescores the differences between Mendieta's experiences, and those of her audiences. The hyper-real details within the images, which earlier were so key to rendering the bodily presence of the artist, here mark a third absence. For, throughout the series of photographs, with their stilling of the vibrant animation of the earth, what is framed in the image is the inability of these documents—these imprints—to capture the excess of the earth and the experiences of the situation. For, just as the bodily limits of form were overcome and exceeded by the natural forces that dissolved them, so too these limits cannot be developed, cannot be presenced, in the photographs, only evoked. The limitations of documentation are made present here. For the photographs imply a triple absence; that of Mendieta's body, the impending absence of the degrading *Silueta,* and the absence, or gap between the excesses of experience within the landscape, those experiences the photograph can picture, and those it can summon up. The outline, and imprints of human bodies and experiences, on the earth or in the photographs cannot exhaust, nor can they capture or contain the matter and forces of the earth.

CONCLUSION: TOWARDS A LANDSCAPE ETHICS?

This chapter has examined the earth-body works of Ana Mendieta. Focusing on the *Silueta* series, and using geographical thinking about landscape as a way into this series, discussion has explored how it is that artworks can produce aesthetic encounters with landscapes. What this chapter has hopefully demonstrated is that an artistically configured embodied engagement with landscape is riven through with a certain sense of politics. These are politics that can go beyond the formulation of bodies and landscapes as discreet atomised forms to develop a consideration of body-landscape relations that is other than one based on the classical epistemology of "looking over." Such a sense of being-in-the landscape, is importantly, not to effect an overly simplistic sense of the collapse of body/landscape, but rather to retain a sense of the difference between the two, another tension to add to those that sit at the heart of understandings of landscape as tension.

But what of the force of these encounters and engagements the Mendieta develops throughout her work? Boetzkes points us toward one answer when she indicates that earth artists elaborate an ethics of ecology not only by expressing moments of physical engagement with natural forces, but also by making the character of that encounter the subject matter of the

artwork.[69] In exploring the consecutive moments of absence within Mendieta's series what is made present and what we encounter are the forces and matter of an animate earth. In pushing us to think about bodies beyond the horizons of their closed contained and atomised forms, in making us think through corporeal materialisms, Mendieta's work resonates with some of the most important questions within geographical preoccupations of the body, as well as raising questions around the politics that inhere within embodied landscape understandings.

Alongside engaging and extending geographical questions of bodies and landscapes, this chapter has further reinforced the analytic importance of attending to the geographies of artistic production and consumption. The presence of Mendieta in the landscape and the absence of the majority of her audience, including you as readers, from the experience of her making her works, and the subsequent importance this gives to the different "sites" and forms of the *Silueta*—as a series, as individual photographs, as video documents—draws out the need to remain sensitive to complexities of art-work geographies. One thought that should not be overlooked in our thinking about the ethics that might propagate from Mendieta's encounters with the earth, is, as Rendell has noted of other earth art, that sometimes the distance in space and time between the work and our consumption of it through images and videos can be key in opening up imaginative spaces within which the forces of the work circulate. These imaginative spaces hold within them, it could be suggested, the possibilities of a more ethical orientation towards the environment.[70]

By Way of Conclusion
Towards an Analytic Framework

Several decades ago, Stephen Daniels observed that between geography and art, there was common ground that was scarcely surveyed.[1] This territory has become increasingly occupied in recent years with geographers embracing a cross-section of artistic mediums in the development of a range of different disciplinary questions, as well as exploring the possibilities of creative practice-based research. Further, arts' own expanded field has seen the movement of artists and art theorists towards practices and concepts normally understood as geographical. In the place of extending these studies, this text has sought to press pause, temporarily, on the proliferation of geography-art relations and spend some time instead marshalling thoughts on the form and import of these relations. This is, of course, not to say I am not interested in thematic development, and each of these chapters has accomplished some work in this respect, whether this be about urban space or landscape. It seemed, however, an appropriate moment, amidst the growing pace of geography-art exchanges, to spend some time parsing the relations between geography and art, and thinking through a geographical approach to arts practices.

The result has been the development of a threefold analytic framework for creative geographies, an analytic framework that suggests we should ask the following interrelated questions: What "work" does art do in the world? What are the geographies of the artwork's production and consumption? And, thirdly, how is it that we encounter art works? I would stress that while this is an analytic framework developed through an exploration of recent visual arts practices, these are questions valid across time periods and artistic mediums, as well as with respect to other forms of creative practice.

As the Introduction outlined, the terms of this analytic framework grew from two different contexts, firstly that of the history of geography-art relations, and secondly, the challenges and opportunities offered by the expanded field of twentieth-century art. To begin to flesh out this framework, and to provide evidence of its application, the text developed seven case study chapters, organised into three parts. These three parts addressed some of the key issues raised by the intersection of the history of geography-art relations and arts' expanded field. Firstly, Part I explored the history

of geography-art relations by way of a consideration of the transformative disciplinary work that art has done, and does, in offering—planned or otherwise—critiques of the practices and spaces of knowledge production. Furthermore, it posited that it was not only in the critical discussions that artistic practices promoted that the interest lay, but also in the possibilities that arts practices could offer the means for knowing otherwise. Part II explored the import of geography as an art world analytic in the light of arts' expanded field. This involved considering the multiple geographies of art developed by way of the shifting spatialities and temporalities that accompanied these new art practices, and situating these as part of the ongoing deterritorialisation of studio and gallery spaces. Part III focused on the emergence of a shared project of the body. This involved exploring the relationship between arts' developing preoccupations with questions of an active, embodied spectator (as a response to the previous decade's critique of vision) and geography's acknowledgement of how cultural geographies are, to use McCormack's phrase, corporeal geographies. The latter is especially true in the wake of the disicpline's response to the widespread fall of vision's hegemony, and its exploration and experimentation with forms of "being" in the midst of the world.[2] By way of a conclusion, I want to spend some time reviewing the three coordinates of this analytic framework in more detail, ahead of this however, I want to reflect further on the two historical anchor points of the text.

GEOGRAPHY, ART, AND THE EXPANDED FIELD

Two key anchor points have been laid out as a backdrop to enable these creative geographies and their analytic framework to come into view: firstly, the history of geography-art interactions, and secondly, the progress of twentieth-century art as seen through the lens of Krauss's "expanded field." Clearly it is beyond the scope, or desire, of the current text to offer anything like comprehensive accounts of either of these. Instead, mapping the two together has enabled the identification and problematisation of some of the key shared analytics, as well as points of difference.

The first touchstone for the text was the history of geography interactions. The work done by Daniels and others on the representational politics of landscape painting over the last thirty years has provided some enduring currents of interest around which geographical approaches towards art have cohered. These include, foregrounding the analysis of artwork, directing us toward the political "doings" of art, and providing a model of interdisciplinarity that was not afraid to challenge existing geographical or artistic approaches. It is also important not to overlook how the "interpretative" lens of this work broke from centuries of previous geographical engagements with art. As Part I makes clear, for many years, geography-art relations have been based on rather different terms, principally enrolling

art, as part of a descriptive tradition, in the service of geographical science and empire. Arts practices, however, also came to be valued for the alternative form of "data," and the epistemological model they offered.

Clearly there is more work to be done on these historical relations, and to reduce them to differences between science and art would be to fall foul of a set of unhelpfully reductive labellings, or in an equally unhelpful move, to smooth over what are clearly the productive differences between them. What Part I of this text looked to do was draw out how setting geography and art in dialogue together, across the centuries, resulted in productive transformations both in this relationship, but also in the production of geographical knowledge itself. As the account develops, this relationship becomes more complex as as art is recognized to offer geographers sources of epistemological critique with which to counter scientism. For developing amidst arts' expanded field was a critical strain of arts practices, wherein the querying of practices, spaces, and terms of knowledge production became art's *raison d'être*. Furthermore, as *Connecting with Gertrude*, and to a lesser extent *Creative Compass*, suggests, we find within these arts practices and often their collaborative forms, a mode of interventionary critique that also offers alternative models by which knowledge production can proceed.

The second framework through which this text brought geography-art relations into view was based on what Krauss termed sculpture's "expanded field." Krauss's description of the changing modes of art practice framed here, as it did for critics at the time, the challenges that these emerging forms of mid-twentieth-century art practice posed to traditional analytic modes and understandings of art. As a result, the "expanded field" makes space within both art theory and practice for the uptake of sets of ideas we might think of as specifically geographical—space, place, site—and the development of sets of common preoccupations, such as the body. As such, Krauss's formulation provides us with a framework and context within which to situate the proliferation of geographical engagements with artistic practices over the last few decades.

Accompanying the expanded field was a broader ontological and epistemological querying around how it is we understand art and our encounters with it. One of the results is that we see geography-art relations operating across a terrain wherein we are required to consider the productive force of artworks, literally the "work" of art. This demands in turn that we explore modes of analysis and art writing that are able to take account of the different forms of "work" that are possible. This is, in short, a research approach that is able to make space for sensory, emotional, and affective responses alongisde conceptual analysis. This is paired with a form of writing that attempts not only to present an exploration of the artwork in question, but also to evoke some sense of that productive encounter with art, to lead the viewer back to the work, and examine what it means to be an active viewer within this encounter. What is important to emphasize is that, while these are questions

that directly propagated from art's expanded field, they apply across a range of mediums and time periods of artistic making.

From within these two contexts an analytic framework for creative geographies comes into view, one that has run across this text, and whose three facets will structure the discussion in the remainder of this conclusion. Following this, I will close with some reflections on the benefits, but also challenges and responsibilities that propagate from understanding geography-art relations in this way.

WHAT WORK DOES ART DO IN THE WORLD?

Art was long cast in the service of geographical science; sanctioned in the nineteenth and early twentieth centuries as a part of the discipline, it contributed to the advancement of geography. Furthermore there was a realisation that we could find in art, not just data, but also the aesthetic working through of geographical concepts. Art thus has a long history of doing different forms of disciplinary work, and to consider creative geographies involves taking seriously the various forms of this work, and its relationship to the discipline and beyond. This is to query what art does, what it sets in motion, to consider art less as produced by, but rather as productive of. Art thus becomes "something" with agency, and productive of effects—these might be aesthetic, they might be about signification, they might be political, they may be affective, they might be all of these at once. Beginning from the identification of key historical terms of art-geography relations—as data on places and people, as aesthetic orientations, as research method and as proffering critical questioning of modes of knowledge production—these ideas where tracked forward into the seven chapters which followed. The case study chapters developed a series of different forms of productive encounter with art, three key of which—remaking the discipline, producing sites and subjects—are explored in more detail in what follows. What this text did not set out to do, and what remains interesting work for the future is to theorize these different forms of art's work in a more prolonged manner.

Remaking Geography

As the episodes in a brief history of geography-art relations that Part I recounted suggest, the place of art within geography is one that has offered a sense of disciplinary critique and transformation. In the projects *Creative Compass* and *Connecting with Gertrude* artworks were seen to do work in the context of the spaces and practices of disciplinary knowledge making. Both the projects promoted intersections of artistic practices and forms of disciplinary knowledge making, and in both cases what became clear was the variety of different roles art has taken up within the discipline over the

centuries. Clearly more work is needed in this area, and the thrust of these case studies was not towards their offering of an historical narrative: they had rather more expansive methodological and epistemological impetus than that. In the development of both case studies, intersecting with arts practices clearly emerged as providing a space for reflecting on the practices, spaces, and politics of knowledge production. However, accompanying this reflective space came a mode of critique that was not only about casting a critical lens onto existing ideologies and practices of knowledge production, but also about proposing new ones in their place.

Therefore, as we take on board the potential of arts practices to offer critiques of knowledge, one of the things to consider is how artistic practices not only challenge disciplinary teleologies, but also move us beyond them. In short, intersecting fields of geography and art might not merely offer one field as a model or form of critique for the other, but rather could instead demand that we move beyond the existing horizons of both.

Sited Works

Artistic practices have long had value as providing geographical information about people, places, species, and landscapes. Indeed, recent methodological trends arguably extend this trajectory as geographers turn to creative practice-based research, as well as to artists, to develop "other" ways of researching and evoking places in their research. In terms though of querying the "work" art does with respect to site and place, we need to appreciate the role of geographical conceptualisations of place, space, and site as always in process. For such understandings were foundational to enabling scholars to move beyond a deterministic relationship to consider the "work" art does on and at a site. Indeed, one of the key challenges of recent times has been to develop a vocabulary and a set of methods and concepts that are up to the task of parsing closely the relationships between art and site, and querying how and in what form art goes to "work" at sites.

The most concentrated exploration of these questions was perhaps found in the three chapters that constituted Part II—for example, in relations that were formed during the processes of *Caravanserai,* or the site-based critiques propagated by *Break Down.* But these ideas spread across the seven case study chapters, whether this be in the form of institutional critique in *Creative Compass,* or alternative forms of politics and aesthetics explored in the studies of Ana Mendieta's work, or the intersections of bodies and spaces promoted in Takahashi's installation.

These studies show how far geography has come in thinking about art solely in terms of providing data about people and places, either in the form of empirical naturalism, or in terms of arts practices as attuning us to elements and ideas of places and regions that had been written out of a scientist geography. What we find across these studies is a sense that we need to consider the forms of "work" art does at site. This might be

about offering us the means to explore and evoke different epistemological understandings of place, and/or it might be that we find within the "work" of art, a production of subjects and knowledges that can operate outside of ingrained sensibilities and understandings, to open us up to ways of being and acting in the world that are other than those we currently know and practice. This is to shape a different understanding of aesthetics than those focused on the shaping of people and places by way of aesthetic conventions, whether these be picturesque landscapes or neoliberal urban regeneration programs. Instead, under the sorts of "productive" understandings developed here, art enables and indeed brings about alternative understandings of politics, of subjects, and our ways of knowing and being in the world.

Bodies, Subjects, and Environments

A third form of the "work" that art does that this text explored was the critical project of the body that it enables. As exemplified in the discussion in Part III, a shared artistic and geographical project of the body finds in art an operation against Cartesianism, and a returning of us, in a sense, to our bodies. In terms of geography-art relations this can be related to a longer history of the place of aesthetics within the production of disciplinary knowledge, wherein art forms the means and a model of experiencing, sensing the world.

The exploration of the "work" that art can do with respect to our explorations of our bodies, and what it means to be "in the midst of the world," was distributed throughout the text, but it was most concentrated in the auto-ethnographic study of the experiences of Takahashi's installation, and the exploration of the body-earth art of Ana Mendieta. In both these discussions the recounting of the experience of the works and their making pointed toward the force of art to stage lived experiences for us. In other words, the event of the art encounter could draw out experience and sense from its backgrounded position in the normal course of our lives, thus enabling us to study, and to theorize it. But yet, as both discussions illustrate, there is more to the work of art than merely sensitising us to normally overlooked elements of lived experience. Rather, artworks moved us beyond an attunement to our bodily capacities, and our enclosed body forms. In doing so, we find within the experience of art the means to make us aware of our limits and our limitations and, of the fragility of our bodily boundaries. This is to open us up to understandings of the world and our human place within it that refuse, in a whole range of ways, our centrality to that world and our teleological world views.

THE ART WORLD'S GEOGRAPHICAL TURN?

If the early geography-art relationships that enrolled the arts within geographer's descriptive tradition, and their later critique by the more interpretative modes of engagement taught us anything, it should be that to

understand the agency of art, the work it does in the world, we need to attend closely to the geographies of its production and consumption.

In considering empirical naturalism there was an assumption that art would offer a mimetic relation to the original, that its representational forms could travel unchanged, that they were perhaps akin to Latour's immutable mobiles. But yet, with the interpretative tradition it was acknowledged that of course there was no originary innocence; that painted scenes always reflected a view from somewhere. And further, that as these images circulated they were put to different uses by different people. So, entire landscapes and communities—as well as individual bodies—were shaped materially and symbolically in response to the aesthetic standards that circulated by means of landscape art and other cultural forms. Thus, while art has long been understood to do work in the world, the understanding of such work depends on our comprehension of the geographies of art.

To study the geographies of arts production and consumption has therefore long been important, but what Part II, and the chapters contained therein, drew out was the increasing currency of "geography" as an art world analytic in the wake of art's expanded field. Captured in the phrase "from studio to situation," we find an increased attention to arts' relationship to the sites and spaces of its production and consumption that resulted from this expansion and shifting in the materialities, temporalities, and spatialities of arts practices.[3] Indeed, the development of a vocabulary and a methodology for studying these art-site relations has become a key preoccupation across the art world.

These discussions of what such a vocabulary and method might look like take their focal point in the three chapters that constitute Part II of this text. These studies explore installations, performances, photographic practices, and site-based, socially engaged practices by way of a range of methods; from visual and textual analysis, to ethnographic and collaborative creative practice-based research. The result is an argument that suggests that if we are to understand the transformative work that artworks can accomplish—on their makers, their audiences, and their sites and spaces— then we need to carefully attend to the sites, spaces, and practices of their making and consuming, and the relays between these different sites.

Thus we see, for example, the analysis of *Break Down* proposing that to understand the force of the work what is needed is a study that is attentive to the heterogeneities of its nested sites. The spaces the work produced, and their productive force, could be best appreciated, it was argued, by an exploration of *Break Down* as a multi-sited work. This required a consideration of the accounts of practice provided by the two artist's books alongside an analysis of the site-specific installation and the dynamics and power relations of the spaces it created. Building on the importance of attending to multiple sites, the exploration of Richard Wentworth's urban imaginary and its particular politics hinged here on bringing together an analysis of image content—their pictured subject—with an appreciation of making practices, but also the practices and

materialities of consumption and display. The final of the three chapters in Part II, Chapter Five, addressed the theoretical and methodological challenge that socially engaged site-specific arts practices proffer to traditional coordinates of art analysis. This study took up the idea of residency with respect to these questions, and examined how the collaborative production of an artists' book catalyzed a form of research relationship that enabled a working from the inside of the site. This was to enable an examination of the forces, materialities and intensities of the social relations of that place (and that project) as they unfolded.

While the geographies of art were crucial analytics in the three chapters in Part II, they were also present across the seven case study chapters more generally, evidencing the value of an analytic attention to the spaces and sites of artistic production and consumption.

EXPLORING ART ENCOUNTERS

One of the key sets of questions propagated by the artworks that emerged as a result of arts' expanded field has been the need to rethink the terms of our encounters with art. If we are to attend to a sense of arts' liveliness, to the distributed sense of poesis that results from this perspective, then we need to appreciate the methodological and interpretative impacts of such understandings. In other words, what is demanded by an appreciation of art in terms of encounter is to recognize and develop methods that enable the study of the activation of the corporeally embodied, socially and politically situated, active audience. The rational, critical framework, and accrued artistic connoisseurship based solely in the scholarship of the distanced, objective viewer are no longer perhaps as appropriate. Sometimes, new forms of artwork demand new methods of study, whether this be the need to research and write aesthetic responses to art, or the demand for new methods able to deal with studying social relations rather than aesthetic objects.

The seven art encounters developed across this text have attempted to make space for the liveliness of these encounters. This involved engaging and developing modes of interpretation and writing that are as open to the conceptual, affective, sensuous, and emotional dimensions of art encounters as they are to deploying art historical and theoretical ideas, and intellectual contexts drawn from elsewhere.

Across the seven case studies the intention has been to demonstrate the critical demands but also the possibilities that research and writing in arts' expanded field presents geographers with. These demands lie in both interpreting these works, but also in being involved in any stage of the production of art works. The methodology for these studies is a methodology that, like any other we might engage, is a developed and honed set of skills, techniques, and further, it demands that we engage, reflect, and develop practices and politics as we go. If the attention to arts encounters, on the

one hand, requires us to take seriously the development of new research and writing models for thinking about the relationships between artwork, world, and audience, then on the other, we can also consider art encounters, as this text has, through the lense of the expansion of geography's own field of practices towards creative and artistic methods.

Intersecting Fields

Each of these chapters has looked to present a different form of encounter with artworks, to think through what it means to become enrolled within these works, and thus to have to respond creatively to them. Further, across the case studies, the role of geographer as interpreter has been joined by geographer as collaborator, as commissioner, and as curator. These different points of involvement have been less about the application of a research idea to the development of an exhibition or a project, and much more about enrolling creative production within a research methodology.

One thing that can tend to be overlooked in geographers' increasing embrace of artistic, but also creative practices more broadly, whether these be creative writing, film-making or photography, is that these practices too are creative encounters and are formative of creative encounters. Therefore, they come with not only opportunities but also a set of risks, responsibilities, and politics. There is a set of open questions here about how it is we produce and judge these works: Are they geography? Are they art? Are they both? What sorts of questions do we ask? Rather than ask whether this is good art, rather than query whether we think it is up to standards, it could perhaps be more productive to ask of geographers' art practice-based engagements the same questions that have been asked in this text of other creative geographies. For, only in doing so will we be taking seriously not only what turning to creative practices means and does in the context of disciplinary questions, but also what it means to be responsible for producing set of creative practices and objects that go to work in the world in particular ways that are productive of forceful creative encounters.

It seems only right, then, that following the creative geographies outlined here, we ask of geographers' own creative outputs the same questions: what work do these creative geographies do? What political and ethical responsibilities might come with the transformations they intentionally (or un-intentionally) bring about? What is it that is somehow different, or differently enabled by undertaking artistic practice-based research? A second set of questions would concern the geographies of the production and consumption of these works: what are the contexts, spaces, and sites of their production and consumption? How do these in turn go to work at their sites and locations? Finally, a third set of questions concern what sorts of encounters are these creative geographies developing? What kinds of engagement are we hoping to promote? What are their politics, and what do we, as geographers, expect might come of them?

FOR CREATIVE GEOGRAPHIES

The story of geography-art relations narrated here is one that has been told in terms of the creative productive encounters that art develops. Going to work in the world, art can produce extensions in understandings and even possibly transformations of knowledge or subjects and of worlds. I am thinking less here of expansive transformations of the sort spoken of in paradigmatic terms; rather, I am thinking of smaller scale ideas, experiences that move us in some way beyond, or outside of, the familiar and accepted horizons of our existing knowledge and practices.

There is a risk here of romanticising the possibilities of geography-art relations, of creative geographies, a danger here of enacting a creative fetish. In other words, of seeing in creativity only benefits, and of embracing arts and creative practices as something geographers should rush towards: after all, as many have pointed out, who does not want to be creative? In doing so, we are maybe overly celebratory of difference and the "new," and as such overlook the hard work, responsibilities, and indeed the much longer histories that go into the formation of contemporary geography-art relations. To be aware of the intersection of geography's and art's fields is also to be aware of, and to be thoroughly respectful of, the long practiced and often hard won sets of skills and expertise that denote each of these fields. The intention here is in no way to dampen the vigor of contemporary geography-art relations, and the excitement of creative practice-based research, but rather to suggest that we need to take seriously the skill sets involved, and the intellectual and political responsibilities, as well as the possibilities of these relations. The analytic framework posed throughout this text provides several ways by which we might begin to think about these questions

When John Kirtland-Wright called for an aesthetic geosophy, he was promoting a relationship between geography and the arts that lay in the belief that this relationship was only to be celebrated when it advanced geographical science.[4] I have argued, I hope, for something rather different than a relationship that has its foundations in securing geographical science, or one that is based in tracking preformed geographical ideas through artworks. Instead, the key to this volume's exploration of creative geographies—whether based on artistic interpretation or on creative practice-based research—has been to consider what it might be that they enable. To explore, therefore, how creative geographies offer rich possibilities for challenging, extending, and even perhaps transforming subjectivities, knowledge and worlds: creative geographies that, in short, make worlds.

Notes

NOTES TO THE INTRODUCTION

1. Edensor et al., *Spaces of Vernacular Creativity;* Hallam and Ingold, *Creativity and Cultural Innovation*; Jeffcut and Pratt, *Creativity and Innovation*; Luckman et al., "Mosquitoes in the Mix"; Peck, "Struggling"; Gibson-Graham, *Postcapitalist Politics.*
2. Hawkins, "Expanding Fields," "Dialogues and Doings"; Tolia-Kelly, "Visual Culture"; Crang, "After a Fashion."
3. Humboldt, *Cosmos*; Meinig, "Geography As an Art"; Daniels, "Human Geography."
4. Smith, *European Vision*; Watson, "Soul of Geography"; Stoddart, "Geography, Education."
5. Colls, "Bodiestouchingbodies"; Crouch, *Flirting;* Hawkins, "Argument"; Gandy, "Contradictory Modernaties"; Cook, "Social Sculpture"; Parr, "Collaborative Film-Making"; Tolia-Kelly, "Participatory Art"; Mackenzie, "Land is Ours"; Pollock and Sharp, "Constellations"; Vasudenvan, "Photographer of Modern Life"; Blunt et al., "My Home"; Butler, "A Walk of Art"; Dixon, "Blade and Claw"; Abrahamsson and Abrahamsson, "Body Conveniently"; Bonnett, "Art, Ideology"; Fenton, "Space, Chance, Time"; Pinder, "Arts of Urban Exploration."
6. These themes mirror the citations given in note five.
7. Kaufmann, *Toward*; Guilbaut, *How New York Stole;* Lubbern, *Colonies;* Jacobs, *Good and Simple.*
8. Doherty, *From Studio*; Kwon, *One Place*; Rendell, *Art, Architecture;* Pearson, *Site-Specific.*
9. Rugg and Martin, *Spatialities*; Rugg, *Exploring;* Deutsche, *Evictions;* Pearson, *In Comes I;* Lippard, *Lure of the Local*; Weizman, *Hollow Land;* Rogoff *Terra Infirma*; Elkins, *Landscape;* Bhagat and Mogal, *An Atlas.*
10. Daniels, writing in 1983 observed a scarcely surveyed common ground between geography and art, "Human Geography," while in 2000 Balm observed an interdisciplinary gulf, "Expeditionary Art."
11. For a summary, see Hawkins, "Dialogues and Doings"; Hawkins, "Expanded Field"; Tolia-Kelly, "Visual Culture;" and Crang, "After Fashion."
12. Driver et al., *Landings;* Nash, "Irish Geographies"; Carter, *Material Thinking*; Hawkins and Lovejoy, *Insites;* Foster and Lorimer, "Some Reflections"; Alfrey et al., *Art of the Garden;* Bonehill and Daniels, *Paul Sandby*; Mclaren, *Art/Geography*; Till, *Mapping.*
13. Other creative practices geographers have explored include visual culture methods (e.g., Garrett, "Videographic Geographies"; Merchant, "The Body and the Senses"; Crang, "Visual Methods") and writing (e.g., Wylie, "A

Single Day's Walking"; Lorimer, "Herding Memories"; McCormack" Drawing"; Hawkins, "Argument").
14. Foster, *Return of the Real.*
15. Thompson et al., *Experimental Geographies.*
16. Bhagat and Mogal, *Atlas;* Fox, *Terra Antarctica;* Pinder, "Subverting Cartography"; Phillips, "Doing Art"; Cosgrove, *Mappings;* Hawkins, "Placing Art"; Kinman and Williams, *Domain;* McCormack, *Drawing.*
17. Crampton, "Cartography: Performative."
18. Till, *Mapping Spectral Traces;* Till, "Wounded Cities"; Pearson, *In Comes I;* Pinder, "Arts of Urban Exploration"; Daniels et al., *Fieldworking;* Biggs, *Between Caterhaugh.*
19. Krauss, "Expanded Field."
20. Hawkins, "Expanding Fields."
21. See, for example, Daniels, *Fields of Vision;* Cosgrove and Daniels, *Iconography of Landscape.* Not long after urban geographers started exploring the practices of the Situationists, see for example, Bonnett, "Art and Ideology."
22. Daniels, *Fields of Vision*
23. Kirkland-Wright, "Terra-Incognita," 1.
24. Lowenthal, "Geography, Expereince," 219.
25. Lowenthal and Prince, "The English Landscape."
26. Berger, *Ways of Seeing;* Daniels, "Marxist Duplicity."
27. Cosgrove, "Ideas and Culture."
28. Ibid.
29. Daniels, "Marxist Duplicity"
30. Ibid.
31. Cosgrove and Daniels, *Iconography;* Daniels et al., *Envisioning Landscapes;* Dear et al. *Geohumanities.*
32. Kaufmann, *Toward.*
33. Seymour et al., "Picturesque Views"; Seymour et al., "Estate and Empire."
34. Daniels, *Fields of Vision.*
35. Mitchell, "Idea of Culture."
36. Tuan, "Literature and Geography," 194.
37. Ibid.
38. Krauss, "Expanded Field."
39. See Foster et al., *Art Since 1900,* for example.
40. Krauss, *Originality;* Foster, *Return of the Real;* Lippard, *Dematerialised.*
41. E.g. Foster's interest in psychoanalysis, *Compulsive Beauty;* Krauss's studies using phenomenology, *Passages;* Deutsche's work on neo-Marxist urbanism *Evictions;* Lippard's exploration of questions of the local and multiculturalism, *Lure of the Local;* Rendell's use of neo-Marxist spatial politics, *Art and Architecture.*
42. Daniels,"Human Geography"; Rendell, *Art and Architecture*, 43.
43. Rendell, *Art and Architecture,* 46.
44. Jones, *Body Art;* Jones and Stephenson, *Performing the Body.*
45. Jones, "Art History/Art Criticism," 39.
46. De Duve, *Kant after Duchamp;* Jones, *Body Art.*
47. Pollock, "Encountering," 16.
48. Pollock, "Encountering"; Rendell, *Site Writing.*
49. O'Sullivan, *Art Encounters.*
50. Tanke, *Foucualt's Philosophy,* 8.
51. Tanke, *Foucualt's Philosophy.*
52. Ibid., 8–9.
53. Deleuze and Guattari, *A Thousand Plateaus; What Is Philosophy?*
54. Deleuze and Guattari, *What Is Philosophy?*
55. Ibid.

56. O'Sullivan, *Art Encounters*, 1.
57. Ibid.
58. Ibid.
59. Massumi, *Virtualities*; O'Sullivan, *Art Encounters*.
60. Best, *Visualising Feeling*; Lomax, *Sounding*.
61. Bourriaud, *Relational Aesthetics*.
62. O'Sullivan, *Art Encounters*, 24.
63. Pollock, "Encountering," 15.
64. Pollock, "Encountering," 16; Rendell, *Site Writing*.
65. Pollock, "Encountering," 16.
66. Ibid., 20.
67. Rendell, *Site Writing*; Lomax, *Sounding the Event*.
68. Jones, "Art History/Art Criticism," 39.
69. Pollock, "Encountering," 20.
70. Rendell, *Site Writing*; Pollock, "Encountering"; Bal, *Spider*.
71. Ibid.
72. Hawkins, "Doings."
73. Dogerty, *From Studio*.

NOTES TO PART I

1. Wimmer, cited in Darby, "Problem," 4.
2. Younghusband, "Natural Beauty."
3. Meinig, "Geography," 325.
4. Ibid.
5. Ibid.
6. Ibid., 318.
7. See Brunn, "Issues" as an example of using presidential addresses to explore disciplinary concerns. Sauer, "Morphology," notes the value of using presidential addresses of the AAG to think through geographical topics—in his case, landscape.
8. Wright, "Terrae."
9. Ibid.,12.
10. Ibid.,12.
11. Ibid.,12.
12. Ibid.
13. Keighren,"Geosophy"; Wright, "Terrae."
14. Watson, "Soul."
15. Ibid., 385.
16. Ibid., 385–386.
17. Ibid., 394.
18. Hart, "Highest Form."
19. Ibid., 2–21.
20. Daniels, "Maps of Making."
21. See also Crang, "After a Fashion"; Cresswell, "New Cultural."
22. Brace and Johns-Putra, "Recovering"; the spaces and sites of creative practice, Sjöholm, "Geographies"; Daniels, "Studio"; as well as creative practice-based research, Driver et al., "Landings"; Hawkins and Lovejoy, *insites*.
23. Daniels, "Maps of Making."
24. Crang, "After a Fashion"; Dwyer and Davies, "Animating"; Tolia-Kelly, "Visual Culture."
25. Dear et al., *Geohumanities*; Daniels et al. *Envisioning Landscapes*.
26. Meinig, "Geographers"; Darby,"Description"; Smith, *European Vision*.
27. Tuan, "Literature,"195.

28. Ibid.
29. Balm, "Expeditionary."
30. Ibid.
31. Smith, *Imagining*; Smith, *Pacific Visions*.
32. Clarke, "Landscape,"105; Smith, *Pacific Visions;* Stafford, *Voyage*.
33. Ibid.
34. Quoted in Smith, *European Visions*, 109.
35. Cosgrove, "John Ruskin"; Gellatley, "Historical"; Gemtou, "Depictions"; Knight, "Glaciers."
36. Zerefos, "Atmospheric."
37. Daniels, "Imaginations,"185.
38. Driver and Martins, *Tropical Visions;* Young-Husband, "Nature"; Matless, "Nature, Myth"; Stoddart, "Geography"; Dixon et al., "Wonder-full"; Hawkins and Straughan, *Geographical Aesthetics*.
39. Stoddart, "Victorian Science"; Dixon et al., "Geomorphology," 3.
40. Bunkse, "Humboldt," 146.
41. Ibid., Humboldt, *Cosmos*.
42. Humboldt, *Cosmos,* ix, fn. 12.
43. Ibid.
44. Bunkse, "Humboldt."
45. Ibid., 135.
46. Ibid., 137.
47. Dettlebach, "Stimulations"; Dixon et al., "Geomorphology."
48. Buttimer, "Beyond,"105.
49. Darby, "Description."
50. Wimmer cited in Darby, "Description," 4.
51. Daniels, "Imaginations,"194.
52. Gilbert, "Idea."
53. Meinig, "Geography," 317.
54. Pocock, "Literature."
55. Lowenthal, "Geography and Experience," 219.
56. Meinig, "Geography," 321.
57. Entrkin, "Contemporary Humanism."
58. E.g. Battista, "Pleasure"; Till, *Mapping*; Edensor, *Industrial Ruins*, Garrett, "Videographic Geographies."
59. Dwyer and Davies, "Animated."
60. Crang, "After a Fashion"
61. Stoddart, "Geography, Education," 296.
62. Ibid. Tolia-Kelly, "Visual Culture."
63. Younghusband, "Natural Beauty," 10.
64. Ibid.
65. Ibid.
66. Ibid., 13.
67. Hart, "Highest Form," 28.
68. Parr, "Collaborative"; Tolia-Kelly, "Participatory"; Tolia-Kelly, "Fear"; Pratt and Johnston, "Nanay."
69. Pratt and Johnston, "Nanay," 138.
70. Ibid., 133.
71. Ibid.
72. Cook, "Social Sculpture."
73. Miles, "Representing"; Gabrys and Yusoff, "Art, Science."
74. Tolia-Kelly, "Visual Culture."
75. Garratt, "Videographic Geographies"; Parr, "Participatory."
76. Ibid.

77. O'Sullivan, *Art Encounters*, 2.
78. Dewsbury, "Seven Injunctions," 321; Thrift, "Summoning," 81.
79. Leighly, "Some Comments," 167.
80. Ibid.
81. We can perhaps hear an echo of Humboldt in here.
82. Ibid.
83. Gilbert, "Idea,"158.
84. Ibid.
85. Harley, "Deconstructing."
86. Ibid.
87. Ibid.
88. Crampton, "Performative."
89. Dewsbury, "Seven Injunctions," 321–322.
90. Ibid., 332.
91. Ibid., 326.
92. McCormack, "Moving Bodies," 1824.
93. Ibid.
94. DeSilvey, "Art, Archive"; Lorimer and McDonald, "Rescue Archeology"; Foster and Lorimer, "Reflections."
95. Knight, "Glaciers"; Baker, "Tangible"; Barry and Kimbell, "Pindices."
96. Haraway, *Simians, Cyborgs and Women*, 36.
97. Dwyer and Davies, "Animating."
98. Ibid.
99. See, for example, Dixon et al., "When Artists"; Krygier, "Cartography"; Cosgrove, "Maps."
100. Blunt, *Travel*; Maddrell, *Complex*.
101. Lorimer, "Small Stories."

NOTES TO CHAPTER 1

1. *Creative Compass* is the second of the two artist-in-residency programmes the Royal Geographical Society has run. The exhibition ran from 6 May–2 July 2010. It was funded by the Arts Council England, and was developed in conjunction with the exhibition *Whose Map is it Anyway?* at the Institute for International Visual Arts. Both exhibitions were accompanied by a programme of interdisciplinary events that brought together artists interested in mapping and geographers and cartographers.
2. Driver, *Geography Militant;* Crampton and Krygier, "Introduction."
3. Withers, "Science"; Driver, "Visualising"; Stoddart, "The RGS"; Maddrell, *Complex Locations.*
4. Harris and Harrower, "Introduction"; Kwan, "Feminist Geography and GIS"; Elwood, "Critical Issues."
5. Crampton and Krygier, "Introduction,"12.
6. Schuurman, "Trouble," discusses the Sciences Wars, whilst Harley, "Deconstructing," was built on by for example; Sparke, "Beyond"; Crampton, "Maps"; Del Casio and Hannah,"Beyond"; Harris and Hazen, "Power of Maps."
7. Crampton, "Performative"; Sui, "Wikification."
8. Cosgrove, "Maps"; Wood, "Cartographic Perspectives"; Casey, *Painting*; Harmon, *You Are Here.*
9. *Magnificent Map*s ran at the British Library, 30 April–19 September 2010.
10. Withers, "Art, Science."
11. *Whose Map Is it? New Mappings by Artists* was on show at Iniva 2 June–24 July 2011.

12. Crampton, "Performative"; kanarinka, "art" ; Pinder, "Cartographies"; Bhagat and Mogal, *Radical*.
13. Cosgrove, "Geography and Vision," 10.
14. kanarinka, "art."
15. Ibid.
16. Heffernan, "Politics."
17. Heffernan, "Politics"; Driver, *Geography Militant*.
18. Driver, *Geography Militant*.
19. Withers, "Science"; Driver, "Scientific Exploration"; Maddrell, *Complex Locations*.
20. Alberro and Stimson, *Institutional Critique*.
21. Buskirk, *Contingent Objects*.
22. Reiss, *Margins*; Alberro and Stimson, *Institutional Critique*.
23. To sum these up, see, for example, Crampton, "Field"; Elwood, "Emerging Research"; Sui, "Wikifiction."
24. Harley, "Deconstructing," 4.
25. Ibid., 5.
26. Ibid., 4.
27. Driver, *Geography Militant*.
28. Driver, "Scientific," 26.
29. Ibid.
30. Driver, "Scientific"; Withers, "Science"; Driver, *Geography Militant*.
31. Withers, "Science."
32. Although, see discussion in Driver, "Made Visible."
33. Ibid.
34. Driver and Jones, "Hidden Histories"; Scalway, *Moving Patterns*; Crang, "After a Fashion."
35. Bennett, "Exhibitionary Complex."
36. Ibid.
37. Ibid., 74.
38. Curzon, "Address 1912," 7.
39. Walker, "An Architectural History," 181.
40. Curzon," Address, 1914," 9.
41. Ibid.
42. Driver, "Made Visible," 3.
43. *Moving Patterns* was exhibited from 7–21 May 2009, at the RGS, London. The exhibition was one of the outputs of the larger project "Fashioning Diaspora Space."
44. Crang, "After."
45. Ibid., 192.
46. Driver and Jones, *Hidden Histories*; Driver, "Made Visible." Hidden Histories was on show at the RGS from 15 October–10 December 2009. It is now available as a travelling exhibition.
47. Driver and Jones, *Hidden Histories*.
48. McEwan, "Power Lines."
49. Driver, "Made Visible."
50. Wright, "Terrea," 33.
51. Wilson, "Cyborg," 509.
52. Cited in *Creative Compass, 20.*
53. Pickles, *History*, 61.
54. Crampton and Krygier, *Introduction*.
55. Harley, "Deconstructing"; Harley, "Cartography."
56. Woodward, *Art and Cartography,* 6.
57. Harley, "Cartography."

58. Cosgrove, "Maps," 51.
59. Krygier, "Cartography."
60. Ibid., 5.
61. E.g. Elwood and Cope, *Qualitative*; Kwan, "Feminist"; Wilson, "Data Matter"; Wilson, "Training."
62. Rose, "Tradition," 414.
63. Bell and McEwan, "Admission."
64. Maddrell, *Complex Locations, 29.*
65. Maddrell, *Complex Locations*; Birkett, *Beaten Track.*
66. Pratt, *Imperial Eyes.*
67. Domosh, "Towards"; Said, *Orientalism.*
68. Haraway, "Science, Technology," 188.
69. Domosh, "Towards"; Rose, *Feminist*; Kwan, "Feminist."
70. Rose, *Feminist,* 414.
71. Crampton, "Cartographical"; Kwan, "Feminist."
72. Wilson, "Training"; Dettlebach, "Stimulations"; kanarinka, "art."
73. Haraway, "Science, Technology."
74. Rose, "Situating."
75. Sparke, "Beyond"; Crampton, "In tension."
76. Del Casino and Hanna, "Beyond."
77. Personal communications with the artists, and discussion sessions during the development of the works, also see Goodwin, "Interview," 18.
78. Harley, "Cartographies."
79. Harley, "Deconstructing," 11.
80. Goodchild, "GIScience"; Elwood, "Geovisualisations"; Wilson, "Data Matters."
81. Harley, "Deconstructing," 4.
82. Elwood, "Emerging"; Sui, "Wikification."
83. Taylor, *Collage.*
84. Goodchild, "Commentary"; Elwood, "Geovisualisations."
85. Wood, "Cartography, Reality," 207.
86. Crampton,"Performative"; Monmonier, "Cartography"; Perkins, "Cartography-Cultures."
87. Details from personal communications with the artist, and discussions during the exhibition development.
88. Poitevin-Navarre in interview in, Patel and Cisneros, *Creative Compass.*
89. Poitevin-Navarre in discussions during the exhibition development and in interview in Patel and Cisneros, *Creative Compass.*
90. Crampton and Krygier, "Introduction."
91. Elwood and Cope, "Qualitative"; McLafferty, "Mapping Women."
92. Elwood, "Emerging"; Sui, "Wikification."
93. Wood, "Cartography, Reality"; Pickles, *Ground Truth;* Pickles, "Social Lives."
94. Pickles, *History.*
95. Ibid., 194.
96. Crampton, "In tension."
97. Pickles, *History*; Pickles, "Social Lives."

NOTES TO CHAPTER 2

1. Howgego, *Harmless Traveller.*
2. Benham to A.B.Rendle of the Natural History Museum, South Kensington, London, undated, File DF400/15/folder 2 (1919), Natural History Museum, South Kensington, London, Archives (hereafter cited as NHM Archives).
3. Beham, "Ascent"; Birkett, *Off the Beaten Track.*

4. Howgego, *Harmless Traveller.*
5. Benham to John Scott Keltie, Royal Geographical Society, 28 October 1913, Royal Geographical Society, London, Archives, RGS/ Benham, G. C88 (hearafter cited as RGS Archives).
6. Ibid.
7. Bell and McEwan, "Controversy and Outcome."
8. Benham's nomination form, received 12 May 1916, proposed 22 May, and elected 5 June 1916, in RGS Archives, RGS/ Benham, G. C88.
9. Information developed during a series of interviews with Houghton carried out during 2009–2011.
10. Maddrell, *Complex Locations.*
11. For example Lorimer and McDonald "Rescue"; DeSilvey, "Art, Archive."
12. Driver, "Hidden Histories"; Lorimer, "Small Stories."
13. Lorimer, "Small Stories."
14. E.g DeSilvey, "Salvage"; Thomas, "Embodying."
15. Mulvey, "Index,"139.
16. Lorimer, "Small Stories," 200.
17. Ibid.
18. Rose, *Feminism,* 416.
19. Maddrell, *Complex Locations;* Blunt, *Travel.*
20. Baignet and Driver, Biography"; Domosh, "Towards"; Driver, *Geography Militant*; Stoddart, "Do we need?"
21. Domosh, "Feminist Historiography"; Stoddart, "Do we need?"
22. Irigary, *Ethics*; Rose, "Situating."
23. Morin, "Peak Practices," 490.
24. Examples of Benham's writings are quoted throughout this chapter, a comprehensive bibliography can be found in Howgego, *Harmless Traveller.*
25. Benham, "On foot"; Hessell Tiltman, *Modern Adventure.*
26. Ryan,"Voyage"; Thomas "Embodying."
27. Pitt, "Regenerating."
28. Hill, "Travelling"; Duclos, "Cartographies."
29. See for example the chapters collected together in Knell, *Museums.*
30. Nash, "Reclaiming Vision."
31. Hill, "Travelling."
32. Bal, "Telling Objects."
33. See concise summaries in Dwyer and Davies, "Animated," and Ashmore, Craggs and Neate, "Working with."
34. Davies and Dwyer, "Animated."
35. DeSilvey,"Art, Archive," 885–887.
36. Ibid., 881.
37. Foster, "Impulse."
38. Ibid., 5.
39. Ibid.
40. Dean quoted in Rainbird, *Tacita Dean,* 12.
41. Personal communication with artist.
42. Foster, "Impulse," 6.
43. Yerushamly, "Performing," 161.
44. Morin, "Peak Practices."
45. Howgego, *Harmless Traveller.*
46. Morin, "Peak Practices," 490.
47. Ibid.
48. Pratt, *Imperial Eyes,* 159–60.
49. Benham, "On Foot Across Africa"; Benham, "A Woman on Kamet: the adventure of an artist"; Benham, "My tramps in the Himalayas."

50. Benham to The Maharaja of Nepal and the Government of India, Ref L/P&S/10/1014–2 in File P.3971/1921Pt8 53ff.1921: P3891: part 8: Tibet: Travellers, Oriental and India Office Collections, The British Library.
51. Notes in Ref L/P&S/10/1014–2 File P.3971/1921Pt8 53ff. 1921: P3891: part 8: Tibet: Travellers, Oriental and India Office Collections, The British Library.
52. See for example the interview in Hessman Tiltman, *Modern Adventure,* 79–94 and Benham in the Times, "On foot."
53. Benham to Rendle RGS, 5th October, 1919. File DF400/15/folder 2 (1919), RGS Archives.
54. Benham's nomination form. RGS Archives, London: RGS/ Benham, G. C88.
55. Ibid.
56. Stoddart, "RGS," 195.
57. Ibid.
58. Driver, "Scientific."
59. Benham to Keltie, Royal Geographical Society, 9 January 1914, RGS/ Benham, G. C88, RGS Archives.
60. Quoted in Howgego, *Harmless Traveller,* 57.
61. Benham to Keltie, Royal Geographical Society, 9 January 1914, RGS/ Benham, G. C88, RGS Archives.
62. Keltie to Benham, Royal Geographical Society, 24 January 1914, RGS/ Benham, G. C88, RGS Archives.
63. Stoddart, "RGS."
64. Keltie to Benham, Royal Geographical Society, 24 January 1914, RGS/ Benham, G. C88, RGS Archives.
65. Keltie, "Geographical Education," 32; Maddrell, *Complex Locations.*
66. Sir George Darwin, RGS, 1886, cited in Stoddart, "RGS," 197.
67. Driver, "Scientific"; Withers, "Science."
68. Sub-Committee Report on "Hints to Travellers," cited in Driver, "Scientific Exploration," 27.
69. Freshfield, cited in Driver, "Scientific Exploration," 28.
70. Halford Mackinder quoted in Stoddart, "RGS."
71. Benham's nomination form, in Royal Geographical Society, London. RGS/ Benham, G. C88.
72. Stoddart, "RGS."
73. Of course, it is likely that Keltie also put a positive spin on Benham's practice to reinforce her worth to the Society, something that given her gender would still have been needed.
74. Benham to John Scott Keltie, 17 January 1917, RGS/ Benham, G. C88. RGS Archives
75. Keltie, "Geographical Education," 381–399.
76. Keltie to Benham, 19 January 1917, RGS Archives, RGS/ Benham, G. C88.
77. Ibid.
78. Detail taken from the images from Benham's catalogue provided by Amy Houghton.
79. Penny, *Object Cultures*; Clifford, "The Others."
80. Hail, "I Saw."
81. Detail taken from the images from Benham's catalogue provided by Amy Houghton.
82. Hail, "I Saw."
83. Ibid.
84. See especially the interviews in Hessman Tiltman, *Modern Adventure* and Benham, "Woman on Kamet."

85. There are a number of notes and short letters in Benham's RGS records, e.g. Benham to Keltie, 23 April 1916, where she describes her exhibitions, and where she invites Hinks and Scott-Keltie to her home to see her collections. RGS Archives, RGS/ Benham, G. C88. The RGS archive does not record however, whether they ever went to Benham's house.
86. Detail taken from the images from Behnam's catalogue provided by Amy Houghton.
87. Detail taken from the images from Behnam's catalogue provided by Amy Houghton.
88. Hail, "I saw."
89. Ibid.
90. Mulvey, "Index," 139.
91. Buchloh, "Process"; Krauss, "Richard Serra."
92. Foster, "Archival."
93. Krauss, "Richard."
94. Ibid., 101.
95. Ibid., 103.
96. Trodd, "Modernist Film," 373.
97. Baker, "Roundtable," 90.
98. Foster, "Archival Impulse," 17.
99. Ibid.
100. Ingold, *Lines*.
101. Foster, "Archival Impulse."

NOTES TO PART II

1. Doherty, *From Studio*.
2. Kwon, "One Place"; Kaye, *Site*; Sunderberg, *Space, Site*; Rendell, *Art*.
3. I have called this a geographical turn here in part to capture the growing sense of geography as an analytic, but also to echo and to situate it within the broader 'spatial' turn, across the arts and humanities. Whilst this was long critiqued by geographers for being often "metaphorical," see for example Smith and Katz, "Grounding Metaphor," something else, more analytic in orientation, is going on here.
4. Daniels, *Fields of Vision*; Mackenzie, *Reclaiming*; Hawkins, "Argument"; Lacy, *Mapping*.
5. Bishop, "Relational Aesthetics"; Kester, *One, Many*.
6. Doherty, *From Studio,* 12; Rogoff, "In Conversation."
7. Miles, *Art and City*; Deutsche, *Evictions*.
8. Kester, *Conversation*.
9. Jackson, *Social Works*.
10. Duncan, *Civilising Rituals*.
11. Loftus, *Everyday Environmentalism*; Ingram, "Diplomacy"; Kester, *Conversation*.
12. Toscano, "Sensuous Religion."
13. Bourriaud, *Relational Aesthetics*, 13.
14. Loftus, *Everyday*; Raunig, *Art, Revolution*; Rancière, *Image*; Guattari, *Chaosomosis*; Roberts, "Art, Enclave."
15. Thrift, *Lifeworld-Inc*.
16. Kaufmann, *Toward*; Guilbaut, *How New York Stole*; Morris, "Cultural Geographies"; Lübbren, *Artists' Colonies*.
17. E.g., Harvey et al. "Thinking"; Gibson and Kong, "Cultural Economy."
18. Bain, "In/Visible Geographies," 425.

19. Nash, "Reclaiming Vision," 152.
20. Glacken, *Traces*, 106.
21. Kaufmann, *Toward*; Glacken, *Traces*, 106.
22. Pevsner, *Englishness*.
23. Kaufmann, *Toward*.
24. Guilbaut, *How New York Stole*; Morris, "Cultural Geographies"; Rycroft, *Swinging*; Rogers, "Butterfly."
25. Rogers, "Butterfly."
26. Daniels, *Fields of Vision*; Ryan, *Picturing*.
27. Daniels, "Studio."
28. Sjöholm, *Geographies*.
29. Daniels, "Studio"; Postle, *Turner,* 47–48.
30. Buren, "Function"; Bain, "Constructing"; Chare, "Passages"; Sjöholm, *Geographies*.
31. Bain, "Female Identity'; Ryan, *Picturing*; Dixon, "Blade"; Harvey, "Thinking"; Daniels, "Studio"; Hawkins, "Coastline Convergences."
32. Zaring, "Romatic Face"; Daniels, *Fields of Vision*.
33. Crouch and Toogood, "Everyday"; Matless and Revil, "Solo Ecology"; Daniels, *Humphrey*.
34. Doherty, *From Studio*.
35. Kwon, *One Place*.
36. Bishop, "Relational Aesthetics."
37. Kwon, *One Place;* Jackson, *Social Work*; Bishop, "Relational Aesthetics."
38. The point here is not to be geographically pedantic about meanings and definitions, but merely to note the importance of the geographies of art. We might though, interestingly recall the differences, for example, between "site," as the geographic location, often described in a Cartesian sense, and "situation," which was about a location understood in terms of a proximity to features, resources and services.
39. Krauss, *Richard,* 37.
40. Kwon, *One Place*; Jackson, *Social Works*; Rugg, *Art.*
41. Kwon, "One Place," 93.
42. Neate, "Provinciality."
43. O'Doherty, *White Cube*.
44. Kwon, "One Place"; Yerushamly, "Relational Archive."
45. Serra in Weyergraf-Serra and Buskirk, *Destruction,* 38.
46. Kwon, "One Place."
47. Buskirk, *Contingent Object*.
48. Phelan, *Unmarked*.
49. Smithson, "Non-Site."
50. Smithson, "Earth," 178.
51. Rendell, *Art,* 23.
52. Meyer, "Functional Site", cited in Kwon, *One Place,* 29.
53. Driver and Martins, *Tropical Visions*; Daniels, *Fields of Vision*.
54. Smith, *European Visions; Imaginaries*.
55. Landry, *Creative City*.
56. Sadler, *Situationist City*.
57. Deutsche, *Evictions*; Miles, *Art, City*.
58. Till, *Mapping*; "Wounded Cities."
59. Garrett, "Videographic Geographies"; Edensor, *Industrial Ruins;* Gandy, *Constellations*.
60. Kwon, "One Place ," 85.
61. Foster, *Return of the Real*, 184.
62. Kwon, "One Place," 85.
63. Ibid.

64. Serra, "Destroyed," 34–47.
65. Kwon, *One Place;* Best, *Visualising Feeling.*
66. Buskirk, *Contingent.*
67. Deutsche, *Evictions.*
68. Ibid.
69. Ingram, "Diplomacy"; Jackson, *Social Works;* Bishop "Antagonism."
70. Crang and Thrift, *Thinking,* 3.
71. Kwon, "One Place,"108. See critique in Lippard, *Lure.*
72. Mackenzie, "Claims to Place" ; Mackenzie, "Re-claiming."
73. Till, "Memory"; DeSilvey, "Memory in Motion."
74. Loftus, *Everyday Environmentalism;* Pinder, *Urban Visions.*
75. Pinder, "Urban Interventions."
76. Loftus, *Everyday;* Miles, *Marcuse;* Pinder, *Urban Visions;* Sadler, *Situationist.*
77. Bourriaud, *Relational.*
78. Ibid., 113.
79. Ibid.
80. Bourriaud, *Relational,* 242.
81. Bishop, "Antagonisms"; Kester, *One, Many;* Ranceire, *Emancipated.*
82. Kaye, *Site-Specific.*
83. Rogoff, "In Conversation"; Lippard, *Lure.*
84. Kwon, *One Place.*
85. Foster, *Return.*
86. Kwon, "One Place."
87. Lippard, *Lure.*
88. Hawkins and Lovejoy, *Insites.*
89. Bishop, "Antagonisms."
90. Kester, *Conversation;* Kester, *One, Many.*
91. Rogoff, "In Conversation," 86.
92. E.g.. Jackson, *Social Works*; Rogoff, *Terra*; Lippard, *Lure.*
93. Marston et al,. "Without Scale."
94. Woodward et al., "Eagles, Flies."

NOTES TO CHAPTER 3

1. The installation element of *Break Down* was installed between 10–24 February 2001 at the abandoned C&A store on 499 Oxford Street, London. The installation can be seen in the film *Michael Landy* (Illuminations, 2004).
2. Landy, *Break Down,* 113.
3. Ibid.
4. Ibid.
5. Marx, *Capital,*1; Landy quoted in Lingwood and Morris, *Off Limits,* 163.
6. Landy, *Break Down.*
7. Madman at C&A, Evening Standard, 2001.
8. Landy, *Break Down.*
9. Stallabrass in Landy, *Break Down.*
10. Woodward and Lea, "Geographies of Affect," 155.
11. Marx, *Capital,* 15, 23.
12. Stallybrass, "Marx's Coat."
13. Ibid., 183–184.
14. Landy, *Break Down;* Landy, *Break Down: Inventory.*
15. Lingwood and Morris, *Offsites;* Cork, "Brutal End"; Harvie, "Witnessing."

16. Harvie, "Witnessing."
17. Landy, quoted in Lingwood and Morris, *Off Limits,* 162.
18. Hartwick, "Geographies of Consumption"; Cook, "Follow the thing"; Klein, *No Logo.*
19. Compare Miller, *Shopping,* with accounts of the production line in Foucault, *Discipline and Punish;* Read, *Micropolitics;* Woodward, "Affective Life."
20. Ibid.
21. Landy, *Break Down: Inventory.*
22. Ibid., unpaginated.
23. Landy, *Break Down.*
24. Ibid., 108.
25. Ibid.
26. Lingwood in Lingwood and Morris, *Offsites,*165.
27. Miller, *Bon Marche;* Lancaster, *Department Store.*
28. Shields, *Lifestyle Shopping.*
29. Shields, *Lifestyle Shopping;* Miller, *Shopping.*
30. Baudrillard, *Consumer Society.*
31. Landy, *Break Down.*
32. Ibid.
33. See discussion in *Break Down,* 107–116.
34. Baudrillard, *Consumer Society,* 27.
35. Landy, *Break Down.*
36. Landy, quoted in Wood, "Going For Broke," 3.
37. Landy quoted in Lingwood and Morris, *Offsite,* 116.
38. This anecdote appears in it's most extended form in Appleyard, "Things ain't and also Dorment, "A deconstructed life," 164.
39. Abelson, "Ladies, a-thieving."
40. This is what Harvie's exploration of "witnessing" the installation suggests, as well as the accounts of visitors that are presented in numerous newspaper articles, including Appleyard, "Things ain't"; Cork, "Going, Going" and reproduced in Lingwood and Morris, *Offsites,* 164–168.
41. Landy, *Break Down: Inventory.*
42. Dorment, "A deconstructed life."
43. Foucault, *Discipline and Punish,* 143.
44. Ibid., 142.
45. Ibid., 142. Ibid., 148.
46. Landy, *Break Down,* 114.
47. Marx, *Capital.*
48. Landy, *Break Down.*
49. Ibid., 109.
50. Landy quoted in Appleyard, "Things ain't."
51. Ibid.
52. Landy, *Break Down,* 110.
53. Ibid., 107.
54. Landy quoted in Cumming, "Going, Going," and Landy quoted in Lingwood and Morris, *Offsites,* 163. Landy refers here to a girl who offered to swap the coat for what she had in her own bag, Landy declined.
55. Landy quoted in Lingwood and Morris, *Offsites,* 163.
56. Gregson, Metcalfe and Crewe, "Moving things along"; Gregson and Crewe, *Second-Hand Cultures;* Gregson and Beale, "Wardrobe Matter."
57. Marx, *Capital,* 36.
58. Stallybrass, "Marx's Coat."
59. Hawkins, "Making, Marking."

60. Gregson and Crewe, *Second-Hand Cultures*; Hawkins and Muecke, *Culture and Waste*.
61. Landy, *Break Down*.
62. Treneman, "I who have nothing."
63. Landy, *Break Down*.
64. Landy quoted in Lingwood and Morris, *Offsites,* 163.
65. Landy, *Break Down*, 34–38.
66. Treneman, "I who have nothing"; Cumming, "Going, Going."
67. Cook, "Follow the thing."
68. Woodward and Lea, "Geographies of Affect."
69. Landy, *Break Down*.
70. Ibid.
71. Ibid., 34.
72. Foucault, *Discipline and Punish*.
73. Landy, *Break Down*.
74. Foucault, *Discipline and Punish*, 141.
75. Ibid.
76. Landy, *Break Down*.
77. Marx, *Capital,* 262.
78. Landy, *Break Down*.
79. Foucault, *Discipline and Punish*, 145.
80. Landy, *Break Down*.
81. Ibid.
82. Read, *Micropolitics*, 14.
83. Ibid.
84. Foucualt, *Discipline and Punish,* 144.
85. Ibid.
86. Ibid., 221–224.
87. Read, *Micropolitics*.
88. Landy, *Break Down*.
89. Woodward and Lea, "Affect," 155.
90. Account of Scrap Heap services in Nesbitt, "Everything must go."
91. Ibid.
92. Nesbitt, "Everything must go."
93. This is described to great effect in Woodward and Lea, "Affect."
94. Marx, *Capital,* 43.
95. Landy, *Break Down*; Lingwood and Morris, *Offsites,* 164–165.
96. Reproduced in Lingwood and Morris, *Offsites,* 164–165.
97. Landy, *Break Down*, 107.
98. I explore this in more detail in Hawkins, "Visions."
99. Hetherington, "Secondhandedness"; Lucas, "Disposability"; Marcoux, "Refurbishment."
100. Gregson and Crewe, *Second Hand;* Gregson et al., "Identity and Mobility."
101. Marx, *Capital,* 23.
102. Landy, *Break Down*, 36.
103. Foucault, *Discipline and Punish*.
104. Landy, *Break Down*.
105. Ibid.
106. Ibid.
107. Ibid.
108. Ibid.
109. Elsewhere I have compared this to Bataille's idea of formlessness, Hawkins, "Visions."

110. Landy, *Break Down.*
111. Stallabrass, *Gargantua.*
112. Stallabrass in Landy, *Break Down,* 110.
113. Stallybrass, "Marx's Coat," 183–184.

NOTES TO CHAPTER 4

1. An Outstanding Area of Unnatural Beauty was an installation on York Way, London, 9 April–17 November 2002. It was sponsored by Art Angel (like *Break Down,* the focus of Chapter 3). The author visited the installation on a number of occasions during this period.
2. Wentworth quoted in Lingwood and Morris, *Off Limits,* 113.
3. Wentworth and Lingwood, "In Conversation," 104.
4. Hawkins, "Turn Your Trash."
5. Wentworth and Lingwood, "In Conversation," 104.
6. Ibid.
7. Battista et al., "Exploring."
8. Wentworth and Lingwood, "In Conversation," 104.
9. Edensor, *Industrial Ruins;* de Certeau, *Practice of Everyday Life;* Till, *New Berlin;* Pile, *Real Cities.*
10. Especially those that follow in the wake of de Certeau's, *Practice of Everyday Life.*
11. Loftus, *Everyday Environmentalism.*
12. de Certeau, *Practice.*
13. Pile, *Real Cities,* 27.
14. Coverley, *Psychogeographies;* See Pinder, "The Arts of Urban Exploration."
15. Phillips, "Cultural Geographies in Practice," 509.
16. Deutsche, *Evictions;* Miles, *Art Space;* Pinder, "Urban Interventions."
17. Pinder, "Urban Interventions."
18. Ibid., 703.
19. Ibid., 734.
20. Harvey, *Spaces of Hope.*
21. Pinder, *Visions of the City,* 265.
22. Ibid.
23. Amin and Thrift, *Cities.*
24. Amin and Thrift, *Cities;* Pinder, "Urban Interventions."
25. Wentworth's work could, of course, also be argued to be a less accessible mode of artistic practice than those "events" that situate themselves on the street and aim at public inclusion.
26. Hatch, "Something Else," 126.
27. Wright, "Material and Memory"; Rose, *Visual Methodologies*
28. della Dora, "Travelling Landscape."
29. De Duve, "Time, Exposure, and Snapshot."
30. Hawkins, *Ethics of Waste.*
31. Wentworth, "Caledonian Road," 30.
32. Ibid., 32.
33. Ibid.
34. Wentworth, "Accident."
35. Ibid.
36. These events accompanied a retrospective of Richard Wentworth's work at Tate Liverpool, January–May 2005. Crang and Wentworth, "Caledonian Culture," in Driver et al. *Landings,* Whybrow, *Art and the City.*

37. Cited in Hatch, "Something Else," 115.
38. Discussions during the walking trips 15–18 March 2005, and a similar walk I attended in London 19 June 2007. Very similar comments are also repeated in Wentworth "The Accident of Where I Live."
39. Buchloh, "Conceptual Art."
40. Ibid.
41. Wentworth, "Accident."
42. Wentworth and Lingwood, "In Conversationm" 106. Coverley, *Psycho-geographies*; Marples, *Shanks Pony;* Solnit, *Wunderlust.*
43. I am thinking here of the Situationists. See Pinder, "The Arts of Urban Exploration" or the walk-works of Richard Long or Hamish Fulton.
44. Wentworth, "Accident."
45. Barthes, *Camera Lucidia.*
46. Wentworth, *101 Monuments*; Wentworth, "Caledonian Road."
47. Wentworth talking at Tate Liverpool, March 2007.
48. Wentworth, "Caledonian Road," 30.
49. Wentworth has given a number of talks since including the one at Liverpool, 2005 (see note 47), and also a talk at Tate Britain, 20 June 2007.
50. Hatch, "Something Else," 109.
51. Wentworth, "Caledonian Road," 36.
52. Barthes, *Camera Lucidia.*
53. Crang, "Death of Great Ships."
54. Wentworth, "Accident," 393.
55. Ibid.
56. Pinder, "Urban Interventions."
57. Threadgold cited in Thrift, *Non-Representational*, 114.
58. There are a limited number of images I can reproduce here. For more, see Hawkins, "Turn Your Trash."
59. Wentworth cited in Watkins, "Ordinary Miracles," 2.
60. Hawkins, "Turn Your Trash"; Crang, "Spaces of Practice," 137.
61. Crang, "Spaces of Practice."
62. Hawkins, "Turn Your Trash."
63. Colleredo-Mansfeld, "Matter Unbound," 246.
64. DeSilvey, "Salvage Memory"; Rathje and Murphy, *Garbage Archeology.*
65. Douglas, *Purity and Danger*; Hawkins and Muecke, *Culture and Waste*; Gregson et al., "Identity and Mobility"; Thompson, *Rubbish Theory;* Hetherington, "Secondhandedness."
66. Hawkins, *Ethics of Waste;* Hawkins, "Plastic Bags."
67. Gregson and Crewe, *Second-Hand Cultures;* Neville and Villeneuve, *Waste-Site Stories.*
68. Wentworth quoted in Meyer, "Making Do and Getting By," 32.
69. Wentworth interviewed, Morgan and Cooke, *Richard Wentworth,* 17–18.
70. Colloredo-Mansfeld, "Matter Unbound," Buchli, *Material Culture,* 16.
71. DeSilvey, "Salvage Memory"; Gregson and Crewe, *Second-Hand Cultures.*
72. DeSilvey, "Observed Decay"; Gregson and Beale, "Wardrobe Matter."
73. Edensor, *Industrial Ruins,* 15.
74. Hawkins, *Ethics of Waste.*
75. Hawkins, "Plastic Bags."
76. Ibid., 5.
77. Gregson et al., "Chocky-Chock."
78. Wentworth quoted in Watkins, "Ordinary Miracles," 8.
79. Ibid., 6.
80. Anderson and Wylie, "On Geography."
81. Hawkins, "Turn Your Trash."

82. Grosz, *Space, Time, and Preservation,* 126–127.
83. Ibid.
84. Threadgold cited in Thrift, *Non-Representational,* 114.
85. Till, "Wounded"; Pinder, "Urban Interventions."

NOTES TO CHAPTER 5

1. *Caravanserai* project report obtained from Annie Lovejoy.
2. Ibid.
3. Lovejoy in conversation with the author, 16 June 2009.
4. Kester, *One, Many.*
5. Bouriaurrd, *Relational Aesthetics.*
6. Kester, *One, Many;* Doherty, *From Studio;* Bishop, "Antagonism"; Hawkins, "Doings."
7. Coles, *Site Specificity.*
8. The research started in January 2009, the ideas developed as we exchanged ideas, I spend three weeks at *Caravanserai* in June 2009, and then a series of long weekends July–September, 2009, as well as ongoing correspondence over the next few years.
9. Driver et al., *Landings.*
10. Foster and Lorimer, "Reflections."
11. Cloke and Jones, "Dwelling."
12. Ibid.
13. Compare discussions in Lippard, *Lure;* Kwon, *One Place;* Kester, *One, Many.*
14. *Caravanserai* project report obtained from Lovejoy.
15. Ibid.
16. Kester, *One, Many;* Doherty, *From Studio.*
17. Bourriaud, *Relational Aesthetics.*
18. Kester, *One, Many,* 112
19. Compare for example Ingram "Diplomacy."
20. Kester, *One, Many,* 187.
21. Kester, *One, Many.*
22. Drucker, *Century.*
23. Philpot, "Artists."
24. Parr, "Participatory," 126.
25. See for example Yerushamly, "Performing."
26. See discussion Kester, *One, Many,* 68.
27. Drucker, *Century,* 9.
28. Kester, *One, Many,* 68.
29. Cloke and Jones, "Dwelling," 654.
30. Pearson and Shanks, *Theatre/Archeology.*
31. Ingold, *Lines.*
32. Newling quotation from one of Lovejoy's notebook.
33. Cloke and Jones, "Dwelling," 652.
34. Jackson, *Social Works,* 68.
35. Kwon, "One Place"; Kwon, "Wrong Place."
36. Lippard, *Lure;* Rogoff, "In Conversation."
37. Bishop, "Antagonism."
38. Ibid.
39. Ibid., 67.
40. Bourriaud, *Relational Aesthetics;* Bishop, "Antagonism," 79.
41. Bishop, "Antagonism," 79.
42. Ingold, *Perception, Environment;* Casey, *Fate Place.*

43. Ingold, *Perception, Environment.*
44. Cloke and Jones, "Dwelling."
45. Kester, *One, Many,* 89.
46. Ibid.
47. Ibid.
48. Cloke and Jones, "Dwelling," 652.
49. *Caravanserai* project report obtained from Lovejoy.
50. Ibid.
51. Kester, *One, Many.*
52. Recounted in the project report, obtained from Annie Lovejoy.
53. Pudup, "It takes"; Robbins, *Lawn*; Kurtz, "Differentiating."
54. Pudup, "It takes"; Tracey, "Guerilla."
55. Hitchings, "People, Plants."
56. Couch, *Flirting.*
57. Pudup, "it takes."
58. Crouch, "spatialities."
59. Pudup, "it takes."
60. Kester, *One, Many.*
61. Gibson Graham, *Post Capitalist.*
62. Recounted in the project report, obtained by Annie Lovejoy.
63. Lovejoy, *insites.*
64. Cited in *insites.*
65. Adamson, *Craft Reader.*
66. Guantlett, *Making/Connecting*; Carpenter, "Activist"; Lees-Maffei and Sandino, "Dangerous Laisons."
67. Gauntlett's perspectives on "making as connecting," whether with things or people, resonates with a broader sense of creative activities as promoting a whole set of different engagements, encounters and connection with our social and physical environments.
68. Greg Humphries's blog entry. Accessed 10 November 2012. http://greghumphries.wordpress.com/.
69. Adamson, *Craft Reader.*
70. Cited in *Caravanserai* project report obtained from Lovejoy.
71. Ibid.
72. Ibid.
73. Ibid.
74. Cited in *Caravanserai* project report obtained from Lovejoy.
75. Ibid.
76. Kester, *One, Many.*
77. Kester, *One, Many.*
78. Bishop, "Antagonism."
79. Button, *Social Systems.*
80. Cited in *insites.*
81. Council Housing is the UK term for Social Housing.
82. Kester, *One, Many,* 138.
83. Ibid.
84. Marston et al., "Eagles and Flies," 273.
85. Ibid.

NOTES TO PART III

1. Sharp, *Body Works.*
2. Jones and Warr, *Artists Body.*

3. Jones and Warr, *Artists Body*.
4. McCormack, "Geographies for Moving Bodies," 1823.
5. Latham, "Research, Performance," 108; Nast and Pile, *Mapping*; Tuan, *Space*; Seamon, *A Geography*; Buttimer, *Lifeworld*.
6. Thrift, *Non-Representational*; Paterson, "Haptic"; Grosz, *Volatile*.
7. Driver and Martins, *Tropical Visions*; Dewsbury and Naylor, "Practising"; Paterson, "Haptic"; Parr, "Mental Health"; Crang, "Touchy-Feely"; Longhust, Ho, and Johnston, "Using 'the Body'."
8. McCormack, "Geographies for Moving Bodies," 1822.
9. McCormack, "Cultural Geographies in Practice"; Nash, "Performance"; Cresswell "Shake."
10. Thrift, *Non-Representational*; Anderson and Harrison, *Taking*.
11. Jay, *Downcast*.
12. Cosgrove, *Geography and Vision*, 5.
13. Foucualt, *Discipline and Punish, Manet;* Deleuze, *Bacon;* Merleau-Ponty, "Eye and Mind."
14. Lorimer, "More than"; Wylie, "Ascending."
15. Dubow, "In the World"; Nash "Reclaiming Vision"; Rycroft, "Op-Art"; Hawkins, "Argument Eye."
16. Nash,"Reclaiming"; Rycroft, "Op-Art"; Vasudevann, "Modern Life."
17. Cameron and Rogalsky, "Conserving"; Geoghegan, "Museum"; Paterson, *Sense of Touch;* Drobnick, "Toposmia."
18. Deleuze, *Bacon;* Deleuze and Guarrati, *What is Philosophy*.
19. Bryant, "Towards."
20. Bois et al., *Informe*.
21. Thacker, *Media;* Dixon, "Blade"; "Aesthetics"; Hawkins and Straughan, "Midas."
22. Thacker, "Data"; Hauser, *Sk-interfaces*.
23. Hawkins and Straghan, "Midas."
24. Dixon, "Semi-Living."
25. Abrahamsson and Abrahamsson, "Body."
26. Ibid., 294.
27. Dyson, *Sounding*; Marks, *Touch*.
28. Ibid.
29. Ibid., 1826.
30. Ibid., 1831.
31. Heidegger in Mitchell, *Heidegger*.
32. Mitchell, *Heidegger*.
33. Ibid.
34. McCormack, "Cultural Geographies in Practice," 1829.
35. Bonnet, "Art Ideology"; Pinder, "Ghostly."
36. Fenton, "Space, Chance,"412; Pinder, *Visions*, 385; see also Amin and Thrift, *Cities*.
37. Paterson, "Haptic," 774.
38. Butler, "Sound-Walk."
39. Pinder, "Ghostly," 2.
40. Ibid., 7.
41. Ibid., 6.
42. Crouch and Toogood, "Everyday."
43. Ibid.
44. McCormack, "Cultural Geographies in Practice," 369.
45. Crang,"Touchy-Feely."
46. Latham, "Research-Performances."
47. Paterson, "Haptic," 766.

48. Crang, "Touchy-Feely."
49. Garrett, "Videographic Geographies."
50. Dewsbury, "Seven Injunctions."
51. Paterson, "Haptic," 327.
52. Paterson, "Haptic"; Dewsbury, "Seven Injunctions"; Hawkins, "Doings and Doings."
53. McCormack, "Geographies for Moving Bodies," 483.
54. Massumi, *Virtual*, xxii.
55. Elkins, *Dry*; Clarke, *Sight*; Hustevadt, *Mysteries*.
56. Bal, *Spider*.
57. Ibid.
58. Ibid., xiii.
59. Ibid., xii.
60. Dewsbury, "Seven Injunctions," 324.
61. Ibid.
62. Rycroft, "Op-Art," 354; Rendell, *Site Writing*.
63. Stoller, *Sensuous scholarship*; Gannon, "(im)possibilities"; Muecke, "fall" DeSivley, "Salvage"; Wylie, "Single Days Walking"; Wylie, "Non-representational Subjects?"
64. Lorimer, "Herding memories."
65. Wylie, "Single days Walking," 235.
66. Rendell, *Site Writing*.
67. Ibid., 2.
68. Hawkins, "Dialogues and Doings."

NOTES TO CHAPTER 6

1. The account of the installation is constructed from ethnographic work carried out on the piece during March and April 2005.
2. Mackinder, "Teaching of Geography"; Rose, "On the Need to Ask"; Driver, "On Geography"; Sui, "Visuality, Aurality"; Thornes, "Visual Turn."
3. See, for example, Berger, *Ways of Seeing*; Crary, *Techniques of the Observer*; Haraway, "Science, Technology"; Jay, *Downcast Eyes*; Mulvey, *Visual and Other Pleasures*; Pratt, *Imperial Eye*; Sobchak, *Address of the Eye*.
4. Driver, "On Geography," 227.
5. Dodge et al., *Map Reader*; Kwan, "Feminist Visualisation"; Cosgrove, *Geography and Vision*; Daniels, *Fields of Vision*; Nash, "Reclaiming Vision"; Hawkins, "Argument of the Eye."
6. Cosgrove discussed geography as building an "argument of the eye," drawing the phrase from John Ruskin (Cosgrove, "John Ruskin").
7. Daniels, "Marxism, Culture"; Nash, "Reclaiming Vision."
8. Rycroft, "Nature of Op Art"; Crouch and Toogood, "Everyday Abstraction"; Vasudevan, "Photographer of Modern Life."
9. Bishop, *Installation*, 6.
10. Hawkins, "Argument of the Eye."
11. Bishop, *Installation*, 11.
12. Judovitz,"Deassembling Vision"; Marks, *Touch*; Dyson, *Sounding*.
13. Dyson, *Sounding*.
14. See, for example, Krauss, *Passages*; Morris, *Notes*.
15. Krauss, *Originality*, 264.
16. Merleau-Ponty, "Eye and Mind"; Krauss, *Originality*; Reiss, *From Centre*; Morris, *Notes*.

17. Fried, *Art and Objecthood*.
18. Merleau-Ponty, *Phenomenology*, 235.
19. Morris, "Notes 2," 17.
20. Jones, *Eyesight*.
21. Wylie, *Single Day's Walking*.
22. E.g., Deleuze, *Francis Bacon*; see Paterson, "Haptic Geographies," for summary of debates within Geography.
23. Deleuze, *Francis Bacon*; Irigaray, *An Ethics*.
24. Longhurst, Ho, and Johnston, "Using the Body."
25. Thrift quoted in Dewsbury, "Seven Injunctions," 327.
26. Dewsbury, "Seven Injunctions," 327.
27. Ibid.
28. Ibid.
29. Wylie, "A Single Day's Walking"; Lorimer, "Forces of Nature"; Straughan, "Touched by Water."
30. Lorimer, "Herding Memories"; Dewsbury, "Seven Injunctions"; Crang, "Touchy, Feely"; Longhurst, Ho, and Johnston, "Using the Body"; Paterson, "Haptic."
31. For models, see, for example, Rendell, *Site Writing;* Lomax, *Writing the Image*.
32. Grosz, *Sexual Subversions*.
33. Ibid.
34. Judovitz, "De-Assembling."
35. For discussions of the visual regimes of the gallery, see O'Doherty, *Inside the White Cube*; Drobnick, "Toposmia."
36. Dubow, "A View In"; Pratt, *Imperial Eyes*.
37. Dubow, "A View In."
38. Ibid.
39. Fisher, "Relational Sense," 9.
40. Bishop, *Installation*.
41. Klee, *Notebooks*.
42. Wylie, "Single Day's Walking."
43. Lingis, *Imperative*, 9.
44. Merleau-Ponty, "Eye and Mind," 295.
45. Merleau-Ponty, *Visible and the Invisible*, 24.
46. Merleau-Ponty, *Phenomenology*, 235.
47. Merleau-Ponty, *Eye and Mind*, 295.
48. Merleau-Ponty, *Visible and the Invisible*, 134–35, my italics.
49. Ibid.
50. Sobchack, *Phenomenology of the Eye;* Marks, *Touch; Carnal Thoughts;* Wylie, "Depths and Folds."
51. Grosz, *Volatile Bodies*, 28.
52. Ibid.
53. Classen, "Don't touch the Art."
54. Merleau-Ponty, *Phenomenology*.
55. Marks, *The Skin of the Film*, 183.
56. Deleuze and Guatteri, *A Thousand Plateaus*, 492–499.
57. Ingold, *Perception*, 277.
58. Paterson, *The Senses of Touch*, 21.
59. Conner, *Cinq Sens*, 27.
60. Lingis, *The Imperative*.
61. Merleau-Ponty, *Phenomenology*, 120.
62. Ibid.

63. Hawkins, "Touching Art: Touching You."
64. See Marks, *Skin of the Film*, 169, where a similarly intimate gaze is considered in the process of looking at exceptionally detailed still-life paintings.
65. Martin, *Sculpture and Enlivened Space*, 59.
66. Hetherington, *The Unsightly*, 199.
67. Alpers, *The Art of Describing*.
68. Derrida, *On Touching*.
69. See also discussions in Paterson, *The Senses of Touch*; Vasseleu, *Textures of Light*.
70. Deleuze and Guatteri, *A Thousand Plateaus*, 499.
71. This sensory mimesis is central to the symbiosis of subject and object, the dissolving of power relations between seen and seen.
72. Massumi, *Semblance and Event*,
73. Ibid., 42.
74. Ibid., 42.
75. Ibid., 44–45.
76. Ibid., 45.
77. Ibid.
78. Merleau-Ponty, *The Visible and the Invisible,* 155.
79. Lorimer, *Herding Memories*.

NOTES TO CHAPTER 7

1. Best, "Serial Spaces"; Sabbatino, "Ana Mendieta."
2. Brett, "One Energy."
3. Blocker, *Where Is Ana Mendieta?*, 17.
4. Mendieta quoted in Brett, "One Energy," 186.
5. See, for example Wylie, "Single Day's Walking"; Lorimer, "Herding"; Cosgrove, "Prospect."
6. Daniels and Nash, "Lifepaths."
7. See account in Blocker, *Where Is Ana Mendieta?*.
8. Mendieta, 1981, Unpublished Artist's statement in Perreault, "Mendieta's body," 10.
9. Blocker, *Where Is Ana Mendieta?*; Rogoff, *Terra Infirma*.
10. Blocker offers a compelling summary of these perspectives in *Where Is Ana Mendieta?*
11. Lippard, "Quite Contrary," "Ana Mendieta."
12. Best, "Serial Spaces."
13. Cosgrove, "Prospect," 55.
14. Ibid.
15. Anderson and Harrison, "The Promise," 6.
16. Lowenthal and Prince, "English Landscape"; Cosgrove and Daniels, *Iconography*.
17. Wylie, "Depths and Folds," 520.
18. Wylie, "A Single Day's Walking," 235.
19. Wylie, "Depths and Folds"; Dubow, "View in the World"; Nash, "Reclaiming Vision."
20. Hinchliffe, "Inhabiting."
21. Lorimer, "Herding," 498.
22. Ibid.
23. For example, Cresswell "Landscape, Obliteration"; Wylie, "Glastonbury Tor."

24. Nash, "Reclaiming Vision"; Crouch and Toogood, "Everyday Knowledge."
25. Jones, *Body Art*; Phelan, *Unmarked*.
26. Quoted in Best, *Serial Spaces*.
27. Viso, *Unseen Mendieta*.
28. See discussion in Chapter 4.
29. Bal, *Quoting Caravaggio,* 41–42.
30. Hinchliffe, "Inhabiting."
31. E.G. Cosgrove, "Prospect, Perspective"; Whatmore and Hinchliffe, "Ecological Landscapes."
32. Merleau-Ponty, *Phenomenology*; see Wyle, "Glastonbury Tor."
33. Ingold, *Perception*.
34. Wylie, "Single Day's"; Cloke and Jones "Dwelling"; Lorimer, "Herding."
35. Wylie, "Landscape, Love," 279.
36. Dubow, "A View In."
37. Merleau-Ponty, *Phenomenology,* XIII.
38. Crouch and Toogood, "Everyday Knowledges"; Dubow, "A View in."
39. Dubow, "A View in," 100.
40. Nash, "Reclaiming Vision," 149; see also Rose, *Feminism*.
41. Jacob, "Ana Mendieta," 8.
42. *Contact: Women and Nature, 30 Contemporary Women*, Hurlbutt Gallery, Greenwich, Connecticut. Selected by Lucy Lippard.
43. Brady, "Aesthetic Regard."
44. Lippard, "Quite Contrary."
45. Viso, *Unseen Mendieta*, 121.
46. Boetzkes, *Ethics*.
47. Cresswell, "Obliteration."
48. Merleau-Ponty, *Phenomenology,* 256; Anderson and Harrison, "Promise," 8.
49. Wylie, "Depths and Folds."
50. See, for example, Whatmore and Hinchliffe, "Ecological Landscapes"; Whatmore, *Hybrid*; Lorimer, *Forces of Nature*.
51. Rose and Wylie, "Animating."
52. Clark, *Inhuman*, Dixon et al., "Of Human Birds."
53. Matless and Revill, "Solo Ecology"; Yusoff and Gabrys, "Times Lapses."
54. Housefield, "Sites of Time."
55. Boetzkes, *Ethics,* 26.
56. Krauss, *Passages*.
57. Boetzkes, *Ethics,* 12.
58. Boetzkes, *Ethics*.
59. Account given in Blocker, *Where Is Ana Mendieta?*; Viso, *Unseen,* amongst other places.
60. This can be linked, as Herzberg does, to Mendieta's earlier imprint studio works, where she "inks" her limbs in blood and drags them down the walls of the studio, "Iowa Years."
61. Cabanas, "Pain"; Blocker, *Where Is Ana Mendieta?;* Jones and Warr, *Body*.
62. Best, "Serial Spaces"; Boetzkes, *Ethics*.
63. Quoted in Best, "Serial Spaces,"75.
64. Viso, *Unseen,* 185.
65. Boetzkes, *Ethics*.
66. Viso, *Unseen*.
67. These ideas are drawn from Elizabeth Grosz's take on Deleuze and Guattari's ideas of the relationship between art and the forces of the earth, Grosz, *Chaos, Territory*.
68. Jones and Warr, *Artist's Body*.

69. Boetzkes, *Ethics,* 146.
70. Rendell, *Art.*

NOTES TO THE CONCLUSION

1. Daniels, "Human Geography," 14.
2. McCormack, "Moving Bodies," 1829.
3. Doherty, *From Studio.*
4. Wright, "Terrae Incognitae."

Bibliography

Abelson, Elaine S. *When Ladies Go A-Thieving: Middle Class Shoplifters in the Victorian Department Store*. Oxford: Oxford University Press, 1992.

Abrahamsson, Christian, and Sebastian Abrahamsson. "A Body Conveniently Known as Sterlac." *Cultural Geographies* 14, no. 2 (2007): 293–308.

Adamson, Glenn. *The Craft Reader*. Oxford: Berg, 2009.

Alberro, Alexander, and Blake Stimson, eds. *Institutional Critique: An Anthology of Artists' Writings*. Cambridge, MA: MIT Press, 2009.

Alfrey, Nick, Stephen Daniels, and Martin Postle. *Art of the Garden: The Garden in British Art, 1800 to the Present Day*. London: Tate, 2004.

Alpers, Svetlana. *The Art of Describing: Dutch Art in Seventeenth Century*. London: Penguin, 1989.

Amin, Ash, and Nigel Thrift. *Cities: Re-Imagining Urban Theory*. Cambridge: Polity Press, 2002.

Anderson, Ben, and Divya Tolia-Kelly. "Matter(s) in Social and Cultural Geography." *Geoforum* 35 (2004): 669–74.

———., and Paul Harrison. "The Promise of Non-Representational Theories." In *Taking-Place: Non-Representational Theories and Geography*, edited by Ben Anderson and Paul Harrison, 1–35. Farnham: Ashgate, 2010.

———, and Paul Harrison. eds. *Taking Place: Non-Representational Theories and Geography*. Farnham: Ashgate, 2010.

———, and John Wylie. "On Geography and Materiality." *Environment and Planning A* 41, no. 2 (2009): 318–35.

Ashmore, Paul, Ruth Craggs, and Hannah Neate. "Working-with: talking and sorting in personal archives." *Journal of Historical Geography* 38, no. 1 (2012): 81–89.

Baignet, Elizabeth, and Felix Driver. "Biography and the history of geography: a response to Ron Johnson." *Progress in Human Geography* 31, no. 1 (2007): 101–106.

Bain, Alison. "Constructing Contemporary Artistic Identities in Toronto Neighbourhoods" *The Canadian Geographer* 47, no. 3 (2003): 303–317.

———. "Female Artistic Identity in Place: The Studio." *Social and Cultural Geography* 5, no. 2 (2004): 179–193.

———. "In/visible geographies: absence, emergence, presence, and the fine art of identity construction." *Tijdschrift voor Economische en Sociale Geografie* 95, no. 4 (2004): 419–426.

Baker, George. "Photography's Expanded Field." *October* 114 (2005): 120–40.

———, and Dawn Ades. *Undercover Surrealism: Georges Bataille and Documents*. Cambridge, MA: MIT Press, 2006.

———. "Roundtable: The Projected Image in Contemporary Art." *October* 104 (2003): 92–93.

Baker, Simon. *The Postmodern Animal*. London: Reaktion, 2000.

———. "Tangible and Real and Vivid and Meaningful: Lucy Kimbell's Not-Knowing About Rats." In *Animal Encounters*, edited by M. Rossini and T. Tyler, 197–218. London: Brill, 2009.

Bal, Mieke. *Louise Bourgeois' "Spider": The Architecture of Art-Writing*. Chicago: University of Chicago Press, 2001.

———. *Quoting Caravaggio: Contemporary Art, Preposterous History*. Chicago: University of Chicago Press, 2001.

———. "Telling objects: a narrative perspective on collecting." In *Museums and the future of collection*, edited by S. Knell, 97–115. Aldershot: Ashgate, 1999.

Balm, Roger. "Expeditionary Art: An Appraisal." *Geographical Review* 90, no. 4 (2000): 585–602.

Barry, Andrew, and Lucy Kimbell. "Pindices." In *Making things Public: Atmospheres of Democracy*, edited by Bruno Latour and Peter Weibel, 872–883, Cambridge, MA: MIT Press, 2005.

Barthes, Roland. *Camera Lucida: Reflections on Photography*. London: Vintage, 1993.

Bataille, Georges. *Visions of Excess: Selected Writings, 1927–39*. Minneapolis, MN: University of Minnesota Press, 1985.

Battista, Kathy, Brandon LaBelle, Barbara Penner, Steve Pile, and Jane Rendell. "Exploring 'An Area of Outstanding Unnatural Beauty': a treasure hunt around King's Cross, London." *Cultural Geographies* 12, no. 4 (2005): 429–462.

Baudrillard, Jean (ed.). *The Consumer Society: Myths and Structures*. Trans. C. Turner. London: Sage, 1991.

Bell, Morag, and Cheryl McEwan. "The Admission of Women Fellows to the Royal Geographical Society, 1892–1914: The Controversy and the Outcome." *The Geographical Journal* 162, no. 3 (1996): 295–312.

Belyea, Barbara. "Images of Power: Derrida/Foucault/Harley." *Cartographica* 29, no. 2 (1992): 1–9.

Benham, Gertrude E. "The Ascent of Mt Assiniboine" *Canadian Alpine Journal*. 1, (1907).

———. "On Foot Across Africa" *The Times* (London) Dec, 20. 1909.

———. "My Tramps in the Himalayas." *Journal of the Madras Geographical Association* 8 (1933): 9–13.

———. "A Woman on Kamet: The Adventure of an Artist" *The* Times (London) Feb, 17, 1932.

Benjamin, Walter. *The Arcades Project*. Cambridge, MA: Harvard University Press, 1999.

Bennett, Tony. "Exhibitionary Complex." *new formations* 4 (1988): 73–102.

Bennett, Jane. *The Enchantment of Modern Life: Attachments, Crossings, and Ethics*. Princeton, NJ: Princeton University Press, 2001.

———. *Vibrant Matter: A Political Ecology of Things*. Durham, NC: Duke University Press, 2010.

Berger, John. *Ways of Seeing*. London: Penguin, 1972.

Best, Susan. "The Serial Spaces of Ana Mendieta." *Art History* 30, no. 1, (2007): 57–82.

———. *Visualising Feeling: Affect and the Feminine Avant-Garde*. London: I. B. Tauris, 2011.

Bhagat Alexis., and Lize. Mogal, eds. *An Atlas of Radical Cartography*. Los Angeles: Journal of Aesthetics & Protest Press, 2008.

Biggs, Iain. *Between Caterhaugh and Tamshiel Rig, a Borderline Episode*. Bristol: Wild Conversation Press, 2004.

Birkett, Dea. *Off the Beaten Track: Three Centuries of Women Explorers.* London: Hardie Grant Books, 2004.

Bishop, Claire. "Antagonism and Relational Aesthetics." *October* 110 (2004): 51–79.

———. *Installation Art: A Critical History.* London: Tate, 2005.

———. *Participation (Documents of Contemporay Art).* Cambridge, MA: MIT Press, 2006.

———. "The Social Turn: Collaboration and Its Discontents." *Artforum* 44, no. 6 (2006): 178–83.

Blocker, Jane. *Where Is Ana Mendieta? Identity, Performativity and Exile.* Durham, NC: Duke University Press, 1999.

Blunt, Alison. *Travel, Gender and Imperialism: Mary Kinsley and West Africa.* New York: Guilford Press, 1994.

———. J. Bonnerjee C. Lipman, Long J. Long, and F. Paynter. "My Home: Text, Space and Performance." *Cultural Geographies* 14, no. 2 (2007): 309–18.

Boetzkes, Amanda. *The Ethics of Earth Art.* Minneapolis, MN: University of Minnesota Press, 2010.

Bois, Yves-Alain, and Rosalind Krauss. *Formless: A User's Guide.* New York: Zone, 1997.

Bondi, Liz ."In Whose Words? On Gender, Identities, Knowledge and Writing Practices." *Transactions of the Institute of British Geographers* 22 (1997): 245–58.

———, and Domosh, Mona. "Other Figures in Other Places: On Feminism, Postmodernism, and Geography." *Environment and Planning D: Society and Space* 10 (1992): 199–213.

Bonehill, John, and Stephen Daniels. *Paul Sandby (1731–1809): Picturing Britain.* London: Royal Academy, 2010.

Bonnett, Alistair. "Art, Ideology, and Everyday Space: Subversive Tendencies from Dada to Postmodernism." *Environment and Planning D: Society and Space* 10, no. 1 (1992): 69–86.

———. "Situationism, Geography, and Poststructuralism." *Environment and Planning D: Society and Space* 7, no. 2 (1989): 131–46.

Bourriaud, Nicholas. *Relational Aesthetics.* Paris: Les Presses du Reel, 2002.

Brace, Catherine, and Adeline Johns-Putra. "Recovering Inspiration in the Spaces of Creative Writing." *Transactions of the Institute of British Geographers* 35, no. 3 (2010): 399–413.

Brady, Emily. "Aesthetic Regard for Nature in Environmental and Land Art. *Ethics, Place and Enviroment* 10, no. 3 (2007): 287–300.

Brett, Guy. "One Energy." *Ana Mendieta: Earth, Body, Sculpture and Performance1972–1985.* Washington, 2004.

Breward, Christopher, and David Gilbert. *Fashion's World Cities.* Oxford: Berg, 2006. Print.

Buchli, Victor. *Material Culture. Critical Concepts in the Social Sciences.* London: Routledge, 2004.

———, and Gavin Lucas. *The Absent Present: Archaeologies of the Contemporary Past.* London: Routledge, 2001.

Buchloh, Benjamin. "Process Sculpture and Film in the work of Richard Serra." In *Richard Serra*, edited by Hal Foster and Gorgon Hughes, 1–19, Cambridge, MA: MIT Press, 2000.

———. "Conceptual Art 1962–1969: From the aesthetics of administration to the critique of institutions." *October* 55 (1990): 105–143.

Bunkse, Edmunds V. "Humboldt and an Aesthetic Tradition in Geography." *Geographical Review* 71, no. 2 (1981): 127–46.

Buren, Daniel. "The Function of the Studio." In *From Studio to Situation*, edited by Claire Dogherty, 15–29. London: Black Dog Press, 2004.

Brunn, Stanley D. "Issues of Social Relevance Raised by Presidents of the Association of American Geographers: The First Fifty Years." *Philosophy & Geography* 1, no. 1 (1998): 93–106.

Burk, Adrienne L. "Beneath and Before: Continuums of Publicness in Public Art." *Social & Cultural Geography* 7, no. 6 (2006): 949–64.

Buskirk, Martha. *The Contingent Object of Contemporary Art*. Cambridge, MA: MIT Press, 2003.

Butler, Judith, Ernst Laclau, and S. Zizek. *Contingency, Hegemony, Universality: Contemporary Dialogues on the Left*. London: Verso, 2000.

Butler, Toby. "A Walk of Art: The Potential of the Sound Walk as Practice in Cultural Geography." *Social and Cultural Geography* 7, no. 6 (2006): 889–908.

———, and Graeme Miller. "Cultural Geographies in Practice: Linked: A Landmark in Sound, a Public Walk of Art." *Cultural Geographies* 12, no. 1 (2005): 77–88.

Buttimer, Anne. "Beyond Humboldtian Science and Goethe's Way of Science: Challenges of Alexander Von Humboldt's Geography." *Erdkunde* 55, no. 2 (2001): 105–20.

———. "Grasping the Dynamism of Lifeworld." *Annals of the Association of American Geographers* 66, no. 2. (1976): 277–292.

Cabanas, Kaira, M. "Ana Mendieta: Pain of Cuba, Body I Am." *Women's Art Journal* 20, no. 1 (1999): 12–17.

Cameron, Laura, and Matt Rogalsky. "Conserving Rainforest 4: Aural Geographies and Ephemerality." *Social and Cultural Geography* 7, no. 6 (2006): 909–26.

Cant, Sarah G., and Nina J. Morris. "Geographies of Art and the Environment." *Social and Cultural Geography* 7, no. 6 (2006): 857–61.

Carpenter, Ele. "Activist Tendencies in Craft" in *Concept Store no 3. Art, Activism and Recuperation, 3*. Bristol: Arnofini, 2010.

Carter, Paul. *Material Thinking: The Theory and Practice of Creative Research*. Melbourne: University of Melbourne. 2004.

Casey, Edward, S. *The Fate of Place: A Philosophical History*. Berkeley, CA: University of California Press, 1998.

———. *Painting and Maps*. University of Minnesota Press, 2002. Print.

———. *Representing Place: Landscape Painting and Maps*. University of Minnesota Press, 2002.

Chare, Nicholas. *Passages to Paint: Francis Bacon's Studio Practice* Parrallax 12, no. 4 (2006): 83–98

Christopherson, Susan. "Beyond the Self-Expressive Creative Worker: An Industry Perspective on Entertainment Media." *Theory, Culture Society* 25, no. 7–8 (2008): 73–95.

Clark, Nigel. *Inhuman Nature: Sociable Life on a Dynamic Planet*. London: Sage, 2010.

Clarke, Timothy, J. *The Site of Death: An Experiment in Art Writing*. New Haven, CT: Yale University Press.

Classen, Constance. "Don't Touch the Art! Touch in the Museum." In *The Book of Touch*, edited by Constance. Classen, 273–88. Oxford: Berg, 2005.

Clearwater, Bonnie, ed. *Ana Mendieta: A Book of Works*. Grassfield: Miami Beach, 1993.

Clifford, James. "The Others: Beyond the 'salvage' paradigm." *Third Text* 3, no. 6 (1989): 73–78.

Cloke, Paul, and Jones, Owen. "Dwelling, Place and Landscape: An Orchard in Somerset" *Environment and Planning A* 33 (2001): 649–666.

Coles, Alex. *Site-Specificity: The Ethnographic Turn*. London: Black Dog, 1999.

Colloredo-Mansfeld, Rudi. "Introduction: Matter Unbound." *Journal of Material Culture* 8 (2003): 245–54.

Colls, Rachel. "Bodiestouchingbodies" *Gender, Place and Culture* 19 (2012): 175–192.

Connor, Steven. Michel Serres' *Cinq Sens*. London: Continuum, 2008.

Cook, Ian, et al. "Follow the Thing: Papaya." *Antipode* 36 (2001): 642–64.

———. "Social Sculpture and Connective Aesthetics: Shelley Sacks's 'Exchange Values.'" *Cultural Geographies* 7, no. 3 (2000): 337–43.

———, and D. P. Tolia-Kelly. "Material Geographies." In *Oxford Handbook of Material Culture Studies*, edited by D. Hicks and M. Beaudry, 99–122. Oxford: Oxford University Press, 2010.

Cork, Richard. "A Brutal End to all Worldly Possessions." *The Times* Feb, 10. 2001.

Cosgrove, Denis. *Geography and Vision: Seeing, Imagining and Representing the World*. London: IB Taurus, 2008.

———. "Ideas and Culture: A Response to Don Mitchell." *Transactions of the Institute of British Geographers* 21, no. 2 (1996): 574–575.

———. "John Ruskin and the Geographical Imagination." *Geographical Review* 69 (1979): 43–62.

———. "Maps, Mapping, Modernity: Art and Cartography in the Twentieth Century." *Imago Mundi* 57 (2005): 35–54.

———. *Mappings*.London: Reaktion Books, 1999.

———. "Prospect, Perspective and the Evolution of the Landscape Idea." *Transactions of the Institute of British Geographers* 10, no. 1 (1985): 45–62.

———. *Social Formation and Symbolic Landscape*. London: Croom Helm, 1984. Print.

———, and Stephen Daniels. *The Iconography of Landscape: Essays on the Symbolic Representation, Design and Use of Past Environments*. Cambridge: Cambridge University Press, 1988.

———, and Veronica Della Dora. *High Places: Cultural Geographies of Mountains and Ice*. IB Tauris, 2008. Print.

———, and William Fox. *Photography and Flight*. London: Reaktion Books, 2010.

Coverley, Merlin. *Psychogeographies*. London: Pocket Essentials, 2006.

Crampton, Jeremy W. "Cartography: A Field in Tension?" *Cartographica* 44, no. 1 (2009): 1–3.

———. "Cartography: Cartographic Calculations of Territory." *Progress in Human Geography* 35, no. 1 (2011): 92–103.

———. "Cartography: Performative, Participatory, Political." *Progress in Human Geography* 33, no. 6 (2009): 840–48.

———. "Cartography: Maps 2.0." *Progress in Human Geography* 33, no. 1 (2009): 91–100.

———, and John Krygier. "Introduction to Critical Cartography." ACME: An International E-Journal for Critical Geographies 4, no. 1 (2006): 11–33.

Crang, Mike. "The Death of Great Ships: Photography, Politics, and Waste in the Global Imaginary." *Environment and Planning A* 42 (2010): 1084–102.

———. "Qualitative Methods: Touchy, Feely, Look-See?" *Progress in Human Geography* 274 (2003): 494–504.

———. "Spaces of Practice: The Work of Michel De Certeau." In *Thinking Space*, edited by M. Crang and N Thrift, 126–40. London: Routledge, 2000.

———. "Visual Methods and Methodologies." In *The Sage Handbook of Qualitative Geography*, edited by D. Delyser, S. Herbert, S. Aitken, M. Crang, and L. McDowell, 208–25. London: Sage, 2010.

Crang, Philip. "Cultural Geography: After a Fashion." *Cultural Geographies* 17, no. 2 (2010): 191–201.

Crary, Jonathan. *Techniques of the Observer: On Vision and Modernity in the 19th Century* Boston , MA: MIT Press, 1992.

Cresswell, Tim. *In Place/Out of Place: Geography Ideology and Transgression.* London: University of Minnesota Press, 1996.

———. "Landscape and the Obliteration of Practice." In *The Handbook of Cultural Geography,* edited by Kay Anderson, Mona Domosh, Steven Pile, and Nigel Thrift, 269–81. New York: Sage, 2003.

———. "New Cultural Geography—an Unfinished Project?" *Cultural Geographies* 17, no.2 (2010): 169–74.

———. *On the Move: Mobility in the Western World.* London: Routledge, 2006.

———. "Value, Gleaning and the Archive at Maxwell Street, Chicago." *Transactions of the Institute of British Geographers* 37 (2012): 164–76.

———. "'You Cannot Shake That Shimmie Here': Producing Mobility on the Dance Floor." *Cultural Geographies* 13, no. 1 (2006): 55–77.

———, and Gareth Hoskins. "Place, Persistence, and Practice: Evaluating Historical Significance at Angel Island, San Francisco, and Maxwell Street, Chicago." *Annals of the Association of American Geographers* 98, no. 2 (2008): 392–413.

Crouch, David. *Flirting with Space: Journeys into Creativity.* London: Ashgate, 2011.

———. "Flirting with Space: Thinking Landscape Relationally." *Cultural Geographies* 17, no. 1 (2010): 5–18.

———. "Spacing, Performing, and Becoming: Tangles in the Mundane" *Environment and Planning A,* 35, no. 11 (2003): 1945.

———. "Spatialities and the Feeling of Doing." *Social and Cultural Geography* 2 (2001): 61–75.

———, and Mark Toogood. "Everyday Abstraction: Geographical Knowledge in the Art of Peter Lanyon." *Cultural Geographies* 6, no. 1 (1999): 72–89.

Cumming, Tim. "Going, Going, Gone." *Guardian Weekly* March, 1, 2002.

———. "Stuff and Nonsense." *The Guardian* 13 Feb. 2002.

Curzon, George. "Address to the Royal Geographical Society 1912." *The Geographical Journal* 40, no. 1 (1912): 1–7.

———. "Address to the Royal Geographical Society 1914." *The Geographical Journal* 42, no. 1 (1914): 1–13.

Daniels, Stephen. "Art Studio" In *The Handbook of Geographical Knowledge,* edited by John Agnew and David Livingstone, 137–148. London: Sage, 2011.

———. *Fields of Vision: Landscape and National Identity in England and the United States.* Princeton, NJ: Princeton University Press, 1993.

———. "Geographical Imagination." *Transactions of the Institute of British Geographers* 36 (2011): 182–187.

———. "Human Geography and the Art of David Cox." *Landscape Research* 9, no. 3 (1984): 14–19.

———. *Humphry Repton Landscape Gardening and the Geography of Georgian England.* New Haven, CT: Yale University Press, 1999.

———. "Love and Death across an English Garden: Constable's Paintings of his Family's Flower and Kitchen Gardens." *The Huntington Library Quarterly* 55, no. 3 (1992): 433–57.

———. "Maps of Making." *Cultural Geographies* 17, no. 2 (2010): 181–84.

———. "Marxism, Culture, and the Duplicity of Landscape." In *New Models in Geography: The Political Economy Perspective,* Vol. 2, edited by N. Thrift and R. Peet, 196–220. London: Unwin Hyman, 1989. Print.

———, Mike Pearson, and Heike Roms H. "Editorial: Fieldworking." *Performance Research* 15, no. 4 (2010): 1–5.

———, Dydia Delyser, Nicholas, J. Entrikin, Douglas, Richardson. *Envisioning Landscape: Making Worlds.* London: Routledge, 2012.

———, and Suzanne Seymour. "Landscape Design and the Idea of Improvement 1730–1914." In *An Historical Geography of England and Wales,*

edited by R. A. Butlin and R. A. Dodgshon, 487–520. London: Academic Press, 1990.

———, and Catherine Nash. "Lifepaths: Geography and Biography." *Journal of Historical Geography* 30 (2004): 449–58.

Dant, Tim. *Materiality and Society*. Maidenhead: Open University Press, 2005.

———. "Materiality and Civilization: Things and Society." *British Journal of Sociology* 57 (2006): 289–308.

Darby, Hugh. C. "The Problem of Geographical Description." *Transactions and Papers (Institute of British Geographers)* 30 (1962): 1–14.

Davies, Gail. "Where Do Experiments End?" *Geoforum* 41, no. 5 (2010): 667–70.

Dear, Michael, Jim Ketchum, Sarah Luria, and Douglas Richardson. *GeoHumanities: Art, History and Text at the Edge of Place*. London: Routledge, 2012.

De Certeau, Michel. *The Practice of Everyday Life*. Berkeley, CA: University of California Press, 1984.

De Duve, Thierry. *Kant after Duchamp*. Cambridge, MA: MIT Press, 1996.

———. "Time, Exposure, and Snapshot: The Photograph As Paradox." *October* 5 (1978): 113–125.

Degen, Monica, DeSilvey, Caitlin and Rose, Gillean. "Experiencing Visualities in Designed Urban Environments: Learning from Milton Keynes." *Environment and Planning A* 40 (2008): 1901–20.

Del Casino, Vincent. Hanna Stephen P. "Beyond the 'Binaries': A Methodological Intervention for Interrrogating Maps as Representational Practices." *ACME* 4, no. 1 (2006): 34–56.

Deleuze, Giles. *Francis Bacon: The Logic of Sensation*. Trans. D. W. Smith. London: Continuum, 2005.

———, and Felix Guattari. *A Thousand Plateaus: Capitalism and Schizophrenia*. London: Althone Press, 1988.

———, and Felix Guattari. *What Is Philosophy?* London: Verso, 1994.

della Dora, Veronica. "Travelling Landscape-Objects." *Progress in Human Geography* 33, no. 3 (2009): 334–354.

Derrida, Jacques. *On Touching—Jean Luc Nancy*. Palo Alto, CA: Stanford University Press, 2005.

DeSilvey, Caitlin. "Art and Archive: Memory-Work on a Montana Homestead." *Journal of Historical Geography* 33, no. 4 (2007): 878–900.

———. "Cultivated Histories in a Scottish Allotment Garden." *Cultural Geographies* 10, no. 4 (2003): 442–68.

———. "Memory in Motion: Soundings from Milltown, Montana." *Social and Cultural Geography* 11, no. 5 (2010): 491–510.

———. "Observed Decay: Telling Stories with Mutable Things." *Journal of Material Culture* 11, no. 3 (2006): 318–38.

———. "Salvage Memory: Constellating Material Histories on a Hardscrabble Homestead." *Cultural Geographies* 14, no. 3 (2007): 401–24.

Dettelbach, Micheal. "The Stimulations of Travel: Humboldt's Physiological Construction of the Tropics." In *Tropical Visions in an Age of Empire*, edited by F. Driver and L. Marins, 43–58. Chicago: University of Chicago Press, 2009.

Deutsche, Rosalyn. *Evictions: Art and Spatial Politics*. Cambridge, MA: MIT Press, 1996.

Dewsbury, John-David. "Seven Injunctions: Performative, Non-Representational, and Affect-Based Research" *Handbook in Qualitative Geography*. Sage, 2010.

———, and Simon. Naylor. "Practicing Geographical Knowledge: Fields, Bodies and Dissemination" *Area* 34 (2003): 253–60.

Dickens, Charles. *Our Mutual Friend*. London: Penguin, 1998 (ed).

Dickens, Luke. "Placing Post-Graffiti: The Journey of the Peckham Rock." *Cultural Geographies* 15, no. 4 (2008): 471–96.

Dittmer, Jason. "Comic Book Visualities: A Methodological Manifesto on Geography, Montage and Narration." *Transactions of the Institute of British Geographers* 35, no. 2 (2010): 222–36.

Dixon, Deborah. "The Blade and the Claw: Science, Art and the Creation of the Lab-Borne Monster." *Social and Cultural Geography* 9, no. 6 (2008): 671–92.

———. "Creating the Semi-Living: On Politics, Aesthetics and the More-Than-Human." *Transactions of the Institute of British Geographers* 34, no. 4 (2009): 411–25.

———, and John-Paul Jones III. "What Next? Guest Editorial." *Environment and Planning A* 36 (2004): 381–90.

———, Harriet Hawkins, and Elizabeth Straughan. "Of Human Birds and Living Rocks: Remaking Aesthetics for Post-Human Worlds." *Dialogues in Human Geography* 3 no. 2 (2012): 249–270.

———. Harriet Hawkins, and Elizabeth Straughan. "Wonder-Full Geomorphology: Sublime Aesthetics and the Place of Art." *Progress in Physical Geography*, 37, no. 2. (2013): 227–247.

———. "When Artists Enter the Laboratory." *Science* 331, no. 6019 (2011): 860.

Dodge, Martin, and Chris Perkins. "The view from Nowhere? Spatial Politics and Cultural Significance of High-Resolution Satellite Imagery." *Geoforum* 40, no. 4 (2009): 497–501.

———, and Rob. Kitchin. "Software, Objects, and Home Space." *Environment and Planning A* 41, no. 6 (2009): 1344–65.

———, and Matt Zook. "How Does Software Make Space? Exploring Some Geographical Dimensions of Pervasive Computing and Software Studies." *Environment and Planning A* 41, no. 6 (2009): 1283–93.

———, Rob Kitchin, and Chris Perkins. *Map Reader: Theories of Mapping Practice and Cartographic Representation*. Hoboken, NJ: Wiley, 2011.

Doel, Marcus. *Post-Structualist Geographies: The Diabolical Art of Spatial Science*. Edinburgh: Edinburgh University Press, 1999.

———, and David. B. Clarke. "Afterimages." *Environment and Planning D: Society and Space* 25, no. 5 (2007): 890–910.

Doherty, Claire. *From Studio to Situation*. London: Black Dog, 2004.

Domosh, Mona. "Towards of Feminist Historiography of Geography." *Transactions of the Institute of British Geographers* 16 (1991): 95–104.

Dorment, Richard. "A Deconstructed Life." *Daily Telegraph Review* 14 Feb. 2001.

Douglas, Mary. *Purity and Danger: An Analysis of the Concepts of Pollution and Taboo*. London: Routledge, 1964.

Driver, Felix. *Geography Militant: Cultures of Exploration and Empire*. Hoboken, NJ: Wiley, 2001.

———. "Hidden Histories Made Visible? Reflections on a Geographical Exhibition." *Transactions of the Institute of British Geographers* (2012): Online first view, 16th May.

———. "On Geography as a Visual Discipline." *Antipode* 35 (2003): 227–231.

———. "Scientific Exploration and the Construction of Geographical Knowledge: Hints to Travellers." *Finisterra*, XXXIII, no. 65 (1998): 21–30.

———. "Visualizing Geography: A Journey to the Heart of the Discipline." *Progress in Human Geography* 19, no. 1 (1995): 123–34.

———, and Luciana. Martins. *Tropical Visions in an Age of Empire*. Chicago London: University of Chicago Press, 2005.

———. et al. *Landing: Eight Collaborative Projects between Artists and Geographers*. London: Royal Holloway, 2002.

———, and Lowri Jones. "Hidden Histories of Exploration: Exhibiting Geographical Collections ." Ed. Society, Royal Geographical. London: Royal Geographical Society with IBG/ Royal Holloway, 2009.

Drobnick, Jim. "Toposmia: Art, Scent, and interrogations of spatiality." *Angelaki* 7, no. 1 (2002): 31–47.

Drucker, Johanna. *The Century of Artists' Books.* New York: Granary Books, Inc., 2004.

Dubow, Jessica. "From a View on the World to a Point of View in It: Rethinking Sight, Space and the Colonial Subject." *Interventions: International Journal of Postcolonial Studies* 2, no. 1 (2000): 87–201.

Duclos, Rebecca. "The Cartographies of Collecting." In *Museums and the Future of Collection*, edited by S. Knell, 49–50. Aldershot: Ashgate, 1999.

Duncan, Carol. *Cilvilizing Rituals: Inside Public Art Museums.* London: Routledge, 1995.

Dunn, Christine E. "Participatory Gis, a People's Gis?" *Progress in Human Geography* 31, no. 5 (2007): 616–37.

Dwyer, Claire, and Gail Davies. "Qualitative Methods III: Animating Archives, Artful Interventions and Online Environments." *Progress in Human Geography* 34 (2010): 88–97.

Dykes, John., Alan M. MacEachren, and M. J. Kraak. *Exploring Geovisualization.* Amsterdam: Elsevier, 2005.

Dyson, Frances. *Sounding New Media: Immersion and Embodiment in the Arts and Culture.* Berkeley, CA: University of California Press, 2009.

Edensor, Tim. "The Ghosts of Industrial Ruins: Ordering and Disordering Memory in Excessive Space." *Environment and Planning D: Society and Space* 23 (2005): 829–49.

———. *Industrial Ruins: Space, Aesthetics and Materiality.* Oxford: Berg, 2005.

———, Deborah Leslie, Steve Millington, and Norma Rantsi (eds.). *Spaces of Vernacular Creativity.* London: Routledge, 2009.

Elkins, James. *Our Beautiful, Dry and Distant Texts: Art History of Writing.* London: Routledge, 2000.

———, and Rachel Z. DeLue. *Landscape Theory.* London: Routledge, 2007.

Elwood, Sarah. and Megan. Cope, eds. *Qualitative GIS.* New York: Sage, 2009.

Elwood, Sarah. "Critical Issues in Participatory GIS: Deconstructions, Reconstructions, and New Research Directions." *Transactions in GIS* 10, no. 5 (2006): 693–708.

———. "Geographic Information Science: Emerging Research on the Societal Implications of the Geospatial Web." *Progress in Human Geography* 34, no. 3 (2010): 349–57.

———. "Geographic Information Science: New Geovisualization Technologies, Emerging Questions and Linkages with GiScience Research." *Progress in Human Geography* 33, no. 2 (2009): 256–63.

———. "Geographic Information Science: Visualization, Visual Methods, and the Geoweb." *Progress in Human Geography* 35, no. 3 (2011): 401–08.

Entrikin, J. Nicholas. "Contemporary Humanism in Geography" *Annals of the Association of American Geographers* 66 (1976): 615–632

Fenton, Jill. "Space, Chance, Time: Walking Backwards through the Hours on the Left and Right Banks of Paris." *Cultural Geographies* 12, no. 4 (2005): 412–28.

Fisher, Jennifer. "Relational Sense: Towards a Haptic Aesthetics." *Parachute* 87, no. 1 (1997): 4–11.

Foster, Hal. "The Archives of Modern Art." *October* 99 (2002): 81–95.

———. "An Archival Impulse." *October* 110 (2004): 3–22.

———. *Compulsive Beauty.* Cambridge, MA: MIT Press, 1995.

———. *Return of the Real: The Avant Garde at the End of the Century.* Cambridge, MA: MIT Press, 1996.

———, Rosalind Krauss, Yve-Alain Bois, Benjamin H. D. Buchloh and David Joselit. *Art Since 1900: Modernism, Antimodernism, Postmodernism.* London: Thames and Hudson, 2011.

Foster, Kate, and H. Lorimer. "Some Reflections on Art-Geography as Collaboration." *Cultural Geographies* 14, no. 3 (2007): 425–32.

Foster, Jeremy. "John Buchan's 'Hesperides': Landscape Rhetoric and the Aesthetics of Bodily Experience on the South African Highveld, 1901–1903." *Cultural Geographies* 5, no. 3 (1998): 323–47.

Foucault, Michel. *Discipline and Punish.* London: Penguin, 1991.

———. *Manet and the Object of Painting.* London: Tate, 2009.

Fox, William. L. *Terra Antarctica: Looking into the Emptiest Continent.* Berkeley, CA: Counterpoint, 2007.

Fraser, David. "'Fields of Radiance': The Scientist and Industrial Scenes of Joseph Wright." In *Iconography of Landscape: Essays on the Symbolic Represenation and Design*, edited by D. Cosgrove and S. Daniels, 119–41. Cambridge: Cambridge University Press, 1988.

Fried, Michael. *Art and Objecthood: Essays and Reviews.* Chicago: University of Chicago Press, 1998.

Frow, John. "Michael De Certeau and the Practice of Representation." *Cultural Studies* 5, no.1 (1991): 52–60.

Fuller, Peter. "The Geography of Mother Nature." In *Iconography of the Landscape*, edited by D. Cosgrove and S. Daniels, 11–31. Cambridge: Cambridge University Press, 1988.

Gabrys, Jennifer, and Kathryn Yusoff. "Art, Sciences and Climate Change: Practices and Politics at the Threshold." *Science as Culture* 21, no. 1 (2011): 1–24.

Gandy, Matthew. "Contradictory Modernities: Conceptions of Nature in the Art of Joseph Beuys and Gerhard Richter." *Annals of the Association of American Geographers* 87, no.4 (1997): 636–65.

———. *Urban Constellations.* London: Jovis, 2012.

Gannon, Suzanne. "The (im)possibilities of writing the self-writing: French Poststructual Theory and Autoethnography. *Cultural Studies: Critical Methodologies* 6, no. 4 (2006): 474–495.

Garrett, Bradley L. "Videographic Geographies: Using Digital Video for Geographic Research." *Progress in Human Geography* 34, no. 4 (2011): 521–541.

Gauntlett, David. *Making is Connecting.* London: Polity Press, 2011.

Gell, Alfred. *Art and Agency: An Anthropological Theory.* London: Claredon Press, 1998.

Gellatly, Anne. F. "Historical records of glacier fluctuations in Mt Cook National Park, New Zealand: a century of change." *Geographical Journal* 151 (1985): 86–99.

Gemtou, Eleni, "Depictions of Sunsets as Information Sources." *Leonardo* 44, no. 1 (2011): 49–53.

Geoghegan, Hilary. "Museum Geography: Exploring Museums, collections and museum practice in the UK." *Geography Compass* 4, no. 10 (2010): 1462–1476.

Gibson, Chris, and Lily Kong. "Cultural Economy: A Critical Review." *Progress in Human Geography* 29, no. 5 (2005): 541–561.

Gibson, Kathy. "Regional Subjection and Becoming." *Environment and Planning D: Society and Space* 19, no. 6 (2001): 639–67.

Gibson-Graham, J. K. "Area Studies after Poststructuralism." *Environment and Planning A* 36, no. 3 (2004): 405–19.

———. *A Postcapitalist Politics.* Minneapolis, MN: University of Minnesota Press, 2006.

Gilbert, Edward. W. "The Idea of the Region." *Geography* 45 (1960): 157–75.

Glacken, Clarence, J. *Traces on the Rhodian Shore: Nature and Culture in Western Thought from the Ancient Times to the End of the Eighteenth Century.* Berkley and Los Angeles, 1967.

Goodchild, Michael F "Geographic Information Systems." *Progress in Human Geography* 12, no. 4 (1988): 560–66.

———. "Giscience, Geography, Form, and Process." *Annals of the Association of American Geographers* 94, no. 4 (2004): 709–14.

Gregson, Nicky. *Living with Things: Ridding, Accommodation, Dwelling.* Oxford: Kingston, 2006.

———, and Crewe, Louise. *Second-Hand Cultures.* Oxford: Berg, 2003.

———, and Vikki Beale. "Wardrobe Matter: The Sorting, Displacement and Circulation of Women's Clothing." *Geoforum* 35, no. 6 (2004): 689–700.

———, Alan. Metcalfe, and Louise Crewe. "Moving Things Along: The Conduits and Practices of Divestment in Consumption." *Transactions of the Institute of British Geographers* 32 (2007): 187–200.

———. "Identity, Mobility, and the Throwaway Society." *Environment and Planning D: Society and Space* 25 (2007): 682–700.

———, Mike. Crang, F. Ahamed, N. Akhtar, and R. Ferdous. "Following Things of Rubbish Value : End-Of-Life Ships, 'Chock-Chocky' Furniture and the Bangladeshi Middle Class Consumer." *Geoforum* 41, no. 6 (2010): 846–854.

Grosz, Elizabeth. *Chaos, Territory, Art.* New York: Columbia University Press, 2008.

———. *Sexual Subversions: Three French Feminists* Sydney: Allen and Unwin, 1989.

———. *Space, Time and Perversion: Essays on the Politics of Bodies.* Sydney: Allen and Unwin, 1995.

———. *Volatile Bodies: Toward a Corporeal Feminism.* Sydney: Allen and Unwin, 1994.

Guattari, Felix. *Chaosmosis: An Ethicoaesthetic Paradigm.* Bloomington, IN: Indiana University Press, 1995.

Guilbaut, Stephen. *How New York Stole the Idea of Modern Art.* Chicago: University of Chicago Press, 1985. Print.

Habermas, Jürgen. "The French Path to Postmodernity: Bataille between Eroticism and General Economics." *New German Critique* 33 (1984): 79–102.

Hail, Barbara, A. "'I saw these things': The Victorian Collection of Emma Shaw Colcleugh." *Arctic Anthropology* 28, no. 1 (1991): 16–33.

Hall, Tim. "Artful Cities." *Geography Compass* November (2007).

———. "Images of Industry in the Post-Industrial City: Raymond Mason and Birmingham." *Ecumene* 4, no.1 (1997): 46–68.

Hallam, Elizabeth and Jennifer Hockey. *Death, Memory and Material Culture.* Oxford: Berg, 2001.

———, and Tim Ingold. *Creativity and Cultural Innovation.* Oxford: Berg.

Haraway, Donna. "Science, Technology, and Socialist-Feminism in the Late Twentieth Century." In *Simians, Cyborgs and Women: The Reinvention of Nature,* 149–81. London: Routledge, 1991.

Harley, J. B. "Cartography, Ethics and Social Theory." *Cartographica* 27, no. 2 (1990): 1–23.

———. "'Deconstructing the Map'." *Cartographica* 26, no. 2 (1989).

———, and Kees Zandvliet. "Art, Science, and Power in Sixteenth-Century Dutch Cartography." *Cartographica: The International Journal for Geographic Information and Geovisualization* 29, no.2 (1992): 10–19.

Harmon, Katherine. *You Are Here. Personal Geographies and other Maps of the Imagination.* Princeton, NJ: Princton Architectural Press, 2003.

Harré, Rom. "Material Objects in Social Worlds." *Theory, Culture & Society* 19 (2002): 23–33.

Harris, Lelia.M., and H.D. Hazen. "Power of Maps: (Counter Mapping for Conservation)." *ACME* 4, no. 1 (2006): 99–130.

Hart, John Fraser. "The Highest Form of the Geographer's Art." *Annals of the Association of American Geographers* 72, no. 1 (1982): 1–29.

Hartwick, Elaine. "Towards a Geographical Politics of Consumption." *Environment and Planning A* 32 (2000): 1177–92.

Harvey, David. "Monument and Myth" *Annals of the Association of American Geographers* 69, no. 3 (1979): 362–81.

———. *Spaces of Hope*. Berkeley, CA: University of California Press, 2000.

Harvey, David. C., Harriet Hawkins, and Nicola Thomas. "Thinking Creative Clusters Beyond the City: People, Places and Networks." *Geoforum*, 43, no. 3 (2012): 529–539.

Harvie, Jennifer. "Witnessing Michael Landy Break Down': Metonymy, affect and politicised performance in the age of global consumer capitalism" *Contemporary Theatre Review* 16, no. 1 (2006): 62–72.

Hatch, Kevin. "'Something Else': Ed Ruscha's Photographic Books" *October* 111 (2005): 107–126.

Hauser, Jens. *Sk-interfaces: Exploding Borders—Creating Membranes in Art, Technology and Society*. Liverpool: Liverpool University Press.

Hawkins, Gay. *The Ethics of Waste: How We Relate to Rubbish*. London. Rowman and Littlefield, 2006.

———. "Plastic Bags: Living with Rubbish." *International Journal of Cultural Studies* 4, no. 1 (2001): 5–23.

———, and Stephen Muecke (eds.). *Culture and Waste: The Creation and Destruction of Value*. Lanham, MD: Rowman, 2003.

Hawkins, Harriet "The Argument of the Eye: Cultural Geographies of Installation Art." *Cultural Geographies* 17, no. 3 (2010): 1–19.

———. "Coastline Convergences: Art-Science Collaborations on the Jurassic Coast." In *Exploratory Laboratory Handbook*, 2012.

———. "Collection as Artistic Practice. The Geographies and Politics of Display." *Womens Studies: An Interdisciplinary Journal* 36, no. 6 (2010): 1–27.

———. "Dialogues and Doings: Sketching the relations between Geography and Art." *Geography Compass* 5, no. 7 (2011): 464–478.

———. "Geography and Art: An Expanding Field: Site, The Body and Practice." *Progress in Human Geography*. 37 no. 1 (2013): 52–71.

———. "Making-Marking. Drawing the Geographical Imagination." *Drawing Permanence and Place*, Bristol: University of the West of England, 2011

———. "Placing Art at the Royal Geographical Society." In *Creative Compass: New Mappings by International Artists*, edited by V. Patel and T.C. Ledda, 7–16. London: Royal Geographical Society, 2010.

———. "Turn Your Trash Into . . . Rubbish, Art and Politics. Richard Wentworth's Geographical Imagination." *Social & Cultural Geography* 11, no. 8 (2010): 805–26.

———. "Visions of Excess: Michael Landy's Break Down and the Work of George Bataille." *Angelaki: Journal of Theoretical Humanities* 15, no. 2 (2010): 19–37.

———, and Annie Lovejoy. *Insites: An Artists' Book*. 2009.

———, and Elizabeth Straughan. *Geographical Aesthetics: Imagining Space and Staging Encounters*. Farnham: Ashgate, 2013.

———, and Elizabeth Straughan. *Midas: The Sight/Sound of Touch*. forthcoming.

Heffernan, Michael J. "Geography, Cartography and Military Intelligence: The Royal Geographical Society and the First World War" *Transactions of the Institute of British Geographers* 21, no. 3 (1996): 504–33.

———. "Politics of the Map in the Early Twentieth Century." *Cartography and Geographic Information Science* 29, no. 3 (2002): 207–226

Herzberg Julia A. "Ana Mendieta: The Iowa Years: A Critical Study 1969–1977." City University Of New York, 1998.

Hessell Tiltman, Marjorie. *Women in Modern Adventure.* London: Harrap, 1934.

Hetherington, Kevin. *The Badlands of Modernity: Heterotopia and Social Ordering.* London: Routledge, 1997.

———. "In Place of Geometry: The Materiality of Place." In *Ideas of Difference*, edited by Kevin Hetherington and Roland Munro, 183–99. Oxford: Blackwell, 1997.

———. "Secondhandedness: Consumption, Disposal and Absent Presence." *Environment and Planning D: Society and Space* 22 (2004): 157–73.

———. "The Unsightly: Visual impairment, Touch and the Parthenon Frieze." *Theory, Culture and Society* 19 (2002): 187–205.

Highmore, Ben. "Benjamin's Trash Aesthetics." In *Everyday Life and Cultural Theory: An Introduction*, 60–74. London: Routledge, 2001.

Hill, Jude. "Travelling objects: The Wellcome collection in Los Angeles, London and beyond." *Cultural Geographies* 13 (2006): 340–366.

Hinchliffe, Stephen. "Inhabiting: Landscapes and Natures." In *Handbook of Cultural Geography*, edited by Kay Anderson, Mona Domosh, Steven Pile, and Nigel Thrift, 207–225. London: Sage, 2002.

Hitchings, Russell. "People, plants and performance: on actor network theory and the material pleasures of the private garden." *Social and Cultural Geography* 4, no. 1 (2003): 99–113

Hollier, Denis. *Against Architecture: The Writings of Georges Bataille.* Trans. Betsy Wing. Cambridge, MA: MIT Press, 1989.

Housefield, James. "Sites of Time: Organic and Geologic Time in the Art of Robert Smithson and Roxy Paine." *Cultural Geographies* 14, no. 4 (2007): 537–61.

Howgego, Raymond, John. *A "Very Quiet and Harmless Traveller": Gertrude Emily Benham, 1867–1938.* Plymouth: Plymouth City Art Gallery, 2009.

Humboldt, Alexander von. *Kosmos: A Sketch of the Physical Description of the Universe.* Baltimore, MD: John Hopkins, 1997.

Hustvedt. Siri. *Mysteries of the Rectangle. Essays on Painting.* Princeton, NJ: Princeton University Press, 2011.

Ingold, Tim. *Lines: A Brief History.* London: Routledge, 2007

———. *The Perception of the Environment: Essays in Livelihood, Dwelling and Skill.* London: Routledge, 2001.

———. "The temporality of landscape."*World Archeology* 25 (1993): 152–174.

Ingram, Mrill. "Washing Urban Water: The Diplomacy of Environmental Art in the Bronx, New York City." *Gender, Place and Culture.* forthcoming, online first view.

Irigaray, Luce. *An Ethics of Sexual Difference.* London: Continnumm, 2005.

Jackson, Shannon. *Social Works: Performing Art, Supporting Publics.* London: Routledge, 2011.

Jackson, Peter. *Maps of Meaning: Introduction to Cultural Geography* London: Unwin Hyman, 1989.

———. "Rematerialising Social and Cultural Geography." *Social and Cultural Geography* 1 (2000): 9–14.

Jacobs, Michael. *The Good and Simple Life: Artist Colonies in Europe and America.* London: Phaedon, 1985.

Jay, Martin. *Downcast Eyes: The Denigration of Vision in Twentieth-Century French Thought* Berkeley, CA: University of California Press, 1993.

Jeffcutt, Paul., and Andy.C. Pratt. (eds.) *Creativity and Innovation in the Cultural Economy.* London: Routledge, 2009.

Johnson, Nuala. "Cast in Stone: Monuments, Geography, and Nationalism." *Environment and Planning D: Society and Space* 13, no. 1 (1985): 51–65.

Jones, Amelia. *Body Art, Performing the Subject.* Minneapolis, MN: University of Minnesota Press, 1998.

———. "Art History/Art Criticism: performing meaning." In Jones, Amelia and Andrew Stephenson. *Performing the Body: Performing the Text.* London: Routledge, 1999, 36–51,

———, and Andrew Stephenson. *Performing the Body: Performing the Text.* London: Routledge, 1999.

———, and Tracy Warr. *The Artists' Body.* London: Phaidon Press, 2012

Jones, Caroline A. *Eyesight Alone: Clement Greenberg's Modernism and the Bureaucratization of the Senses.* Chicago: University of Chicago Press, 2005.

Judovitz, Don. "De-Assembling Vision: Conceptual Strategies in Duchamp, Matta-Clark, Wilson." *Angelaki: Journal of Theoretical Humanities* 7 (2002): 95–114.

kanarinka. "Art-Machines, Body-Ovens and Map-Recipes: Entries for a Psychogeographic Dictionary." *Cartographic Perspectives* 53 (2006): 24–40.

Kaufmann, Thomas, De Costa. *Toward a Geography of Art.* Chicago: University of Chicago, 2004.

Kaye, Nick. *Site-Specific Art: Performance, Place, and Documentation.* London: Routledge, 2000.

Keighren, Innes M. "Geosophy, Imagination, and Terrae Incognitae: Exploring the Intellectual History of John Kirtland Wright." *Journal of Historical Geography* 31, no. 3 (2005): 546–62.

Keltie, John. Scott. *Geographical Education Report to the Council of the Royal Geographical Society.* London: John Murray, 1885.

———. "Thirty Years' Work of the Royal Geo-Graphical Society." *The Geographical Journal* 49, no. 5 (1917): 350–72.

Kester, Grant. *Conversation Pieces: Community and Communication in Modern Art.* Berkely, CA: University of California Press, 2004.

———. *The One and the Many. Contemporay Collaborative Art in a Global Context* Durham, NC: Duke University Press, 2011. Print.

Kinman, Edward L., and John R. Williams. "Cultural Geographies in Practice: Domain: Collaborating with Clay and Cartography." *Cultural Geographies* 14, no. 3 (2007): 433–44.

Knell, Simon. *Museums and the future of collection.* Aldershot: Ashgate, 1999.

Knight, Peter. "Glaciers: Art and History, Science and Uncertainty" *Interdisciplinary Science Reviews* 29, no. 4 (2004): 385–393.

Krauss, Rosalind, E. *Originality of the Avant Garde and Other Modernist Myths.* Cambridge, MA: MIT Press, 1985.

———. *Passages in Modern Sculpture.* Cambridge, MA: MIT Press, 1977.

———. "Richard Serra: A Translation." In *The Originality of the Avant Garde and Other Modernist Myths,* edited by R. E. Krauss, 260–7. Cambridge, MA: MIT Press, 1985.

———. "Richard Serra: Sculpture." In *Richard Serra,* edited by Hal Foster and Gordon Hughes, 1–19. Cambridge, MA: MIT Press, 2000.

———. "Sculpture in the Expanded Field." *October* 8 (1979): 30–44.

Kristeva, Julia. *Powers of Horror (Paper): An Essay on Abjection.* New York: Columbia University Press, 1984.

Krygier, John. B. "Cartography as an Art and a Science?" *The Cartographic Journal* 32, no. 1 (1995): 3–10.

Kurtz, Hilda. "Differentiating multiple meanings of garden and community." *Urban Geography* 22, no. 7 (2001): 656–670.

Kwan, Mei-Po. "Affecting Geospatial Technologies: Toward a Feminist Politics of Emotion'." *The Professional Geographer* 59, no. 1 (2007): 22–34.

———. "Feminist Visualization: Re-Envisioning GIS as a Method in Feminist Geographic Research." *Annals of the Association of American Geographers* 92, no. 4 (2002): 645–61.

———. "Introduction: Feminist Geography and GIS." *Gender, Place and Culture* 9, no. 3 (2002): 261–62.

———. "Is GIS for Women? Reflections on the Critical Discourse in the 1990s." *Gender, Place & Culture* 9, no. 3 (2002): 271–79.

———, and L. Knigge. "Doing Qualitative Research with GIS: An Oxymoronic Endeavor?" *Environment and Planning A* 38 (2006): 1999–202.

Kwon, Miwon "Bloody Valentines: Afterimages of Ana Mendieta." *Inside the Visible: An Elliptical Traverse of 20th Century Art in, of, and from the Feminine.* Ed. de Zegher, Catherine, M. Cambridge, MA: MIT Press, 1996.

———. "One Place After Another: Notes on Site Specificity." *October* 80 (1997): 85–110.

———. *Site Specificity in Art. The Ethnographic Turn.* London: Black Dog Press, 2001.

———. "The Wrong Place." *Art Journal* 59, no. 1 (2000): 33–43.

Lacy, Suzanne. *Mapping the Terrain: New Genre Public Art.* Bay Press, 1995.

Lancaster, William. *The Department Store: A Social History.* London: Leicester University Press, 1995.

Landy, Michael. *Break Down.* London: Art Angel, 2001.

———. *Break Down Inventory.* London: Ridinghouse, 2001.

Landry, Charles. *The Creative City: A Toolkit for Urban Innovators.* London: Routledge, 2008.

Latham, Alan. "Research, Performance, and Doing Human Geography: Some Reflections on the Diary-Photograph, Diary-Interview Method." *Environment and Planning A* 35, no. 11 (2003): 1993–2017.

———, and David Conradson. "The Possibilities of Performance." *Environment and Planning A* 35, no. 11 (2003): 1901–06.

Lees-Maffei, Grace, and Sandino, Linda. "Dangerous Liaisons: Relationships between Design, Craft and Art." *Journal of Design History* 17, no. 3 (2004): 207–220.

Leighly, John. "Some Comments on Contemporary Geographic Method." *Annals of the Association of American Geographers* 27 (1937): 125–41.

Lingis, Alphonso. *The Imperative.* Bloomington, IN: Indiana University Press, 1998.

Lingwood, James, and Michael Morris (eds.). *Off Limits: 40 Artangel Projects.* London: Merrell, 2002.

Lippard, Lucy. "Ana Mendieta, 1948–1985." *Art in America.* November (1985): 190.

———. *The Lure of the Local: Senses of Place in a Multicentered Society.* New Haven 1998.

———. "Quite Contrary: Body, Nature, Ritual in Women's Art." *Chrysalis* 2 (1977): 31–47.

———. *Six Years: The Dematerialization of the Art Object.* Berkeley, CA: University of California Press, 1973.

———. "Sweeping Exchanges: The Contributions of Feminims to the Art of the 1970s." *Art Journal* Fall/Winter (1980): 362–65.

Loftus, Alex. *Everyday Environmentalism: Creating an Urban Political Ecology.* Minneapolis, MN: University of Minnesota Press.

———. "Intervening in the Environment of the Everyday." *Geoforum* 40, no. 3 (2009): 326–34.

Lomax, Yves. *Sounding the Event: Escapades in Dialogue and Matters of Art, Nature and Time.* London: IB Taurus, 2004.

———. *Writing the Image. An Adventure with Art and Theory.* London: IB Taurus, 2000.

Longhurst, Robyn, Elsie Ho, and Lynda Johnston. "Using 'the Body' as an 'Instrument of Research': Kimch'i and Pavlova." *Area* 40, no. 2 (2008): 208–17.

Lorimer, Hayden. "Forces of Nature, Forms of Life: Calibrating Ethology and Phenomenology." Ben Anderson and Paul Harrison. *Taking Place: Non-Representational Theories and Geographies.* Farnham: Ashgate, 2010: 55–78.

———. "Herding Memories of Humans and Animals." *Environment and Planning D: Society and Space* 24 (2006): 497–518.

———. "Telling Small Stories: Spaces of Knowledge and the practice of Geography." *Transactions of the Institute of British Geographers* 28, no. 2 (2003): 197–217.

———, and Fraser McDonald. "A Rescue Archeologgy, Taransay." *Cultural Geographies* 9 (2002): 95–102.

Lowenthal, David. "Geography, Experience, and Imagination: Towards a Geographical Epistemology." *Annals of the Association of American Geographers* 51, no. 3 (1961): 241–260.

———, and Hugh. C. Prince. "English Landscape Tastes." *Geographical Review* 55, no. 2 (1965): 186–222

Löwy, Michael. "Consumed by Night's Fire: The Dark Romanticism of Guy Debord." *Radical Philosophy* 87 (1998): 31–34.

Lübbren, Nina. *Artists' Colonies in Europe 1870–1910.* Manchester: Manchester University Press, 2001.

Lucas, Gavin. "Disposability and Dispossession in the Twentieth-Century." *Journal of Material Culture* 7 (2002): 5–22.

Luckman, Susan. Chris. Gibson, and T. Lea. "Mosquitoes in the Mix: How Transferable Is Creative City Thinking?" *Singapore Journal of Tropical Geography* 30 (2009): 70–85.

Mackenzie, A. Fiona D. "'Against the Tide': Placing Visual Art in the Highlands and Islands, Scotland." *Social and Cultural Geography* 7, no. 6 (2006): 965–85.

———. "Claims to Place: The Public Art of Sue Jane Talyor." *Gender, Place and Culture* 13, no. 6 (2006): 605–27.

———. "Leinn Fhàin Am Fearann? (the Land Is Ours): Re-Claiming Land, Re-Creating Community, North Harris, Outer Hebrides, Scotland." *Environment and Planning D: Society and Space* 24, no. 4 (2006): 577–98.

———. "Place and the Art of Belonging." *Cultural Geographies* 11, no. 2 (2004): 115–37.

———. "Re-Claiming Place: The Millennium Forest, Borgie, North Sutherland, Scotland." *Environment and Planning D: Society and Space* 20, no. 5 (2002): 535–60.

Mackinder, Halford. J. "The Teaching of Geography and History As a Combined Subject." *The Geographical Teacher* 7, no. 1 (1913): 4–19.

Macpherson, Hannah. "Cultural Geographies in Practice: Between Landscape and Blindness: Some Paintings of an Artist with Macular Degeneration." *Cultural Geographies* 15, no. 2 (2008): 261–69.

———. "Non-Representational Approaches to Body–Landscape Relations." *Geography Compass* 4, no. 1 (2010): 1–13.

Maddrell, Avril. *Complex Locations: Women's Geographical Work in the UK 1850–1970.* Oxford: Blackwell, 2009.

Marcoux, Jean-Sebastian. "The Refurbishment of Memory." In *Home Possessions: Material Culture behind Closed Doors*, edited by Daniel Miller, 107–22. Oxford: Berg, 2001.

Marks, Laura U. *The Skin of the Film. Intercultural Cinema and Embodiment.* Durham, NC: Duke University Press, 2000.

————. *Touch: Sensuous Theory and Multisensory Media*. Minneapolis, MN: University of Minnesota Press, 2002.

Martin, F. David. *Sculpture and Enlivened Space. Aesthetics and History*. Lexington, KY: University Press of Kentucky, 1981.

Marples, Morris. *Shanks Pony: A Study of Walking*. London: JM. Dent and Sons, 1946. Print.

Marx, Karl. *Capital*. London: Penguin [1867] 1991.

Massumi, Brain. *Parables for the Virtual: Movement, Affect, Sensation*. Durham, NC: Duke University Press, 2002.

————. *Semblance and Event: Activist Philosophy and the Occurent Arts*. Cambridge, MA: MIT Press, 2011.

Matless, David, and George Revill. "A Solo Ecology: The Erratic Art of Andy Goldsworthy." *Cultural Geographies* 2, no. 4 (1995): 423–48.

Mauss, Marcel. *The Gift*. London: Routledge, 2002.

McCormack, Derek P. "Cultural Geographies in Practice: Drawing out the Lines of the Event." *Cultural Geographies* 11, no. 2 (2004): 211–20.

————. "Geographies for Moving Bodies: Thinking, Dancing, Spaces." *Geography Compass* (2008): 1822–1836.

McEwan, Cheryl. "Cutting Power Lines within the Palace? Countering Paternity and Eurocentrism in the 'Geographical Tradition'." *Transactions of the Institute of British Geographers* 23, no. 3 (1998): 371–84.

Mclafferty, Sara. "Mapping Women's Worlds: Knowledge, Power and the Bounds of GIS." *Gender, Place and Culture* 9 (2002): 263–69.

Mclaren, Holly. *An Art/Geography Collaboration*. Queen Mary University of London, 2007.

Meinig, Donald. W. "Geography As an Art." *Transactions of the Institute of British Geographers* 8, no. 3 (1983): 314–28.

Merchant, Stephanie. "The Body and the Senses: Visual Methods, Videography and the Submarine Sensorium." *Body and Society* 17 (2011): 53–72.

Mereweather, Charles. "From Inscription to Dissolution: In Essay on the Consumption in the Work of Ana Mendieta." *Ana Mendieta*. Ed. Moure, Gloria. Barcelona 1996.

Merleau-Ponty, Maurice. "Eye and Mind." In *Maurice Merleau–Ponty: Basic Writings*, edited by T. Baldwin, 290–324. London: Routledge, 2003.

————. *Phenomenology of Perception*. London: Routledge, 2002 (1945).

————. *The Visible and the Invisible, Followed by Working Notes*. Translated by A. Lingis, 1998 ed. Evanston, IL: Northwestern University Press, 1968.

Merriman, Peter, et al. "Landscape, Mobility, Practice." *Social and Cultural Geography* 9, no. 2 (2008): 191–212.

Meyer, James. *Minimalism: Art and Polemics in the Sixties*. New Haven, CT: Yale University Press, 2004.

Meyer, W. "Making Do and Getting By. The Photographs of Richard Wentworth." *Richard Wentworth*. London, Freiburg, Goppingen, Bonn: British Council, 1997.

Milbourne, Paul. "Everyday (in)justices and ordinary environmentalisms: community gardening in disadvantaged urban neighbourhoods." *Local Environment: The International Journal of Justice and Sustainability* 17, no. 9 (2012): 943–957.

Miles, Macolm. *Art Space and the City*. London: Routledge, 1997.

————. "Aesthetics in a Time of Emergency." *Third Text* 23, no. 4 (2009): 421–33.

————. "Geographies of Art and Environment." *Social and Cultural Geography* 7, no. 6 (2006): 987–93.

————. *Herbert Marcuse: An Aesthetics of Liberation*. London: Pluto Press, 2012.

————. "Representing Nature: Art and Climate Change." *Cultural Geographies* 17, no. 1 (2010): 19–35.

————. *Urban Avant-Gardes.* London: Routledge, 2004.
Miller, Daniel (ed.). *Home Possessions.* Oxford: Berg, 2001.
————. (ed.). *Material Cultures: Why Some Things Matter.* London: UCL P, 1997.
————. (ed.). *Materiality.* Durham, NC: Duke University Press, 2005.
————. *A Theory of Shopping.* Cambridge: Polity, 1998.
Miller, Michael, Barry. *The Bon Marche: Bourgeois Culture and the Department Store, 1869–1920.* Princeton, NJ: Princeton University Press, 1981.
Mitchell, Andrew. *Heidegger and the Sculptors: Body, Space and the Art of Dwelling.* Palo Alto, CA: Stanford University Press, 2010.
Monmonier, Mark. "Cartography: Uncertainty, Interventions, and Dynamic Display." *Progress in Human Geography* 30, no. 3 (2006): 373–81.
Morin, Karen, M. "Peak Practices: Englishwomen's "Heroic" Adventures in the Nineteenth-Century American West." *Annals Association of American Geographers* 89, no. 3 (1999): 489–514.
Morris, Andy. "The Cultural Geographies of Abstract Expressionism: Painters, Critics, Dealers and the Production of an Atlantic Art." *Social and Cultural Geography* 6, no. 3 (2005): 421–37.
Morris, Nina J., and Sarah G. Cant. "Engaging with Place: Artists, Site-Specificity and the Hebden Bridge Sculpture Trail." *Social and Cultural Geography* 7, no. 6 (2006): 863–88.
Morris, Robert. "Notes on Sculpture Part 4: Beyond Objects" *Artforum* April (1969).
Mouffe, Chantal. *The Democratic Paradox.* London: Verso, 2000.
Mulvey, Laura. "The Index and the Uncanny." In *Time and the Image*, edited by Carolyn Bailey Gill, 139–148 Manchester: Manchester University Press, 2000.
————. *Visual and Other Pleasures.* Bloomington, IN: Indiana University Press, 1989.
Myers, Fred. "Some Properties of Art and Culture: Ontologies of the Image and Economies of Exchange." *Materiality.* Ed. Daniel Miller. Durham, NC: Duke University Press, 2005, 88–117.
Nash, Catherine. "Irish Geographies." Nottingham: Djanogly Art Galler, 1996.
————. "Performativity in practice: some recent work in Cultural Geography." *Progress in Human Geography* 24, no. 4 (2000): 653–664.
————. "Reclaiming Vision: Looking at Landscape and the Body." *Gender, Place and Culture* 3 (1996): 149–169.
Nast, Heidi, and Steve Pile. *Places through the Body.* London: Routledge, 1998.
Natter, Wolfgang., and John Paul Jones. "'Response to J. B. Harley's Article 'Deconstructing the Map" *Cartographica* 26, no. 3 (1989).
Neate, Hannah. "Provinciality and the Art World: The Midland Group 1961-1977." *Social and Cultural Geography* 13 no. 3 (2012): 275–294.
Nesbitt, Judith, John Slyce, and Michal Landy. *Michel Landy.* London: Tate, 2004.
Neville, Brian, and Johanne Villeneuve (eds.). *Waste-Site Stories: The Recycling of Memory.* Albany, NY: State University of New York Press, 2002, 1–28.
Nielsen, Tom. "The Return of the Excessive, Superfluous Landscapes." *Space and Culture* 5 (2002): 53–62.
Nigro, Roberto. "Experiences of the Self between Limit, Transgression, and the Explosion of the Dialectical System. Foucault as Reader of Bataille and Blanchot." *Philosophy and Social Criticism* 31 (2005): 649–64.
O'Doherty, Brian. *Inside the White Cube: The Ideology of Gallery Space.* Santa Monica: Lapis Press, 1987.

Ogborn, Miles. "Book Review: Art for the Nation: Exhibitions and the London Public, 1747–2001." *Cultural Geographies* 7, no. 4 (2000): 479–80.

Olkowski, Dorothea., and Gail. Weiss. *Feminist Interpretations of Maurice Merleau-Ponty.* University Park, PA: Penn State University Press, 2006.

O'Sullivan, Simon. *Art Encounters Deleuze and Guattari: Thought beyond Representation.* London: Palgrave, 2009.

Parr, Hester. "Collaborative Film-Making as Process, Method and Text in Mental Health Research." *Cultural Geographies* 14, no. 1 (2007): 114–38.

———. "Mental Health, Ethnography and the Body" *Area* 30, no. 1 (1998): 28–37.

———. "Mental Health, the Arts and Belongings." *Transactions of the Institute of British Geographers* 31, no. 2 (2006): 150–66.

Patel, Vandana, and Teresa Cisneros. *The Creative Compass: New Commissions by Agnes Poitevin-Navarre and Susan Stockwell.* London: Royal Geographical Society, 2010.

Paterson, Mark. "Haptic Geographies: Ethnography, Haptic Knowledges and Sensuous Dispositions." *Progress in Human Geography* 33, no. 6 (2009): 766–788.

———. *Sense of Touch.* Oxford: Berg.

Pearson, Mike. *In Comes I: Performance, Memory and Landscape.* Exeter: Exeter University Press, 2007.

———. *Site-Specific Performance.* London: Palgrave, 2010.

———, and Michael Shanks. *Theatre/Archaeology: Disciplinary Dialogues.* London: Routledge, 2001.

Peck, Jamie. "Struggling with the Creative Class." *International Journal of Urban and Regional Research* 29, no. 4 (2005): 740–70.

Pels, Dick, Kevin Hetherington, and Frederic Vandenberghe. "The Status of the Object: Performances, Mediations, and Techniques." *Theory, Culture & Society* 19 (2002): 1–21.

Penny, Glenn, H. *Objects of Culture Ethnology and Ethnographic Museums.* North Carolina: University of North Carolina Press: 2002.

Perkins, Chris. "Cartography—Cultures of Mapping: Power in Practice." *Progress in Human Geography* 28, no. 3 (2004): 381–91.

———. "Cartography: Mapping Theory." *Progress in Human Geography* 27, no. 3 (2003): 341–51.

Perreault, John. "Mendieta's Body of Work." *Ana Mendieta: A Retrospective.* New York, The New Musuem of Contemporay Art, 1987, 13.

Pevsner, Nikolaus. *The Englishness of English Art.* London: Penguin, 1964,

Phelan, Peggy. *Unmarked: The Politics of Performance.* London: Routledge, 2003.

Phillips, Andrea. "Cultural Geographies in Practice: Walking and Looking." *Cultural Geographies* 12, no. 4 (2005): 507–13.

Phillips, Perdita. "Clotted Life and Brittle Waters." *Landscapes: The International Centre for Landscape and Language* 3, no. 3 (2009).

———. "Doing Art and Doing Cultural Geography: The Fieldwork/Field Walking Project." *Australian Geographer* 35, no. 2 (2004): 151–59.

Phillpot, Clive, "Some Contemporary Artists and their Books" In *Artists' Books : A Critical Anthology and Sourcebook.* ed. Lyons.

Pickles, John. "Ground Truth 1995–2005." *Transactions in GIS* 10.5 (2006): 763–72.

———. *Ground Truth: The Social Implications of Geographic Information Systems.* New York City: Guildford Press, 1995.

———. *A History of Spaces: Cartographic Reason, Mapping and the Geocoded World.* London: Routledge, 2004.

———. "On the Social Lives of Maps and the Politics of Diagrams: A Story of Power, Alchemy, Seduction, and Disappearance." *Area* 37, no. 4 (2006): 355–64.

———. "Tool or Science? GIS, Technoscience, and the Theoretical Turn." *Annals of the Association of American Geographers* 87, no. 2 (1997): 363–72.

Pile, Stephen. *Real Cities: Modernity, Space and the Phantasmagorias of City Life.* Oxford: Sage, 2005.

Pinder, David. "Arts of Urban Exploration." *Cultural Geographies* 12, no. 4 (2005): 383–411.

———. "Cartographies Unbound." *Cultural Geographies* 14, no. 3 (2007): 453–62.

———. "Ghostly Footsteps: Voices, Memories and Walks in the City." *Ecumene* 8, no. 1 (2001): 1–19.

———. "Subverting Cartography: The Situationists and Maps of the City." *Environment and Planning A* 28 (1996): 405–427.

———. "Urban Interventions: Art, Politics and Pedagogy." *International Journal of Urban and Regional Research* 32, no. 3 (2008): 730–36.

———. *Visions of the City: Utopianism, Power and Politics in Twentieth-Century Urbanism.* Edinburgh: Edinburgh University Press, 2005.

Pinney, Christopher. "Things Happen: Or, From Which Moment Does that Object Come?" In *Materiality*, edited by Daniel Miller, 256–72. Durham, NC: Duke University Press, 2005.

Pocock, Douglas C. "Geography and Literature." *Progress in Human Geography* 12, no. 1 (1988): 87–102.

———. ed. *Humanistic Geography and Literature, essays on the expereince of Place.* London: (1981).

Pollock, Griselda. *Vision and Difference: [Femininity, Feminism, and Histories of Art].* London: Routledge and Methuen, 1987.

———. "Encountering Encounter." In *Encountering Eva Hesse*, edited by Griselda Pollock and Vanessa Corby, 13–23. London: Prestel, 2006.

———, and Vanessa Corby eds. *Encountering Eva Hesse.* London: Prestel, 2006.

———, and Sharp, Joanne. "Constellations of Identity: Place-Ma(R)king Beyond Heritage." *Environment and Planning D: Society and Space* 25, no. 5 (2007): 1061–78.

Pratt, Geraldine, and Caleb Johnston. "Turning Theatre into Law, and Other Spaces of Politics." *Cultural Geographies* 14, no. 1 (2007): 92–113.

———. "Nanay (Mother): A Testimonial play" *Cultural Geographies* 17 (2010): 123–133.

Pratt, Mary-Louise. *Imperial Eyes: Studies in Travel Writing and Transculturation.* London: Routledge, 1992.

Prince, Hugh. "Art and Agrarian Change, 1710–1815." In *The Iconography of Landscape*, edited by D. Cosgrove and S. Daniels, 98–118. Cambridge: Cambridge University Press, 1988.

Pudup, Mary Beth. "It takes a Garden: Cultivating citizen-subjects in organsized garden projects." *Geoforum* 39 (2008): 1228–1240.

Rainbird, Sean. *Tacita Dean.* London: Tate, 2005.

Raine, Anne. "Embodied Geographies: Subjectivity and Materiality in the Works of Ana Mendieta." In *Generations and Geographies in the Visual Arts—Feminist Readings*, edited by Griselda Pollock, 228–50. London: Routledge, 1996.

Rancière, Jaques. *The Emancipated Spectator.* London: Verso, 2009.

Rathje, William., and Murphy, Cullen. *Rubbish!:The Archaeology of Garbage.* Tucson Arizona: The University of Arizona Press, 2001.

Raunig, Gerald. *Art and Revolution: Transversal Activism in the Long Twentieth Century.* Los Angeles: Semiotext(e), 2007.

Read, Jason *Micropolitics of Capital: Marx and the Prehistory of the Present.* Albany, NY: SUNY Press, 2003.

Reiss, John. H. *From Margin to Center: The Spaces of Installation Art.* Cambridge, MA: MIT Press, 2001.

Rendell, Jane. *Art and Architecture: A Space Between.* London: IB Tauris, 2006.

———. *Site Writing. The Architecture of Art Criticism.* London: IB Tauris, 2010.

Ritzer, George. *Enchanting a Disenchanted World: Revolutionizing the Means of Consumption.* Thousand Oaks, CA: Pine Forge, 2004.

Robbins, Paul. *Lawn People: How grasses, weeds and chemicals make us who we are.* Philadelphia: Temple University Press, 2008.

Roberts, John. "Introduction: Art, Enclave Theory and the Communist Imaginary." *Third Text* 23, no. 4 (2009): 353–67.

———. "Preface." *Third Text* 23, no. 4 (2009): 351–51.

Rogers, Amanda. "Butterfly Takes Flight: The Translocal Circulation of Creative Practice." *Social and Cultural Geography* 12, no.7 (2011): 663–683.

Rogoff, Irit. "In Conversation." In *From Studio to Situation*, edited by Claire Dogherty, 104–108. London: Black Dog, 2004.

———. *Terra Infirma: Geography's Visual Culture.* London: Routledge, 2000.

Rose, Gillean. "Feminism and Geography." Cambridge: Polity Press, 1993.

———. "On the need to Ask How, Exactly, Is Geography 'Visual'?" *Antipode* 35, no.2 (2003): 212–221.

———. "Situating Knowledges: Positionality, Re-flexivities and Other Tactics." *Progress in Human Geography* 21 (1997): 305–20.

———. *Visual Methodologies: An Introduction to the Interpretation of Visual Materials* London: Sage, 2001.

Rose, Mitch. "Landscape and Labyrinths." *Geoforum* 33 (2002): 455–67.

———, and John Wylie. "Animating landscape." *Environment and Planning D: Society and Space* 24, no. 4 (2006): 475–479.

Roulet, Laura. "Ana Mendieta and Carl Andre: Duet of Leaf and Stone." *Art Journal* 63.3 (2004): 80–101.

Rugg, Judith. *Exploring Site-Specific Art. Issues of Space and Internationalism.* Oxford: IB Tauris, 2010.

———, and Craig Martin, ed., *Spatialities: The Geographies of Art and Architecture.* London: Intellect, 2012.

Rundstrom, Robert A. "Mapping, Postmodernism, Indigenous People and the Changing Direction of North American Cartography." *Cartographica: The International Journal for Geographic Information and Geovisualization* 28, no. 2 (1991): 1–12.

Ryan, James. "'Our Home on the Ocean': Lady Brassey and the Voyages of the Sunbeam, 1878–86." *Journal of Historical Geography* 32 (2006): 579–604.

———. *Picturing Empire: Photography and the Visualizations of the British Empire.* Chicago: University of Chicargo Press, 1998.

Rycroft, Simon. "The Nature of Op Art: Bridget Riley and the Art of Nonrepresentation." *Environment and Planning D: Society and Space* 23, no. 3 (2005): 351–71.

———. *Swinging City: A Cultural Geography of London, 1950–1974.* London: Ashgate, 2011.

———. "Towards an Historical Geography of Nonrepresentation: Making the Countercultural Subject in the 1960s." *Social and Cultural Geography* 8, no. 4 (2007): 615–33.

Sabbatino, Mary. "Ana Mendieta: Silueta Works: Sounds and Influences." *Ana Mendieta (1948–1985)*, 45–49. Helsinki: Helsinki City Art Gallery, 1996.

Said, Edward. *Orientalism.* London: Vintage, 1979,

Sauer, Carl. O. "The Morphology of Landscape." *University of California Publications in Geography,* 2, no. 2 (1925): 19–53.

Scalway, Helen *Moving Patterns.* London: The Royal Geographical Society (2009).

Schuurman, Nadine. "Speaking with the Enemy? A Conversation with Michael Goodchild." *Environment and Planning D: Society and Space* 17 (1999): 1–2.

———. "Trouble in the Heartland: GIS and Its Critics in the 1990s." *Progress in Human Geography* 24 (2000): 569–90.

———, and Mei-Po Kwan. "Introduction: Taking a Walk on the Social Side of GIS." *Cartographica* 39 (2004): 1–3.

Schwabsky, Barry and Calvin Tomkins. *Michael Landy: H2NY.* London: Ridinghouse, 2007.

Serra, Richard. "Tilted Arc: Destroyed." *Art in America* 77, no. 5 (1989): 34–47.

Serres, Michel. *The Five Senses: A Philosophy of Mingled Bodies.* Trans. Cowley, Margaret Sankey and Peter. London: Continuum, 2008.

Seymour, Suzanne. Stephen, Daniels and Charles Watkins. "Estate and Empire: Sir George Cornewall's Management of Moccas, Herefordshire and La Taste, Grenada, 1771–1819." *Journal of Historical Geography* 24, no. 3 (1998): 313–51.

———. "Picturesque Views of the British 'West Indies." *The Picturesque* 10 (1995): 22–28.

Sharp, Joanne. "The Life and Death of Five Spaces: Public Art and Community Regeneration in Glasgow." *Cultural Geographies* 14, no. 2 (2007): 274–92.

Sieber, Renee. "Public Participation Geographic Information Systems: A Literature Review and Framework." *Annals of the Association of American Geographers* 96, no. 3 (2006): 491–507.

Sjöholm, Jenny. *Geographies of the Artist's Studio* London. Squid and Tabernacle, 2012.

Smith, Bernard. *Imagining the Pacific in the Wake of the Cook Voyages* Melbourne: Melbourne University Press, 1992.

———. *European Vision and the South Pacific 1768–1850: A Study in the History of Art and Ideas.* New Haven, CT: Yale University Press, 1988.

Smith, Neil, and Cindi Katz. "Grounding Metaphor: Towards a Spatialized Politics." In *Place and the Politics of Identity,* edited by M. Keith and Steven Pile, 67–83. London: Routledge, 1993.

Smithson, Robert. *The Collected Writings.* Edited by Jack Flam. Berkeley, CA: University of California Press, 1996.

Sobchack, Vivienne. *Carnal Thoughts: Embodiment and the Moving Image.* Berkeley, CA: University of California Press, 2004.

Sobchack, Vivienne, *The Address of the Eye: A Phenomenology of Film Experience.* Princeton: Princeton University Press, 1991.

Solnit, Rebecca. *Wanderlust: A History of Walking.* London: Penguin, 2001.

Sparke, Matthew. "Between Demythologizing and Deconstructing the Map: Shawnadithit's New-Found-Land and the Alienation of Canada." *Cartographica: The International Journal for Geographic Information and Geovisualization* 32, no. 1 (1995): 1–21.

———. "The Look of Surveillance Returns." In *The Map Reader,* edited by M. Dodge, R. Kitchin, and C. Perkins, 430–439. Hoboken, NJ: Wiley, 2011.

Spero, Nancy. "Tracing Ana Mendieta." *Art Forum* April (1992): 75–77.

Stafford, Barbara. *Voyage into Substance: Art, Science, Nature and the Illustrated Travel Account, 1760–1840.* Cambridge, MA: MIT Press, 1984.

Stallabrass, Julian. *Gargantua: Manufactured Mass Culture.* London: Verso, 1996.

———. *High Art Lite: British Art in the 1990s.* London: Verso, 1999.

Stallybrass, Peter. "Marx's Coat." *Border Fetishisms: Material Objects in Unstable Spaces*, edited by Patricia Speyer, 183–207. London: Routledge, 1998.

Stoddart, David R. "Do We Need a Feminist Historiography of Geography—and If We Do, What Should It Be?" *Transactions of the Institute of British Geographers* 16, no. 4 (1991): 484–87.

———. "Geography, Education, Research." *The Geographical Journal* 147, no. 3 (1981): 287–297.

———. "The RGS and the 'New Geography': Changing aims and changing roles in Nineteenth Century Science." *The Geographical Journal* 146, no. 2 (1980): 190–202.

———. "'That Victorian Science': Huxley's Physiography and Its Impact on Geography." *Transactions of the Institute of British Geographers* 66 (1975): 17–40.

Stoller, Paul. *Sensuous Scholarship*. University of Pennsylvania Press: 1997.

Straughan. Elizabeth. "Touched By Water." *Emotion, Space and Society* 5, no. 1 (2012): 19–26.

Sui, Daniel Z. "Visuality, Aurality, and Shifting Metaphors of Geographical Thought in the Late Twentieth Century." *Annals of the Association of American Geographers* 90, no. 2 (2000): 322–43.

———. "The Wikification of GIS and Its Consequences: Or Angelina Jolie's New Tattoo and the Future of GIS." *Computers, Environment and Urban System* 32 (2008): 1–5.

Sunderberg, Erika. *Space, Site, Intervention. Situating Installation Art*. Minneapolis, MN: University of Minnesota Press, 2000.

Tanke. Joseph, J. *Foucault's Philosophy of Art*. New York: Continuum, 2010

Taussig, Michael. *The Nervous System*. London: Routledge, 1992.

Taylor, Brandon. *Collage: The Making of Modern Art*. London: Thames and Hudson, 2004.

Thacker, Edward. "Data Made Flesh: Biotechnology and the Discourse of the Posthuman." *Cultural Critique* 53 (2003): 72–97.

Thomas, Nicola, J. "Embodying Imperial Spectacle: Dressing Lady Curzon, Vicereine of India 1899–1905." *Cultural Geographies* 14, no.3 (2007): 369–400.

Thompson, Michael. *Rubbish Theory: The Creation and Destruction of Value*. Oxford: Oxford University Press, 1979.

Thompson, Nato. *Experimental Geographies: Radical Approaches to Landscape, Cartography, and Urbanism*. Brooklyn, NY: Melville House, 2009.

Thornes, John E. "The Visual Turn and Geography (Response to Rose 2003 Intervention)." *Antipode* 36, no. 5 (2004): 787–94.

Thrift, Nigel. "LifeWorld Inc.—and What To Do About It." *Environment and Planning D: Society and Space* 29, no. 1 (2011): 5–26.

———. *Non-Representational Theory: Space, Politics, Affect*. London: Routledge, 2007.

———. "Summoning Life." In *Envisioning Human Geographies*, edited by Paul Cloke, Mark Goodwin, and Phil Crang, 81–103. London: Arnold, 2004.

Till, Karen. "Artist and Activist Memory Work: Approaching Place Based Practice." *Memory Studies* 1, no. 1 (2008): 99–113.

———. "*Mapping Spectral Traces*." Ed. Tech, Virgina 2010.

———. *The New Berlin: Memory, Politics, Place*. Minneapolis: University of Minnesota Press, 2005.

———. "Wounded Cities: Memory Work and Place-Based Ethics of Care." *Political Geography* 31, no. 1 (2012): 3–14.

Tolia-Kelly, Divya. P. "Fear in Paradise: The Affective Registers of the English Lake District Landscape Re-Visited." *The Senses and Society* 2 (2007): 329–51.

———. "The Geographies of Cultural Geography II: Visual Culture." *Progress in Human Geography* 36, no. 1 (2012): 135–142.

————.–"Mobility/Stability: British Asian Cultures of Landscape and Englishness?" *Environment and Planning A* 38, no. 2 (2006): 341–58.

————. "Participatory Art: Capturing Spatial Vocabularies in a Collaborative Visual Methodology with Melanie Carvalho and South Asian Women in London, UK." In *Participatory Action Research Approaches and Methods: Connecting People, Participation and Place*, edited by Sara Kindon, Rachel Pain, and Mike Kesby, 132–140. London: Routledge, 2007.

————. "Spill: Liquid Emotion and Transcultural Art." *Spill Exhibition Catalogue*. SASA Gallery, 2007.

Toscano, Alberto. "The Sensuous Religion of the Multitude: Art and Abstraction in Negri." *Third Text* 23, no. 4 (2009): 369–82.

Treneman, Alan. "I Who Have Nothing." *Times 2* 19 Dec. 2001: 4.

Trodd, Tamara. "Lack of Fit: Tacita Dean, Modernism and the Sculptural Film" *Art History* 31, no. 3 (2008): 368–86.

Tuan, Yi-Fu. "Literature and Geography: Implications for Geographical Research." In *Humanistic Geography: Prospects and Problems*, edited by David Ley and Marwyn Samuels, 194–206. Chicago: Maaroufa Press, Inc., 1978.

————. *Space and Place: The Perspective of Experience*. University of Minnesota Press, 1977.

Vasselau, Catherine. *Textures of Light: Vision and Touch in Irigaray, Levinas and Merleau-Ponty* London: Routledge, 1998.

Vasudevan, Alexander. "'The Photographer of Modern Life': Jeff Wall's Photographic Materialism." *Cultural Geographies* 14, no. 4 (2007): 563–88.

Virrantaus, Kirsi, David Fairbairn, and Menno-Jan Kraak. "Ice Research Agenda on Cartography and Geographic Information Science." *Cartographica: The International Journal for Geographic Information and Geovisualization* 44, no. 1 (2009): 45–55.

Viso, Olga. *Unseen Mendieta: The Unpublished Works of Ana Mendieta*. Munich: Prestel, 2008.

Waitt, Gordon, and Chris Gibson. "Creative Small Cities: Rethinking the Creative Economy in Place." *Urban Studies* 46, no. 5–6 (2009): 1223–46.

Walker, Joanna S. "The Body Is Present even if in Disguise: Tracing the Trace in the Artwork of Nancy Spero and Ana Mendieta." *Tate Papers* 11 (2009).

Walker, Lynne. "The Royal Geographical Society's House: An Architectural History. *Geographical Journal* 146, no. 2 (1980): 178–189.

Walsh, Maria. "The Immersive Spectator: A Phenomenological Hybrid." *Angelaki, Journal of Theoretical Humanities* 9 (2004): 169–85.

Watkins. John. "Ordinary Miracles" In Watkins, J., editor, *Richard Wentworth, Ordinary Miracles*. London, Japan: Lisson Gallery with Kohji Ogura Gallery, 1992: 1–4.

Watson, John. Wreford. "The Soul of Geography." *Transactions of the Institute of British Geographers* 8, no. 4 (1983): 385–99.

Weiss, Allen. *The Aesthetics of Excess*. Albany, NY: State University of New York Press, 1989.

Weiss, Gail. *Body Images. Embodiment as Intercorpreality*. London: Routledge, 1998.

Weizmann, Eyal. *Hollow Land. Israel's Architecture of Occupation*. London: Verso, 2007.

Wentworth, Richard, and James Lingwood. "In Conversation." In *From Studio to Situation*, edited by Claire Dogherty, 100–109. London: Black Dog, 2004.

————. "Caledonian Road." In *Richard Wentworth*, edited by Gregory Muir, 15–40. London: British Council, 1997.

———. "The Accident of Where I Live: Journeys on the Caledonian Road." In *The Unknown City: Contesting Architecture and Social Space*, edited by Ian Boarden, J. Kerr, and Jane Rendell, 286–305. Cambridge, MA: MIT Press, 2002.

Weyergraf-Serra, Clara, and Martha Buskirk, eds. *The Destruction of Tilted Arc: Documents*. Cambridge, MA: MIT Press.

Whatmore, Sarah. *Hybrid Geographies: Nature, Cultures and Spaces*. London: Sage, 2002.

———, and Steven Hinchliffe. "Ecological Landscapes." In, Hicks, Dan. and M. Beaudry (eds.) *Oxford Handbook of Material Culture Studies*. OUP, Oxford. (2010): 439–454.

Whybrow, Nicolas. *Art and the City*. London: I. B. Tauris, 2010.

Wilson, Matthew W. "Cyborg Geographies: Towards Hybrid Epistemologies." *Gender, Place and Culture* 16, no. 5 (2009): 499–516.

———. "Data Matter(s): Legitimacy Coding and Qualifications-of-Life." *Environment and Planning D: Society and Space* 29, no. 5 (2011): 857–72.

———. "'Training the Eye': Formation of the Geocoding Subject" *Social and Cultural Geography* 12, no. 4 (2011): 357–76.

Wilson, Mick. "Autonomy, Agonism, and Activist Art: An Interview with Grant Kester." *Art Journal* Fall (2007): 107–19.

Withers, Charles W. J. "Science, Scientific Instruments and Questions of Method in Nineteenth-Century British Geography." *Transactions of the Institute of British Geographers* (2012): 38, no.1. 167–179.

———. "Art, Science, Cartography, and the Eye of the Beholder." *Journal of Interdisciplinary History* XLll, no. 3 (2012): 429–37.

Wood, Denis. "The Cartographic Perspectives Catalogue of Map Artists." *Cartographic Perspectives* 53 (2006): 61–67.

Wood, Gaby. "Going for Broke." *The Observer* 18 Feb. 2001: 3.

Woodward, Keith. "Affective Life." *A Companion to Social Geography*. Eds. V. Del Casino, et al. Oxford: Blackwell, forthcoming.

———. "Events, Spontaneity and Abrupt Conditions." In *Taking Place: Non-Representational Theories and Geography*, edited by Ben Anderson and Paul Harrison, 321–40. Hampshire: Ashgate, 2010.

———, John-Paul Jones III, and Sallie Marston. "Of Eagles and Flies: Oreintations toward the Site." *Area* 42 (2009): 271–80.

———, and Jen Lea. "Geographies of Affect." In *The Sage Handbook of Social Geographies*, edited by Susan Smith et al., 154–75. London: Sage, 2010.

———, Marston Sallie, and Jones John Paul. III "Human Geography without Scale." *Transactions of the Institute of British Geographers* 30 (2005): 416–32.

Woolgar, Stephen. "After Word?—On Some Dynamics of Duality Interrogation: Or: Why Bonfires Are Not Enough." *Theory, Culture & Society* 19 (2002): 261–70.

Wright, Chris. "Material and Memory: Photography in the West Solomon Islands." *Journal of Material Culture* 9 no. 1 (2004): 73–85.

Wright, Dawn J., Michael F. Goodchild, and James D. Proctor. "Demystifying the Persistent Ambiguity of GIS as tool Versus science" *Annals of the Association of American Geographers* 87, no. 2 (1997): 346–62.

———. "Reply: Still Hoping to Turn That Theoretical Corner." *Annals of the Association of American Geographers* 87, no.2 (1997): 373–73.

Wright, John Kirtland. "Terrae Incognitae: The Place of the Imagination in Geography." *Annals of the Association of American Geographers* 37 (1947): 1–15.

Wylie, John. "Depths and Folds: On Landscape and the Gazing Subject." *Environment and Planning D: Society and Space* 24, no. 4 (2006): 519–535.

———. "An Essay on Ascending Glastonbury Tor." *Geoforum* 33, no. 4 (2002): 441–454.

————. "Landscape, Absence and the Geographies of Love." *Transactions of the Institute of British Geographers* 34, no. 3 (2009): 275–289.

————. *Landscape*. London: Routledge, 2007.

————. "A Single Day's Walking: Narrating Self and Landscape on the South West Coast Path." *Transactions of the Institute of British Geographers* 30, no. 2 (2002): 342–247.

Yerushamly, Merav. "Performing the Relational Archive." *Photography and Culture* 2, no. 2 (2009): 153–170.

Younghusband, Francis, K. "Natural Beauty and Geographical Science." *The Geographical Journal* 56 (1920): 1–13.

————, Lewis Beaumont, and Lord Curzon. "Address to the Royal Geographical Society: Discussion." *The Geographical Journal* 44, no. 1 (1914): 11–12.

Yusoff, Kathryn. "Antarctic Exposure: Archives of the Feeling Body." *Cultural Geographies* 14 (2007): 211–33.

————, ed. *Bipolar*. London: Arts Catalyst, 2008.

————, and Jennifer Gabrys. "Time Lapses: Robert Smithson's Mobile Landscapes." *Cultural Geographies* 13, no. 3 (2006): 444–50.

Zaring, Jane. "Romantic Face of Wales." *Annals of the Association of American Geographers* 67, no. 3 (1977): 397–418.

Zerefos, Christos.S., V.T. Gerogiannis, D. Balis, et al. "Atmospheric Effects of Volcanic Eruptions as Seen by Famous Artists and Depicted in Their Paintings." *Atomspheric Chemistry and Physics* 7, no. 15 (2007): 4027–42.

Index

Note: Page numbers in *italics* refer to figures.

An environmentally friendly book printed and bound in England by www.printondemand-worldwide.com

#0011 - 270215 - C0 - 229/152/17 [19] - CB